'A romp through the story of an artistic revolution, its love affairs and its rivalries, its squabbles and its wild drinking bouts – and throws in lots of salaciously lip-smacking detail'
The Times, Books of the Year

'Entertaining . . . bringing to life the excitement and impact of genuinely new ideas' *The Times*

'Evocative' *Financial Times*

'A colourful narrative describing the travails and triumphs of an equally colourful cast' *New Statesman*

'Roe is a skilled and graceful writer. An accessible, nimble narrative'
Daily Telegraph

The Private Lives of the Impressionists

Gwen John

In Montmartre

*Picasso, Matisse and Modernism
in Paris 1900–1910*

SUE ROE

PENGUIN BOOKS

PENGUIN BOOKS

UK | USA | Canada | Ireland | Australia
India | New Zealand | South Africa

Penguin Books is part of the Penguin Random House group of companies
whose addresses can be found at global.penguinrandomhouse.com.

First published by Fig Tree 2014
Published in Penguin Books 2015
001

Copyright © Sue Roe, 2014

The moral right of the author has been asserted

Typeset in Dante MT Std by Palimpsest Book Production Ltd, Falkirk, Stirlingshire
Printed in Great Britain by Clays Ltd, St Ives plc

A CIP catalogue record for this book is available from the British Library

ISBN: 978-0-241-95603-8

www.greenpenguin.co.uk

Penguin Random House is committed to a
sustainable future for our business, our readers
and our planet. This book is made from Forest
Stewardship Council® certified paper.

MIX
Paper from
responsible sources
FSC
www.fsc.org FSC® C018179

Contents

Contents

Contents

List of Illustrations

Introduction

Inside the glowing-red simulated windmill, the girls danced the can-can to Offenbach's deafening music, tossing their heads, their petticoats raised in a froth of white as they kicked their legs, revealing tantalizing glimpses of black and scarlet. They performed on the dance floor, mingling with the punters – aristocrats, celebrities, artists, boulevardiers and strangers; in those days there was no raised platform in the Moulin Rouge. In the daytime, on a stage rigged up in the gardens outside, there were open-air performances of singing and dancing, including makeshift ballets danced by the young Montmartroises everyone still called the 'little rats'. To the side of the stage stood a model elephant, an incongruous exhibit left over from the 1889 World Fair, which housed the orchestra. It was at night, however, that the place really came into its own.

When the young Pablo Picasso arrived in Paris in October 1900 he made his way up the hillside of Montmartre to the lodgings he was borrowing from another Catalan artist before heading down to investigate the nightlife. At first, he was dismayed by the Moulin Rouge, finding it tinselly and expensive in comparison with the all-male taverns of Barcelona. He had been expecting artistic bohemia, not cavorting women. His Catalan friends, habitués of Montmartre, usually gathered at the top of the hillside, around the place du Tertre, preferring the shady, cramped little bars where they could drink and talk until dawn. Up there, in the heights of Montmartre, Picasso discovered the other, less outrageous popular dance hall, the old Moulin de la Galette, a real converted windmill where the neighbourhood girls and their beaux still danced into the small hours, as they had in Renoir's day. Here, artists such as Henri Matisse and the Dutch painter Kees van Dongen (whose portraits of women with elongated limbs, monocles and short haircuts would later earn him a central place among modernist artists) went

to sketch the dancers. Nevertheless, it was not long before Picasso succumbed to the allure of the cabarets at the foot of the Butte, where prostitutes spilled out into the streets, strolling along the boulevards. They were among his first Parisian subjects.

A Spaniard, Joseph Oller, had created the Moulin Rouge on the site of the old Reine Blanche. Ingeniously, he constructed it in the shape of a windmill (competition for the old place at the top of the hillside), with eye-catching sails and red electric lighting, opening it under its new name in 1889. He commissioned a painting by Toulouse-Lautrec for the foyer and poached the dancers with the best legs from the Élysée Montmartre. From the day it opened the red 'windmill' became Montmartre's most popular attraction, even in summertime; when Parisians left the city for their country retreats, visitors came in from all over the world, gravitating towards Montmartre in search of cheap cabaret entertainment and lively nightlife. Behind the scenes, the Moulin Rouge traded prostitutes, but the visitors (and their wives) who patronized it saw only the surface gaiety and glamour of the place, enjoying the atmosphere of risqué sensuality without taking any real risk.

As for the performers, they were unforgettable. La Goulue ('Queen of the French Cancan') belted out songs celebrating the low life of Montmartre. Her replacement, Jane Avril, had been treated for hysteria by neurologist Jean-Martin Charcot in his clinic at the Salpêtrière mental hospital before dancing in nightclubs on the Left Bank. She later grew bored of these and came to Montmartre, where she shook off her inhibitions in the Moulin Rouge, spindly legs flying in all directions. She was not interested in material things, she once said, only in *l'amour*.

The poor, the displaced, those who had known destitution, deprivation and suffering, seemed to find a natural home for their talents in Montmartre; the district was already suffused with its own distinctive melancholy. Higher up the hillside – up the narrow steps, past the small, tree-lined squares – windmills still stood among the gardens and vineyards that covered the steep slopes. Though they no longer milled flour, it was to these that the Butte owed its

distinctive, fragile beauty, immortalized in the sketches of van Gogh, who briefly lived there during the 1880s and painted the view from his attic window in shades of greyish blue.

In later years, Picasso looked back with nostalgia on Montmartre, where he lived out the formative years of his career and established the emotional foundations of his work. 'My inner self,' he once said, 'is bound to be in my canvas, since I'm the one doing it . . . Whatever I do, it'll be there. In fact, there'll be too much of it. It's all the rest that's the problem!' The ten years following his arrival in Paris, he painted the world of Montmartre, seen through the prism of his inner life, responding, too, to the emotions and ideas of those who converged on the place during the first decade of the twentieth century – Matisse, André Derain, Maurice de Vlaminck, van Dongen, Modigliani, couturier Paul Poiret and writer Gertrude Stein – each of whom became his friend. They were all inspired by the world of Montmartre, responding to the mood of artistic self-consciousness which had replaced the decadence of the Belle Époque and came to characterize the modern age. 'All the rest' – the plethora of challenges set by the changing social climate, their awareness of the art of the past, the technical demands presented by their rapidly emerging ideas – would increasingly make claims on them.

During the first decade of the twentieth century, art, as well as entertainment, was profoundly influenced by travellers and outsiders. Artists from Spain, Italy, Russia and America converged on Montmartre, providing entertainment, inspiration and fresh social interaction. Newcomers to the artistic scene were brought together by an unlikely nexus of brilliant talents – including Gertrude Stein, Paul Poiret and art dealer Ambroise Vollard – and the decade saw the formation of a new avant-garde. In the village environment at the top of the hillside, in muddy lanes and broken-down shacks, inspired by the circus and silent movies, close to the locals still dancing the night away in the old Moulin de la Galette, the leading artists of the twentieth century spent their early years living among acrobats, dancers, prostitutes and clowns. Their spontaneity,

libertine lifestyles and love of popular culture contributed to the bohemian ambience of *haute* Montmartre and to the development of path-breaking ideas. By the end of the decade Matisse was exhibiting his dynamic works *La Danse* and *La Musique*, Picasso had shocked his friends with *Les Demoiselles d'Avignon*, Poiret was dressing *le tout Paris* in garments inspired by the costumes worn by the performers in the Ballets Russes production of Rimsky-Korsakov's *Scheherazade* and every gallery in Paris was showing cubist art. How did all this come about?

The decade saw the emergence of major artistic discoveries as well as significant social change. In the years following the end of the Belle Époque, young artists weary of decadence and satire were already looking for new subjects and novel, more rigorous methods of painting which reflected their feelings about their lives. As an incomer, Picasso was fascinated by what he saw around him – itinerant circus performers and acrobats, streetwalkers and the day-to-day life of those who lived in the shanty town that was the northern flank of Montmartre. At the foot of the Butte dramatic shifts were beginning to take place in the world of entertainment. During the years immediately following 1900, cinema took over from the circus as a major recreational diversion, and its progression from circus venues to designated spaces and the transition from the earliest silent movies to motion pictures with narrative, featuring popular screen stars, were also profoundly influential; the artists who gathered in Montmartre modelled themselves, for fun, on film stars and comic-book heroes.

In retrospect, it seems that, if the Impressionists had sought to capture on canvas a moment in time, the natural world *en passant*, by contrast, in Montmartre between 1900 and 1910, there was a spirit of iconoclasm at work. With the rise of photography as an artistic medium, the painters' previous ambition of imitating life in art now belonged to photographers and, increasingly, cinematographers. The aim of painting was now to find ways of expressing the painter's own response to life, vividly demonstrated by the early work of Derain, Vlaminck and van Dongen, whose vigorous forms and bold

colours would earn them the nickname '*les Fauves*' ('wild beasts'). With this decade, which witnessed searches for originality and artistic impersonality, came – paradoxically – vibrant personalities. New relationships suddenly seemed possible, between artists and their patrons, their dealers, their lovers – and among the artists themselves. Those who gathered in Montmartre just after the turn of the century soon became competitive and sometimes combative, falling regularly in and out with one other, discovering, exchanging and strategically guarding original ideas. They sought personal freedom and innovative creative directions, yet they were not without nostalgia. In the '*cabaret artistique*' at the top of the Butte, everyone sang the songs of the 1830s, accompanied by Frédé, the proprietor (who sold fish, and the odd painting, from a cart in the daytime), on his guitar. The red-shaded lamps and rough red wine reminded the Catalan artists of home. More significantly, in forming new methods and ideas, the artists also drew on the art of the past – El Greco, the Italian primitives and the classical art of ancient Greece. When African and Indonesian masks and carvings began to appear in Paris, the excitement they caused was heady, and lasting.

As the decade unfolded, artists continued to spur one another on, forming allegiances, making discoveries, sparring and changing sides. Derain and Vlaminck, still painting together in Chatou, a suburb of Paris, in 1900, began to follow Matisse; by 1910, the ideas they were calling into question were Picasso's. Braque was a friend of Marie Laurencin (the only female painter in their circle) before he began working closely with Picasso – who loathed her. Paul Poiret, the first couturier to treat fashion as an art form and to compare himself with the painters of his circle, knew Derain and Vlaminck from the early days, when all three lived by the Seine in Chatou; within a few years, the designer was throwing huge parties, inviting Picasso and his friends to gatherings on the colossal houseboat he kept moored on the river. Gertrude Stein sat for Picasso ninety times (or so she claimed) in the beaten-up Bateau-Lavoir, making her way every week from the Left Bank to Montmartre. Intrigued and inspired by Picasso, she began giving her famous soirées; then

the artists came to her. Against the backdrop of continual discussion in the cafés and bars of Montmartre, the subtle almost-feud between Matisse and Picasso played itself out in continual stand-offs and rapprochements as the world of artistic Paris evolved – as Alice B. Toklas once put it – 'like a kaleidoscope slowly turning'. By the end of the decade, the Futurists were launching their plangent appeal for aggressive action, announcing 'a new beauty: the beauty of speed', calling for the radical renovation of techniques of painting and denouncing all forms of imitation. In Montmartre, much of what they dreamed of was already happening.

The years that saw the birth of modern art in Paris were those directly following the turn of the century, *before* the Great War. By 1910, Paris had become a hive of creative activity in which all the arts seemed to be happening in concert. The cross-fertilization of painting, writing, music and dance produced a panorama of activity characterized by the early works of Picasso, Braque, Matisse, Derain, Vlaminck and Modigliani, the appearance of the Ballets Russes and the salons of Gertrude Stein. The real revolution in the arts first took place not, as is commonly supposed, in the 1920s, to the accompaniment of the Charleston, black jazz and mint juleps, but more quietly and intimately, in the shadow of the windmills – artificial and real – and in the cafés and cabarets of Montmartre during the first decade of the twentieth century. The unknown artists who gathered there and lived closely overlapping lives are now household names. This book tells their story.

The World Fair and Arrivals

The Arrival of Picasso

On 14 April 1900, Paris was transformed into a vast garden shimmering with light, glass and steel. Visitors flocked in from all over the world for the World Fair, opened by President Loubet of France to the sound of the Marseillaise. The public approached through the Porte Binet, an exotic red and gold archway on the place de la Concorde, lit up at night with thousands of multicoloured electric lights. Before the close of the fair in October, a group of Catalan artists arrived, four of them posing beneath the archway, arms clasped, while the fifth, Pablo Picasso, made a quick sketch of his friends. He added himself in at the front of the group, marking himself, in the drawing, 'Me'. He had just arrived in Paris for the first time, to see his painting *Last Moments* displayed at the fair.

The streets bustled with visitors to the exhibition halls, which stretched across the city in the shape of a letter 'A', from the École Militaire to the Trocadéro. The traffic was infernal, the rumble of horses pulling carriages across the cobbles almost deafening. For the 39 million visitors to the fair, the most popular exhibit was the Palace of Electricity, which transformed the old Trocadéro (now the Musée de l'Homme) into a dazzling, animated display. At night, even the River Seine sparkled, the boats strung up with electric lights. The *grands cafés* hummed with visitors. The *chanteuses* still sang, some nights, in décolleté sea-green dresses and long black gloves perhaps, at the Café des Ambassadeurs. Night and day, stylish women strolled along the boulevards, dressed by Doucet or Worth in heavy satins and silks with nipped-in waists, bustles and hats top-heavy with ornamental feathers or flowers. The streets were no less decorative. In the *grand avenues*, art nouveau – *le style 1900* – predominated, embellishing the apartment buildings, façades and interiors of cafés, shops and bars and the entrances to the newly

constructed Métro stations. The interiors of the *grands cafés* boasted ornate gildings and friezes in the new style, intertwined sheaves of corn and laurel leaves set off by glittering mirrors and chandeliers.

In the immense hall of the Salle des Fêtes, Gaumont news was being projected on to a gigantic screen, with spectacular close-ups and the earliest examples of synchronized sound. 'Every member of the audience,' marvelled one visitor, 'had a listening-tube, hung on the back of the seat in front, with a pair of little knobs that you placed in your ears; at the other end of the listening-tube a phonograph played a text synchronized with the pictures.' Gaumont, Pathé Lumière and Raoul Grimoin-Sarran all showed films at the fair, taking the opportunity to show off their most spectacular technical advances. Lumière, in particular, showcased the company's stunning developments in colour photography, *'visions d'art'*, photographic stills tinted with 'natural' colour – 'roses twelve feet in diameter, delicately shaded, finely modelled, so subtle and elegant!' Outside, American dancer Loïe Fuller, pioneer of improvisation, performed her serpentine moves in her booth (rejected by the Paris Opèra, she was appearing as a curiosity at the fair), her coloured drapery eerily lit, and making her look (as someone remarked in passing) like a human bat . . .

The *Guide Hachette* made great claims – 'the Fair shows the ascent of progress step by step – from the stagecoach to the express train, the messenger to the wireless and the telephone, lithography to the x-ray, from the first studies of carbon in the bowels of the earth to the advent of the airplane . . . It is the exhibition of the great century, which opens a new era in the history of humanity.' Entire streets had been transformed into simulated colonial dwellings; pavilions from across the world exhibited national products, electric lights, hot-air balloons, experimental flying machines, and arts and crafts. High in an insignificant corner of the Spanish pavilion hung Picasso's *Last Moments*.

Picasso arrived in Paris two weeks before the close of the Fair, on 25 (his nineteenth birthday) or 26 October. He had travelled from

Barcelona with his friend Carles Casagemas, a moody fellow painter with a taste for Nietzsche and a tendency to depression and anarchy; he was linked with the Spanish liberation movement. They arrived by way of the Gare d'Orsay, and made their way along the bank of the river, heading for Montmartre. In Barcelona, they had been fitted out for the occasion by a local tailor in arty black corduroy suits with loose jackets and high collars designed to hide the absence of a waistcoat (even, if times got really hard, a shirt). The wherewithal for Picasso's trip had been provided by his parents, who by the time they saw him off at the station had little more than the loose change in their pockets to see them through to the end of the month. The local newspaper, notified most likely by Picasso himself, had duly announced the departure for the French capital of two of Barcelona's most promising young artists.

On the Left Bank they briefly stopped off to visit a friend in Montparnasse before crossing the river and making their way to the Butte de Montmartre, either on foot or perhaps by omnibus. If the latter, they would have taken the Batignolles–Clichy–Odéon *imperiale*, pulled by three dappled grey horses, the cheapest 'seats' buying its passengers a place on the crowded roof, legs dangling, along the boulevard Rochechouart, past the old model market in the place Pigalle (where 'types', all got up in various costumes – shepherdesses, Marie Antoinettes, harlequins – could be hired for genre paintings), then on up the steps of the hillside; some of the pair's friends from Barcelona were living there in small studios. They hauled their luggage up as far as the grandly named Hôtel Nouvel Hippodrome (probably in fact a *maison de passe*) in the rue Caulaincourt, which was lined mainly with shacks and brothels. There they left their possessions, before continuing the climb up the hillside as far as the rue Gabrielle, where at number 49 their friend Isidre Nonell, a painter of sad-faced women, kept a studio. In Montmartre they found themselves in a hilltop village with squat crumbling houses, vineyards and squares bordered with chestnut trees, the outlooks plunging down into the mists of Paris, where life was lived slowly and quietly, like going back in time. On low green benches

old bohemians sat watching the world go by, while the local urchins ran about, scruffy dogs wandered here and there and sparrows pecked in the dirt. The artists who gathered in the cafés were mainly Catalans, poets and aspiring *amateurs*.

When Picasso went down to the fair to see his painting, the artists who accompanied him were his travelling companion, Carles Casagemas; Ramon Casas, a society portraitist who painted the political and financial elite of Barcelona; Miquel Utrillo, artist, writer and shadow puppeteer; and Ramon Pichot, whose works showed the influence of Gauguin's Pont-Aven paintings. (Pichot owned a dilapidated, rose-coloured cottage in Montmartre, near the rue Cortot, where, at number 10, in the 1880s, both Gauguin and van Gogh had once briefly lived.) Casas, Utrillo and Pichot were all ten or more years Picasso's senior, all old habitués of Montmartre. Another of their crowd was a ceramicist, Paco Durrio, who had been in the area since van Gogh and Gauguin's day. He still had paintings by the latter in his studio (from the Pont-Aven years), which he pulled out at any time of the day or night for anyone who wanted to see them – until, one day, they mysteriously disappeared.

In the Spanish pavilion, Picasso discovered that his traditional depiction of a Spanish deathbed scene was not prominently displayed (the picture no longer exists, as he later painted over it). The Catalan friends progressed to the Grand Palais, the glorious, purpose-built exhibition hall (not really a palace) which, in architectural terms, was the most notable feature of the 1900 World Fair. An example of late-Beaux-Arts splendour, it was part of the newly built complex comprising the Grand Palais, the Petit Palais and the Pont Alexandre III, which had been designed to celebrate the Franco–Russian alliance signed in 1894 and opened to coincide with the commencement of the fair. Inside were displays of major works of art, the French section dominated by the work of academic painters from the École des Beaux-Arts: portraits, landscapes and seascapes, religious scenes, draped nudes and historical tableaux. The 'modern' section (consisting of eighteenth- and early- to

mid-nineteenth-century work by David, Delacroix, Ingres, Daumier, Corot and Courbet) hardly represented the avant-garde. Impressionism – brought before the public in the form of the collection bequeathed by Gustave Caillebotte as recently as 1896, was represented only by Manet's *Le Déjeuner sur l'herbe* and Monet's *Water Lilies*. Works by James Ensor and Gustav Klimt were shown by foreign exhibitors, but there was no trace here of anything by Gauguin or van Gogh, both of whom were still considered subversive or dismissed as mere poster artists. In Paris, their works were barely talked about and almost never seen, except occasionally in the small galleries in Montmartre.

When Picasso saw the exhibition of modern (as opposed to ancient) French masterpieces in the Grand Palais he found his first glimpses of David, Ingres and Delacroix awe-inspiring; he was hardly sufficiently *au fait* with French modern art to notice the absence of contemporary work. Soon after his arrival in Paris, he made his first visit to the Louvre, where he marvelled at the works of ancient Egypt and ancient Rome. In the Musée du Luxembourg, he saw Caillebotte's collection of Impressionist art, acquired in June 1894, which it had taken the museum two years to put on display. The professors of the École des Beaux-Arts had threatened to resign if the legacy was accepted, so the State had accepted only part of the collection – eight works by Monet, three by Sisley, eleven by Pissarro, one by Manet and two by Cézanne. Picasso was dazzled by his first glimpse, particularly, of works by Monet and Pissarro; though he had begun to study new ways of painting light in Barcelona, he had seen nothing like this. What mostly impressed him as he explored the streets of Paris, however, was the poster art. Posters by Steinlen – the Swiss-born painter who painted scenes of low-life Montmartre (couples kissing on street corners, or huddled together in bars), and publicity material for the cabaret where the literati gathered, the Chat Noir (including the still-famous poster featuring the alarming black cat with yellow eyes) – and Toulouse-Lautrec, who brought the life of the *café-concerts* to the streets, were pasted on every wall, even in the poorest districts. Picasso

could see immediately that these quasi-anarchist depictions of urban reality were not merely decorative or provocative but progressive works of art.

By the time he made his first visit to the French capital, Picasso was already an accomplished draughtsman. As a young child in Malaga he had been taught to draw by his father, José Picasso, an art teacher and curator of the municipal museum. Since his schooldays, young Picasso had shown little aptitude for anything but drawing. He seems to have been happy in Malaga; asked once to name something characteristic of his native city, he recalled a singing trolley-car conductor who slowed and increased the speed of the car to fit the rhythms of his song, sounding his bell in cadence as he bowled along. But he was insecure at school, uninterested in his lessons and obsessed by the worry that his parents would forget to collect him at the end of the day. He always took something of his father's to school – his cane, or a paintbrush – to be sure of being redeemed along with the treasured object. When he was thirteen, his eight-year-old sister, Conchita, died of diphtheria. The family moved to Barcelona, where his father accepted a job at the art college, but he was never happy there: life in Barcelona was overshadowed for both parents by the loss of their daughter. Pablo, however, seemed resilient. He attended classes at the art college, where, aged just fourteen, he produced two portraits of old Galician villagers which demonstrated not only his extraordinary drawing skills but also, it was remarked, an unusual degree of psychological observation for one so young.

In autumn 1897, he left Barcelona to attend the Royal Academy of Fine Arts in Madrid, where his education was traditional and rigorous. Students practised first with two-dimensional images, then with plaster casts, before working from life, learning technique partly by consulting the drawing manuals left open in the studios at pages showing perspective schemes, geometric shapes or drawings of eyes, arms and noses, Greek and Roman statues and examples of bones, musculature and veins. Thus, by the time he graduated,

Picasso already possessed a strong and varied artistic vocabulary, the result of a thorough classical training.

In spring 1898, he experienced the ways of life in rural Spain after falling ill with scarlet fever. Sent to the countryside to convalesce, he spent June of that year with the family of a friend in Horta, a tiny, deserted village where life was still essentially feudal. There, he learned to speak Catalan, living in the countryside and working in the open air. The experience had a profound effect on him; rural life and the sense of freedom from material considerations suited him; he later said he had learned everything he knew in Horta, where day-to-day experiences included attendance at a village autopsy. Picasso saw one performed on an elderly woman who had been struck by lightning; he fled before watching that of the woman's granddaughter, who had suffered the same fate. Perhaps the experience of seeing the body segmented informed his later, cubist vision. Norman Mailer thinks so, though Picasso's cubist style emerged much later, some ten years after the village experience. (Picasso was not the only painter to have observed a village autopsy: Cézanne had seen them, too, in his native Provence.)

When he returned to Barcelona in February 1899, no longer a student, Picasso was ready to embark on his career as a professional artist. He shared a studio with the moody Casagemas, both of them trying to make their way as graphic artists, illustrating posters and restaurant menus and painting scenes of local life, vignettes of cabaret performers, boulevardiers, priests, street orators and musicians, dancers and poets. Picasso was good at these; some of the older artists called him 'little Goya'.

In Barcelona, the lives of the city's artists revolved around Els Quatre Gats, a large tavern decorated with ornamental tiles in the traditional Spanish style in a narrow cobbled alley running between high buildings in the then unfashionable old part of town. 'The Four Cats' was a Catalan expression meaning (approximately) 'the only four cats in town'; the tavern's educated, well-connected clientele saw itself as exclusive. Here, everyone gathered to display new work and to debate the issues of the various strands of Catalan

'*modernisme*', which was broadly Symbolist – depictions of loss, yearning and erotic desire inscribed within religious and mythological iconography; the Els Quatre Gats crowd prided itself on its knowledge of the Decadents and on its own intellectualism. The basis of their ideas was as much literary as pictorial; they craved bohemianism, art for art's sake, decadence, the libertine life of the 'moderns', a break from the traditions and prejudices of the bourgeoisie (their parents). Their own national modern artist, Gaudí, they dismissed as too conservative (his architectural eccentricities had been found acceptable by the establishment). They read the Symbolist poets, Verlaine, Mallarmé and Baudelaire, all of whose work Picasso was familiar with. Their idea of Paris was bars and *café-concerts*, nightlife and wild women.

Paris was the artistic mecca of the world, and many of the Els Quatre Gats crowd made regular visits to the French capital. Back home in Barcelona, they mounted exhibitions of their work (landscapes of local scenes and portraits of one another wearing bohemian scarves and large overcoats, paintbrushes sticking out of their pockets) and dreamed of Paris, since the tavern in Barcelona offered neither the decadence nor the overt sexual appeal of the French *boîtes* or café-bars; and no woman would ever have been seen in Els Quatre Gats. In Barcelona, there were brothels behind closed doors, but prostitutes would never be seen openly drinking in the taverns or strolling through the streets, as they were in Montmartre.

As for '*modernisme*', Picasso's biographer John Richardson explains the vagueness of the term, the word perhaps best described as 'Catalan art nouveau with overtones of symbolism', and believes that the eclectic intellectual, artistic and literary movement was essentially born out of the *Renaixença*, or Catalan Cultural Revolution – the recognition that the region was closer in its cultural aspirations to the rest of Europe than to the conservative values and beliefs of Spain. A group of artists from Els Quatre Gats, including Picasso's friends Ramon Casas and Miquel Utrillo, had been instrumental in promoting the values of the Catalan Cultural Revolution,

especially since spending time in Montmartre, where in 1891 they had lived for a while in an apartment above the Moulin de la Galette. Utrillo had an even longer association with Montmartre. In the early 1880s, he had lived there with Suzanne Valadon, the daughter of an unmarried laundress who had been the mistress of Toulouse-Lautrec (and, briefly, Erik Satie) before meeting Utrillo. She had trained as a tightrope walker before her career as a circus performer came to an abrupt end when she fell and injured her leg. She had also modelled for Degas, who discovered her talent as an artist, effectively launching her career as a painter. In 1883, she had produced a son, Maurice, rumoured to be the child of Utrillo, but, though he signed the paternity papers, she continually taunted her son by refusing to tell him who his father was.

In Spain, the group of '*modernistes*' had founded an arts centre in Sitges, a village twenty-five miles from Barcelona, where they had held a series of exhibitions and concerts which became a *festa modernista* of art, music and drama. In an introduction to one of the first concerts, they announced their aims and intentions: 'to translate eternal verities into wild paradox; to extract life from the abnormal, the extraordinary, the outrageous; to express the horror of the rational mind as it contemplates the pit . . .'; they had all read Nietzsche and Rimbaud. 'We prefer to be symbolists and unstable,' the speech went on, 'and even crazy and decadent, rather than fallen and meek . . .' As John Richardson also points out, unfortunately, they were none of them sufficiently skilled or imaginative to be able to transpose such ideas into paint . . . except for Picasso. It would not take the local artists and writers in Montmartre long to notice that here was someone who painted in a way no one had seen before.

On their first evening in Paris, Picasso and Casagemas wrote home. They were disappointed by the nightlife, Picasso's friend reassured his parents: the famed *boîtes* at the foot of the hillside seemed to them nothing but fanfare and tinsel, papier mâché stuffed with sawdust; it was all too showy and expensive for them – entry to the cheapest *palais de danse*, even the cheapest theatres, was steep, at

one franc. So far, their dream of Paris seemed to have little to do with the reality. Amorous couples like the ones Steinlen depicted in his paintings stood entwined after dark in the rue Saint-Vincent, a narrow alley beyond the rue Cortot where the single sputtering gas jet could be relied upon to fizzle out no sooner than it was lit. Aristide Bruant, in his day, had sung songs about this street, but this was not the Montmartre of la Goulue and the Moulin Rouge. Montmartre at the top of the hillside consisted of crumbling houses, tiny, cramped studios in dilapidated buildings, shabby cafés and gloomy bars smelling of soup and cheap red wine.

Down at the foot of the hillside, Picasso and Casagemas explored the boulevard de Clichy, finding it 'full of crazy places like Le Néant, Le Ciel, L'Enfer, La Fin du Monde, Les 4 z'Arts, Le Cabaret des Arts, Le Cabaret de Bruant – and a lot more which had no charm but made lots of money: a Quatre Gats here would be a goldmine . . .' As for the Folies Bergère and the Moulin Rouge, if they entered those dens of vice, where the crowd exploded with excitement while the female performers high-kicked and did the splits, such places went unmentioned in the letters home. The two friends had certainly, in any case, discovered some of the least salubrious places in Montmartre. Most 'cabarets' were merely small rooms, sparsely furnished with rough tables and benches behind unprepossessing shopfronts, the exception being L'Enfer, where the façade was as startlingly gothic as the entrance to a fairground ghost train. Compared to Els Quatres Gats, the lesser known *boîtes* in Montmartre were poky, tawdry and unexciting.

Casagemas continued his description of life in Paris with a long (surely spoof) inventory of Nonell's studio. Apparently, it boasted a table, a sink, two green chairs, one green armchair, two non-green chairs, a bed 'with extensions'. A corner cupboard (not corner-shaped), two wooden trestle tables supporting a trunk, an oil lamp, a Persian rug, twelve blankets, an eiderdown, two pillows and lots of pillow cases . . . the list went on. (Perhaps it was just a playful recitative, written to entertain or reassure their families.) He omitted to add that three girls also seemed to be included. After a few

days, Nonell returned from Barcelona, which now made three couples living in his studio. Picasso's girl, who soon disappeared from his life, spoke no Spanish (nor he any French) and seems to have been called Odette. There were cooking utensils, wine glasses, bottles, flowerpots, a kilo of coffee . . . If the place really did contain everything Casagemas itemized, they were living in the lap of luxury by comparison with most of the surrounding dwellings in the heights of Montmartre.

2.

In Montmartre

'*À la moule!*' Frédé, with his long, matted beard, in battered felt hat and wooden clogs, came clumping through the lanes with Lolo the donkey, pulling a cart selling shellfish and the odd painting. '*Voilà le plaisir, mesdames! . . . Du mouron pour les petits oiseaux!* [seeds for your little birds] . . . *Tonneaux, tonneaux!* [sticks for your batons, for fire-lighting, or tightrope-walking] . . . *Couteaux! Couteaux!* [any knives, for sharpening?]' Only the sounds of the merchants pushing their carts up the steep, muddy lanes, some of them mothers accompanied by dishevelled children, resonated against the peace and quiet of the hillside, undisturbed by traffic. Horse-drawn carriages did not get up as far as the top; even the *funiculaire* would not arrive until 1901. The area at the summit of the Butte was still a rural village, despite its attachment to Paris. It had hung on to its vineyards and scrubland; the water carrier still trudged through the streets, buckets suspended from a wooden pole across his shoulders; in the allée des Brouillards, women in plain, ankle-length skirts and simple blouses gathered water at the communal pump. Urchins played in the unpaved streets. Some of the small, shady restaurants in the lanes around the place du Tertre were little more than soup kitchens, where artists could invariably get a bowl of soup or a carafe of wine on credit. In the shops selling bric-a-brac, with jumbles of old chairs, clocks and cooking utensils piled up outside, you might still find the odd painting by Renoir or Manet. It had been known.

The indigenous population of Montmartre consisted largely of small tradesmen, entertainers, petty criminals, prostitutes, and artists with varying degrees of talent. The rural backstreets at the peak of the hillside provided shelter for 'foreigners', including those of Spanish, Flemish – even northern French – descent. They came to Montmartre in search of labouring jobs, cheap rents and tax-free

wine, finding lodgings in half-derelict buildings and shacks, where they settled among the acrobats and whores, poor workers, mattress menders and circus performers of Paris, together with the factory workers, seamstresses, laundresses and artisans who made their way down the hill to their places of work every day, leaving the painters in the lanes sitting at their easels.

There had always been painters in Montmartre; its reputation as the centre of artistic life dated back to the reign of Louis VI, who was a great supporter of the arts. (Montmartre appears in records dating back to the twelfth century.) The Abbey of Montmartre, founded under his rule and built on the site now occupied by St Peter's Church, between the place du Tertre and the Sacré Coeur, attracted generous donations, earning Paris the title of 'Ville de Lettres'. Montmartre's reputation had originally been founded not on prostitutes but on nuns, some of whom had achieved sainthood. During the next hundred years, other abbeys, monasteries and convents arose on the hillside, the thirty-nine windmills, also owned by the Church, providing food for the religious communities they housed. The Moulin de la Galette, originally named the Blute-Fin, was the hillside's main vantage point. By 1900, there were no nuns and the windmills no longer produced flour, but there were still artists in the streets, painting to the sounds of the merchants who tramped up and down the lanes calling their wares.

The vibrant, glittering spectacle enjoyed by visitors to the 1900 World Fair hid the reality: this was still a period of great uncertainty for France. Between 1875 and about 1910, the franc stayed stable, with no inflation or deflation: a sou in 1875 bought the same amount of bread as in 1910; there was no income tax; but the wages of the workers remained debilitatingly low. If the pleasures and excesses of the Belle Époque were still evident, so, too, were the inequality and poverty that characterized the period. In the backstreets beyond the area designated for the fair, where the crumbling buildings were still medieval, dark and unsanitary and the roads unpaved, the poor mended mattresses in courtyards or sold their wares in the open air. The motley collection of battered goods and old iron spread out on

the ground on market day was a reminder that not everyone enjoyed the fruits of prosperity. Female travellers sat at the roadside, their skirts spread, babies in their laps, selling heather. Around the outskirts of the city, bohemians set up camp in gypsy caravans like the ones van Gogh had painted, though rarely so colourful. In cramped workshops the seamstresses and laundresses who lived in Montmartre worked ten hours a day, seven days a week. To the painters they occasionally sat for, their life of labour made them ethereal, giving them a kind of ghostly beauty.

The greatest poverty in Montmartre was on the northern flank of the hillside stretching from the allée des Brouillards (where Renoir had lived before moving to the South of France) to the rue Caulaincourt, below the Sacré Coeur. The area of waste ground called the Maquis had effectively become an illegal shanty town, where the abject poor wandered in the scrubland in torn clothing and broken-down shoes among the chickens they reared for food. The area had been demolished with a view to the reconstruction of the future avenue Junot, the small farmers removed and their plots destroyed. However, subsequent building works had been halted because of problems with the terrain, and the poor had moved in, creating an ad hoc village with makeshift architecture. Those with no work and no prospects lived on chickens and rabbits, roaming around the Butte, their children playing in the mud. Here, too, was where the anarchists lived, in shacks with corrugated roofs, or beaten-up caravans.

Although, since the events of 1871 (when, following the war with Prussia, which left many Parisians starving, the government had responded to the protests of the Communards with mass executions), the anarchist movement had been strong, by 1900 the comrades were relatively peaceful; any trouble on the hillside was now more likely to be the result of personal dispute than anarchist revolution, though their newspapers, *L'Anarchie* and *Le Libertaire*, were still published from dingy rooms that passed for offices in the rue d'Orsel. In any case, during the next few years, the anarchist cause quietened down as the workers' movements slowly began to

recover. In 1901, workers gained the right to form associations and, in theory at least, there had been some improvements in working conditions; by 1900, women's working hours had been reduced by law to ten hours a day. In practice, there was still great hardship. Conditions in the workplace remained brutally exploitative, the workers subject to long hours, appalling conditions and mercilessly cruel employers.

In a draughty barracks on the rue Sacrestan, Marcel Jambon, a well-known theatrical designer, paid the workers in his atelier one franc an hour to work a nine-hour day, bent double, crouched over canvases spread out on the ground 'as if they were breaking stones'. They were kicked if they appeared to be slacking or disobeying orders. For three weeks in spring 1900, Henri Matisse was one of their number, put to work painting friezes of laurel leaves to decorate the halls of the Grand Palais for the World Fair. When the fair opened, he and a friend had come looking for work. They obtained the addresses of several *ateliers de décoration* and went from street to street, seeking employment. They ended up at Jambon's, 'a kind of hell-hole near the Buttes Chaumont'. Matisse got on well with his fellow workers, who taught him the tricks of surviving the gruelling conditions of the artisan's life, but he was not a natural subordinate. After three weeks, unable to tolerate Jambon's attitude any longer, he stood up to his employer. He was promptly sacked for disobedience, and found himself out of work once more.

In 1900, Matisse, aged thirty, was well in advance of Picasso in terms of his integration into the Parisian art scene, and already a familiar figure in Montmartre. When he arrived in the capital in the 1890s from his birthplace in le Nord, he was abandoning the study of law to focus on art, first at the Académie Julian – which disappointed him; he thought the place had seen better days – and subsequently in the courtyard of the École des Beaux-Arts, where students went to make studies of the statues ranged on pedestals in the open air, learning to draw from the antique while receiving instruction from various masters, who gave lessons in the courtyard. There he was taught by the ageing Gustave Moreau, one of the leading painters

of the Symbolist movement (famous for his decadent painting of Salome, celebrated in Huysmans' novel *À Rebours*), whose works depicted 'a world of exotic fantasies, luxurious sensationalism, [and were] mystically erotic, hinting at sensual depravities existing under a veneer of religious iconography'.

Matisse found Moreau's work disquieting (he preferred Monet's), but he was fascinated by its elaborate textures – Moreau encrusted his pictures with jewels, stones and other ornamentation – and, although master and student diverged in doctrine, Moreau aiming for 'a kind of literary and symbolic idealism', Matisse for 'pure painting', prioritizing pictorial texture over narrative content, he found Moreau in person a sympathetic and encouraging master. Moreau took a great interest in his students and accompanied them to the Louvre, where he talked informally but passionately about the paintings. There, Matisse found himself surrounded by a wealth of styles and ideas that broadened his mind and made him reluctant to align himself with any particular genre or method. Anyway, Moreau had no desire to turn his students into theorists: 'Don't be satisfied with going to the Museum, go down into the street,' he used to say; and it was by sketching at street corners, drawing horses, cabmen and passers-by that Matisse and his contemporaries learned the art of simplifying their drawing, capturing the atmosphere of crowds and single figures in animated motion by reducing forms to a few essential lines.

In 1898 (the year of Moreau's death), Matisse enrolled at the Académie Camillo in the rue de Rennes, where the students received sporadic instruction from Eugène Carrière, painter of romantic portraits and idealistic depictions of motherhood. At the academy, Matisse noticed a student whose work seemed different from that of the others; this one painted portraits in simple, pared-down forms and scenes empty of symbolism. The student was André Derain, aged eighteen in 1898, who had spent his childhood in Chatou, where he still lived in lodgings at the riverside. In the 1860s, the Impressionists had painted there, in the open air. Derain was full of vitality. An avid reader, he seemed interested in everything

– philosophy, occultism, spirituality and all manner of esoteric ideas. As a child, he had been taught by the Catholic Fathers and he remained essentially deist all his life. He also displayed a laconic sense of humour; someone once memorably compared him to an actor from the old days, *'un grand comic triste de café-concert'*. Once enrolled as a student at the Académie Camillo, he spent most of his time in the Louvre, where his particular passion was the art of the Italian primitives, 'to me at that time', as he later recalled, 'pure, absolute painting'.

In the Louvre in those days, all sorts of people set up their easels to make copies of the old masters; there was no controlled entry and the place was full of students, who fraternized with the down-and-outs who sought shelter in the Salon Carré. Nobody thought to move them on. One day, Derain noticed a crowd gathered around a young artist working in the Primitive Room, copying Ucello's *The Battle* – 'transposing rather, for the horses were emerald green, the banners black, the men pure vermilion'. Recognizing him as an old schoolfriend, he took a closer look. Inspired by such a display of audacity, Derain himself began to experiment with colour. His first work as an inventive colourist was a copy of Ghirlandaio's *Bearing the Cross* which he kept all his life; when, in later years, he sold the entire contents of his studio, it was the only painting he refused to part with.

Models and Motifs

In 1900, Matisse was living in lodgings in the rue de Châteaudun, in the 9th *arrondissement* (near the boulevard de Clichy and the Gare Saint Lazare, the district bordering on Montmartre); the studio he rented was on the fifth floor of an apartment on the Left Bank, at 19, quai Saint Michel. By the time he turned thirty, on the eve of the new century, he had been married for two years to Amélie Parayre, the daughter of influential civil servants. Though Amélie was Matisse's first wife, she had been preceded as the woman in his life by an artist's model, Camille Joblaud, who had borne his first child, Marguerite, now five and a half years old. In the 1890s, Matisse and Camille, both in their twenties (she had been only nineteen when he met her as a student), had led a bohemian life among the cabarets and bars of Montmartre, until Camille became pregnant. She was forced in penury to give birth to Marguerite in the workhouse in the rue d'Assas, the district which smelled of 'pommes frites and chloroform', according to the poet Rainer Maria Rilke, who arrived in Paris two years later to write a monograph on Rodin. The workhouse birth was to haunt Camille's dreams throughout her life. In the few years following it, however, Matisse enjoyed his first success as an artist when, in May 1896, the Salon de la Société Nationale des Beaux-Arts accepted five of his canvases for exhibition, including a portrait of Camille reading which had strongly appealed to popular taste. His luck had not lasted.

The portrait, *Woman Reading*, painted in delicate shades of bitumen and grey (inspired perhaps by the romanticism of Carrière), had seemed to set him on course as a successful painter; following the exhibition, it was purchased by the State. The following summer, Matisse made a visit to Kervilahouen, in Brittany. There he met artist John Peter Russell, an Australian Impressionist who

painted with great verve in a style all his own but inspired by Monet and van Gogh. Russell introduced Matisse to the expressive possibilities of colour; when the Frenchman returned to Paris his viewers looked on aghast as work they judged crude and garish emerged from the painter whose subtle shades of grey had seemed so soothing on the eye. The Société Nationale des Beaux-Arts disowned him. With a baby to feed, Camille did everything she could to persuade him to return to his old, successful methods of painting in subtle pastels. She tried in vain. For Matisse, nothing was more important than the development of his new ideas as a colourist, though, since his experiences among the workers of Montmartre, he would never have been satisfied with depicting colourful, leisurely riverside scenes. For the time being, his focus was all on his experimentation with colour. Already, like Derain, he was ready to depart from the 'natural' palette of Impressionism, wanting to explore a more subjective interpretation of his subjects. Camille remained unconvinced. Under the strain of his apparent disintegration as a painter, their relationship broke down. She no longer felt able to express unequivocal support for his work.

Matisse's first encounter with Amélie Parayre, at a wedding in 1897, was the start of a whirlwind romance. They married three months later and, with her generous dowry, began their honeymoon in London, where Matisse first saw Turner's paintings, in the National Gallery. Afterwards they travelled to Corsica, where the intense, natural colours of the landscape, the sultry heat and the heady, herbal scents of the foliage had the effect of releasing in Matisse a surge of creative energy. Colours were different here, intensified by the strong deep-blue and coral-toned light, a revelation to the man brought up in le Nord – no glorious deep-blue skies there, where the textile factories dominated his home town of Bohain. Throughout his youth he had endured long, hard winters in a place where the workers' habits of self-discipline and self-denial were merely strategies for survival. In Corsica, with his new wife, his passion for his work was allowed to blossom and

his fascination with colour, and with the virtuosity and texture of paint itself, continued to grow.

Amélie, practical and level-headed as well as staunchly loyal, understood from the start the need to nurture her artist husband's evident talent, and she was prepared to devote her life to creating the conditions he needed to pursue his work. When they returned to Paris, she took his illegitimate daughter, Marguerite, under her wing, an unusual act of devotion and generosity, given the conventions of the time. She understood, too, Matisse's lapses into extravagance. He was lured first by a pressed butterfly he found in a shop on the rue de Rivoli, for which he parted with fifty francs (half his monthly allowance from his father), unable to resist the beauty of its sulphur-blue wings. The second was a painting which he purchased one day in 1899 from Ambroise Vollard, a dealer with a small gallery in the rue Laffitte – a justifiable expenditure, surely, since the picture was by Cézanne. After some determined haggling, he acquired *Three Bathers* for 1,600 francs (clearly a triumph for Vollard, since he generously threw in a plaster bust by Rodin). Amélie made no objection; on the contrary, she helped by pawning her emerald ring, a wedding gift from her parents' employers, and uncomplainingly mourned the loss of it when Matisse finally returned to the pawn shop only to discover the ticket had expired.

By 1900, Matisse and Amélie were expecting their second child. (Their son Jean had been born in 1899; Pierre was due the following June.) Despite his personal happiness, Matisse was anxious, for his prospects as an artist were still bleak. He now found himself, to all intents and purposes, back at the beginning of his career. When he left Jambon's, he had had no income and no prospect of further success in the art world. Now, a young family of five was relying for its survival on Amélie's job as a *modiste* (a salesgirl who also modelled the wares) in her aunt Nine's hat shop on one of the grand boulevards, until her parents' employers set her up in a small hat shop of her own.

In the evenings, while Amélie looked after the children, Matisse

went out to earn the few extra sous they badly needed, sketching in the cabarets and bars at the foot of the hillside of Montmartre, in the Cirque Medrano or the Moulin Rouge, or up at the top of the Butte in the popular windmill-turned-dance hall, the Moulin de la Galette (just a few paces from where Picasso was living in Nonell's studio in the rue Gabrielle). Here, back in 1876, Renoir had painted the local girls dancing outside in the sunlight. The place had changed since those days; there was now a large indoor dance hall, gaslit in the evenings. The light reflected off the green distempered walls, creating the effect of a mirror. There were palm trees in the corners, plenty of space for dancing and a platform for the orchestra, but artists still went up there to sketch. Van Dongen was often seen there.

Van Dongen had been in Paris for three years, mainly occupied with his daytime work as an illustrator for the satirical magazine *L'Assiette au beurre*. In the evenings, he sat sketching in a corner of the Moulin de la Galette, smoking his clay pipe. In his navy-blue fisherman's jersey and leather sandals, he was the only person in the place in casual dress; since the refurbishment, hats for the dancers were de rigueur. By 1900, the artists who sketched there included newcomer Pablo Picasso, though meeting either Matisse or van Dongen (who became a close friend when Picasso found him a studio in the same building as his own) had yet to happen. In the foreground of *Au Moulin de la Galette*, painted by Picasso in autumn 1900, women with rouged lips sit at tables, leaning in, exuding sensuality; behind them, the forms of dancers merge indistinctly into the general atmosphere of vitality and warm colour. His painting of the old dance hall announces the beginnings of a radical new vision; nuanced forms are subtly melded, backlit in mellow, rose tones by a row of soft-glowing gaslights.

By the end of their first day in Paris, Picasso and Casagemas had already hired a model and begun painting in Nonell's studio. The next day, they met their Catalan friends in a café, where Picasso

began to sketch the locals, who clearly failed to live up to the standards set by the patrons of Els Quatre Gats. The cafés of Paris seemed full of 'pompous bachelors . . . None of them can compete with the serious way we discuss people . . .' Instead, they went to the Théâtre Montmartre, where they saw a horror show – 'lots of deaths, shootings, conflagrations, beheadings, thefts, rapes of maidens . . .' There was little to stimulate them in the cafés.

In the 1890s, the artists, writers and intellectuals of Montmartre had gathered in the Chat Noir at the foot of the Butte, where the waiters dressed as academicians and the editorial staff of *La Revue blanche* mingled with celebrated artists of the Belle Époque. The place had, however, closed in 1897 and, by 1900, anyone seeking an intellectual conversation tended to head for the cafés and bars of *haute* Montmartre, their territory bounded on the right by the rue Lepic, on the left by the rue Lamarck. You had to know which café to patronize; and, at the turn of the century, the intellectual ambience was still predominantly satirical, as reflected in the small-circulation magazines *L'Assiette au beurre*, *La Vie parisienne* and *Le Rire*, which provided lucrative work for any skilled artist prepared to turn his hand to caricature.

Like Matisse and van Dongen, for the time being, Picasso and Casagemas found more to entertain them in the Moulin de la Galette. And, despite his initial reluctance, Picasso soon found his way to the foot of the Butte, where the atmosphere of the cabarets – the Moulin Rouge, the Folies Bergère, and the Divan Japonais, where Jane Avril used to dance – was very different. If the nightlife here had initially seemed tawdry and prohibitively expensive, it nevertheless soon exerted its allure. In any case, it was not really necessary to enter the *boîtes*, since their mood spilled out on to the streets. Wine was tax-free throughout Montmartre – another reason why the bohemian lifestyle of the district had succeeded in setting the tone of the French capital; there was more Montmartre in Paris, people said, than Paris in Montmartre.

At the foot of the Butte, along the boulevard Rochechouart, the whores with painted faces strolled through the streets, their hair dyed blue-black, as though the streets of Montmartre were just another theatrical stage. In the bars, they sat waiting over a drink or leaning on their elbows, head in hands, blatantly unchaperoned. Picasso celebrated them in paintings smouldering with seductive sensuality. The women of Montmartre fascinated him, this nineteen-year-old boy from Spain, where devout women wore their lace mantillas and the whores plied their trade behind firmly closed doors. His paintings of autumn 1900 seem to give off the scents of musk and patchouli oil, the chatter of the crowd, the hum of accordion music; all the sensual heat of the streets. The works he painted that autumn are moody, visceral descriptions of the low life of Montmartre, paintings such as *L'Attente* and *The Absinthe Drinker*, in which the human form becomes vivid, colourful, subtly exaggerated. In *L'Attente*, colour itself seems to create perfume and warmth, the curves of the female form strongly modelled in shades of auburn against a background of shimmering yellow, the eyes of the sitter outlined in complementary blue, reflected in the tones of her hand. The streets of Paris had already exerted the intoxicating allure of new subjects; this was oil painting as it had never been seen before. And Picasso must have found the money to go to the cabarets occasionally, since he also made pastel sketches of singers onstage, in yellow or emerald-green dresses, their arms dusted with rice powder. These were small, delicate works, beautifully drawn, with titles such as *La Diseuse* and *The Final Number*. Like Matisse, he must have stood in the streets to sketch, as he also made drawings of the theatregoers on their way into the Opéra, the coachmen waiting for them to come spilling out, capturing all the glamour of the theatre.

One of the Catalans in Picasso's circle was thirty-year-old Père Mañach, son of a Barcelona safe and lock manufacturer, a fashionable anarchist and natural networker with considerable artistic judgement. He had set himself up, albeit modestly, as a dealer in

modern Spanish art, principally by getting to know Berthe Weill, an American born in Paris, dealer of rare books and antiques, whose scraped-back hair and distinctive pince-nez gave her the look of a schoolteacher. She had just opened her first art gallery, at 25, rue Victor-Massé, where she had already exhibited work by some of the young Spanish artists around Montmartre. (Degas, who still lived in the street, disdainfully ignored her, though she was far from undiscerning; some years later, in 1917, she organized the only ever solo exhibition of Modigliani's work to take place in his lifetime.) She now agreed to take on a few works by Picasso, including *Au Moulin de la Galette*, which she sold immediately. Soon afterwards, Mañach arrived in Nonell's studio, bringing with him the Spanish consul, who also bought a painting by Picasso, *The Blue Dancer*. On the strength of the painter's obvious prospects, Mañach offered him a contract: the Spaniard would pay him 150 francs a month to represent his work in Paris. He then went to see Ambroise Vollard, the dealer in the rue Laffitte who had sold Matisse *Three Bathers* by Cézanne. Mañach had an entrée to Vollard through a friend, a manufacturer in Barcelona who had made Vollard's acquaintance in Spain. The dealer remembered the encounter, since he had been invited to visit the factory, where a lamp burned at the entrance to the workshops before the statue of a saint. 'The workmen pay for the oil,' Mañach's friend had told him. 'So long as the little lamp is burning, I am safe from a strike.'

Picasso worked intensively for the best part of the next two months, producing pictures for Mañach to show Vollard, at the end of which he had amassed plenty of sketches of the street life and characters of Montmartre. However, by December, life in Nonell's studio was already beginning to pall. Casagemas was hopelessly in love with a beautiful Montmartroise, a model called Gabrielle who persistently refused to marry him. He was becoming desperate, and beginning to disrupt Picasso's work with his bouts of depression. Christmas was coming; perhaps they should

go home to see their families. Maybe a return to Barcelona, and a break from Gabrielle, would bring Casagemas to his senses. Mañach was still waiting for paintings, but the sketches could probably be worked up into paintings just as well there as in Paris. A day or two before Christmas, the two returned to Barcelona.

4.

The Picture Sellers

When Mañach offered to handle Picasso's work and Vollard sold Matisse a painting by Cézanne, most of the *marchands de tableaux* in Montmartre were still hardly more than pedlars of bric-a-brac; they sold paintings along with old furniture and miscellaneous junk. If they came upon a painting they thought was valuable, it might be stowed in a cupboard, away from prying eyes. Others accepted paintings in return for payment and redeemed them later, the galleries acting as pawn shops to painters who were down on their luck. The picture sellers were all clustered in the same area of Montmartre, between the rue Laffitte (where, at the far end, the sellers of more traditional paintings and *objets d'art* kept their shops) and the foot of the Butte. Few of them ever became successful or well known, though their names were at the time familiar throughout the neighbourhood. Portier had a mezzanine in the rue Lepic; Père Martin kept a miserable little place in the rue des Martyrs, but it was well stacked with magnificent paintings – at least, so the rumour went. In the early days, he had bought Renoir's *La Loge* for 485 francs (his rent was overdue; that was the sum he owed). Who knew what else he might turn up?

Rumours of significant discoveries quickly circulated and everyone was always on the lookout for a work by a celebrated artist, whether or not he had any real taste in or knowledge of painting. Soulier, like Martin, kept a bric-a-brac shop in the rue des Martyrs, where he sold old beds and other bits of cheap furniture, until he took to buying pictures; he would give the artist a few francs and throw in a drink. He had no aesthetic judgement whatsoever; he simply bought whatever was cheap – in those days, Rousseau, van Dongen, young Maurice Utrillo and, occasionally now, Picasso. Pictures became such a passion for Soulier that he

gave up the bric-a-brac trade as a rising tide of canvases rose from the ground floor right up to his bedroom, forcing him to sleep in a hotel. Some shrewd dealer poking around his premises had on one occasion discovered a picture by Manet so, ever afterwards, Père Soulier was convinced that every painting he bought might prove to be another.

A character known as Bouco was regularly seen trailing through the streets of Paris with a donkey cart, calling, 'Pictures! Frames!' When Soulier died suddenly of illnesses brought on by alcoholism, Bouco bought his collection en bloc and carried it off to his home in Bicentre. No one ever knew what became of it. The sign outside the shop of Clovis Sagot – a former clown from the Cirque Fernando (now renamed the Medrano), who had turned an old pharmacy at 46, rue Laffitte into a gallery where he sold paintings and dispensed 'cures' mixed from potions left behind by the shop's previous owner – read, 'SPECULATORS! Buy art! What you pay 200 Francs for today will be worth 10,000 Francs in ten years' time.' Père Angely, known on the Butte as Léon – bald, fat, a retired solicitor's clerk who was losing his sight – collected indiscriminately until, eventually, he had to sell the lot for as little as he had paid for it. He was rumoured to be the first ever purchaser of a Picasso, who afterwards somewhat uncharitably remarked that the only person who had seen the value of his work in those days had been blind. (Many years later, he once avowed that no one who looks at a painting really knows what he is seeing.)

There were also those with money to invest, professional dealers including the Bernheim-Jeune brothers (Josse and Gaston, sons of Alexandre Bernheim) and the fabulously rich Russian textile magnate Sergei Shchukin, regarded as an eccentric in his native Moscow, who had begun to collect contemporary Western art. (German dealers came in later in the decade; Daniel-Henry Kahnweiler opened his first small gallery in 1907.) For the time being, young artists desperately needed new outlets and, by mounting one-man exhibitions in their galleries, dealers were now, albeit on a small scale, beginning to provide them. One of

their main supporters was Berthe Weill, but, though she actively encouraged these younger artists, her maternal approach never seemed to succeed in making any of them rich. It was at her gallery that Picasso had first met Mañach, to whom he now owed the prospect of the first exhibition of his work in Paris, since Mañach had eventually managed to persuade Ambroise Vollard to show it in his gallery in June.

Vollard was different from the other dealers. Neither a chancer nor, in those days, an established international figure in the art world, he had a shrewd eye for a painting and a passion for collecting. No one could ever be sure what he kept hidden away in his cupboards, accumulating value until he judged it timely to reveal it. He had opened his first boutique, at 37, rue Laffitte, back in 1893, a place with just a shop window, back room and bedroom. When he had the idea of exhibiting the work of a single artist, he was perhaps the first dealer to do so. His inaugural show was an exhibition of works from Manet's studio; following that show, Mme Manet had introduced him to Renoir and to both Pissarros (Camille and his son Lucien). Between 1894 and 1897, Vollard dealt in the works of Manet, Renoir, Degas and Cézanne, and already by 1895 he was able to move to larger premises.

In April 1895, he moved to 39, rue Laffitte, where his new gallery was not the dark and gloomy cubbyhole people later remembered but actually (though memorably dusty) a sizeable place, with a mezzanine floor and large window, strategically placed near the fashionable boulevards so that, as he once pointed out, the ladies could go shopping for outfits while their husbands looked for a bargain work of art. While the rest of Paris was still admiring the paintings of the Belle Époque, Vollard celebrated the opening of his new premises by mounting the first exhibition in Paris of the works of van Gogh (loaned by the artist's brother, Theo). That autumn, he mounted the first ever solo show of Cézanne's work, comprising approximately a hundred and fifty pieces. He timed the exhibition to coincide with the wake of the Caillebotte legacy, when the State had just accepted Caillebotte's gift of his

Impressionist collection but had refused several works by Cézanne. Vollard chose one of the rejected paintings, *Baigneurs au repos*, to display in his window to advertise the exhibition. Outside on the pavement, a row broke out between a young Montmartrois and his fiancée, who was demanding to know why he had brought her here to look at such obscenities. If casual passers-by were easily shocked, however, the exhibition was greeted enthusiastically by Renoir, Degas and Monet, who understood that, in his final years, Cézanne still had a future as an artist. In 1899 (the year Matisse purchased *Three Bathers*), Vollard commissioned Cézanne to paint his portrait.

Since the works of the Impressionists had gone on display in the Musée du Luxembourg, the students at the academies had had an opportunity to study them. Though, generally, they admired them, they found them unchallenging; most were searching for ways of painting that would feel more iconoclastic, wanting to find methods of capturing the more radically political spirit of the turn of the century. In general, Cézanne's work, with its emphasis on breaking forms, interested them more than that of Monet, Sisley or Pissarro. Although Matisse certainly admired, and gained from discovering, the work of the Impressionists, as a friend of his (writer Marcel Sembat) once put it, even Matisse was 'never a real Impressionist. One couldn't be any more, since Cézanne.'

In 1889, Cézanne, then fifty, was still renting a studio in Montmartre, in the Villa des Arts on the western slope of the Butte. The building had a Belle Époque hallway and a grand double staircase and held twelve north-facing studios; the artist lodged in a studio-apartment in the long, low house on the opposite side of the leafy, tranquil courtyard. He continued to move between Provence and Paris and, in his last years, was still painting what are now regarded as some of his major works, including (in the mid- to late 1890s) his paintings of card players, his still-life studies of oranges and apples and his landscapes of the countryside around Mont Sainte Victoire, as well as the occasional commissioned portraits he produced in Paris. Cézanne was always the odd man out

among his fellow Impressionists, and his style eventually departed fully from theirs, as he continued to develop the experiments with perspective he had begun with Pissarro back in the 1870s, applying his radical reappraisals of structure to figures now, as well as landscapes. In his work of the 1890s and early 1900s, using chalky surfaces and exploring the inner structures of figures and objects so that they seemed to be brought up close to the viewer, he created virtuoso correspondences between surface and depth. It almost seemed as if the viewer were enfolded within the formal spaces of the picture.

Cézanne had suffered major emotional upheavals in the years preceding. His friendship since childhood with writer Émile Zola had famously ended with the publication in 1886 of Zola's novel *L'Oeuvre*, which many assumed was based on Cézanne's struggles as an artist. (Cézanne's letter acknowledging receipt of his copy was graciously formal, as he may have thought befitted the occasion; Zola never replied.) The following year, Cézanne's mother died, and her instructions regarding the division of her estate meant that the Jas de Bouffan, the family home in Aix-en-Provence, had to be sold. In 1899, Cézanne moved to a small apartment at the centre of Aix, where he lived for the rest of his life, journeying deep into the countryside to work. In Paris (since Vollard's second exhibition of 1889), his work was at last beginning to attract the attention of ambitious young art students – including Matisse.

In 1901, in Cézanne's studio in the Cité des Arts, Vollard posed, as 'still as an apple' on 115 occasions while the artist worked on a portrait that would depict the dealer as 'a man of learning and introspection'. When Cézanne finally announced he could do no more, there remained two unpainted areas on Vollard's right hand. In Cézanne's late work, areas left unpainted invariably contribute to the sense that the painting appears before the viewer still in the process of coming into being (or into focus, perhaps, as the spectator enters into the final stage of the process of the artist's dialogue with the viewer). No such explanation, however, would have served to satisfy Vollard; to him, the painting merely looked unfinished. While

he painted the portrait, Cézanne continued his habit of studying every morning in the Louvre. If his work there went well, the following day, he told Vollard, he might discover the right tone to complete the hand. However, it was not simply a question of adding a couple of details, since, if he introduced a tone that jarred at this stage, the whole portrait would be destroyed and he would have to start again. Vollard was forced to concede that this would indeed be a daunting prospect.

The portrait, despite Vollard's disappointment, not only depicted the sitter's commanding presence but also expressed his interior life. Somehow, by the position of the knees and the set of the head, Cézanne had conveyed the dealer's shyness and reserve. The artist had for a long time been thinking about the heads of his figures, developing a way of remodelling them which was partly the result of his study of Egyptian statues in the Louvre. If he asked his sitter to pose like an apple, he once explained, it was so that he could paint 'a head like a door'. Though Vollard had little time for talk of this sort, he remained heartened by the knowledge that, since he had shown Cézanne's work for the second time, it was finally 'beginning to catch on with the public'. At the start of 1901, he again moved to larger premises, again in the rue Laffitte, this time to number 6. To celebrate the opening of his new gallery he was planning a second show of van Gogh's work – for which he had acquired more than sixty paintings from the artist's studio in Amsterdam, together with a large number of watercolours and drawings – to be held in February.

If his ultimate goal was to make sales, Vollard's primary passion was collecting; on his own admission, he was always reluctant to sell his precious acquisitions, hence his reputation for hiding things away in cupboards and bringing out works reluctantly one by one (though that was partly, too, a strategic sales technique). As a sensitive child brought up on the island of La Réunion, he had gazed at the family parrot on its perch in the garden and longed to possess one of its feathers. He loved flowers, noting that white ones were all different shades of white. His first collection had been a heap of pebbles, which he had been forced to part with when the grown-ups

retrieved them to repair a wall; then his precious hoard of bits of old blue china disappeared (confiscated for being too sharp for him to play with). He had thus learned early in life that treasured collections could easily disappear. Initially, his parents had wanted him to be a doctor, an ambition they soon relinquished when they took him to the local hospital to witness an operation and saw his horrified reaction. Their second choice was a career in the law, and Vollard had originally arrived in Paris to study it. He had hated law, but he loved Paris.

On his arrival in Paris, he had found lodgings in the rue Apennins and discovered the Chat Noir. He was seduced by the beauty of the light, the vibrant streets, the *bouquinistes* (second-handbook dealers) by the Seine, the whole sensuous atmosphere of Paris. When he happened upon some books of fine etchings in the booksellers' green boxes at the side of the river, he soon became, and remained, a serious bibliophile. He knew he had arrived at the right moment to collect works of art, since, in those days in Paris, there were 'masterpieces everywhere, and going, so to speak, for a song'. And he kept an open mind. You never knew: perhaps one of these young Spaniards might turn out to be worth backing.

By 1900, despite his reputation as a grumpy old man who glared at prospective customers from the depths of his fusty gallery, he lived surrounded by artists. In the basement of his gallery he had a dining room, familiarly known as '*la cave*' (the cellar), where he entertained the artistic and literary elite of his day, and others, including collectors, politicians and a nun who joined them regularly, until it emerged that the 'sister', despite her convincing attire, was not actually of the faith. In the early days, Renoir was a regular guest, as were Bonnard, Vuillard and Misia Natanson, the sparkling socialite and wife of the editor of *La Revue blanche* (she would later marry Spanish painter José-Maria Sert and become Sergei Diaghilev's most loyal friend). Vollard cooked for his guests himself, preparing dishes from La Réunion, spiced in the Caribbean style. He was an enthusiastic, if not very talkative, host. First

and foremost, however, he was a shrewd and talented business-man. Van Gogh, he still believed in. Cézanne, despite his increasing years, might turn out to be a major winner yet; and he was always on the lookout for younger newcomers.

5.

Blue Notes

Back in Spain, Picasso and Casagemas had spent a week or so in Barcelona celebrating Christmas with their families before going on to Malaga for New Year. At the end of January, Picasso left for Madrid, where, with a friend from Els Quatre Gats, he founded an arts magazine, *Arte Joven*. (The first issue appeared in March 1901; there were just four subsequent issues.) He signed a year-long lease on a studio, evidently intending to stay in Madrid for at least twelve months, while Casagemas returned to Barcelona, but not for long. Soon, Casagemas was back in Paris, this time without Picasso.

In February 1901, still in Madrid, Picasso received tragic news. Casagemas, driven to despair by his unrequited love for the resistant Gabrielle, had shot himself dead in front of her in a restaurant in Montmartre – just like a melodrama in the Théâtre Montmartre. For Picasso, who had already suffered the anguish of his little sister's untimely death, it was a second horrifying tragedy and a terrible shock. He decided he must return to Paris. He arrived in late May, huddled in an oversized overcoat against the unseasonably cold weather, in time for the show Mañach had succeeded in persuading Vollard to hold for him in June. In Montmartre, Picasso took over the care of not only Casagemas's small studio in an apartment at the foot of the Butte (at 130 ter, boulevard de Clichy) but also, if only for a while, the heroine of the drama, Gabrielle.

At Vollard's gallery in June 1901, Picasso exhibited some sixty-four paintings and drawings, many of them executed in the three weeks since his return to Paris. The works were shown more or less pell-mell, hung haphazardly right up to the ceiling, many of them unframed. Some were not even hung, presented instead in large folders for viewers to riffle through. On 15 July, *La Revue blanche* ran

a review of the exhibition. The reviewer, anarchist critic Georges Faillet, announced Picasso as 'the painter, utterly and beautifully the painter; he has the power of divining the essence of things . . . Like all pure painters he adores colour for its own sake.' His personality as a painter was embodied in his 'youthful impetuous spontaneity', but Faillet warned that such impetuosity 'could easily lead to facile virtuosity and easy success . . .'

The show included works such as *Overdressed Woman* and *French Cancan*, in which a flurry of white – the dancers' petticoats – dominates the foreground, accented with mere flashes of red garter and black stocking. In *La Nana* (sometimes called *Dwarf-Dancer*), the influence of Klimt shows strongly in Picasso's depiction of the circus girl's dress, as well as the background, painted in strong, primary colours in poignant contrast with her slender, delicate arms and legs and pearly-pink ballet shoes; her large head is accentuated by her top-heavy, coal-black hair. There is exaggeration in the detail, as there is, too, in his portrait of Bibi la Purée, a local poet and ragamuffin and a familiar, tattered figure in the lanes of Montmartre; in the portrait, Picasso gives him showy clothes, a clown's white face and smile, and a clown's rose in his buttonhole. In *Spanish Dancer*, a woman sits on the ground, one knee raised, head in hand, her red skirt a cacophony of scarlet billowing around her, white petticoats showing at the hem, against a background of teeming, abstract colour. *Yellow Irises*, a brilliant, visceral, approximate scribble of yellow and green which, viewed from a distance, seems to take on the exact form of irises, reveals that Picasso had probably somewhere already seen at least one or two works by van Gogh (at Vollard's, perhaps).

If this was, as some called it, Picasso's Toulouse-Lautrec period, the Spanish artist's work introduced a psychological dimension entirely his own: he was looking at the people of Montmartre with the fresh eye and empathy of an outsider. Picasso was also compared with Steinlen, but while Steinlen's art emphasized abjection and soulless lust, Picasso's celebrated raw sensuality, warmth and passion. And there were one or two surprises – *Spanish Woman*, a

more conventionally Spanish portrait, showed Picasso hinting at Goya or Velázquez and highlighting not so much the small, defiant face and pose (chin resting on one hand) of the woman as her ornately decorated skirt, black with silver embellishments, and the luxurious, gold-framed chair she sits in, which together establish the picture's heart-shaped form.

Two contrasting self-portraits reveal two different states of mind and treatments of self-portraiture. *Self-Portrait (Yo Picasso)* startlingly contrasts the stark white of the artist's smock with his orange-red kerchief, and the twisting pose accentuates his sparkling, currant-black eyes. The second painting, *Self-Portrait (Yo)*, is painted on wood in simple vertical, horizontal and diagonal brushstrokes in dark, subdued browns and greens. A subtle halo of light illuminates the face, and the figure emerges like an apparition or a painting of a martyred saint, locking the viewer's gaze into the figure's own. Critic Gustave Coquiot, one of Rodin's secretaries, reviewed the show, which also included portraits of both Mañach and an unknown figure (*Portrait of a Man*) thought to be Coquiot (or possibly Vollard). Even in his early years, Picasso was nothing if not strategic. *Le Journal* ran Coquiot's review on 17 June. He detected the influence of Steinlen and hailed Picasso as a new painter of modern life and of 'every kind of courtesan'.

The skills of an original colourist and interpreter of street life in Montmartre were not, of course, consistent with the priorities of the average purchaser of works of art. Most consumers of art in 1901 were still concerned with polish, finish, narrative subject matter – soothing landscapes tastefully executed, in pastel or grey tones – or with the snob value attaching to the work of known academicians. Nevertheless, here was a young newcomer of astonishing talent and, by the standards of the time, the show was a success – more than half the works were sold – even if, from Vollard's perspective, Picasso had achieved nothing out of the ordinary. If, for Vollard, the exhibition amounted to little more than a *succès d'estime*, to the artist, Picasso's earnings seemed a small fortune. He felt rich . . . and soon got through the money. He evidently

enjoyed the annual Bastille Day celebrations; his painting *Four-teenth of July* (1901) captures the feverish excitement of the crowds on the boulevard de Clichy. However, he was soon feeling dejected and disillusioned. If he had expected success to follow from the exhibition, he was disappointed. He received commissions for posters and illustrations for magazines such as *Frou-Frou*, but he regarded these as hack work. And no further invitations to exhibit seemed to be forthcoming from Vollard.

The expensive *boîtes* at the foot of the Butte were forgone once more, still for reasons of economy but also because, by now, the rural summit of Montmartre better suited Picasso's mood. Despite the proximity of more promising painters and more challenging companions (Matisse, van Dongen), for the time being Picasso's *bande* still consisted of his old Catalan friends and their acquaintances, together with the odd bohemian inhabitant of Montmartre, including Max Jacob, one of the area's more waspish characters, theatrically turned out in frock coat and top hat, who painted after his own fashion (mixing cigarette ash with his colours), wrote decadent esoteric poetry that harked back to Symbolism, studied the occult and read palms; he knew the Cabbala and specialized in the language of astrology. He had seen and admired Picasso's show at Vollard's and had introduced himself; he became one of the artist's first true friends in Paris, helping him to learn French. Picasso drew him into his circle of Catalan friends. Jacob was also a great mimic, and entertained them in the evenings with his impressions of Sarah Bernhardt and other *grandes dames* of the stage.

In the evenings, they all went to the Zut, a hovel of a place at 28, rue Ravignan. A far cry from the *café-concerts* at the bottom of the hillside, even from the Moulin de la Galette, the Zut was a filthy dive which had recently been taken over by Frédé (the fish-seller who also sold paintings from his cart and would later become the proprietor of the Lapin Agile). Born Frédéric Gérard, Frédé had trained as an artist himself, at the École d'Arts et Métiers in his native Gagny, in the eastern suburbs of Paris (only eight or so miles

from the centre of Paris but, for a man with young children and only a donkey for transport, a world away from Montmartre). He drew well and made pottery and ceramics; he also sang and played the cello, flute and guitar. In Gagny, he had started work as an illustrator, making sketches in cafés and at open-air fairs, where he heard tell of Montmartre, the artistic centre of the world, where everyone played music, sang and set up their easels to paint in the streets. He decided to see for himself, arriving in the 1890s with his wife, children and donkey, Lolo. Frédé's dream was to run a cabaret like the Moulin Rouge.

His first venue hardly compared. He had initially taken over Le Tonneau, a fleapit in the rue Bréda where there were not even enough chairs and where he began his tradition of holding evenings of music, poetry and song that ran on into the early hours, even though the place had no licence as a nightclub. In 1900, he had progressed to the Zut, which was bigger but hardly more salubrious. In fact, it was in such a state of dilapidation, with strips of plaster hanging from the ceiling, that one of the two rooms was nicknamed 'the stalactite room'. One of the Catalan crowd persuaded him to clean and disinfect both rooms (one for the Catalans, the other for local artists, models and poets), and the artists painted the walls with frescoes. Here he continued his musical evenings and, though it was hardly the Moulin Rouge, he succeeded in making the Zut into a popular gathering place. All those who could not afford the *boîtes* at the foot of the Butte quickly began to congregate in the run-down pit managed by Frédé. Once it was spruced up, Picasso and his friends met there most evenings, talking into the small hours, when outside, after the shutters were closed, the lanes at the top of the hillside became completely dark. They talked on until long after the tables in the cafés had emptied and only the hardened alcoholics were left, slumped for the night against walls, huddled in doorways or stretched out beneath the benches. In the lanes, hunched forms could be seen in the shadows, making their way back from midnight Mass. In the distance, down at the bottom of the hillside, Paris still teemed with the

light of thousands of gas jets casting their sputtering shadows across the streets. At dawn, Picasso and his friends made their way home to the sounds of the early-morning trains, their wild calls rising up from the Gare du Nord and the Gare de l'Est, the Moulin de la Galette coming into view like a pale ghost against the sky.

6.

The Impact of van Gogh

Six-year-old Marguerite Matisse lay in the Hôpital Bretonneau in Montmartre. She was suffering from typhoid fever, contracted in the hospital. In July 1901, while most of Paris was out on the streets celebrating the anniversary of Bastille, she had fallen ill with diphtheria and almost died of asphyxiation. A doctor visited her at home, where she underwent an emergency tracheotomy, her father holding her down as the operation was performed without anaesthetic on the family dining table. For the rest of her life she wore a black ribbon or choker to hide the three-inch scar. In the portrait Matisse painted of her that autumn she is ghastly white, her enormous dark eyes staring out from her small, swollen and distorted face.

The trauma of his daughter's illness was compounded for Matisse by his worry that, as an artist, he was going nowhere. During the previous five years, his prospects seemed only to have diminished since he had abandoned the shades of grey that had appealed to the public in his search for a new style and more expressive ways of using colour. His allowance from his father was about to be curtailed, as his brother was due to marry, making it his turn to receive their father's support. Matisse applied for work at the Opéra Comique, but without success. In the course of 1901, he sold five or six drawings to Vollard: the sum total of his sales that year.

In the same year, the Bernheim-Jeune brothers mounted a small exhibition of paintings by van Gogh. Matisse visited both Vollard's exhibition of the Dutch painter's work, and the brothers'. In the Bernheim-Jeunes' gallery, at 8, rue Laffitte, he ran into André Derain, the tall, loping student with the 'primitive' style of painting he had met at the Académie Camillo. Derain was talking to a hugely built young man with pale-blue eyes and flame-red hair

who was extolling with great animation the virtues of painting with strong, pure colours – cobalts, vermilions, veronese. Despite Derain's height, his friend towered above him, his voice so powerful he seemed to be shouting rather than talking, throwing back his head when he laughed. The colossal stranger was Maurice Vlaminck, Derain's neighbour in Chatou, whom he now introduced to Matisse.

All three were bowled over by van Gogh's paintings, especially Vlaminck. He had seen works by Renoir, Monet and Sisley in the gallery of the Impressionists' dealer Paul Durand-Ruel, where he had admired their nuanced depictions of the landscapes and wished he had the facility to paint as they did; van Gogh was another matter. These vivid, imaginative colours, these expressive brushstrokes . . . Now this was exactly how Vlaminck felt when he looked at the landscapes the Impressionists had painted, but he had been frustrated – so far – by his own attempts to depict his strong feelings for those familiar places in his own paintings. Perhaps if he allowed himself to paint those same landscapes more freely, like this . . . van Gogh's work was a revelation. Derain shared his enthusiasm. In October 1901, after the exhibition, he wrote to Vlaminck, 'I believe the Realist period is over. We have only just begun . . . lines and colour are enough . . . to enable us to discover a simpler kind of composition.' He stressed that 'feeling and expressing are two entirely separate actions. [The latter] presupposes that you have previously analysed your means of expression.' By then, Derain had already produced a sufficiently impressive portfolio of work to be accepted for membership of the Société des Artistes Indépendants. But now it was his turn, in this autumn of 1901, for the mind-numbing distraction of three years' military service.

Vlaminck and Derain had known each other only a few months when they went to see van Gogh's work together. Vlaminck, aged twenty-five in 1901, four years older than Derain, was already married with two children. The two artists had met the previous summer, when a train they were both travelling on derailed on the

way back from Paris to Chatou. Vlaminck was familiarly known around Chatou as the *'bougre des guinguettes fleuries'* ('the chap from the open-air bars'). Like Derain, he had grown up in the riverside *banlieues* in the vicinity of Chatou. He was born in Paris; his father was a tailor who later gave music lessons, his mother a gifted musician who had won second prize for piano at the Paris Conservatoire. They moved when he was three, first to Le Vésinet, a leafy suburb, like Chatou, with grand villas in walled gardens, a district generally regarded as distinguished, though the Vlaminck family house was modest and they were by no means wealthy. Later in life, he once said that, even if he came into a fortune of millions, he would never attain that air of security and belonging he had observed in the rich kids in Le Vésinet. He had spent his childhood on the river, on the barges among the dockers and watermen, with no artistic aspirations: 'You need to be rich to paint!' He was one of four, and his father's main concern had been to provide them all with food and shelter. He did have one childhood memory of walking with his father: 'I must have been about eight or ten. It was in the plaine de Rueil in midsummer, we followed a path beneath the scorching midday sun and [suddenly] before me there was a field of corn – a cornfield with poppies and cornflowers and humming flies. I painted the cornfields. And every time I painted them it was with the same feeling, that feeling of astonishment I had when I was ten.'

Vlaminck was fearless. He looked at the world head on, perceiving the grandeur in sadness, seeing things from an angle no one else would have dared look at them from. And he was outspoken, *'fauve'* by temperament, rough, with a burly appearance that made him seem even rougher. He was musical rather than academic, a free spirit, like Derain. He once said that, as an artist, he had had two teachers, a Monsieur Robichon of the Société des Artistes Français, hired by his parents to give him lessons, and a local saddler who painted portraits on bits of glass. His sensibility, he said, had been more deeply touched by the latter. When he met Derain, just after the latter had been demobilized, Derain's parents forbade their son to mix with him, so Vlaminck would go to their house after dark

and whistle beneath the window until Derain leaned out. Then, in a stage whisper, 'Hey, look, André, it's amazing! I've painted it all in red.' 'Oh yes? . . .' came the reply, 'I've done mine all in black!' Soon afterwards, they rented a makeshift studio together in an old disused restaurant not far from the Maison Fournaise, where Renoir had painted *Luncheon of the Boating Party* back in 1881, and where, in 1869, Renoir and Monet had painted the Grenouillère, the open-air bar tethered to the banks of the river to which the Sunday crowds flocked from Paris to bathe before repairing to the bar to drink and dance the night away.

Vlaminck had loathed army life, too, particularly since it had followed the abrupt curtailment of his career as a racing cyclist (brought to an end in 1896, just as he had been selected to ride in the Grand Prix de Paris handicap, by an attack of typhoid fever). No sooner had he recovered from his illness than he found himself separated from his wife and daughters and packed into barracks with hordes of disenchanted men, to tramp all day across fields, four abreast, pursued at night by the whores who followed the regiment from town to town, in the name of the military apprenticeship he regarded as worse than futile. With the help of a friend, he managed to gain access to the officers' library, where he read Victor Hugo, Zola, Maupassant and the Goncourts, and the philosophy of Pascal and Diderot. Army pay was five centimes a day, which meant that the men had to work to earn enough for anything more than the meagre food and lodgings supplied by the army, so Vlaminck gave violin lessons to the local children and played for anyone who would employ him in the village where he was stationed. His only solace was to focus on the skies flecked with clouds and think of van Ruysdael'sseventeenth-century Dutch landscapes, his contemplation 'a nobler occupation and much more important to me than my apprenticeship as a murderer'.

Released from the army, tired out by life in barracks, craving the privacy and personal freedom he had been deprived of for three years, he took a casual job as a violinist in a low *café-chantant*, but he found the experience hardly more inspiring than army life; it, too,

seemed deadening, decadent and sexually disquieting. From the orchestra pit, the musicians were obliged to spend the night looking straight up the skirts of the *chanteuse*; Vlaminck would then have to watch her, 'wrapped in an expensive fur, going off on the arm of a lucky escort, oblivious of the desire she had distilled in me'. It was a nocturnal existence which, he considered, could easily have sent him off the rails.

In 1900, he had been enthralled by the gypsy orchestras who played at the World Fair. Inspired by them, he left his job in the *café-chantant* to play in one of them in an expensive nightclub, but playing for the rich was not exactly uplifting. The only consolation for being poor amidst waiters bearing trays of crayfish, lobster *à l'américaine* and other artfully prepared dishes to revealingly dressed women and their escorts was that the rich clients seemed as bored and disenchanted by it all as did the orchestra, which valiantly attempted to churn out sufficiently romantic music to seduce one or two of the rich punters into taking the *chanteuses* off for the night. Walking home across the Pont des Arts in the early hours one morning, Vlaminck had enviously watched as the coal heavers unloaded a barge, their sacks on their shoulders, running down the ramp like acrobats. He asked the skipper for work but was refused on the grounds that he was not a member of the union.

He finally managed to find a job he enjoyed, playing in the orchestra of the Théâtre du Château d'Eau, which had an ambience that seemed to him 'more serious, more worthwhile'. (He would work there until 1903, when he lost his job with the closure of the theatre.) In the daytime, he painted out of doors, where 'with a few colours in a box, a canvas and a cheap easel under my arm . . . on the banks of the Seine I would forget everything. I painted to restore my peace of mind.' He had no training other than a few lessons from a local painter, and no desire either to master the classical tradition or to break new ground. He was not intrinsically an experimentalist; still less a theorist. His aim was not to capture the fleeting beauty of nature so much as to find a way of expressing himself.

For Vlaminck, subjective expression was not so much an aesthetic as a personal compulsion, a private quest driven by 'a tremendous urge to re-create a new world seen through my own eyes, a world which was entirely pure. I was poor, but I knew that life was something pure, and I realized that all I wanted to do was to find some new and profound way of identifying myself with the soil.' Questioned some years later about his reinterpretation of colour, he replied that he simply put down the colours he saw. When he painted with Derain on the bridge at Chatou, the locals always gathered to see what they were doing, startled by their pictures. They were painting at the riverside there one day when Henri Matisse came across the bridge. The next day, he came again. He told Vlaminck, *'Je n'ai pas pu dormir de la nuit'* ('I haven't been able to sleep all night').

The riverside area, with its farms, barns, factories, châteaux and loop of pretty villages, was Vlaminck's native land, the terrain he felt passionate about. He painted red, blue, green – whatever colour seemed to express his response to the scene before him – without worrying about the critics, the *amateurs*, the connoisseurs or the dealers. 'I really do not care what anyone thinks of me,' he would say. He was nostalgic, too; he regarded the railway as a gaping sore running through the landscape and hated the factories, but, unlike Monet before him, he had no thought of choosing a spot from which the view of them would be obscured: he painted them, venting his indignation in hot tones of yellow, purple and scarlet red. He scattered his fiery red landscapes with shreds of crimson, bathing the river in a strong, ragged light, rendering the land the Impressionists had painted not as they had seen it – soothing, leisurely, essentially pastoral – but, rather, vulnerable in the face of the invasions of factories, industrial buildings, the machine that pumped water at Marly: all, to him, indications that the modern world threatened to slice up the cornfields and poppy fields of his childhood.

On his release from the army, Vlaminck had remained friends with some of the more subversive members of his regiment,

anarchists who held their meetings in Montmartre, in the offices of *Le Libertaire* in the rue d'Orsel. They invited him up there to meet their comrades, though Vlaminck was hardly interested in the cause of reigniting the flame of the 1871 Commune. There was nobody up here resembling the intellectuals from the old Chat Noir. On the contrary, most of the 'apostles' he met struck him as 'hard-bitten and tenacious old liberals'. He wrote a few articles for the newspaper for the pleasure of seeing his name in print, but was never really persuaded by the anarchists' idealism. The male company was welcome, and he must have been popular, since he used their offices to work on a scurrilous novel based on stories he had heard in the army, hoping to make some literary capital out of his fellow soldiers' off-duty experiences. The book, *D'un Lit dans l'autre*, was published the following year, 1902, with illustrations and cover design by Derain.

Meanwhile, the two artists exhibited their paintings where they could – at a colour merchant's on the corner of the Pont de Rueil, where their bold colour schemes and Vlaminck's use of thick impasto caused another minor scandal – hardly surprisingly, if he was showing *Sur le Zinc* (*At the Bar*), one of his rare figure paintings, done in 1901, a startling almost-caricature of an old whore with red hair, crimson corsage and rouged mouth brandishing her glass of beer, or even *Portrait of a woman at the Rat Mort* – almost as startling, for 1905–6, with its bold lines and strong use of scarlet. By his own account, 'I heightened all my tone values and transposed into an orchestration of pure colour every single thing I felt. I was a tender barbarian, filled with violence. I translated what I saw instinctively, without any method, and conveyed truth, not so much artistically as humanely. I squeezed and ruined tubes of aquamarine and vermilion which, incidentally, cost quite a lot of money at the paint shop at the *Pont de Chatou* where I used to be given credit.' On rainy days he made his way up the steps of the hillside of Montmartre to the offices of *Le Libertaire*, where he was already writing his next shady novel, *Tout pour ça* (published in 1903), again with illustrations by Derain.

Also living in Chatou, in one of the large riverside villas inhabited by the wealthier residents, was 22-year-old Paul Poiret, stylishly turned out in top hat and cane and soon to become the most influential fashion designer in Paris. In 1901, he had just been taken on by the illustrious House of Worth, where he had been told that the Worth brothers (sons of the couturier Charles Worth) needed a new recruit to design the '*pommes frites*' of fashion targeted at the younger clientele, rather than the glorious '*gâteaux*' in which Worth himself dressed the upper crust of Paris. Poiret had noticed Vlaminck at his easel at the riverside and seen the 'ferocious air and savage look' he adopted if anyone approached him as he worked. Poiret had also heard tell of the exhibition at the colour merchant's, of which one of his friends had remarked that, if one sped past the window in a carriage going fast enough, 'they produced quite a good impression'. Many years later, Poiret remembered watching Vlaminck and Derain as they trudged along the riverside, forced to move out of their lodgings (their shared studio, presumably) when the landlady grew tired of giving them credit. 'I can still see them by the flowery banks,' he reminisced, 'their boxes of colours under their arms, their canvases piled in a wheelbarrow.'

7.

Poiret: Art and Design

Poiret had been more fortunate than his artist-neighbours. His unusual ingenuity, and an advance from his mother on his inheritance of fifty thousand francs, had ensured his rapid success. Within two years of joining the House of Worth, in 1903, he would open his own premises at 5, rue Auber, at the corner of the rue Scribe, attracting customers with his innovative window displays, which he created himself, using artfully placed natural foliage from the Forest of Fontainebleau. In autumn, he introduced golden leaves into assemblages of velvet and other fabrics; in winter, he draped white tulle and muslin against dried branches. As he himself eloquently remarked, he 'dressed the passing moment', capturing a mood of modernity in the making and ravishing all who passed his window. Soon 'all Paris had stopped at least once'. In dressing the backdrop as well as the figure, Poiret was already anticipating the holistic approach to the stage and costume design which came to fruition in 1909 with the debut performances of the Ballets Russes. The production by Sergei Diaghilev and his set designer Léon Bakst would send the world mad for the ballet, and women from all over Paris to Poiret, who would make them clothes mimicking the exoticism of the Russian dancers' costumes.

Poiret's first employer, the couturier Jacques Doucet (known for his elegant, flimsy dresses in pastel-coloured, semi-transparent fabrics with ruffles and frills and sinuous curving lines), had realized early on that young Poiret's interest in dress was essentially theatrical. He had sent him to the Comédie-Française, the Théâtre Libre and the Théâtre de l'Oeuvre, with young models dressed in Doucet's creations hanging on his arm, initially with a view to circulating his dresses among the *haut monde*. Even Doucet, however, underestimated the extent to which his young recruit instinctively understood

the connection between fashion and drama. For Poiret, *haute couture* was itself a form of theatre. He would soon be dressing leading actresses and designing outrageous confections inspired by the 'orgy of colours' that caught his attention when one of the department stores displayed a consignment of carpets from the Far East. When he moved from Doucet's to the House of Worth, he dressed Worth's clients in the soft lines, brilliant hues and rich fabrics of the Orient, designing Oriental-inspired jackets in rich silks and satins decorated with flamboyant motifs and vivid colours. At the time, the vogue was for lilac, sky blue or straw: 'anything that was cloying, washed out, and dull to the eye'. Poiret changed all that, creating gowns in reds, royal blues, bright oranges, 'and my sunburst of pastels made a new dawn'.

Poiret was soon being sought out by the great actresses, dressing both Gabrielle Réjane, Sarah Bernhardt's rival and one of the most popular actresses of her day, and '*la divine* Sarah', darling of the turn-of-the-century stage. In 1900, Bernhardt had a theatre in Paris refurbished throughout in red and gold, decorated with her insignia and renamed after her. She was also one of the leading actresses of the silent movies, making her debut that year in the two-minute *Duel d'Hamlet*, one of the first examples of the sound-and-image synching system (ear-pieces plugged into a phonograph) pioneered at the World Fair. The year he opened his own premises (1903), Poiret reproduced the costume he had designed for Réjane hundreds of times in many variants, an initiative which anticipated his later invention (in 1922) of the ready-to-wear system of charging a royalty on each garment sold rather than a set price for one individually made garment. This system forms the basis of modern fashion manufacture.

In autumn 1902, Poiret met a girl with brown eyes, tall and slender, with slim hips and long legs, whose influence on him would change the course of fashion design. However, since Denise was only sixteen, he resigned himself to a long wait; it took three years for her parents to consent to their engagement. They finally married in 1906. She became and remained his top model, 'the inspiration

for my creations . . . the expression of all my ideals'. During the next few years, inspired, too, by the paintings of Botticelli, and the statue of the Venus de Milo, which he admired above all works of art in the Louvre and had studied closely, he began to design garments to suit Denise's slender figure. He would soon be creating the hobble skirt, which quickly became fashionable, despite the difficulty of getting into a carriage, or even walking, in them; then boat-necked, subtly draped, sheath-style garments with ankle-revealing skirts, and coloured, low-heeled boots. 'To dress a woman,' as he would one day tell readers of *Vogue*, 'is not to cover her with ornaments'; the art of the designer was to show her to her best advantage, creating original garments with contours that accentuated her natural, individual grace: 'All the talent of the artist consists in a manner of revealment.'

All this might have seemed radical to the point of recklessness, but Poiret's designs caught on immediately. Already, from about 1902 onwards, his pared-down forms and daring colour schemes became synonymous with the idea of freedom of movement and self-expression, in fashion as in art. Poiret was a true innovator, quickly taken up and feted when Réjane wore his clothes in America, where he was hailed as the king of fashion. In Paris, he made friends with his contemporaries, extending his circle during the next few years from Derain and Vlaminck outwards, to include Picasso, Matisse, van Dongen and, eventually, Modigliani and Brâncuşi. He collected their works with no particular ambition as a collector; he was simply excited by the work of his new friends. In Montmartre, he befriended Max Jacob, to whom he sent those of his wealthy clients with leanings towards the occult to have their palms read.

Poiret's success left not only Derain and Vlaminck but all the painters of his acquaintance behind; none managed to rival his spectacularly rapid career rise. In February 1902, Berthe Weill included Matisse's work in one of her first mixed shows of contemporary artists, but she was as unsuccessful as ever in converting her enthusiasm and support into sales. As for Picasso, he was exhibiting nothing. He had discovered the Saint-Lazare women's prison, where

artists were free to wander in and sketch the inmates at no charge. He was shocked by the presence of children and deeply affected by the spectacle of motherhood rendered poignant by penury and incarceration; at that time, fallen women were sometimes reduced to petty crime as a way of making sure they had a roof over their heads when they gave birth. When he worked up his sketches into paintings, Picasso based the forms of his figures on the simplified forms of El Greco, giving some of them a different setting, removing them to the seashore (taking them home to Barcelona), adding fathers and sons to some of the tableaux and painting whole families as well as individual men and women, in scenes of misery and tragedy that recalled the melancholy work of his friend Nonell as well as reflecting the influence of El Greco. These paintings, characterized by his use of elongated lines and monochromatic blue, were some of the earliest examples of the work he did in what would later be known as his Blue Period. Picasso was still haunted by the death of Casagemas; the misery he recognized and depicted in his subjects were powerful expressions of his own grief and sadness. In autumn 1901, he was living in cheap lodgings in the rue Clichy near the Gare Saint-Lazare, where he continued to mourn Casagemas as he roamed the streets, preoccupied by the sight of the abject poor, whose lives, to his dismay, had begun to seem not entirely indistinguishable from his own.

By December, Picasso was growing restless. He had no money and no prospects and was becoming ashamed of as well as depressed by his poverty. His lack of success made him an outsider, too, casting him down with feelings of demoralization for which nothing could have prepared him. As the beloved son of doting parents, in Barcelona he had grown up with a sense of natural entitlement; in Paris, the world seemed to owe him nothing. Again, he began to yearn for home. At the end of the year, he broke his contract with Mañach, thereby risking his connection with Vollard, but by now that seemed unlikely to amount to much. When Vollard saw examples of Picasso's work from the Blue Period – paintings of the women from the Saint-Lazare prison with their babies; a man with

a blue guitar; a blind man with his frugal bowl of broth – he promptly lost interest; these were hardly works to gladden the hearts of prospective purchasers. Dejected, early in January 1902, aged twenty, Picasso returned to Barcelona, where his parents gave him back his old room.

8.

Reconstructions . . . and Ruin

In 1902, developers sent construction workers to Montmartre, where they began to cut into the Maquis. As buildings were demolished, large areas of dusty waste ground appeared up on the northern flank of the Butte, between the Moulin de la Galette and the rue Caulaincourt. Each time another building was condemned for demolition, Frédé joked that he hoped the job would be carried out without disturbing the artist in the garret. In any case, work soon ceased, when the terrain beneath the surface proved unsuitable for laying proper foundations, leaving desolate empty spaces across which the very poor wandered, looking for shelter.

In late spring, Berthe Weill sold a still life by Matisse and a smaller study, his first sales since he had begun working with strong colours and more simplified forms. She proposed to include more of his work in a mixed exhibition she was planning for June. In the meantime, Vollard had paid a thousand francs for five canvases, among which he had spotted three large ones that particularly appealed to him. Throughout 1902, Matisse continued to develop his new style, working on through significant stresses and strains in his domestic life (worries about his children's health, disasters in the professional lives of his parents-in-law), painting in vibrant turquoises, violets, greens and crimson pinks, inspired by van Gogh – and perhaps also by Vlaminck. At the same time, he began to pay attention to the work of Paul Signac and his friends Paul Seurat and Lucien Pissarro, who had been searching for a way of developing the discoveries of the Impressionists into a more scientific system. In 1899, Signac had brought out a collection of articles, previously published in *La Revue blanche*, which now appeared in book form as *From Eugène Delacroix to Neo-Impressionism*. The book effectively laid out the method of painting the three friends had

together discovered, a system of creating images through juxta-position using only pure colours – a kind of democracy of tonal relations which at the time appealed strongly, both theoretically and as a practice, to Matisse. Signac's critics were disparaging, calling the new method *pointillisme* ('painting by dots'), but he did have followers. He was popular with young students in the academies and he regularly opened his studio in the boulevard de Clichy to them. Matisse, too, now began to spend more time in Signac's company.

Back in Barcelona, Picasso was soon yearning for Paris. By contrast with Montmartre, the world of Els Quatre Gats now seemed frustratingly provincial, especially since its starriest artists all seemed to have moved to the French capital. The misty hillside, the proximity of the *boîtes* at the foot of the hillside, the world of cafés open until dawn – the ambience of Montmartre soon seemed alluring again. But the prospect of military service loomed; and, anyway, there seemed to be no way of resuming an independent life in Paris. Under the terms of the agreement, which still stood, any desultory income forthcoming from sales of his work was Mañach's. While he was in Barcelona, Picasso had missed an exhibition of his work. Mañach had followed up the one at Vollard's by showing Picasso's work together with that of other artists at Berthe Weill's gallery in the first two weeks of April. Included among Picasso's works were his paintings of a glittering yellow clown, a fanciful pierrot (both, according to the catalogue preface, displaying the artist's 'facility in capturing attitudes') and his 'brilliant, clamorous' *Fourteenth of July*, in which he brings the streets of Paris alive with movement and festivity, the scene vibrantly evoked in reds and yellows. The catalogue preface hailed the talent of the young newcomer: 'all nerve, all verve, all impetuosity'. Meanwhile, Picasso himself, stranded in Barcelona, had resumed his old routine of painting and sketching portraits of his friends. He received a number of commissions and several of his drawings appeared in Barcelona's major newspaper, *El Liberal*, but life was

dull. In Paris, Mañach's attempts to promote him had evidently come to nothing. By the autumn, Mañach himself was back in Barcelona.

In late October 1902, help came when Picasso's uncle Salvador bought him out of military service. Picasso was free to return to Paris. Released from his commitment to Mañach, the artist reasoned that he could look for someone else to represent his work – at least, in theory. He put up at a couple of cheap hostels in Montparnasse, going up to Montmartre only to visit Paul Durand-Ruel; although he handled the work of another of the Catalan painters, Picasso's friend Ricard Canals, the meeting with Picasso came to nothing. Otherwise, he stayed away from Montmartre, hoping to avoid running into old friends, embarrassed by what he felt was his failure to develop his work or make his way in Paris. In November, Berthe Weill included his work in another of her group shows. This time, the catalogue essay was positively off-putting. Picasso's works were described as 'cameos showing painful reality, dedicated to misery, loneliness and exhaustion'. He did have one new supporter, Symbolist poet and critic Charles Morice, who had promoted Gauguin. He was editor of the revised 1901 Louvre edition of *Noa Noa*, Gauguin's published writings about his life in the South Seas, and may have become aware of Picasso's work through Paco Durrio, the Catalan ceramicist who had known Gauguin in Montmartre. Morice gave Picasso a copy of *Noa Noa* and reviewed Berthe Weill's show, albeit somewhat equivocally, acknowledging Picasso as a born painter – 'What drawing! . . . What composition! . . . as disturbing and provocative as one of the *Fleurs du Mal* . . .' Even that (perhaps unsurprisingly) did not lead to sales.

It may have been reading about Gauguin's earthly paradise in Tahiti that encouraged Picasso to make a break with the Saint-Lazare prison and his melancholy Blue Period. He now began to spend his days, instead, at the Louvre, producing gloomy old master-style drawings on scraps of paper which he hoped to sell for a few sous. He could no longer afford his rent and had been reduced to stealing bread and coins by the time he ran into Max

Jacob, now working in a department store to make ends meet and living on the fifth floor of a house at 137, rue Voltaire, in what was then an unprepossessing industrial area of Paris; he offered Picasso a share of his lodgings. Since there was only one bed, Picasso painted all night while Max slept, going to bed himself in the daytime while Max was out at work. But such a way of life was not to be endured for long. By mid-January, Picasso was once again back in Barcelona, beneath the blue-black skies of Spain.

By February 1903, Matisse was also living in his parents' home, in Bohain, northern France. The past year had been almost absurdly traumatic for his wife, Amélie, and her family. Her parents had been implicated in a devastating court case, 'the greatest swindle of the century', which had exposed their employers as crooks who had reduced their investors to penury. Though Amélie's parents were proved innocent, they underwent humiliating public exposure and the loss of their professional positions before finally being reduced to destitution after the saga, exhaustively covered by the press, had dragged on for several months. By the time it was resolved, Matisse himself was overcome with exhaustion. The scandal meant that he and Amélie also suffered – Matisse's studio was searched, they were forced to abandon their lodgings in Montmartre and Amélie's millinery business went to the wall. Her premises were also searched, then closed. Matisse returned briefly to Paris, only to move out of the rue de Châteaudun and close up his wife's shop. In spring, he moved within Bohain, into a vacant property owned by his father, where he set up his studio in a poky attic, lit only by tiny skylights. Not until July did his spirits begin to lift, when he and Amélie took a house eight miles away in Lesquielles-St-Germain, a quiet town, home to textile workers, where he was able to live calmly with his family for a while, painting domestic scenes and still lifes while he attempted to recover his equilibrium. When he returned to Paris, he and Amélie left their boys with their grandparents while they set up home with Marguerite in what had been Matisse's studio, at 19,

quai Saint Michel. Amélie returned to work as a *modiste* in her aunt Nine's hat shop. Matisse resumed work on his views of the Seine and Notre Dame. Cézanne's *Three Bathers*, one of the few possessions to have survived the family's financial ordeals, hung for inspiration above his easel.

At the Académie Humbert

At the foot of the Butte de Montmartre, the women came and went, their hair dyed black as coal, their mouths and cheeks rouged the colour of poppies. In the cafés they sat hunched over glasses of blue-green absinthe. A few doors along from the Moulin Rouge, at 104, boulevard de Clichy, art students carrying portfolios could be seen wandering in and out of the Académie Humbert. Like Julian's and Camillo's, it was loosely affiliated to the École des Beaux-Arts, and provided sporadic or indifferent tuition. The Salon des Beaux-Arts was still (as in the Impressionists' student days) the only real hope of exhibiting work. Back in 1884, the Salon des Indépendants had been founded with a view to showing more contemporary art, selected without the academic criteria (and retrograde prejudices) of the École des Beaux-Arts, but still by jury. Despite the fact that its members included Paul Signac, it had not so far succeeded in bringing anything particularly sensational to the public's attention.

There were, however, plans afoot for the creation of a new Salon. A group of liberal critics and painters, drawn by lot, had already formed to instigate a more radical annual autumn exhibition of work, which, like the Salon des Indépendants, would be selected by an unbiased jury whose mission was to champion new work by young artists. This time, the selection of artists would cover a broader range of styles, reflecting democracy of taste in practice rather than merely in theory. Despite attempts by the École des Beaux-Arts to stymie it, preparations were underway and the new Salon – to be called, simply, the Salon d'Automne – was due to mount the first exhibition that year. Meanwhile, progressive art was confined to the galleries of Montmartre. In the academies, tuition was still farmed out to lesser known academicians, and the students,

who from autumn 1903 included Georges Braque, were left more or less to their own devices.

Braque cut a stylish figure. A fashion trend-setter and natty dresser, he stood out among the students in his tweed suits, shiny white collars, heavy black silk cravats and black bowler hat. (He even carried a cane, of Javanese bamboo, which a decade or so later would again be all the rage when Charlie Chaplin made his appearance on the cinema screen.) He attracted the attention of the other students, particularly that of another recruit, Georges Lepape, then aged only sixteen but who later became a leading fashion illustrator for *Vogue*. Lepape's schooling had been interrupted by a leg injury. When he showed a talent for drawing and a keen interest in illustration, his parents had sent him to the Académie Humbert in the hope that, despite his lack of formal education, he might become a draughtsman. On the Monday of his second week he noticed Georges Braque in the life class and engaged him in conversation.

Unlike Lepape, Braque was athletic, with a strong physique, thick-set, with tight-curly hair, a broad face and solid shoulders, and he could swim, box and even tap-dance. In his native Le Havre, the sailors had taught him to dance the jig, to which he whistled his own accompaniment. 'And what a teacher he was too,' Lepape observed. 'If only he'd been willing to pass on his tips about painting. But he never did anything but draw.' Braque had enrolled at the academy after finishing his military service, reduced from three years to one because he had served an apprenticeship; he had begun his training as a painter and decorator in Le Havre with his father and completed it in Paris, under one of his father's friends. In 1900, while Picasso had been living in Nonell's studio in the rue Gabrielle, Braque lived just two streets away, in lodgings in the rue des Trois Frères – another significant encounter still, as yet, to take place.

Born in 1882 in Argenteuil (home to Monet in the 1870s and the scene of many of his riverside paintings), at the age of eight Braque moved with his family to Le Havre. His father was a good

semi-professional painter in the traditional style, respected in the art world of Le Havre, and had at least once exhibited in Paris. At weekends, he took his son, Georges, in the family horse-drawn cart to the countryside of Normandy to paint landscapes, where Corot was their great inspiration, though Braque (*fils*) always said his real education as an artist actually came from reading *Gil Blas*, the literary periodical, advertised by Steinlen's posters, to which his father subscribed. As a schoolboy, Georges had visited Paris and seen the Impressionists' work in the Musée du Luxembourg, where he had been particularly struck by a small landscape of L'Estaque by Cézanne. Like Monet before him (also a native of Le Havre), he had bunked off school to explore the port of Le Havre – the chandlers' shops, the boats, the seashore – where he wandered about on his own, ruminating on the mystery of infinity. He was a natural solitary only in the sense that he kept his thoughts to himself; he was never melancholy or lonely, always effortlessly sociable.

When he first arrived in Paris to serve his apprenticeship, his inspirations, like Picasso's, had been mainly Steinlen and Toulouse-Lautrec. He, too, loved poster art; he hung about in the streets sometimes after dark, peeling posters from the walls when no one was looking; he had one by Toulouse-Lautrec on the wall of his lodgings. As an apprentice, he had learned how to prepare colours, grind pigments and mix tones, and discovered that paint could be mixed with other materials: soil, sand, sawdust, ash, iron filings, pipe tobacco or coffee grounds. At the Académie Humbert he shared his knowledge with Lepape, explaining that 'the oil to use as an additive is linseed or *sacatif de Courtrai*, brown or clear, exposed first to the light in order to fade; that there must be over forty shades of blue, and that he could make at least one of them appear like a puff of smoke . . . that black, too, is a spectrum, a case study in "the behaviour of colour" . . . that the grinding and mixing of colours is an art in itself, a question of temperament and "feel" as much as pigment and properties.'

All this was unusual. Braque seemed quite uninterested in aes-

thetics, Lepape noted, maintaining a healthy nonchalance when-
ever the discussions turned to theoretical matters. He would draw
studiously for the designated three quarters of an hour, then relax
and chat for fifteen minutes about nothing in particular, with an
instinctive, easy modesty. Though Lepape's talent for drawing was
evident, he had no real knowledge of oil painting. He was fas-
cinated to know how Braque had learned all he knew. Braque
explained that he had been painting since childhood. Then he
must have acquired plenty of experience already? Yes, said Braque,
he had a lot of experience. What was his preferred medium? 'I'm
quite good at marbling, wood-grain, ornamental mouldings,'
Braque replied. Was he joking? 'It's quite tricky, you know. There
are all colours of marble, and the veins and little threads are all
different shapes; it's the same with wood. It's very difficult, but
you can learn. It's actually quite fascinating.' The interrogation
continued, until Lepape asked him when he intended to begin
painting at the academy. 'Here? Never. I'm just here to draw, do
composition; exercises. Painting – that's another story. For that
you need to be alone at home in peace and quiet, or out in the
countryside. You need solitude to paint. Here, believe me, it's just
exercises, exercises . . . then more exercises.'

At the Académie Humbert, there were two sessions a day.
Braque attended only in the mornings, but Lepape went back for
the evening sessions, when the students included women. The
semi-clad model would be lit by large, shaded lamps, leaving the
rest of the room in partial darkness, which must have made
drawing a challenge. In the gloom one evening Lepape noticed a
student who had not been there before, a girl with frizzy hair
plaited into a bun at the nape of her neck, simple clothes and no
make-up. When she drew she wore a pince-nez suspended from
a cord behind her ear. She worked with intense concentration,
standing quite still even when the model changed her pose, draw-
ing skilfully and apparently effortlessly, with a boldness and
assurance Lepape had never seen before. He persuaded Braque
to go along with him one evening to see the girl's work. They

discovered her name was Marie Laurencin, though she told them everyone called her Coco. She had a Creole appearance – as, coincidentally, did Braque – though her ancestry was a mystery. She claimed her grandmother was Creole, but that was invention; in fact, her Creole blood probably dated back centuries, to when her mother's family lived in Cherbourg, from where the fishermen regularly made sea voyages to Africa and the Antilles. She was quirky and offbeat and something about her appealed to the poetic side of Braque. His appreciation of her indirectly earned her a place in Picasso's circle, the patronage of Gertrude Stein and later commissions to design sets and costumes for Diaghilev. Over the following two decades she became established as one of the few prominent women painters of her time.

Marie had progressed to the Académie Humbert from the École des Dessins de la Ville de Paris, where she had trained in porcelain painting, studying Persian miniatures and rococo art. Her career as a painter had been decided on the top deck of a horse-drawn omnibus one Sunday afternoon on the way home from a visit to the Louvre with her mother. 'I'll never be a painter,' she complained, whereupon her mother, Pauline, replied that it was indeed unlikely; she had never been able to draw. That was not true, but Pauline's idea had been that Marie would become a teacher. They compromised when Marie agreed to study porcelain painting, since in those days it was still (as in Renoir's day) a fashionable and reasonably lucrative skill. At the École des Dessins she was taught by Guignolot, who, according to Marie, had also at some stage taught Braque. When she started at the academy she was already a proficient and expressive artist, but she painted only in black and white – 'colours terrified me. Red terrified me.' She made merciless self-portraits in brown, grey and black. At twenty, still living at home with her mother and their cat, Pousiquette, she felt ugly, sad and hopeless.

Marie and Pauline Laurencin lived the reclusive lifestyle then typical for a woman with a child born out of wedlock, at 51, boulevard de la Chapelle, an extension of the boulevard Rochechouart, at the

foot of the hillside of Montmartre. Mother and daughter enthralled and exasperated each other, Marie idolizing Pauline's beauty but convinced that her mother did not love her enough. She loved to hear Pauline sing, which she did often. In her notebooks, Marie recorded that 'Our lonely Sundays resonated with the *Dies Irae* sung by my mother.' She sang popular songs, too, and sailors' songs. Many years later, Marie reflected that 'without the music and the airs my mother used to sing to me, I would never have touched a paintbrush'. When she was not singing, Pauline liked everything to be quiet. The two of them passed their cloistered evenings, Pauline silently reading Latin texts while Marie patiently read her way through Lewis Carroll and her large collection of illustrated journals.

Pauline's instruction was severe. She taught her daughter that sadness was a mortal sin, as was envy; Marie should strive for self-improvement, but she must never be jealous. When she once complained of boredom, she was severely punished. They held each other in complex thrall, driven by a mixture of religious instruction and fantasy, their days punctuated by the regular arrival of a monsieur in smart jacket and top hat whom Pauline told Marie was her father. This was true, but Marie did not believe her. (The facts came to light only some two decades later.) She never, then or later, mentioned him to any of her friends. She later said that, between the ages of thirteen and twenty, with the exception of one school-teacher who taught her elocution, needlework and deportment, she got to know nobody and experienced 'nothing else at all; a complete vacuum' until she entered first the École des Dessins, then the Académie Humbert.

Though for the time being she kept her mother's secrets, Lepape and Braque brought her out of herself; despite her apparently inhibited manner she was actually a quirky and entertaining character, poetic and imaginative. When they asked to see more of her work she brought them portfolios and notebooks full of drawings, watercolours, notes and drafts; and imaginary compositions of strange, mythological animals. Braque, particularly, was very fond of her; he

found her diverting and admired her work. She was also discerning; keen to take their advice on her work, she also gave them good advice on theirs. She and Braque developed a casual, teasing intimacy that never became a romantic or sexual attachment; they hung around happily together, not doing very much. 'Yesterday Braque and I were being lazy together – too lazy to do anything but fight. We didn't though. Very silly, just sitting there, each in his armchair. To amuse me he put on blue glasses . . .' In the summer evenings of autumn 1903, when they left the academy at the end of the day, the three of them – Braque, Marie and Lepape – made their way past the Moulin Rouge, along the boulevard Rochechouart and all the way up the hillside, where Braque introduced them to the Moulin de la Galette.

The old windmill-turned-dance hall was nowhere near as decadent as the Moulin Rouge. In fact, by the standards of Montmartre, the Moulin de la Galette was really quite proper. Since its refurbishment in the 1890s, the pink and green outer door of the building at the foot of the old windmill was surmounted in a circle of white globes by the words 'Bal Dubray'. At night, the place was festooned with coloured lights, rivalling the cabarets at the bottom of the hillside which flashed their neon strips and flashy new electric lighting. The walls of the immense *salle* of the Moulin de la Galette reflected the room like mirrors as gas-powered projectors trained a torrent of darts of light on to the surging crowd of dancers. There was a palm tree at each corner and a raised platform for the orchestra, and the evening was still presided over by a Dubray – Monsieur Auguste Dubray, who cut a formal figure in tail coat and top hat. He kept a table for his artist friends, who, to avoid resentment among the other clients, entered through a secret door at the rear. Entry for everyone else was through a corridor which ascended into a vast lit room scattered with tables and benches, the dance floor surrounded by a balustrade in red wood. At the centre of the hall stood the bouncer, Monsieur Henri, over six feet tall, with 'the shoulders of a gorilla and the neck of a bull', as Georges Lepape

once remarked. Monsieur Henri was arresting in every way, his broad face accentuated by his crew cut, thick black eyebrows and little moustache waxed with kiss-curls. For maintaining orderly standards in the dance hall, he dressed the part in frock coat and smart black trousers, shiny white starched collar and cuffs; a cravat in white piqué secured with a tiger's-tooth tiepin a pale waistcoat embroidered with flowers. Neither the java nor the cancan was allowed in his establishment, both dances considered too rowdy. 'If a couple indulged in wayward behaviour, or dared move the wrong way, with a single rapid butt of his copious stomach [he] would propel the offenders to the exact spot where they went wrong.' One of the most popular dances was the farandole, danced in an open chain. It was this ring of dancers that had first caught the attention of Matisse when he sat sketching there in the early days; it was to reappear, transformed into a circle of pared-down nude figures, in two of his major works of the end of the decade, *La Danse* and *La Musique*.

The orchestra, conducted by Mabille (descended from the owner of the famous Bal Mabille) and formed mainly of brass, created an infernal din, especially on Sundays, when the dancing went on from three until eleven, the dancers kicking up acrid dust from the wooden floorboards as they danced on for hours without interruption. Since its refurbishment, the place attracted a better class of clientele than in Renoir's day, when its customers had been the jobless poor. Now, seamstresses, factory workers and their cavaliers regularly came up from the bottom of the hillside to the place where the drinks, at fifteen centimes a *demi de bière*, were still the cheapest anywhere and they could dance quadrilles, polkas and waltzes all afternoon for just four sous. The girls of Montmartre would peel off from the crowd when they found someone handsome enough to lose their virtue with; young men hung around looking for a girl to dance with before moving her on to the next bar, at the foot of the rue Ravignan. Marie Laurencin adored it all, especially when Braque expertly led her round the dance hall in a

waltz – yet another of his accomplishments. Lepape sat in a corner making stylish sketches of them, Braque in his bowler hat and checked 'English' suit, Marie in leg-of-mutton-sleeved blouse and tiny-waisted skirt – early precursors of the illustrations for fashion plates he would later supply for Poiret and contribute to *La Gazette du bon ton* and *Vogue*.

The First Salon d'Automne

On the bitterly cold night of 31 October 1903, artists and viewers gathered for the inaugural exhibition of the Salon d'Automne, which took place in the freezing, unheated basement of the Petit Palais. The crowd of carriages lined up outside indicated that not only artists but fashionable socialites had been attracted by the prospect of a daring new Salon; they attended the opening in full evening dress. The works represented included paintings by Gauguin, Cézanne and Matisse, though the two the latter had submitted were hardly groundbreaking: one was a flower painting, *Tulipes*, the other an old-fashioned interior in the Flemish style, *Dévideuse picarde (intérieur)* – hardly the likely precursors of *La Danse* and *La Musique*. It would be another two years before the introduction of the wild, fiery landscapes by Derain and Vlaminck that earned them the label 'Fauves'; a further five before the first appearance of cubism, which by 1910 signalled the beginning of abstraction and the end – as Braque was to put it – of art as imitation. (It was first identified when Braque produced landscapes some said looked like 'little cubes'.) In autumn 1903, the discoveries that by the end of the decade would form the basis of modern art were still in the future. Matisse was still willing to please his unambitious public. Picasso, still in Barcelona, was probably unaware that the first exhibition of the Salon d'Automne was even taking place.

Though the hundreds of artists showing their work were all practically unknown, the exhibition was huge in scale. The catalogue, a modest-looking small-format publication (printed on cheap paper illustrated with a simple cover sketch and priced at one franc), listed 990 works. Among them were three avant-garde works by a Spanish artist, Joaquim Sunyer, who lived in the rue de Notre-Dame-de-Lorette and had studied with Nonell.

Fernande Olivier, an artist's model living with her lover Laurent Dubienne, an aspiring sculptor, in the place Ravignan, had already noticed Sunyer coming and going in the lanes around the place du Tertre. He was small and wiry, she noted, 'like a Spanish guitarist'. She and Dubienne were living in a beaten-up old building with no running water which resembled one of the laundry boats that were familiar sights along the Seine. During the next year or so it would acquire the nickname 'the Bateau-Lavoir'; at the time, it was still familiarly known as the Maison du Trappeur. In 1900, Picasso's friend Paco Durrio had left his shack in the Maquis and moved into a studio there; it was fast becoming a cheap place for artists renting makeshift studios that doubled up as living spaces.

Fernande had also been there since 1900, when she came up from the country one April day on the early-morning train looking for work. She had made her way straight to the employment bureau. When they asked her to come back at four she had wandered about looking longingly in pastry-shop windows – in Paris, the patisserie was so pretty – while she waited to see if they could find her a position (in an office, perhaps, since she was educated) that would enable her to buy food and rent a room. She was spotted by Dubienne, who took her to a café and asked her what kind of life she hoped to live in Paris. He pointed out that any employer would expect her to work for a month before she earned a penny and she would have no life of her own (though the working day for women had been reduced to ten hours, the weekly day's holiday for workers was not introduced until 1906). She would surely do better to go up to the heights of Montmartre with him. In exchange for a few modelling sessions he could offer her a roof over her head and her freedom, with no strings attached. She accepted his offer and thereafter spent her days modelling for him and other local artists.

She had been happy with Dubienne but had begun to notice he had his limitations. Though he was kind and understanding, he had started to seem to her somehow lacking in ambition. He

did everything slowly. It took him weeks to put up shelves, and he was no quicker at producing his sculptures. She was keeping a weather eye out, since clearly there were other artists in Montmartre who, unlike Dubienne, had drive and initiative, more notable talent, and perhaps even prospects.

The Rose Period

The Bateau-Lavoir

April 1904. News had spread that Picasso was back in Paris. One of his Catalan friends, painter Manuel Martinez Hughé, known as Manolo, who lived in the Maquis, knew he was borrowing Paco Durrio's studio in the ramshackle building they called the Bateau-Lavoir. (It was burned down in the 1970s but a replica, in notably better condition than the original, now stands on the site.) One evening at dusk, Manolo took two friends, writer André Salmon and poet Guillaume Apollinaire, up the hillside with him to see for themselves.

Manolo was a great character around Montmartre: he said he was a sculptor, but he never sculpted, as he could never afford the materials. He had somehow acquired some pastels he said nobody wanted but he did not seem to be drawing or painting either; mainly he was writing – or at least, reciting – poetry, inspired by Symbolist poet Jean Moréas. So far, his greatest achievement, delivered in his rolling Catalan accent, was the line *'Et couché, el soir, yo souis comme oune baiyolone dedans sa vouatre.'* ('Asleep at night, I'm like a violin in its case.') His main occupation, however, consisted in selling the expectation of a major lottery win. He sold rolls of cardboard marked with numbers door to door, each roll containing an attractive drawing – a novel package. Nobody ever won. When his friends asked him how he explained this to his customers, he said, 'I just tell them, you didn't win.'

Manolo, Salmon and Apollinaire made their way up the steps of the hillside to meet Picasso. At the corner of the rue des Trois Frères and the rue Ravignan, the Hôtel Poirier, where more obscure poets and painters lodged, came into view like a set in a melodrama, garish in the gaslight as if painted by Vlaminck (whom they would all soon get to know). In the twilight, the pear trees seemed to hang

suspended, yellowed by the light of the gas lamps. The three friends turned into the place Ravignan, where the low, dilapidated building that looked like a laundry boat flanked one side of the square.

'*C'est ici*,' said Manolo.

Inside the building, they trod carefully across creaking floorboards beaten by winter storms and splintered by summer heat until they found the interior door to Picasso's small, uncurtained studio. The front door of the Bateau-Lavoir had been open: it was never closed before midnight, as the comings and goings of the inhabitants were frequent – so Picasso had heard them enter the building. He responded as soon as he heard Manolo's voice and came to open his door. They found him alone, his studio poorly lit by a single lamp. Propped against the dusty walls were paintings he had brought back with him from Spain. He showed them to his visitors one by one, holding a candle at arm's length to each. They saw melancholy pictures painted in monochrome blue, of down-and-out men and frail-looking women. An emaciated, blind beggar strummed at a guitar. Vagrants stood huddled at the roadside, men in rags and sad-looking women with bony shoulders and worn-out faces. And there were desolate family groups, one gathered barefoot on the beach, the woman bent over a ragged bundle, perhaps an ailing newborn. Salmon thought they looked like the work of a cross between an adolescent inspired by Toulouse-Lautrec and Steinlen and a man revealed to himself by El Greco. All the paintings told stories of destitution, sadness and loss. Picasso also showed them some of his earlier works; these were signed Pablo Ruiz (Ruiz was his mother's maiden name).

In Barcelona, *El Liberal* had reported two days running (on 11 and 12 April) that 'The artists Messrs Sebastian Junyer Vidal and Pablo Ruiz Picasso are leaving Barcelona on today's express for Paris, in which city they propose to hold an exhibition of their latest works.' Picasso had (again) arranged the announcement himself. In recent months, his career as an artist seemed to have dwindled to a standstill. Even Els Quatre Gats was no longer functioning, closed since the previous July. There seemed to be nothing doing in Barcelona.

After three false starts in Paris and several seasons of disappoint-
ment and tragedy, Picasso was ready to try again. By now, he had
more or less recovered from the shock of Casagemas's death and he
was better prepared for the challenges of life in Montmartre. His
opportunity came when another of the Catalan artists, Paco Dur-
rio, left Paris, vacating his studio in the Bateau-Lavoir.

The place Ravignan (since renamed place Émile Goudeau) was a
small, roughly shaped square towards the top of the Butte shaded
by chestnut trees, just below the place du Tertre. Some said the
Bateau-Lavoir (as mentioned, then known as the Maison du
Trappeur) had once been a piano factory. In 1867, it had belonged to
a blacksmith, whose initials, MFS, were still nailed in wrought iron
above the doorway. By 1904, it was little more than a stack of shacks,
built up the sloping hillside. The main door on to the place Ravig-
nan gave it the appearance from that side of a one-storey building.
By a quirk of the terrain, on the courtyard side, the ground floor
was three floors below, so one entered apparently at ground level
and immediately ascended a broken-down staircase, reaching the
top only to descend again. It was labyrinthine, with corridors and
precarious makeshift staircases, and deceptively large. In 1899, it had
been divided up; it contained twelve artists' studios and as many as
thirty rooms in all. The place would probably have made more
architectural sense as a piano factory, when it may have been con-
structed around a spiralled ramp, the better to roll the pianos out
(though how they would have descended the Butte is anyone's
guess). It looked like a factory, too, with lines of rectangular win-
dows with small, square panes. In fact, it was a slum. There were
planks of wood piled up outside, the windowpanes were cracked,
the woodwork battered and broken. The walls seeped; the place
smelled of mildew and cats. Everything about it was precarious,
even the ventilation shafts, which lethally crossed the building at
roof height. One winter a tenant had leaned out of his window, try-
ing to sweep away the banked-up snow, and fallen to his death down
one of the shafts.

Picasso's studio was at the top of the building, with a grimy view

across the rooftops. The household consisted of artists, models, a farmer whose cellar room was stacked in summer with asparagus, carrots and onions and in winter with sacks of mussels, and a puppeteer who practised in his room to the sound of drum rolls. The whole building was unbearably hot in summer and freezing in winter. There was no heating, no lighting, no running water other than a scaly indoor fountain on the ground floor, and sanitation consisted of a reeking hole in the ground, in a cubbyhole with a broken door, shared by everyone. There was a concierge, who always had a bowl of soup ready for anyone who had reached starvation point; she lived around the corner at the back of the building. But nobody thought much about what her life must be like, except Fernande Olivier, the sculptor's model. As she passed by the concierge's lodge on her way to and from her modelling work, she noticed the woman sitting there, all day long in her shadowy world, perched cross-legged on a table behind the window.

Life in some parts of *haute* Montmartre had begun to change during the past couple of years, especially since the arrival of the *funiculaire*, which since its installation in 1901 brought tourists up the hillside to enjoy the views and cheap restaurants, perhaps even to catch sight of an artist at work. In 1904, you might have seen the occasional young man striding through the lanes with his smart cane, in suit and panama, watched by a gang of roughshod urchins. The local children hung around on summer evenings playing in the shade, the boys in torn short trousers, the girls in grubby pinafores. Posters, defaced and peeling at the edges, plastered the walls of most of the buildings, but Spielman's restaurant in the place du Tertre had smartened up and polished its windows, the better to advertise the *plat du jour*. The Hôtel du Tertre and the few cafés for tourists also now had smart façades. You might even see the occasional horse-drawn carriage crossing the square. But the scrubland of the Maquis still stretched the length of the north flank of the hillside; that whole district, from behind the Moulin de la Galette down to the rue Caulaincourt, was still a shanty town.

In those early days, Picasso's gang still consisted mainly of his

Catalan friends, joined, from now on, by André Salmon (who crossed the river from the Left Bank) and Max Jacob – the first to create an aura around Picasso – who moved from 7, rue Ravignan to the dreariest, most uncomfortable studio in the basement of the Bateau-Lavoir. They gathered in the more run-down cafés or sat beneath the plane trees in the place Ravignan, where they could look down across the roofs and spires of Paris as they discussed the affairs of the day. Picasso was still most comfortable speaking in Spanish; though his French had improved since his first arrival, it could hardly be called fluent. The *bande* of Spanish artists would draw up their chairs outside the front door of the Bateau-Lavoir and sit conversing loudly in Catalan on the pavement. At midday and in the evenings, they went to Azon's in the rue Ravignan, or Vernin's in the rue Cavalotti near the pawn shop (neither as smart as Spielman's, both more like local *tabacs*), where they could eat indefinitely on credit. The gang was constantly swelled by the addition of somebody's new friend, making a curious, random assemblage, all crowded together in a hot, cramped room where the smell of cooking mingled with the strong scent of rough red wine.

Settled back into the neighbourhood life of Montmartre, Picasso continued to paint the scenes of the street in works inspired by Goya and embellished in part by his imagination. In 1904 and 1905, he painted incessantly, sometimes producing as many as three canvases a day. His subjects were changing, however. On the whole, he had stopped painting the women with rouged lips and faces and tinted hair who strolled the streets and frequented the bars of Montmartre. That fascination with the seductions of decadent pleasure had deserted him with the shock of Casagemas's death. Now, the itinerants who wandered the streets of both *haute* and *bas* Montmartre began to find their way into his work. He had begun to paint the families of travelling circus performers he saw resting in groups between performances: acrobats and their exhausted-looking wives sitting about on the waste ground of the Maquis, still in their costumes; a hurdy-gurdy man with his instrument; children balancing on balls, agile and thin as blades.

Norman Mailer has described the itinerant people who from about 1904 began to appear in Picasso's work, 'travelling jugglers and acrobats, performers living on the last line between society and the nomadic life' who reminded Picasso of his native Spain. In childhood, he had seen troupes of tumblers, sometimes leading apes or bears, and now his 'saltimbanques' pictures depicted 'not so much the circus proper as dusty vagrants, wandering through bare, indeterminate landscapes in the clothes they wore for their performance'. The expanses of waste ground were real, though – they belonged to the Maquis – and itinerant performers could still be seen in the streets of Paris with their children and sometimes their animals, trailing a monkey or a bear on a lead. These nomads represented freedom and skill, but also rootlessness and penury. As a struggling artist himself, at some level Picasso empathized with them. Nevertheless, he was still determined to find a way of becoming successful; at present, he seemed to be watching as others achieved recognition before him. In another of his coloured pencil and ink sketches, he and Vidal, the friend he arrived in Paris with, are shown meeting Paul Durand-Ruel, who is handing over a bag of gold – to Vidal.

Picasso knew that to achieve success he would need to have a substantial, large-scale work to show. In 1904, he produced a life-size painting in subtle rose colours of a beautiful naked boy approaching the viewer, leading a white horse. The work has an atmosphere of extraordinary poise; in a sense it epitomizes what came to be known as Picasso's Rose Period, combining delicate colour, virtuoso drawing and a mood of awe-inspiring calm. This painting, given its scale, was obviously intended to attract the attention of the dealers, and it had the power and gravitas of an exemplary work. The time was ripe, since Vollard had finally promised Picasso a solo show. It must have taken at least two men to transport *Boy Leading a Horse* down the steps of the Montmartre hillside to the rue Laffitte, where Picasso showed it to Vollard, along with other new works. The account of the exchange between them was hearsay:

'How much?' asked Vollard.

'I want twenty francs.'

'You must be mad!'

'All right then, fifteen francs.'

'Not fifteen, not anything, now scarper.'

Perhaps actors on stage, then, would prove more appealing subjects. Though Picasso did not especially enjoy the theatre, he did sometimes go to the local Théâtre Montmartre. (He and Max Jacob were once thrown out for eating sausages.) Built for the people of Montmartre on the scale of a theatre in a small town, the Théâtre Montmartre was hugely popular. The entertainment was raucous and, from the cheapest seats in the top balcony, the audience joined in the action by yelling insults at the villain and applauding the heroine. The walls of the balcony were scrawled over with graffiti, rough drawings of tough-looking men and scantily clad girls. Although Picasso was not particularly interested in the plays themselves, the actors fascinated him, with their tawdry costumes and melodramatic gestures. Picasso's second large-scale work of 1904, *The Actor*, which today hangs in the Metropolitan Museum of Art in New York, is his tribute to them. The painting depicts a tall, ungainly character dressed all in red, making his exaggerated gestures onstage in a hapless appeal to the audience. At the foot of the canvas the prompter's hands and script are clearly visible, adding to the general impression of ham acting, the awkwardness of the lanky figure and the gaucheness of the performance. In the theatre, the players were generally no more talented – in fact, usually rather less so – than the wandering acrobats and circus performers. But Picasso's strong, bold colours and the actor's elongated form make him vivid, arresting and poignant.

Georges Braque loved the theatre, especially the popular melodramas of the day; he may even have attended some of the same performances as Picasso, though it would be another two years before their paths eventually crossed. In summer 1904, Braque was in Kergroes, near Pont-Aven, with a crowd very different from his Académie Humbert friends. They included his mistress, Paulette, who ran a low-level salon in Montmartre, a kind of *maison clos* for the literati, as well as a private opium den in the rue de Douai,

behind the Moulin Rouge. In Kergroes, the group of friends that revolved around Paulette called themselves the Vincent Colony (modelled, presumably, on both Gauguin and van Gogh). When he returned to Paris, Braque abandoned his studies at the Académie Humbert and moved out of his lodgings into a rented studio in the rue d'Orsel, near the offices of *Le Libertaire*, barely a couple of hundred yards from the place Ravignan and the Bateau-Lavoir, but, for the time being, he and Picasso moved in very different circles and frequented different cafés and bars.

In Picasso's life, the role of women was as yet uncertain. For him, women were transitory, provisional; like the itinerant actors, they came and went. The general image of womanhood in his work at this time is melancholy and fragile: he painted frail, vulnerable madonnas. No longer robust and seductive, as they had been in 1900, his muses were now working women, laundresses or seamstresses, like the models Toulouse-Lautrec and Degas favoured, worn down by their labours but with a poignant, ethereal beauty. Picasso had become romantically involved with a wraith-like girl named Madeleine, probably a local laundress, whom he painted in a thin chemise, her hair piled up to highlight her delicate bone structure, in accents of pale, chalky rose (*Girl in a Chemise*). Another of his regular models was a girl called Alice Géry. When he nicknamed her *la vierge* he was being ironic; since adolescence, she had been the lover of government actuary and gifted mathematician Maurice Princet, faithful to him 'in the Montmartre way' – that is, despite her other 'amusements'. Though she was in real life quite tough, she had a celestial aura, with huge eyes, golden hair and pious looks somehow not at all at odds with her quality of natural wildness. In his work, Picasso fused the features of Madeleine and Alice, producing at the beginning of his Rose Period some of his most gentle, compassionate studies of women.

He may already have spotted Fernande Olivier coming in and out of the Bateau-Lavoir by the time he met her at Coco's, the colour merchant's in the boulevard de Clichy. Here she was now, the beautiful, tall redhead. She seemed languid, aloof, more voluptuous than

the girls he was accustomed to, with strong, vivid features and a contrasting aura of lightness. From now on, wherever he went, he kept seeing her. When he spoke to her at Coco's, she said her real name was Fernande Belle-Vallée. She had already noticed Picasso. 'There is a Spanish painter,' she wrote in her journal. 'I keep coming across him, looking at me with big, heavy eyes. I couldn't say how old he is – his mouth is a nice shape, but he has a deep line from his nose to his mouth, which ages him.' She thought him a little coarse, but there was something – '*une personnalité émouvante*' – which somehow shone through.

Summer 1904 came early, and Paris was stifling. The sky seemed to press down 'like a heated roof', as Fernande described it, the intense blue broken up only at the end of the day, when everyone gathered beneath the trees in the place Ravignan, looking for shade. The benches blistered. Working men and women trudged heavily up the steps of the Butte after a day's work, weary with the heat. Not until late August did it begin to abate, when finally there seemed to be some air. Now, the shutters were tentatively pushed back, creating bays of shade between the houses. The leaves, already brown, fell from the trees, rustling on the ground. A gentle breeze began to agitate the leaves. When Picasso and his friends brought their chairs outside to sit discussing the day's events, they noticed Fernande, already seated outside the Bateau-Lavoir, quietly reading her book.

Anarchy and the Joy of Life

Matisse was in St Tropez. He owed this much needed retreat from Paris to Paul Signac, who owned a big house and garden there and had found Matisse a small fisherman's cottage just large enough to house him, Amélie and their son, Pierre. During the past few years, Matisse had had increasingly more to do with Signac, who by now was vice-president of the Société des Artistes Indépendants. Signac clearly saw Matisse as something of a protégé; he had made him a member of the hanging committee and recently appointed him as one of his deputies. The assumption of these public roles, however, had had no impact at all on the way Matisse's work was received. Though he had shown work at the Salon des Indépendants, only two minor purchases had resulted. His sole substantial sale that spring was to André Level, who regularly patronized the small dealers of Montmartre before founding the Peau d'Ours, a society to enable young collectors to acquire the works of their contemporaries. When Level paid him four hundred francs, it seemed like a fortune.

In 1904, Matisse was still wrestling with Signac's divisionist techniques and broadly anarchist agenda, which he related to his own thoughts on the fundamental question of the social purpose of art. He had begun to reflect that, if painting could come closer to a form of decoration, it could surely be introduced into the lives and homes of ordinary working people. Painting would thus be liberated from the realms of academic art, becoming *artisanal*. In a subtle paradox, art might thus become decorative in its most intrinsic, expressive sense, and useful rather than ornamental. When Matisse looked at Signac's work, he saw 'canvases which restore light to the walls of our urban apartments, which enclose pure colour within rhythmic lines, which share the charm of oriental

carpets, mosaics and tapestries', and asked himself, 'are they not also decorations?'

However, Signac in person was another matter. There was a controlling side to his personality, which had begun to grate on Matisse. One problem was that Signac regarded his theories of divisionism as inflexible rules, whereas Matisse would have liked to see them simply as a way of moving beyond Impressionism which opened up new possibilities for improvisation – the beginning, not the end, of true freedom of expression. St Tropez might have been liberating, as Corsica had once been, but Matisse was stymied by Signac, since as soon as he began to improvise on Signac's rules, Signac criticized his work, making him so angry that only Amélie could calm him down. Nevertheless, he continued to admire Signac's painting, particularly his major work of art, *The Age of Anarchy*, which showed beautiful, half-naked people in an Arcadian idyll – his vision of freedom from the tyrannies of industrial exploitation. Matisse had almost certainly seen this work in St Tropez when he began to paint his own vision of Arcadia, *La Joie de vivre*.

It had been not Matisse but Vlaminck who had made the greater impact at the 1904 Salon des Indépendants, where he had been accepted for the first time, with four of his works showing. This was only the second time he had ever shown his work, the first, earlier that spring, in a group exhibition at Berthe Weill's gallery, where his paintings had seemed to make the walls explode with colour. Although Vlaminck himself was completely indifferent to the business of exhibiting his work, Matisse took the opportunity of introducing him to Vollard, who had already noticed him in the rue Laffitte, 'a tall, powerful fellow whose red scarf, knotted round his neck, might have suggested some militant anarchist, if, from the way in which he was carrying a canvas, I had not immediately recognized him for an artist'. As for the picture, a sunset, it seemed to have been 'squeezed out of tubes of paint in a fit of rage' – a description not inconsistent with Vlaminck's own explanation of his methods. As for Vollard's first impressions of Vlaminck, he thought the man's eyes looked kind, but also that, if crossed, he would probably put up a strenuous fight.

Vlaminck had received Matisse and Vollard in his studio, Vlaminck this time somewhat bizarrely wearing 'a wooden tie of his own invention, the colours of which he changed to suit his fancy'. In his memoirs, Vollard adds that he bought all his pieces, but he is conflating two occasions; his purchase of Vlaminck's work was still to come. After effecting the introduction, Matisse continued to frequent Vollard's gallery, despite having little respect for the dealer, who saw him (or so he assumed) as a potential money-spinner rather than a cutting-edge artist of the future, like Vlaminck or Derain. Matisse's patience was eventually rewarded when Vollard promised to give him an exhibition in June. Meanwhile, in St Tropez, he wilted in the heat, enervated by the sun and the change of location, irritated by Signac and feeling uncomfortable and isolated, since, apart from Signac, there seemed to be nobody in the place but wine-growers and fishermen.

In June, as promised, Vollard exhibited Matisse's work. No one could have guessed from the exhibition the new directions his work had begun to move in, since the show consisted entirely of old, unsold work from the mid-1890s. Matisse had included a few early experimental works painted in Corsica but, otherwise, Vollard was showcasing only work painted in the shades of grey he still believed his clients preferred. In the event, neither style seemed to appeal; there were no purchases. After the close of the show (for his usual sum of two hundred francs), Vollard contrarily purchased *The Dinner Table*, Matisse's first strongly experimental work, which had scandalized his appreciative viewers and ruined his reputation; the dealer promptly sold it on to a German collector. From every point of view, Matisse's prospects still seemed wildly unpredictable.

3.

Fernande; and the Lapin Agile

All summer long, Picasso kept catching sight of the striking red-head. Sometimes, he saw her hanging around with other painters in the place Ravignan. Then, one day in the Bateau-Lavoir, he met her at the communal tap at the foot of the staircase and they started a conversation. Picasso's command of French was halting, but Fernande had an enticing way of leaning in as she listened or spoke. At the end of August, the weather broke, in a sudden, dramatic storm. Fernande, caught in the rain, came rushing into the Bateau-Lavoir, where Picasso seemed to be waiting for her. He had a kitten in his hands, which he playfully held out to her. She smiled and took it, and he invited her up to his studio, where, for the first time, she sensed the full impact of his magnetism. He said he wanted to get to know her better, and she realized she wanted that, too. During the next few days, she told herself she was probably about to do something silly, but she blamed her mood on the storm.

In his studio, she looked about her in dismay, seeing works that fascinated and astonished her. The painter seemed to live in a state of total disorder. Canvases of all sizes stood all over the studio: everything there suggested work, 'but . . . what chaos!' Picasso's washing arrangements consisted of an earthenware basin propped on top of a small, rusty stove, with a towel and a bit of old yellow soap lying on a table amidst tubes of paint, brushes and plates. He had only a straw-seated chair and a small trunk, painted black; the bed was a mattress balanced on four wooden feet. The floor was littered with paints, brushes and bottles of paraffin. In the drawer of a table lived a white mouse, which the artist had tamed. As for Picasso, he had changed his sartorial style and now wore a workman's 'meccano' or 'monkey suit' (washed-out blue overalls, the belt left undone at the back like a monkey's tail), with an old cotton shirt, canvas shoes and

a cap. No longer the budding artist-about-town, he had become the humble artisan.

Fernande began to look closely at the canvases. One painting in particular caught her attention, of a man leaning on one crutch, a basket of flowers on his back. Everything was painted in mono-chrome blue except the basket of flowers, which was in fresh, brilliant colours. The contrast between the gaunt, bowed man and the brightly coloured flowers seemed to her 'strange, tender and infinitely sad'. She wondered about the basis of Picasso's vision: was it merely intellectual, or did it reveal 'a deep and despairing love of humanity?' Picasso, watching her as she looked at his work, saw that Fernande was not only beautiful and seductive, she was also intelligent and interested in his work. For him, the attraction was instant. He painted them as two lovers entwined and levitated by love, flying through the air; he begged her to come and live with him. However, for her, things were not so simple.

By the time she met Picasso in August 1904, Fernande had been living with Laurent Dubienne for five months in the Bateau-Lavoir, on the ground floor, in room number three, on the rue d'Orchamps side. In the evenings, she sat in the square and watched the artists gather on the doorstep of this *'étrange et sordide maison'*, in front of the dirty, ochre-painted wooden portal, 'like the doorway of a Protestant chapel'. She loved Montmartre, with its harmonious mix of amateur painters, office workers, labourers and streetwalk-ers, admiring the theatricality of the women with their vampish clothes and painted faces who unashamedly strolled through the lanes. She enjoyed watching the merchants who pushed their bar-rows up and down the lanes, the poets and the *'gnaf'* on the corner, the coal merchant, the fried-potato seller, the stringer, the urchin, the old man, the Italian model, the young girl, the shop assistant, the hat-box seller, all chanting their wares or singing popular street songs – *'C'est moi qui les fais/C'est moi qui les vends/C'est ma femme qui boulotte l'argent.'* ('It's me who makes them/Me who sells them/The wife who scoffs the takings.') She even liked the sordid old Bateau-Lavoir, noisy from morning until night with the sounds of

talking, shouting, singing, doors slamming, the din of buckets which people dragged along the corridors then left to roll around the floor. Would she really be happier there with Picasso than with Dubienne?

Despite these ruminations, what neither Picasso nor Dubienne realized was that Fernande was already married. When she arrived in Paris in 1900, she was running away from her husband, Paul-Émile Percheron, who had been abusive and violent. She had met him through her aunt's maid (he was a friend of the maid's *petit-ami*) and run away from her aunt's house to live with him – until her aunt discovered her whereabouts. Arriving on the doorstep one day accompanied by a policeman, her aunt had announced that, since Fernande had already brought the family into disrepute, she had no choice but to marry. Fernande had done so under duress, suffering a miscarriage in the bitterly cold winter of 1899/1900, when the snow froze over and she slipped on the ice. By spring 1900, she could bear it no longer. She fled the house early one morning and caught the first train to Paris, where Dubienne discovered her as she waited outside the employment agency.

During the day, she sat for him and for various other artists, mainly the genre painters and *'pompiers'* (hacks) who still aimed in their work for exact copies of nature. She posed in Flemish costume before a window for a painter working in the 'Dutch' style and veiled from her chin to her eyes for a Turkish artist; she sat in place of the *femmes du monde* far too busy with their social lives to give time to the tedious business of posing for their own portraits, posing *'en grand tralala'* as Madame or Comtesse so-and-so. All had gone well until the day she returned from work to find Dubienne sound asleep with a young model. He disappeared for a few days, then returned announcing he wanted to marry her, not realizing this would have been impossible. In fact, it had begun to occur to Fernande that the ideal life would be to live alone, as an independent woman. She spent everything she earned on stockings, handkerchiefs, hats and perfume – rose, or her favourite, chypre – and the artificial violets she wore in her hair, placed just above her large,

almond eyes to create an air of mystery. She was happy with her new self-image and had no intention of giving up her freedom.

Yet she had also begun to succumb to the attentions of Picasso. She told herself that she had always thought, 'perhaps I could love this boy one day'. Of course, to go on seeing him, she had to keep deceiving Dubienne. She woke sometimes to find Picasso keeping vigil at her bedside. He made drawings of himself sitting beside her as she lay asleep. Once, he drew Dubienne at her bedside instead, reading a poetry book, thus endowing him with accomplishments beyond his own reach (Picasso still barely spoke French). In another drawing, Dubienne appeared as Christ on the cross, ascending into heaven. Picasso, a mere mortal, the sketch implied, would remain rooted, earthed, at her side. While she tried to make up her mind, Fernande moved out of Dubienne's studio and went to live with friends, continuing to see Picasso when Dubienne's back was turned. Then Dubienne was called up for a week of military service, giving the two lovers free rein. Perversely, at this point she decided she would not live with Picasso. He was jealous by nature, had absolutely no money and he had already said he did not like her going out to work. And she did not want to live in another miserable studio. She began to sit for the Catalan artist Ricard Canals, who had known Picasso in Barcelona. He posed her and his wife, Benedetta, as two Spanish *majas* in glamorous lace mantillas. When she told them she wanted to leave Dubienne, the Canals invited her to stay with them. In the evenings, they were usually joined by Picasso.

Fernande's overriding need to be admired led her into a series of unsatisfactory relationships. She was followed down the street one day by Joaquim Sunyer, an artist, who she thought looked like a Spanish guitarist and had exhibited at the previous year's Salon d'Automne. Soon, she became his mistress, a decision as baffling to her as any other she had yet made. What did he have, she asked herself, that Picasso lacked? (Prospects, perhaps?) By now, she seemed to be refusing Picasso almost as a kind of ritual, without really understanding why. Her liaison with Sunyer was predictably brief but, while it lasted,

it meant her moving permanently out of Dubienne's studio in the Bateau-Lavoir. When the affair came to an end, she moved in with a friend, a girl named Renée. Nevertheless, when spring came, she began to feel obscurely melancholy. Though she could see no reason other than habit to return to her former lover, she did so.

Back in the Bateau-Lavoir, she watched Picasso and his friends as they came and went. Sometimes, she joined them for an opium-smoking session in Picasso's studio, during which she was suddenly able to see with great clarity that life was beautiful . . . After one such evening in early 1905, she suspected that she might after all be falling in love with him. Three days later, under the influence of love and opium, she was still there. Picasso told her she should stop her modelling work and come to live with him, but she was concerned about her commitments to her artists. When he made sixty francs from the sale of some drawings, he took her to dinner at the Lapin Agile, the first time she had entered the *cabaret artistique*; she was embarrassed by the sight of Frédé, whose grimy appearance, shabby clothes and matted beard shocked her – it was the first time she had seen him at close quarters. She found the place sordid and crowded, and the couple were constantly disturbed by a group of strangers who said they wanted to talk to Picasso. Irritated, he eventually attempted to deter them by firing a few shots from his revolver, whereupon Fernande fled back to the Bateau-Lavoir, and Dubienne.

In her search for adoration, Fernande gravitated towards people who let her down. She had escaped from her cruel aunt into the arms of Percheron, who had turned out to be more vicious by far. Now, Dubienne had cheated on her. Being bullied seems to have been habit-forming; she had been used to it since childhood. 'Fernande Olivier' was in fact just a name she had assumed (as she also sometimes used the name Belle-Vallée); she was born Amélie Lang. The child of an illicit love affair, she had been left soon after birth with her paternal grandparents and raised by her aunt, who had a daughter of her own. The aunt was mercilessly mean to Fernande, who always felt self-conscious and gauche compared with her pretty

cousin. They lived in an apartment crowded with ugly furniture next door to her uncle's shop and workshop, where he made and sold wonderfully delicate ornamental flowers and feathers, then the height of fashion as adornments for corsages and hats. Sometimes, Fernande was allowed to wrap these beautiful objects in fine, silk paper and lay them carefully in long boxes, ready to be sent to Paris. She acquired an appreciation of beautiful things – a taste for luxury otherwise sustained only by reading romantic novels – but it had become a need. Her perfume, her hats, her ornamental flowers were more than baubles, they were essential to her view of herself; more than an effort to keep up appearances, she needed to keep acquiring them to maintain a sense of self-worth. She was still hoping for the romantic vision of her dreams. So why would she contemplate life with an unknown Spanish artist? Picasso was mercurial, but he was worryingly insistent. Perhaps he would make too many demands on her. Perhaps he, too, would make her feel intolerably trapped. Perhaps even he would turn out to be a bully. And, anyway, he was penniless. As the summer wore on, she remained undecided.

While Picasso waited for Fernande to make up her mind, he spent his evenings in the Lapin Agile. The *cabaret artistique* was a dark little two-roomed cottage nestling beneath the trees at the corner of the rue Cortot and the rue des Saules. Picasso had rediscovered Frédé, its new proprietor, here – it was a step up from the old Zut. The place had been rescued from demolition the previous year by Aristide Bruant, former cabaret singer and *comedien* of the Chat Noir, immortalized, in black sombrero and vivid red scarf, in the famous poster of 1892 by Toulouse-Lautrec. The Lapin Agile exists to this day, ivy still bordering the blue, yellow, red and green harlequin-style windowpanes, trees shading the small paved terrace outside.

The place had an illustrious history, since the original part had been a shooting box built to the order of Henri IV, whose mistress had lived secretly at the top of the Butte. In the eighteenth century,

it became a rendezvous for highwaymen until, at some stage, the second part was added, when it became a country tavern under the name Ma Campagne, frequented by local gangsters and their molls. In the mid-1880s, Mère Adèle, a former dancer at the Élysée Montmartre, acquired it and renamed it the Cabaret des Assassins, a soubriquet inspired not by the dubious clientele but by the scenes from the underworld a local artist had daubed on the walls. It gained its familiar name, Lapin Agile, in 1875, when caricaturist André Gill famously painted the jaunty red and green sign still there above the entrance – a rabbit dressed in conductor's cap, bow-tie and cummerbund leaping out of a saucepan and balancing a bottle of wine on its paw. The Lapin à Gill ('the rabbit by Gill') became the Lapin Agile ('the agile rabbit'), the name soon adopted by everyone, and 'Cabaret des Assassins', still scrawled across the outer wall, was partially whitewashed and amended to reflect Frédé's new ambition for the bar: it now read 'Cabaret Artistique'.

By 1904, when Picasso began to frequent it, the clientele mostly consisted of the motley inhabitants of the Bateau-Lavoir. The old, sinister murals were gone and the interior walls decorated with paintings, poems and posters. Above the door, Frédé had inscribed his personal motto, *'Le premier devoir d'un honnête homme est d'avoir un bon estomac.'* ('The first duty of an honest man is to have a good stomach'.) Just as before, in the sleazy old Zut, Frédé created the atmosphere, bringing the Lapin Agile alive with his drinking songs and his music (continuing the tradition established by Aristide Bruant, who had made a fortune in cabarets at the foot of the Butte, entertaining the rich with the street songs of the poor, all sung in the authentic argot of Montmartre). The Catalan artists, particularly, loved the Lapin Agile; it reminded them of the inns in Spanish villages where everyone sat in the shadows cast by similar red-shaded lamps. When the place became so dirty people could barely see, Frédé got the locals to help him paint the walls, paying them in the cocktail *de la maison*, his own special concoction of Pernod and grenadine. Picasso contributed a mural, an improvisation of *The Temptation of Saint Anthony*. On the far wall, Christ on the cross

dominated the scene, between a statue of Apollon Musagète (the subject, coincidentally, some years later, of one of Diaghilev's ballets) and one of a Hindu divinity. Other contributions included a harlequin by Picasso and paintings by Steinlen and Maurice Utrillo, the son of Suzanne Valadon and Miquel Utrillo, Picasso's old friend from Barcelona, master of shadow puppet shows at Els Quatre Gats. Frédé even provided a visitors' book, which over the years accumulated some illustrious signatures, including those of Renoir and Georges Clemenceau, who was to lead France throughout the First World War.

The Lapin Agile was the inspiration for one of Picasso's most striking early works, *Woman with a Crow*, a portrait of Frédé's stepdaughter, Margot, hunched over her pet bird. She leans on the bar, absorbed in her crow, so wrapped up in it that the two forms, woman and bird, seem fused; Picasso has given Margot a crow's head, wing-like shoulders and elongated, claw-like fingers. The following year, in 1905, he gave Frédé another painting, which he called *Au Lapin Agile*, in which Picasso himself, in full harlequin costume, sits morosely at the bar, a girl at his side, exotic in feather boa, pill-box hat with jaunty feather and jewel-encrusted collar, her face garish with white rice powder and red lipstick. The dress code at the Lapin Agile varied widely in those days: some really did arrive looking like shepherdesses or harlequins, others as if dressed for a Louis XV costume ball; perhaps these were mostly artists' models, still wearing the costumes they hired to pose in from the model market in Clichy. Frédé, seated in the background of Picasso's painting in his distinctive wooden clogs, looks as if he has been imported from an early work by van Gogh. The vibrant reds and yellows of this painting distinguish it from other works of 1904 and 1905, most of which show Picasso moving more tentatively from monochrome blue to shades of muted red and pale rose. In fact, though he gave Frédé *Au Lapin Agile* in 1905, the work may have been painted earlier, dating back even to the days of the Zut, or perhaps Picasso painted it in 1904, soon after his definitive return to Paris.

As the evenings wore on, the singing in the Lapin Agile gathered

momentum as bawdy couplets, street romances, Marseilles refrains, Breton melodies and provincial folk songs were belted out, accompanied by Frédé on his guitar. Poets read their poetry; painters sat swapping stories. People would become regulars for a while, then disappear. Some rolled out at the end of a long night on to a nearby bench, or just stretched out on the ground beneath the trees. The Lapin Agile soon became the centre of the community in *haute* Montmartre, the place where artists gathered with artists *manqués*, the jobless bourgeois or the black sheep of the family, the place where the local scoundrel became an autodidact. Dancers who had seen better days occasionally came up from the Moulin Rouge to sell opium (also available in Montparnasse, at the Closerie des Lilas). The Lapin Agile was where everyone went to be seen, and to share their troubles, drown their sorrows, confess to secret romances or expound their particular theory of life.

Not everyone who went there had an interest in painting, writing or music; the place still occasionally attracted undesirables. Frédé, distinctive in this period in his red scarf and broad-brimmed hat (a battered version of Bruant himself, perhaps, though Frédé kept his tangled, greying beard), was not above deterring them by firing a few pistol shots. Eventually everyone who was still standing would make their way home after a long night's revelry, singing and calling to one another across the square, and sometimes firing a few shots of their own, out of sheer exuberance. Most people, including Picasso, carried guns; it is a wonder there were not more accidental killings and dramatic suicides in this strange rural underworld consisting of Catalans, artists *manqués*, poor workers, petty criminals, whores and gangsters. In 1904, the artists who would soon bring about a revolution in the arts were still in the wings.

4.

New Searches for Arcadia: Enter the Steins

By autumn 1904, Matisse was back in Paris. He brought with him another new painting, *Luxe, calme et volupté*, a sunny Arcadian scene painted predominantly in warm pink tones depicting a group of nude women relaxing on the beach and a single figure, her arms raised to her wet hair, emerging from the sea. However, the Arcadian dream, even on canvas, remained elusive, and under the constraining influence of Signac. Though the new picture was painted entirely in the divisionist method, Signac had once again been disapproving. Matisse had taken his title from Charles Baudelaire's poem *'L'Invitation au voyage'* – *'Là, tout n'est qu'ordre et beauté, / Luxe, calme et volupté . . .'*, the borrowed title implying shared ideals of balance and harmony – but Signac saw only elements of deviation from his own inflexible methods.

Despite his exasperation with his protégé's work, Signac continued to assign Matisse public roles. He had now made him assistant secretary of the Salon d'Automne and a member of the selection committee. But none of that paid the rent; Matisse and Amélie were down to their last fifty francs when, in autumn 1904, she made the journey from Paris to Perpignan, where her sister Berthe now lived. After visiting Berthe, she took the opportunity of continuing along the coast to explore the area between the mountains and the sea. At the end of a road that wound steeply down the hillside, past the pink house where the anchovies were salted and on towards the harbour, she discovered a small fishing village where secluded beaches caught the light, giving the dark-blue water a silver, sparkling sheen. The church of St Vincent, with its glittering gold altar, stood at the edge of the harbour. At dusk, its stone seemed to draw a delicate, pink light across the waves. When the sun began to set, the sky glowed pale blue and pink, and a sail, billowing out, made a

shape like a pale-yellow flame. Perhaps this would be the place where Matisse would finally discover his own vision of Arcadia.

In October 1904, the second Salon d'Automne took place, this time in the Grand Palais, the larger of the two 'palaces' built to celebrate the Franco–Russian alliance. The exhibition included, among its 2,044 works, a Renoir room (thirty-five), a Toulouse-Lautrec room (twenty-eight) and a section on '*Photographie*', consisting of photographic reproductions of paintings by a small selection of artists, including Cézanne, represented by three containers of nine photographs each. The third (no. 2047) was the property of Monsieur Vollard – his latest piece of ingenuity, cleverly tantalizing the audience with reproductions, the better to augment the value of the original works. The exhibition included a work everyone found spellbinding, *The Artist's Wife* (or *Madame Cézanne à l'éventail*), Cézanne's arresting portrait of his wife in a blue dress, seated in a dark-red armchair, which was being seen in Paris for the first time. In the painting, Madame Cézanne's face seemed to be composed in two halves, one side expressive, the other mask-like. The posture of the figure (like Cézanne's earlier portrait of his father) seemed powered by a centrifugal energy, the picture planes interconnecting to establish a particular kind of sculptural dynamic, as if the figure were truly alive. The artist has captured his wife's slight unease as a sitter, her delicacy and her fragility, as well as the softness of her flesh and the contrasting coarseness of her clothes. The impact of Cézanne's work at the exhibition was substantial, spreading as far as America, where the anonymous reviewer in the *New York Sun* reported that he was the central attraction of the exhibition, with his 'crude, violent . . . altogether bizarre canvases', his 'tang of the soil'.

Visitors to the exhibition included a young American, a tall, graceful man from Pennsylvania with a long, bony, almost translucent face and golden hair. His name was Leo Stein. He returned to the Grand Palais several times, sometimes with his older brother, Michael, and younger sister, Gertrude, who cut a strikingly squat figure. Vollard, who had lent the painting by Cézanne to the Salon,

also visited several times. Every time he went, he saw the Steins, the two brothers and their sister, seated side by side on a bench, looking up at the portrait. After the exhibition closed, Leo and Gertrude Stein approached Vollard to make him an offer for the painting, which he accepted, struck by their remarkable passion for the work they were about to possess. '"Now," said [Gertrude], "the picture is ours!" They might have been ransoming someone they loved.'

Leo Stein had arrived in Paris two years earlier, in 1902, to study (like Matisse before him) at the Académie Julian. He took a spacious apartment in a large, Haussmann-built building at 27, rue de Fleurus, close to the Jardins du Luxembourg, where, the following autumn, Gertrude joined him. Leo's life had been dedicated to the study of art for the previous three years, since, in 1900, aged twenty-four, he had graduated from Harvard University. With fellow Harvard alumnus and American art connoisseur Bernard Berenson as his older guide, he had begun by familiarizing himself with quattrocento Italian art, encouraged by Berenson, who was in the process of writing the essays on the history and aesthetics of Italian painting which were eventually collected and published (in 1956) as *The Italian Painters of the Renaissance*. Leo had been planning to write a book of his own, on northern Italian Renaissance artist Andrea Mantegna, until he discovered there were two already being written, whereupon he resumed his general study of art and aesthetics. He had expected to be excited by modern French art, but, so far, he had been disappointed. He had not yet discovered Montmartre, nor really seen any modern art in Paris. His main acquisition as yet was a painting by the British painter Philip Wilson Steer, purchased in London before he left for France, an auspicious purchase, since it had made Leo realize that people did not need to be millionaires to collect art, a revelation that had made him feel 'a bit like a desperado'.

During the first few weeks of 1903, a decisive event had convinced Leo Stern that his future lay in Paris. Dining with cellist Pablo Casals one evening, as he did every week, he had suddenly 'felt myself growing into an artist'. He had rushed back to his hotel, built a rousing fire, discarded his clothes and begun work on a nude

self-portrait. He spent the following week in the Louvre, practising his figure drawing by sketching statues. Nevertheless, his artistic ambition was manifested primarily in conversation, which before long he would develop into what he was to call his 'atmosphere of propaganda'. In spring 1904, Berenson happened to ask him if he knew Cézanne's work: 'I said that I did not. Where did one see him? He said, "At Vollard's"; so I went to Vollard's, and was launched.'

Leo spent many happy hours trawling through dusty piles of canvases, turning paintings the right way up and getting on amiably with the dealer. That summer, Berenson introduced him to another Harvard alumnus, Charles Loeser, heir to the fortune of Macy's Brooklyn department store and owner of a prominent collection of works by Cézanne, who now lived in Florence, where Leo visited him. What followed, Leo called his 'Cézanne debauch'. By looking at the artist's work, he absorbed principles of painting which made him determined to discover the works of other modern painters.

By 1904, Michael Stein had also made his home in Paris, with his wife, Sarah, and their young son, Allan. They settled in the rue Madame, also on the outskirts of the Jardins du Luxembourg, round the corner from the rue de Fleurus. As the eldest child of deceased parents, Michael was in charge of the Stein family finances. He had brought his considerable business acumen to bear on the wise investment of their inheritance, selling their father's holdings in his cable-car company at a profit to the head of the Central Pacific Railway, where he, Michael, became branch manager before extricating himself, in 1902, from the still-thriving business. Though they were not exactly millionaires, the Steins were certainly wealthy by the standards of those whose company they were about to keep. Leo and Gertrude had about a hundred and fifty dollars a month to spend on travel, books or pictures, at a time when rents in Paris were comparatively low and food was inexpensive. Occasionally, there was a windfall; on one occasion, Michael announced that there was an extra eight thousand francs to be spent: 'As this was regarded as a criminal waste, we went at once to Vollard's.' Such

sums would soon be invested in pictures which would later be regarded as some of the twentieth century's most significant works of art.

Though *The Artist's Wife* was purchased by Michael Stein, it soon appeared at 27, rue du Fleurus, where Gertrude hung it above her desk so that she could look at it every day. By the opening of the 1904 Salon d'Automne, Leo was on the lookout for undiscovered talent, but he saw there nothing that interested him as much as the works of Cézanne. He noticed paintings by Matisse, but dismissed them as too divisionist for his taste. Nevertheless, his general disappointment did not prevent him, as he explained to friends, from feeling keenly from now on 'the obligation that I have been under ever since the Autumn Salon, of expounding L'Art Moderne (you will observe that this is not the same as L'Art Nouveau)'. As yet, for Leo, the 'Big Four' were still Manet, Renoir, Degas and Cézanne. None of the Steins had yet been introduced to the work of Picasso. In autumn 1904, Leo purchased works by Henri Manguin, a French painter associated with the Fauves, and the Swiss Félix Vallotton, but, as far as the Steins were concerned, Cézanne was still, for the time being, the incontestable master.

Vollard, however, was keeping his eyes wide open, all the more so since the Steins had appeared on the scene; and he was still closely watching Matisse. He was also (since Matisse's appointment to the committees of the Salon d'Automne and Salon des Indépendants) beginning to trust the artist's judgement; he had recently taken on work by Manguin, Albert Marquet and Jean Puy, all associates of Matisse. It is possible he may also have known that, at the end of 1904, Matisse's work was reproduced in *Mir Iskusstva* (*The World of Art*), a magazine published from St Petersburg since 1899, its editor the future maestro of the Ballets Russes, Sergei Diaghilev. It is unclear how Matisse knew of it – perhaps through Russians in Paris, or through one of the gallery owners in Montmartre. By contemporary Russian standards, Diaghilev's magazine was radical in its outlook; the issue in which Matisse's work appeared also included reproductions of work by Degas, Gauguin

and van Gogh. In fact, by late 1904, the future of *Mir Iskusstva* was already precarious, given the developing political situation in Russia and also because, by that point, Diaghilev's interest in it had begun to wane. On the whole, then, *Mir Iskusstva* made little impact in Paris. Nevertheless, its existence was significant, since the appearance of works by Matisse, Gauguin and van Gogh in its final issue clearly signalled the extent of Diaghilev's steadily developing interest in contemporary French art.

In Montmartre, Vollard was beginning to make new investments. Although he was watching Matisse with interest, since the exhibition of 1901 he had shown no further interest in Picasso, whose paintings of acrobats were about to be included in a show (from 25 February to 6 March) with two other artists at the Serrurier Gallery at 37, boulevard Haussmann. Picasso had high hopes. 'It's such a terrible waste of time, scrounging the last peseta to pay for the studio or a restaurant,' he wrote home to friends in Barcelona. 'God willing, people will like it and I'll sell everything I'm showing.' It was the first time he had shown his work since the previous October, when Berthe Weill had included him in a group show. He had been described in the catalogue preface as 'a good image maker'; the author had praised his pastels and his depictions of 'flowers, draperies, dresses, the shawls of lively Spanish women' – it sounds almost as if he was being confused with another painter. Max Jacob was among the visitors; in a postscript to a letter of 27 February to André Salmon, he reminded him, 'Exposition Picasso – *Lundi* a 2 h ½ précises.' Picasso added greetings: 'Bonjour à Salmon, Picasso.' Though the Serrurier show brought him some attention in the press, however, he sold little; just enough, perhaps, to consider the possibility of a short retreat from Paris once summer came.

In March 1905, Matisse helped Signac organize the first official exhibition of forty-five works by van Gogh, shown as part of the Salon des Indépendants. The show constituted a turning point for Matisse; he later said that, when he finally broke away from the constraints of Signac's divisionist methods, it was van Gogh's work that had encouraged him. At the Indépendants, he showed

eight paintings, including *Luxe, calme et volupté*, which, despite his persistent criticisms, Signac immediately snapped up. When the influential critic Louis Vauxcelles saw it, he hailed Matisse in the press as the new *'chef d'école'*. The public was more equivocal; Berthe Weill said she heard sarcastic laughter the length of the exhibition hall. Viewers in early 1905 had barely had an opportunity to absorb the shock of Impressionism: this alarming new spectacle of paintings consisting of coloured dots and depicting naked figures in mythological settings was still too much for them. As soon as the exhibition closed, in May, Matisse and his family headed south to investigate the place Amélie had come across when she had made her extended journey along the coast near Perpignan.

5.

In Collioure

When she discovered the small fishing village of Collioure the previous autumn, Amélie had seen at once that it might be the perfect retreat for Matisse, perhaps even the Arcadian idyll he was searching for. In this tiny, animated place, where most of the locals spoke only Catalan, in summer the hillsides were burned orange by the sun and the oleander faded to the colour of old roses. Above the port, the place was sparse and deserted, the foliage reminiscent of the shrubland of Corsica; there was dense woodland and the fir trees stood tall and dark against indigo skies. In 1905, summer came early; in May, the place already dazzled in the sunlight. The couple arrived in searing heat, which remained unabated all summer long.

Lining the steep, twisting lanes that cut streets into the hillside were narrow houses paved with stones of shale, bound by the sand and limned into the colour of the earth. Here, the fishing people lived, in their tall, three-storey dwellings consisting of three rooms, one above another. The Matisses put up at the somewhat misleadingly named Hôtel de la Gare, above the port behind the railway line; in fact, it was nothing more than a modest lodging house, where la dame Roussette let out one or two spare rooms to the occasional travelling salesman or railway worker. On the ground floor was a large room sometimes used for weddings and banquets, and at the back a courtyard, where the rabbits' cage was kept and hens pecked about in the dirt. La dame Roussette was an alarming-looking woman with an enormous beaked nose and chin and scraggy neck; her hair was rolled into the traditional Catalan coif. A widow of a certain age, and in character typical of the women of the region, she took a dim view of 'foreigners' – anyone, in other words, not from Collioure – and admitted only

those who spoke Catalan, unless they were long known to those in the village. One look at Matisse, however, convinced her that this gentleman was special: he had about him the quiet air of a man who means business.

Collioure, despite its ambience of remoteness, was the principal fishing port on the Mediterranean coast, abundant in anchovies and sardines, which served the entire region. It was a fishing port typical of the Catalan coast, and the way of life had evolved to suit its location, nestling among the mountains. The elderly still wore the accessories of the traditional costume: a white, lace-trimmed bonnet and wide woollen belt in red, blue or black, and a black or white kerchief right up to the chin. The women were matriarchs; they ran the homes, worked in the salting shop and mended the nets. In the narrow, winding lanes paved with polished pebbles lived a vibrant, working population.

The people of the town were volatile. In the streets, there were yells; insults were hurled, cutlasses brandished. Shutters were fastened ajar; combats were discreetly witnessed. The perfume of Collioure was salt, fish and detritus as the women came out to empty the night's waste into the sea and the rocks swarmed with hundreds of spider crabs. Then the village cats came out, mangy, lean, their threadbare coats striped with livid scars, to fight over the pickings. By the time the catch was in, the women were already seated on the beach, deftly mending the nets. Within minutes, the beaches would be covered with a carpet of shining fish scales. The decks, the sides of the boats, the hands of the men, shone with silver until, at first light, with the first breeze, the scales were dispersed along the lanes like confetti. There would be no rest for those housed within yards of all this dawn activity, as Matisse now was. The quiet time was the couple of hours following midday, when the men rested after their morning's work. Then, the village fell silent. On the beaches, suddenly empty, there remained only the chains, hooks, ropes and crossbars, which the old people tidied up and put to rights. While the menfolk took their siesta, the old women did their knitting in the shade and kept

watch, and the younger women gathered around the wells to catch up on the day's gossip and news.

Matisse went down to the beaches and made pen and ink sketches of the women mending the nets, the fishermen rolling them and the boats on the shoreline, their sails down, a row of masts in the foreground, and in the background the castle, church or bell tower. He drew boats, sails flapping, scudding along, with others just coming in, little figures in the foreground and the line of men throwing their weight behind the crossbar. With Amélie, he walked up into the hills and sketched the mountains rising up against the sea. They left early in the mornings and walked right away from the town, seeking secluded spots where he could paint her without fear of attracting curious onlookers. She modelled for unclothed Arcadian nymphs and sat for a work which became *The Green Line*, a semi-abstract portrait in orange and violet, turquoise, green and red, in which her hair is a mass of blue-black, her face bisected by a broad green stripe. That summer, the heat made the water calm. On a still day, the sky threw dappled, silvery reflections on to the surface of the sea. In Matisse's sketches, boats wait, moored on the beach, the low waves behind them; sailors, or a little dog, stroll along; a few rapidly drawn circles indicate the pebbles on the shingled shoreline.

After a while, however, Matisse began to crave the company of other artists. Despite his difficulties with Signac, he had appreciated the stimulation he and his neighbours had provided in St Tropez. From Collioure, he wrote to a number of his friends inviting them to join him, but received only one reply, from André Derain, released from the army since September, who immediately accepted, making plans to arrive in the port in the last week of May or the first week of June. The neighbours of la dame Roussette included a local fruit and vegetable seller, old Mathieu Muxart, who had lived in the place for decades. He happened to be at the Hôtel de la Gare to witness the arrival at the station of the extraordinary 'Monsieur André'.

Tall, lanky, dressed entirely in white but with a red beret, when he stepped down from the train Derain caused consternation.

Mathieu saw appearing at the door of the Hôtel de la Gare 'a sort of giant . . . with a long, thin moustache, and the eyes of a cat'. Derain took off his beret, announced he was a friend of Matisse and asked to be shown to the hotel foyer. La dame Roussette immediately ordered Mathieu to put him out into the street: 'Poor me! He'd have made . . . five of me.' He was dressed like a carnival, she protested, as Derain looked on, bewildered. Mathieu suggested that, were he to throw the gentleman out, Monsieur Matisse might be sorely offended. So Derain, too, came to lodge at the Hôtel de la Gare. The next day, Mathieu was sent up to the station to fetch his luggage. There, waiting at the station, was a little handcart bursting with boxes and trunks and a huge umbrella.

The searing heat continued, and the extraordinary light it created captured the young painter's imagination from the moment he arrived. In a letter home to Vlaminck, Matisse described the 'blonde, gilded light, which suppresses the shadows . . . it's a revelation, a work of art; amazing . . .' Where Matisse had envisaged opportunities for developing the new divisionist techniques he had begun to experiment with since meeting Signac, what struck Derain was the flattening effect on colour created by the strong light of the region. The strong sunlight bronzed the people chrome and created stark contrasts between the dark blue of the sea, the burnt-orange hillsides and the terracotta rooftops, highlighting the varied colours of the boats on the water and rendering the sails a scintillating white.

Derain got to work straight away, undeterred by the heat, painting the lanes, the local people, the sea, the boats in the harbour or on the water. (Today, his *Fishing Boats, Collioure* hangs in the Metropolitan Museum of Art, as does his vivid, somewhat wild-looking portrait of Vlaminck.) He observed with fascination the men with blue-black beards, the women with their lovely, graceful gestures and traditional costumes with black camisoles; he loved the donkeys, the multicoloured boats, even the local pottery painted bright red and green. Exploring the area, he found churches with wooden sculptures he thought would make Vlaminck turn pale,

architecture in unusual colours and lanes winding up from the port, where he listened to a Spanish beggar singing gypsy songs. He began to paint broad expanses of dark water shimmering with dappled silver light, lines of pure yellow depicting light glancing across the boats. From the top of the town, looking down on the church, he observed a row of orange rooftops, the hills, in the background, burned, dark russet and orange, a scene he depicted in numerous paintings, in which, between the line of the sloping rooftops and the flat planes of orange hillside, a freely painted sweep of indigo blue indicates the sea, creating the impression of pure, hot, flat colour. Derain produced paintings apparently without effort. In his *Bateaux à Collioure*, seen from the second floor of the Café Olo, the bay is a flutter of blue and yellow marks, highlighted by a few touches of pure, bold red – the same red he used in *Le Séchage des voiles*, the final painting he did in Collioure at the end of that summer. The light provided such stark contrasts that he depicted it in broad, scarlet lines scoring the beach, the little figures going about their business shown in green and yellow.

In his first summer following his release from three years' military service, Derain revelled in the freedom of life in Collioure, excited by everything he saw but, mainly, as he wrote to Vlaminck, bowled over by the effect of the light and its potential to transform his work. At twenty-five, free of responsibility, he was living out his own version of Arcadia. Like Matisse, he had experimented with divisionism; unlike Matisse, he now shed his own divisionist methods as easily as he threw himself from the rocks into the refreshing sea.

As the summer wore on, the heat seemed to intensify. The two painters worked incessantly, from morning until night, before Collioure's vivid *motifs*. They painted more or less the same locations, though never from the same angle; only four or five of their works were evidently painted at the same time. After being in the same place for two months, they still met on occasion, but sought different locations, wanting to be alone to work. Derain became increasingly more fugitive, combative and determined

as he painted a greater number of canvases, and on a grander scale, than Matisse. The pictures he painted on arrival – still pointillist – may be clearly distinguished from those he did at the end of the summer, painted in broad, flat bands of pure colour. By the end of the summer, he had completely abandoned divisionism for the magnificent works with flattened surfaces in bold, sparkling colours he brought back from Collioure. Things were not at all the same for Matisse, who moved towards and away from pointillism throughout the summer, even in works such as *La Plage rouge*, in which the foreground is a vivid sweep of scarlet; when he arrived back in Paris in the autumn, he would still be painting his final divisionist works.

In the Hôtel de la Gare, Derain hung his paintings on the walls and sat smoking his pipe and contemplating his work, creating a perturbing spectacle. La dame Roussette was still sceptical. His work was no less alarming than the man himself. 'But what can he possibly see in them?' she asked Mathieu, who scrutinized them carefully. 'Well, they're better than the pictures in the calendar.' When Derain painted a sign for the hotel, it looked to Mathieu like a brightly coloured firework with the words 'Hôtel de la Gare' written over the top. For la dame Roussette it was a step too far. She threw it into the courtyard, where Mathieu rescued it and placed it discreetly on top of the rabbit cage so that Monsieur Derain would not find it in the ditch. The incident seemed to him disappointing, since until then the hotelier had seemed reconciled to the idea of the strange, lanky gentleman in the red beret, especially since he was very good at entertaining the neighbours. To Matisse, however, Derain was becoming an ever more irritating presence. When they went down in the morning to watch the fishermen bring up their catch, Derain, at the front of the crowd, stood tall and unself-conscious, scribbling energetically in his sketchbook, confident of his place among them. Matisse, demure in his city suit and bowler hat, stood awkwardly at the back, as if wishing to pass unnoticed, not observing, not sketching, apparently impassive, as if the two of them had nothing to do with each other. In the evenings

after dinner, they painted each other's portraits in the Hôtel de la Gare dining room. Derain's portrait of Matisse depicts an anguished, startled figure.

At the beginning of July, Matisse and Amélie moved down to the Café Olo, at the port overlooking Boramar beach. From the first-floor apartment of the café in the boulevard Boramar, Matisse could look straight out across the port and paint the boats from his open window; *La Fenêtre ouverte* and *La Plage rouge* were both painted from here. Derain remained at the Hôtel de la Gare, but when Paul Soulier, the photographer, offered Matisse a room in his house to use as a studio, Derain came too. To add to his problems, now that they were so close to the port, Matisse was unable to sleep. Amélie was kept up into the early hours, reading aloud in an attempt to settle his nerves. Down at the port in the Boramar cove, Matisse would invariably have been woken at dawn, when the catch came in and the place was suddenly transformed into a clamorous hive of agitation, the beach full of people shouting across to one another as the boats arrived, men jumping on land, lowering baskets heavy with fish, pressing forward to start auctioning their haul or releasing the great, heavy nets which snaked up from the depths of the boat, coiling them into the stretchers they shouldered up the beach, two by two, before unrolling them and laying them out to dry.

Collioure's motto was '*La Joie de vivre*', 'the joy of life'. Matisse went to the most secluded beach, farthest from the port, to paint the work he named after this motto. In it, he was still working with the divisionist methods of *Luxe, calme et volupté*. Using an Italian model (sent down from Paris) for all the figures, he painted nude nymphs dancing with abandon in this small, glittering Arcadia, developing them into mythological, imaginary creatures. The composition and the figures owe something to his cherished possession, Cézanne's *Three Bathers*, though in '*La Joie de vivre*' there are seven figures, and Matisse's Arcadia, unlike Cézanne's, was clearly imaginary.

Before he left Collioure, Matisse had hoped to pull together all

the ideas he had accumulated in sketches, drawings and watercolours into one definitive work that he could send to the Salon d'Automne. He was still painting in a mixture of divisionism and the 'flat' treatment of colour he and Derain had both discovered in Collioure, moving back and forth between Signac's methods and the method of *'la couleur pour la couleur'* which he and Derain were now progressing towards, albeit in their different ways. The discovery of a new method involved emotional complexity and daring, which, for Derain that summer, seemed to pose few problems. For Matisse, matters were more complicated. His commitment to Signac was important from every point of view and the break with divisionism represented risk and uncertainty at a time when, after years of strain, he was searching for stability, not yet more stress.

By the end of July, the rains came. Suddenly, the light dramatically dimmed; the scintillating colours faded to pale blues, pinks and greys and the deluge teemed down. Derain was confined to the Hôtel de la Gare. By the time the rain arrived, it was a relief: the demands of the unremitting heat and light had finally begun to take their toll on him too. On 28 July, he wrote wittily to Vlaminck, 'I'm taking advantage of the rain to write to you, as usually the light is so strong that I despair at the way it increases my synthetic difficulties and my acrobatic exercises on the subject of Light.' He considered he had gained two major insights in Collioure, firstly 'a new conception of light, which consists of . . . the negation of shadow'; he had noticed that when sunlight is very strong, shadows are not darker but, on the contrary, very pale. That observation had made him think about shadow – a whole world of luminosity shielded by the brightness of the sun, which lengthens shadow and converts it into reflections. Secondly, he now understood that, in a luminous, harmonious panel, the juxtaposition of clarity and luminosity was logical, though that way of seeing failed to take account of things that took their expression from internal harmonies, a style of depiction which destroyed itself from within if pushed to the limit. He realized that sunlight,

in other words, naturally 'deforms' what we see, so light cannot truly be seen as a material element produced by the act of painting, a flash of colour shot – as it were – by a projector (the cannon shots of the Fauves), but rather as a medium which itself determines the dimensions of contrasting surfaces and the rhythm of their proportions. It was not, he now saw, a question of 'lighting' the contents of a picture but of making the light emanate from them. Though aesthetically revealing, in some respects these observations seemed so challenging as to be merely dispiriting. After the excitement, turbulence and tensions of the summer, he was tired, and thirsty for life, and for Paris – the courtesans, the *mots d'esprit*, the repartee – which seemed ridiculous, since in the past he had had no time for any of that.

Old Mathieu Muxart had noticed a change in Derain since Matisse had left the hotel. He no longer laughed; he seemed sad. In letters to Vlaminck, he confided his *ennui*: 'I'm fed up, but not really about anything.' He was annoyed with himself for still feeling unsettled. 'I am just a stupid artist, lawless, outside the rim, not really in the world, a hybrid. I find myself looking back on that soldier I was last year, his feet firmly on the ground.' He felt he had exhausted the possibilities of Collioure, his morale was hardly improving and he was counting on the winter to clear his head. He was beginning to wonder if he and Vlaminck had anything in common with other men; he just wanted to get back to Paris and on with his work – his loneliness was beginning to get on his nerves. With the contrariness of youth, he sometimes even found himself longing for a house in the country, a wife, children, dogs; 'oh, to never have to go back to Paris for exhibitions'.

At the time, Vlaminck felt the same. For the past two years, he had been living on the pittance he earned from giving violin lessons in Le Vésinet, where his grandmother, a fruit and vegetable seller who had a stall in Les Halles, owned the family home. The job he had enjoyed, playing in the orchestra of the Théâtre du Château d'Eau, had come to an end two years earlier when, in 1903, the theatre had closed down. The closure had been announced on a

beautiful day, and he had decided to devote his life to painting, despite the resultant 'pecuniary embarrassments'; 'I had had quite enough of Paris and of its scenes which were so far removed from my own personal preoccupations', and quite enough, too, of walking home to Chatou in the early hours, unable to afford the train fare. When he did return to the city, he used to stroll among the rag-pickers' shacks around the Fort Mont-Valérien, where, as in the Maquis, a shanty town had sprung up around areas of waste ground and quarries which were the result of abandoned construction works, enlivened, for the time being, with poor families whose coloured washing, hung out on trellises to dry, he found strangely soothing.

Derain was planning to return on 1 September with a substantial portfolio of work. He had thirty completed canvases, twenty drawings and about fifteen sketches and was happy with the quantity, he told Vlaminck in his letters, but not the quality. He was preparing a large painting for his return, though he was not, he assured Vlaminck, even thinking of the Salon d'Automne. He had made around thirty studies for it; he had never before produced such a complicated work, quite different from anything he had done before; nor had he ever been quite so sure of disconcerting the critics. Meanwhile, he was enjoying his last few weeks in Collioure driving around la Catalogne *'en automobile'* (most likely a makeshift peasant's cart).

During the first few days of August, it went on raining hard, a *salamandas*, declared Mathieu, a tempest in midsummer he would remember all his life. A terrific gust of wind came in from the south, uprooting trees, tearing off leaves, stripping the branches as in winter. Windowpanes shook with the force of the gusts. The storm went on all night and throughout the morning of 5 August. La dame Roussette began to feel sorry for her lonely lodger, stranded indoors. To cheer him up, she allowed him to paint one of the inner doors of the hotel. She stood watching as he painted the centre of the door with a colourful scene depicting the torso of Don Quixote mounted on Rocinante, adding the bust of Sancho

Panza in the right-hand-bottom corner in yellow, purple and green: 'A yellow moon in a green sky! . . . Nobody had ever seen that before! Wherever does he get these ideas, Monsieur André? Did he ever make us laugh!' Eventually, on 24 August, Derain packed all his boxes, put on his smart red beret, picked up his umbrella and left Collioure. Matisse never worked with him again.

6.

At the Circus

On 3 September 1905, Picasso was rewarded for his patience when Fernande Olivier finally decided to move in with him. Perhaps his tales of buxom Dutch girls had sounded a warning bell. He had been in the Netherlands with a Dutchman he met in Paris who had introduced him to Kees van Dongen before persuading him to accompany him on a visit to his homeland. Picasso returned with little more to show for his trip than some gouache and oil paintings of his landlady's monumentally tall daughter, who had scandalized the locals by posing in the nude. What had struck him was how tall the Dutch girls were, those 'little girls' who towered head and shoulders above him, kissing him and sitting on his knee, or so he told Fernande. In any case, he assured her, the Netherlands had been uninspiring – too foggy.

Fernande moved in with all her clothes, her perfume, her books, justifying the decision to herself as a reckless impulse. She still blamed the storm for her impulsiveness, telling Picasso, 'A caprice had flung me into your arms on a stormy night.' Paris had been stiflingly hot all summer; in early September, the heat was still torrid. Once installed in Picasso's studio, Fernande had little incentive to move very far. She spent her time stretched out on the divan enjoying her new situation, happy at last, resolving to live a life of leisure, content to be pampered and adored. She had already broken the news to the painters for whom she modelled. One complained that his picture was nearly finished; he only needed her for another week or two. She relayed this to Picasso. '*Mais je m'en f—*', he replied. Fernande's reputation for laziness dates from this period. In fact, she had thought long and hard about relinquishing her independence, and when she finally made up her mind she committed herself fully to being with Picasso. Her decision was really more about collusion

than indolence: she was finally allowing herself to be indulged and cherished, which was what Picasso wanted for her. She had got into the habit of going to bed early after a long day posing; this, she continued. Picasso still sat at her bedside until she slept, then spent the rest of the night working.

At the back of the studio, Fernande found a small shrine, with two cerulean-blue vases of artificial flowers like the ones in Cézanne's paintings, and a white, fine silk blouse. Picasso's biographers have tended to assume the shrine was to Fernande, but Fernande herself does not say so; she assumed it was 'erected in memory of a woman he had loved'. It sounds like a traditional shrine to the dead, such as are kept in Catholic countries to guard the soul of the departed. (Perhaps it was to honour the memory of his sister, Conchita; or one of the romantically fragile women of Montmartre, fleetingly one of his models, perhaps, also tragically departed before her time.) She wondered what had inspired the composition of this carefully constructed installation, his 'chapel', and reflected that there was perhaps in Picasso an element of mysticism, a spiritual quality 'inherited with his mother's Italian blood'.

Picasso was still painting his usual Montmartroise models, working either from memory or from life. They sat for works such as *Girl in a Chemise*, the portrait of Madeleine in which she is semi-transparent in her thin, white blouse against shades of blue. It would be a while before he would use Fernande as his model. Hadn't he insisted she give up modelling? He bought her Turkish chocolates and she lay reading novels in happy solitude while he worked. Picasso did the errands, locking her safely in before he left, bringing back macaroni and sardines. When they had no money at all, Paco Durrio, who still lived nearby, left food parcels on the step. Anyway, Picasso's poverty seems to have ceased to worry Fernande – this was *le grand amour*.

In the evenings, everyone went to the circus – Max Jacob (now also living, for the past year, in the Bateau-Lavoir), André Salmon and the Catalan *bande*. They went mainly to the Cirque Medrano, a spectacular covered one-ring circus housed in a large permanent

building at the foot of the Butte, at the corner of the boulevard Rochechouart and the rue des Martyrs, the steep lane leading up the hillside towards the Sacré Coeur. The original Cirque Fernando, where, back in 1879, Degas had painted Miss Lala on her tightrope, was British and had belonged to the Austen brothers. When they travelled to Europe they renamed the troupe 'Robert Austen's Mediterranean Circus' – the MedRAno – also, coincidentally, the name of one of their Spanish clowns.

Picasso adored the circus, where, seated round the open ring with no footlights or railings, the audience was intimately involved with the performers. He loved the atmosphere and the spectacle, excited not only by the individual acts but by the whole ambience of the world of horse riders, acrobats and clowns, as well as by the pierrots and harlequins who appeared between the acts. He went to the Medrano every week, sometimes several times. For him, the big top was as exciting as the bullring, with its pool of spotlight and the palpitations of the crowd as the performers entered. He loved the heat, the skill of the performers, the smell of warm straw and animals, the heady excitement of it all. Acrobats piled one on top of another, balancing in pyramids just as Picasso had seen them do as a boy in Spain. Trapeze artists in skimpy costumes performed extraordinary feats of skill. The most popular acts were the riding stunts, performed by equestrians in skimpy, spangled costumes who spun on the backs of white horses. Circus performers, particularly the horse riders and trapeze artists, were regarded as skilled artists, and so they were, infinitely more so than the hammy actors who performed in the Théâtre de Montmartre or the vaudeville acts in some of the cheaper *café-concerts*. Circuses included elephants, lions and marvellous balancing acts, and there were theatrical performances between the circus acts, featuring illusionists, conjurers and magicians of all kinds.

Behind the scenes, the corridors of the circus provided another kind of theatrical arena. Picasso and friends made their own entrances backstage, dressed in outfits that could have been confused with the performers'. The women, for example, wore bright

dresses and hats excessively decorated with feathers, since, in those days, the circus was patronized by celebrities and the fashionable, who turned the bars and corridors of the circus into places to be seen: in the Champs Élysées the stables of the Cirque d'Êté were as fashionable as the corridors of the Opéra. In the less salubrious Cirque Medrano, Picasso hung around all evening in the bar, 'always thick with the hot, slightly sickening smell' which seeped up from the stables, talking to the clowns.

Afterwards, everyone crowded into the Hôtel des Deux Hémisphères in the rue des Martyrs, a popular bar where André Salmon joked that there were more Spaniards than he had ever seen in Spain. This was the international out-of-hours haunt of performers from the circus, music halls and variety theatres. The clowns gathered at the bar while, on the benches, the dancers relaxed, their chignons resting against the walls papered with posters advertising theatrical establishments all over the world. All the girls from the cabarets gathered there, together with those looking for work, some sent up from the rue de Clichy by their garrulous, swarthy employers with visiting cards literally, if somewhat unfortunately, translated from the Catalan: 'Mme Conception facilitates Spanish dancers.' Those who frequented the Hôtel des Deux Hémisphères were friends of the circus performers and included people from all nationalities and walks of life. Even Prince Oznobichinie, aide-de-camp to Tsar Nicholas II of Russia, had been spotted there. Picasso now began to introduce the circus performers into his work. He painted them off duty rather than in the ring, lone figures like the boy who appears in *Boy with a Pipe* (1905), pale and dreamy in his blue artisan's overalls, posing with his opium pipe against a rough cement wall over which someone has painted a mural of a huge bouquet of flowers. Around his head is a garland of roses, echoing the background flowers, an affectation added by Picasso almost as an afterthought, giving the boy the aura of a poet or romantic hero. In a contrasting work, he painted a family of saltimbanques relaxing between performances with their ape, the great, primitive creature seated meekly at their side gazing adoringly at the baby. These

works, predominantly in delicate tones of red and rose, added to the developing body of paintings devoted to the itinerant actors and acrobats who had already become Picasso's central subjects. As he mingled with the performers out of hours, they and their families directly inspired what came to be known as Picasso's Rose Period, in which an atmosphere of freedom and lightness began to emerge in his work. He had left the melancholy of the Blue Period behind. The travelling performers who peopled his works of this later period were still outcasts but, unlike the beggars and prisoners of his Blue Period, they were not helpless; in his work, he was acknowledging not only their skills but their resourcefulness and independence, recognizing that they had devised a way of life that epitomized the freedom, rather than abjection, of the outsider. Just as the whores of Montmartre had seemed like actors from another world, so, too, the circus performers seemed to inhabit an alternative universe, a world of intensity and dynamic interaction, the contemplation of which took Picasso out of himself, away from his own painful memories and his preoccupation with the poverty of the streets. Their talent inspired him, and he was flattered by his intimacy with the clowns, the jugglers, the horses and their riders, proud to be moving in their circles.

At the circus, Fernande watched her lover with fascination, noticing how he admired the swarming crowds in the ring, their shouts and wild gestures, their tumultuous excitement, skidding from adoration to abuse, according to the skill or lack of it. She realized he was drawn to people with talents he would never acquire himself, stimulated by their difference; she also now observed that Picasso was not an intellectual. 'He loved anything with strong local colour . . . It seemed as though nothing abstract or intellectual could move him.' The paucity of entertainment in *haute* Montmartre made the circus utterly spectacular, and it was the spectacle Picasso adored, since in everything he did he was primarily an observer. 'How foreign he was in France,' Fernande reflected, 'this Andalusian with Italian blood.'

Best of all, Picasso loved the clowns. Captivated by their oddness,

the way they talked, their jokes, he took them seriously. He knew them all – Inès and Antonio, Alex and Rico. Once, he invited a Dutch clown and his wife, a Polish equestrian, home to dinner. In Fernande's opinion, they were 'the coarsest people imaginable', but Picasso was delighted with them. More than thirty years later, he told photographer and film-maker Brassaï, 'I was completely captivated by the circus! I sometimes spent several evenings a week there. That's where I saw Grock for the first time.' As Picasso remembered it, 'He was debuting with Antonet. It was wild. I especially liked the clowns. Sometimes we went back-stage and stayed all evening to chat with them at the bar. And did you know that it was at Medrano that clowns began to give up their traditional costumes and to dress in burlesque outfits? A regular revolution. They could invent costumes, characters, indulge their fantasies.'

Grock had made his debut only a few months earlier, in December 1904, causing 'tornadoes of laughter and hysteria' when he appeared with Albert Fratellini, the Medrano's resident star clown; together, they ushered in an era of change for clowning. Born in Moscow, trained in Russia under the Durov Brothers, Fratellini, like Grock, was of the genre of clowns known as 'auguste'. Unlike the traditional white-faced, scarlet-mouthed clowns, the auguste clown still wore exaggerated make-up but with a flesh tone rather than a white base. He wore a tiny hat and oversized shirt and a tweed or checked brown coat, both with oversized, wide lapels. His movements were exaggerated and his demeanour bewildered, he was unintelligent but lovable and his appearance was urban rather than fairground (a precursor in the ring to Charlie Chaplin on the cinema screen).

Popular culture sowed the seeds of the twentieth-century avant-garde. With the appearance of Grock, audiences followed the trend set by the performers; the new 'chic' in Montmartre was the misfit costumes of the clowns. Harlequin costumes were abandoned in favour of cheaply made versions of ill-fitting English tweed, or the clothes of English jockeys, as worn by Chocolat, a freed African slave born Rafael Padilla in Cuba, who usually performed at the

Medrano or the Nouveau Cirque with Footit, a white English clown from Manchester, in a double act in which Footit played the authority figure, Chocolat the abject *misérable*. Their antics were hugely popular with a wide range of audiences – working people, artists and intellectuals alike.

Appearances were important in Montmartre; bohemianism, even for those down on their luck, was a studied affair. In the Bateau-Lavoir, Picasso and his friends put on shows for one another, mimicking the clowns at the Cirque Medrano and the actors and singers at the Trianon Lyrique. Picasso, still invariably wearing his outsized overcoat, grew his hair long on one side so that it hung over one eye. Derain and Vlaminck trailed around the streets of Montmartre dressed in baggy tweed overcoats and brightly coloured cravats, like the new urban clowns. Seen together, they made a highly colourful double act in the lanes, Derain in a tweed suit with a bowler over one eye, Vlaminck in baggy old tweeds, dressed like a clerk but for his bright-red neckerchief.

And the circus was influential in one further significant respect. In the early days, people went to circus venues to see the movies, since designated cinema spaces were still relatively rare. Pathé reels may even have been shown at the Cirque Medrano, as well as in makeshift cinema sites such as the open-air one in the rue de Douai, at the foot of the Butte just off the rue Pigalle, which consisted simply of a screen and a projector pitched on a bit of waste ground. (When, in 1962, Fellini remarked that the cinema was 'very much like the circus . . . carnival, funfair, a game for acrobats', he was acknowledging its roots.)

In 1905, motion pictures were still new. The first film ever made had been shown as recently as 1896, in the basement of the Grand Café, when the audience had watched, enraptured, as the stream of workers leaving the Pathé factory at the end of the day passed jerkily before their eyes. Soon afterwards, a film featuring an approaching train had been so startling that the terrified audience fled the picture house in fear of being mowed down. The following year, 1897, the sceptics' worst fears were realized when a projection lamp caused a

fire at the annual Bazar de la Charité, reviving general suspicion of the disconcerting new medium. Only since films were shown at the 1900 World Fair had public confidence in the medium been revived.

Picasso later remembered going to the movies during those early years without thinking about it, just the way everyone went to the cafés. The first film screenings he and his friends saw were still very much entertainment for the working classes. In the silent movies, the actors depended on exaggerated gestures that imitated theatrical melodrama and urban clowning. Cinema, like vaudeville, was a subversive, irreverent art. Animated cinema soon followed, lasting only a few minutes and consisting of sequences of a few simple line drawings. Audiences watched, transfixed, as a man removed and replaced his own head. A man first blew smoke in a woman's face, then grew 'old' with the acquisition of beard and wrinkles; his little dog jumped back and forth through a hoop. To the first cinema audiences, all this was astonishing; like the conjuring tricks of magicians, an art of prestidigitation. In the theatre, dramatic action moved progressively through time; while a painting or sculpture presented a durable image, the cinema defied the laws of time, rendering images fluid, unfixed and unpredictable. One of the earliest film-makers, Georges Méliès, had begun his career as an illusionist, performing magic tricks in the vaudeville theatres. The world of the movies unfolded like magic as extraordinary, backlit images rose and fell, appearing, disappearing and reappearing in Méliès' first films *A Trip to the Moon* (1902) and *The Impossible Voyage* (1904). It would be a while – though not long – before narrative techniques evolved and sirens of the silver screen began emerging; at that point, enthusiasts of the cinema would include Fernande.

The luxuries Fernande craved were never going to be hers while Picasso remained unsuccessful in finding purchasers for his work; so far, all attempts at substantially improving his prospects seemed to have failed. He invited Clovis Sagot, the dealer and former clown, to the Bateau-Lavoir to see his recent output. Sagot picked out two of the Dutch pictures and *Girl with a Basket of Flowers*, a nude portrait of a little flowerseller outside the Moulin Rouge, and offered seven

hundred francs for the three, which Picasso refused. A few days later, Sagot visited again, this time offering five hundred. Again, Picasso declined. By the time Sagot made a third visit, the offer had been reduced to three hundred – a simple tactic among dealers. Vollard had learned it by observing another dealer at the start of his career. Then Sagot turned up once more, this time producing with a flourish from behind his back an armful of flowers, 'So that you can make a study of them, and give it to me for a present.' He was, Fernande observed, a sly old fox, unscrupulous and merciless. She once noticed him attempting to slip a couple of extra drawings in with some he had already paid for. His methods were not atypical of the way business was conducted in Montmartre.

7.

Wild Beasts

The third Salon d'Automne, held at the Grand Palais in October 1905, caused a sensation and had a lasting impact on retrospective perceptions of the history of modern art. In room 7, colour blazed from the walls – and it was not only the high-key colour but the subject matter that earned some of that year's painters their lasting reputation as 'wild beasts'. Van Dongen was exhibiting two paintings surely submitted with the express intention of shocking his viewers; both *La Chemise* and *Torse* showed single female figures posing unashamedly in their undergarments. That year, he also painted a portrait of a woman in hot reds, greens and yellows, one breast bared, almost certainly modelled by Fernande, perhaps while Picasso was in the Netherlands, and certainly not with his blessing. It emerged that van Dongen and Fernande had already established a close rapport.

Despite their disenchantment with Paris, both Derain and Vlaminck had submitted work. Derain showed nine of the thirty paintings he had brought back from Collioure, including *Vue de Collioure*, a dazzling display of red roofs, deep-blue sea, white sails shimmering in the searing southern light. Vlaminck had been relatively restrained in his submissions, which consisted of five landscapes (including *La Maison de mon père*) which nevertheless marked him out as a 'wild', subjective colourist. Dismayed viewers might have counted themselves lucky to have been spared the figure paintings he produced that same year. The woman in *Reclining Nude* (1905), almost a grotesque, was clearly a whore. Splayed out against an abstract background, her cheekbones flushed red, eyes circled with green, face powdered as white as a clown's but with a prominent black 'beauty' spot, she looks not just whorish but syphilitic. Even his interior, *The Violoncellist at the Moulin de la Galette* (1905),

would have been more disconcerting to viewers than his landscapes. In it, he distilled the vitality of the popular dance hall into a close-up of the orchestra, evoked in thick bright dabs of paint in predominant yellow. The flowers on the podium, merged with the figure of the cellist, are almost abstract, their patterns blending into the background against the neck of the instrument. Highly decorative, wildly divisionist (though with brushstrokes more like Klimt's than Signac's), the painting is a riot of textured colour. Nonetheless, his landscapes were wild enough, the riverside walks along the banks of the Seine celebrated before him by the Impressionists transformed into vivid, eye-catching spectacles, alive with strong yellows, reds, purples and greens.

As Derain put it some years later, 'Fauvism was our ordeal by fire . . .' His and others' attempts to move beyond the techniques of Impressionism were not restricted to the bold, subjective use of colour; the artists were also aiming to express on canvas new ways of seeing. Looking back on his Fauvist phase some years later, Derain reflected:

> It was the era of photography. This may have influenced us, and played a part in our reaction against anything resembling a snapshot of life. No matter how far we moved away from things, in order to observe them and transpose them . . . it was never far enough. Colours became charges of dynamite. They were expected to discharge light. It was a fine idea, in its freshness, that everything could be raised above the real. It was serious, too. With our flat tones, we even preserved a concern for mass, giving for example to a spot of sand a heaviness it did not possess, in order to bring out the fluidity of the water, the lightness of the sky . . . The great merit of this method was to free the picture from all imitative and conventional contact.

The result was that figures and shapes became extended, even distorted, anticipating by some years the first movements towards abstraction.

The emphasis on colour as a form of attack seemed to belong largely to Derain and Vlaminck. Certainly, it bypassed Picasso, whose contact with the two at this stage was sporadic, and primarily social; in the bars and cafés of Montmartre, they exchanged banter rather than ideas. The need to find a way of moving beyond the 'snapshot' model was another matter; that problem, Picasso would soon begin to find his own ways of addressing. In the meantime, he remained inscrutable. Although they no longer saw themselves as Matisse's disciples, it was not yet the moment for Vlaminck and Derain to move in on Picasso's gang.

That summer, Vlaminck had been one of the first to make a casual discovery that was to have a profound and lasting influence on virtually all the painters in Montmartre. One hot, sunny afternoon, he had been painting the barges on the Seine at Argenteuil. At the end of the day, he went to a bistro frequented by bargees and coal heavers. While he was drinking his white wine and soda, he noticed, on the shelf behind the bar between the bottles of Picon and vermouth, two African sculptures. The tale was endlessly told and retold over the years, amended and/or embellished with different details depending on whose version was being recounted. (According to Braque, there were three statuettes, two from Dahomey, a former African colony situated in what is now Benin, streaked with red, yellow and white, the third black, from the Ivory Coast.) The owner agreed to part with them in exchange for a round of drinks. 'Was it because I had been working in the blazing sun for two or three hours? Or was it the particular state of mind I was in that day? Or was it the connection with certain experiments I was constantly preoccupied with? Whatever it was . . . those three statuettes caught my attention. I instinctively realized their potential. They revealed Negro art to me' – so went another version. As told by Vlaminck himself in his autobiography, the story is more straightforward. He made no particular claim to having discovered anything especially significant; when he first saw them, the sculptures had inspired in him 'the same feeling of wonder, the same profound feeling of humanity' as the puppets in the coconut shy at the fairs he had visited in his youth.

Soon afterwards, he acquired more examples, from a friend of his father who, when Vlaminck showed him the statues, said he had some himself; his wife was always threatening to discard them. Invited to his home, Vlaminck left with a large white mask and two figures from the Ivory Coast. He showed them to Derain, who was immediately fired up by them: He . . . offered him twenty francs . . . fifty . . . He took the mask away and hung it on the wall in his studio . . . When Picasso and Matisse saw it in Derain's studio they were dumbfounded, too.

Where did these particular examples come from? Were they left-over exhibits from the 1900 World Fair, which had brought so many examples of colonial art to the French metropolis? In around 1905, Iberian sculptures went on display for the first time at the Louvre, but, in general, they were still regarded as having no particular value. They normally turned up in bric-a-brac and pawn shops, brought back from the colonies by sailors or servants, as Vlaminck's probably had been. During the next few years, they would become the talk of Montmartre, particularly once they were brought to the attention of Matisse, and, soon afterwards, Picasso. (This predates the 'discovery' of African sculptures in 1920 by the British artist and critic Roger Fry, and his article 'Negro Carvings', by fifteen years.) Examples of complete plastic freedom, for Vlaminck, Derain, Picasso and Matisse they were simply a progression of their pre-occupation with acrobats and clowns; for Picasso, in particular, not so much the abandonment of the Rose Period (which Fernande nicknamed 'the acrobat period') as the recognition of another attempt to liberate in paint unmediated human feeling – primal, totemic, profoundly expressive depictions of what it really means to be human.

Matisse showed only two works at the Salon d'Automne. He had planned to submit one of his divisionist-influenced paintings of the port at Collioure, *Port d'Avall*, but on the way back to Paris he had stopped off in his home town of Bohain and shown the new work to his mother. She said, 'That's not painting,' whereupon Matisse

slashed the canvas with a knife – his clearest expression of frustration with divisionism, from which he now finally began to detach himself. As far as he was concerned, Collioure had been a disappointing, unproductive interlude; his prospects as an artist had hardly improved since the dark years of his wife's parents' public downfall. In place of his view of the harbour, he showed *La Fenêtre ouverte*, painted from the window of his lodgings at the Café Olo above the port, his first major work depicting a scene viewed through an open window, a format he would often use in subsequent years. The view of boats on the water, red sails rhyming with both the flower pots inside the window and the shutters thrown open on the scene, is strongly evoked in bold blocks of colour. Broad bands of colour also form the frame, which itself becomes an element of the picture, so that the viewer is looking both at and through the window. In later years, this painting came to be seen as the announcement of a dramatic new development in Matisse's work, becoming regarded as one of his central masterpieces of the period.

Matisse, however, was not satisfied with it. He wanted another piece to send to the exhibition, so with just a few days to spare he dashed off a startling portrait of Amélie wearing an elaborate multi-coloured hat heaped with fruit and flowers, *Madame Matisse in a Green Hat*. It was as if the deep emotion he had been forced to suppress all summer – even, indeed, since the events of 1902 – now finally found expression. Seated and twisting round to face the viewer, her arm draped across the arm of her chair, her waist slashed by a scarlet belt, Amélie models her elaborate confection. She wears a dark dress with lace sleeves and holds a white fan decorated with flowers, like the Catalan women. She does not smile. Her mouth is turned down, her eyes are dull; her face, in stark contrast to the vividness of her hat, is dead white. In a gesture Matisse had used before in the painting he called *The Green Line*, a livid green line on her forehead, just above her brows, emphasizes her pallor. Matisse has put her back where she was before their summer in Collioure, as a *modiste* for her aunt Nine. Their prospects of success, happiness or even security had remained unimproved since she had been

forced to give up her hat shop. Amélie knows it. She swings around to face the viewer, as if to say, '*Alors?*' She is a dynamic, active participant in the subtly arresting drama of the picture, a defiant, rather than alluring model. Although its impact was shocking, the painting is exquisitely rendered, with flourishes of variegated colour, beautiful in its dynamism.

These two works by Matisse (both submitted too late to appear in the catalogue) were as subversive and high voltage, in their different ways, as anything being shown by Vlaminck or Derain, although Vollard, for one – still wistfully nostalgic for those shades of grey – was unimpressed. 'Matisse has been a disappointment to those who like an artist to stick to the same manner all along,' he lamented. 'Forsaking those greys that please his admirers so much, he suddenly turned to the most brilliant colours.' According to him, the painting had also put the president of the Salon d'Automne, Monsieur Jourdain, on his guard. Though the president wished to appear tolerant of the new painting, he could not be seen to be too openly breaking with academic tradition, and he had begged the jury not to accept Matisse's only submission, insisting that their refusal could only be in the interests of Matisse himself. He was, however, overruled. 'Poor Matisse!' he had apparently groaned, 'I thought we were all his friends here!' He may have been genuinely concerned for Matisse's reputation for political reasons, on grounds of the painting's somewhat unfortunate subject matter, since the hat shop Amélie had been forced to relinquish had been set up with her parents' disgraced employers' backing and the story had received wide coverage in the national press. Or perhaps his objections were purely aesthetic: by any standards, in both colouration and treatment of the subject, the painting was shocking, and it was indicative of the general tone of the room, as critic Louis Vauxcelles described it in his review of the exhibition. At the centre of the hall were two academic sculptures. They stood out, as Vauxcelles famously reported, each like 'a Donatello among the wild beasts'. The viewing public was singularly dismayed; and this time viewers included Matisse's potential rivals. Each morning 'long lines of revolutionaries [came] pouring down

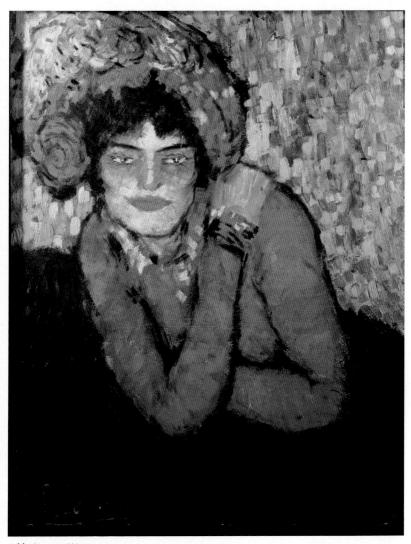

Pablo Picasso: *L'Attente*, 1901

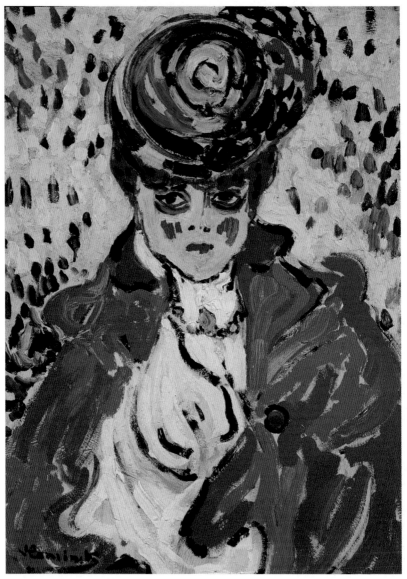

Maurice de Vlaminck: *Portrait of a Woman at the Rat Mort, c.*1905–6

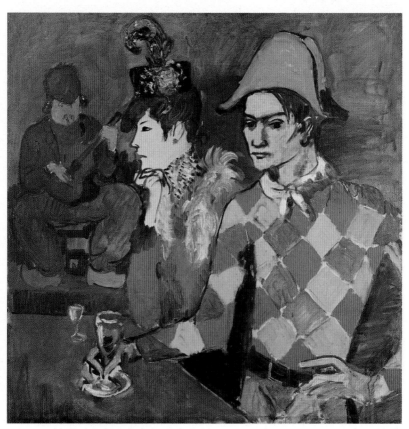

Pablo Picasso: *Au Lapin Agile*, c.1904–5

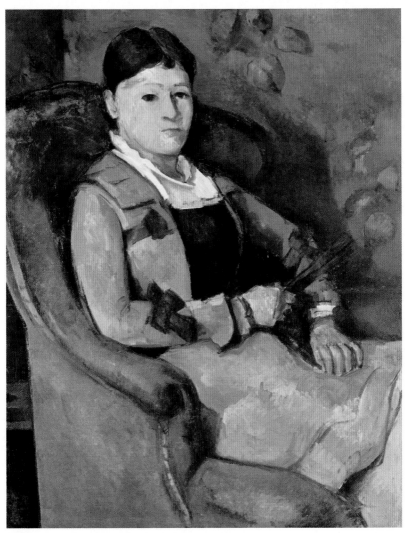

Paul Cézanne: *The Artist's Wife in an Armchair, c.*1878–88

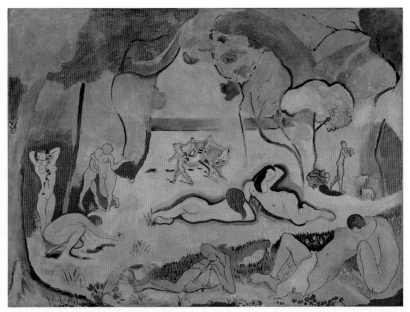

Henri Matisse: *La Joie de vivre*, 1905/6

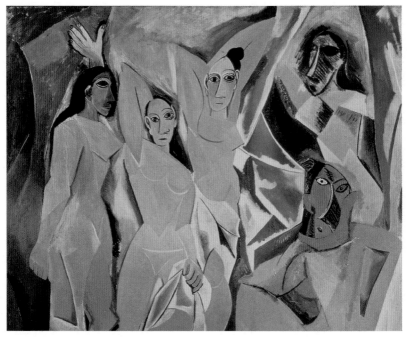

Pablo Picasso: *Les Demoiselles d'Avignon*, 1907

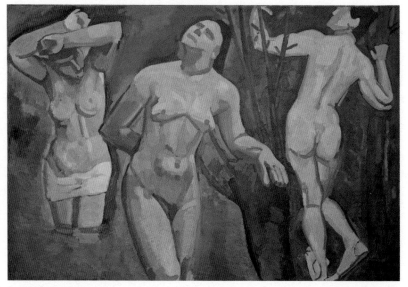

André Derain: *Bathers*, 1907

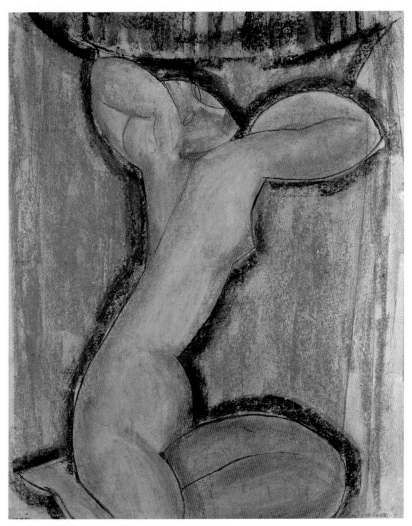

Amedeo Modigliani: *Caryatid*, 1911

from Montmartre', including, of course, Picasso and his friends. Unlike the viewers and critics, however, they evidently realized they were in the presence of a powerful work of art. It was noted that Picasso, in particular, 'felt he had been decidedly outflanked'.

Matisse's luck was about to change. Shortly after the close of the exhibition, he received a telegram. It shocked him so much Amélie thought he had been taken ill. Leo Stein and his sister, Gertrude, were offering three hundred francs (two hundred less than the asking price, the bargaining tactic normally recommended by the Salon Committee) for *Madame Matisse in a Green Hat*. Matisse was ready to rush out and accept their offer; Amélie persuaded him to hold his nerve and demand the full asking price. They did not have long to wait before Leo agreed to the purchase.

Leo Stein had reflected for a while before urging his brother, Michael, to buy the painting. Once his decision was made, however, he became hugely excited by their new acquisition, particularly when, shortly afterwards, he met Matisse. He now became embarrassed at having hesitated for even a moment; had he known he was looking at 'something decisive', he assured everyone, he would have snapped it up at once. He had naturally recognized that the painting was 'a tremendous effort' on Matisse's part, a thing brilliant and powerful, despite being 'the nastiest smear of paint I had ever seen'. In fact, he now realized, it was just what he had been waiting for; he had simply needed a few days to get used to 'the unpleasantness of the putting on of the paint'. Matisse in person he found 'really intelligent' – high praise from Leo – and very attentive, which delighted him; he was thrilled to discover someone willing to listen to him discourse on the subject of art, since he was already in, as Gertrude put it, his 'explaining' period. The Matisses were now invited to evenings at the rue de Fleurus, where they could listen to Leo expounding at length and where they were introduced to the Steins' elder brother, Michael, and his wife, Sarah, who adored *Madame Matisse in a Green Hat* and was keen to see more. In the company of viewers doubled up with scornful laughter before Matisse's work, she had calmly judged it superb.

After the exhibition had closed, Vollard paid a visit to Derain. He purchased his entire studio (except the copy of Ghirlandaio Derain had made in the Louvre – his first Fauvist experiment, using his own, free expressive colour scheme, which the artist refused to part with). He then visited Vlaminck, from whom he bought a hundred francs' worth of paintings, astonishing the painter, who was delighted by this unexpected windfall. His third daughter had just been born, and the money paid for the confinement, but he could hardly believe it; he felt as if he had swindled Vollard, who, when he arrived in his car to collect the pictures, discovered that Vlaminck had added a huge table he had made, and just finished in time.

In November, Vollard sent Derain to London to paint the views of the Thames that had earlier proved so successful for Monet. Derain loved the city, where he saw Turner's work and discovered the British music halls, which delighted him. He also visited the Negro Museum (the ethnological collection of the British Museum), which he found 'amazing, wildly expressive'. He returned wearing some extraordinary 'English' outfits, which his friends told him looked like dentist's uniforms. When, some months later, Vollard sent him to London again, he returned with another, even more eye-catching look: 'I got a green suit and a red jacket, and the most yellow shoes I could find, and a summer jacket – all white with chocolate and coffee-coloured quadrilles.'

'You look as if you're just back from Monte Carlo,' remarked Picasso.

8.

New Tensions, New Opportunities

In Montmartre that November, Leo Stein made another exciting discovery, this time in Sagot's old pharmacy gallery. Presumably aware that the Steins had just purchased a painting by Matisse, Sagot asked the American if he had yet seen anything by a young Spanish artist, Pablo Picasso. Leo said he had seen the works of one young Catalan painter (he did not reveal which one) – was Picasso like him? 'No,' replied Sagot. 'This is the real thing.' The painting he brought out to show Leo was Picasso's depiction of a family of itin-erant travellers seated on the ground with their chimpanzee. Sagot helpfully pointed out that the ape was looking at the child in the picture so lovingly that the animal must surely have been painted from life. Leo, who by his own account knew more about not only paintings but apes than anyone else, thought it unlikely. (Picasso later confirmed that Leo was right: he had drawn the ape from imagination.) Leo purchased the picture and shortly afterwards returned to Sagot's, where Sagot showed him another, *Girl with a Basket of Flowers*, Picasso's nude portrait of the little Montmartroise who sold flowers outside the Moulin Rouge. This time, Leo decided to take Gertrude to see the picture. They made their way up to the rue Laffitte and found Sagot in his shop, sucking on Zan, his favour-ite brand of licorice. When she saw the painting, Gertrude was not keen. The head and torso were pretty enough, she said, but the girl's little 'monkey's' feet she found ugly. Very good, replied Sagot, we'll cut off the feet. After some discussion, all agreed that that would be no solution. They prevaricated, then Leo returned by himself and bought it. Back in the rue de Fleurus, he delivered the news to Gertrude, who was eating her lunch. Now he had ruined her appetite, she told him.

★

On Tuesday evenings, Picasso and his friends habitually walked all the way from Montmartre, across the river to the Closerie des Lilas at the top of the boulevard Saint Michel. Weekly gatherings were run by Symbolist poet Paul Fort, who had left Montmartre that year to edit and manage (with André Salmon as secretary) the literary magazine *Vers et prose*. These events were always crowded with poets, painters, sculptors, journalists, musicians and artists young and old, from the most well-known figures to the most eccentric bohemians. Leo Stein had been going there since his days as a student at the Académie Julian. The talk ranged widely, from politics to banter. Fernande once overheard the wife of a poet tell Manolo's hero, poet Jean Moréas, a regular habitué of salon and café life, that she had no intention of living beyond forty; she had much rather die before she got old. 'But my dear lady,' replied Moréas, 'your last day is imminent.' The supply of drink was unlimited, and by midnight everybody was usually in a state of high excitement. Paul Fort, perpetually restless and agitated, would try to make himself heard above the noise; occasionally, his shrill voice would penetrate the din. Some nights, the talk ended only when the proprietor threw them out on to the street.

At the Closerie des Lilas one evening, Leo Stein finally met Picasso, through journalist, art critic and dealer Henri-Pierre Roché. He was a friend of Isadora Duncan's brother Raymond, in Paris since 1900, whom the Steins, coincidentally, knew from their San Francisco days, when they had been neighbours as children. Roché, as Gertrude Stein remarked, was 'one of those characters that are always to be found in Paris' – an 'introducer' with a reputation for knowing foreigners. 'He had . . . gone to Germany with the Germans and . . . to Hungary with the Hungarians and . . . to England with the English. He had not gone to Russia although he had been in Paris with Russians. As Picasso always said of him, "Roché is very nice but he is only a translation."' He was also a keen collector of contemporary art, and later became a successful writer (his works include *Jules et Jim*, later made into a film starring Jeanne Moreau). Sometime in late 1905, he met Marie Laurencin, adding her to the

not inconsiderable number of women with whom he maintained amorous liaisons; for her, it must have been a challenging first romance.

Roché it was, then, who took the Steins up through the lanes of Montmartre to the Bateau-Lavoir to meet Picasso, where, amidst the usual disorder of tubes of paint, dogs, his pet mouse, bowls of unemptied liquid of varying description and piles of Fernande's clothes, they found Picasso himself, ready and waiting for his visitors. He brought out some drawings to show them, and Leo noticed how closely he scrutinized his own work; he was 'surprised that there was anything left on the paper, so absorbing was his gaze'. The artist seemed vividly alive; somehow (in Leo's words) 'just completely there . . . more real than most people while doing nothing about it'. Gertrude thought he looked like a boot-black. Shortly afterwards, they invited him to dinner at the rue de Fleurus, where Gertrude observed him more closely. She found him oddly seductive, 'thin, dark, alive with big pools of eyes and a violent but not a rough way'. At dinner, he picked up her bread, mistaking it for his. When she retrieved it and he protested, her laughter broke the ice. After dinner, Leo showed the guests his fine collection of Japanese prints, 'beautiful masterpieces', according to Fernande, which she admired, lost in contemplation. As for Picasso, he 'solemnly and obediently looked at print after print', then said 'under his breath to Gertrude Stein, "he is very nice, your brother, but like all Americans . . . he shows you Japanese prints. *Moi, j'aime pas ça*, no, I don't care for it,"' whereupon 'Gertrude Stein and Pablo Picasso immediately understood each other.' Picasso and Fernande now became regular guests at the Steins' Saturday soirées at 27, rue de Fleurus, bringing with them various members of the motley crowd from the Bateau-Lavoir.

Ambroise Vollard also managed to secure an invitation, through one of his mysterious high-society friends (the Marquise de S—). He remarked that 'outsiders might easily have imagined themselves in a public gallery; no one paid any attention to them'. But the inner circle was routinely treated to a detailed recitation of the artistic

opinions of Leo, who barely moved from the armchair on which he lay, half reclining, his feet resting on a bookshelf, a position he considered 'excellent for the digestion' – and for orating. As for Gertrude, Vollard got the point of her immediately, seeing eyes that sparkled with intelligence and finding her attractive and observant, 'the investigator whom nothing escapes'. (When, some years later, she published her memoirs, he had no trouble identifying himself as 'the fellow leaning with both hands on the doorposts, glaring at the passers-by as though he were calling down curses on them', making him wish, for once, he had been endowed with a more naturally benevolent nature.) He also noted that the Steins were becoming serious collectors of modern art.

On 23 November, Vollard paid another visit to Derain in Chatou. This time, he left with eighty-nine paintings and eighty watercolours, the bulk of Derain's output, presumably, since his last visit in February, including the results of the artist's productive summer in Collioure and his subsequent trip to London. The rumour in Montmartre was that he had piled the works into his carriage without even opening the crates, paying Derain in wads of banknotes (3,300 francs in total) secured with an old elastic band, which he peeled from his pocket. It was at around this time that Picasso had a brainwave: he asked Gertrude Stein if she would be willing to sit for her portrait.

Picasso and Gertrude Stein

Until she came to live with Leo in the rue de Fleurus, Gertrude Stein had shown no particular interest in painting. As a child in Baltimore, she had managed to win the weekly school drawing competition only by getting one of her brothers to produce her entry, whereupon she promptly mislaid the winner's trophy. In late 1905, aged thirty-one, when she met Picasso her ambition was to write a novel. She was the youngest of the Steins, and a graduate of Radcliffe (the ladies' branch of Harvard University, in those days called Harvard Annex), where she had studied medicine, obstetrics and psychology, and philosophy with William James. She had been fascinated by philosophy and psychology and bored by medicine and her study of deviations from the norm. She decided she disliked abnormality: 'the normal is so much more simply complicated and interesting'. She had joined Leo in Paris in late summer 1903, following a traumatic season in London trying to recover from a disappointing lesbian attachment. London had merely depressed her: it seemed to consist only of drunken women and children, gloom and loneliness; she thought it 'just like Dickens and Dickens had always frightened her'. She had arrived in Paris still unsure of herself, reticent, shy and decorous-looking in those days, in her dark suits, high-collared blouses and smart hats, her long hair twisted into a neat bun.

On her first day in Picasso's studio, she took her pose, while 'Picasso sat very tight on his chair and very close to his canvas and on a very small palette which was of a uniform brown grey colour, mixed some more brown grey and the painting began . . .' Towards the end of the afternoon, Michael and Sarah Stein arrived, anxious already to see the result. Picasso had produced a sketch which excited them all; they begged him to leave it just as it was. 'Non,' he

replied. It would in fact be months before he was ready to show anyone the finished picture. For the rest of the autumn, and on through the winter, almost every day Gertrude left her spacious apartment near the Jardins du Luxembourg, took a horse-drawn omnibus from Odéon as far as the place Blanche, then climbed the steps of the Butte to the place Ravignan to sit for her portrait in the ramshackle disorder of the Bateau-Lavoir. Sometimes, Fernande entertained her with the fables of La Fontaine, reading aloud in her beautiful, musical speaking voice; or Gertrude sat in silence. When there were just the two of them, she and Picasso talked, at first just about ordinary things. On Saturday evenings, Picasso and Fernande walked back with her to dine at the rue de Fleurus.

Picasso and Gertrude Stein had established an immediate rapport. Whatever the rest of the *bande* thought of the Steins, with their artistic leanings, strong opinions and obvious wealth – at least by Montmartrois standards; André Salmon called them the 'millionaires from San Francisco posing as transatlantic bohemians' – Picasso took to Gertrude at once. Naturally, he recognized her as a potential purchaser and needed her patronage, but also, right from the start, she seems to have evoked in him 'some kind of visceral reverence'. As an intellectual bohemian lesbian with a complex knowledge of philosophy and psychology, she was, after all, unusual in his experience. They were flirtatious together; her androgyny intrigued him and they were on first-name terms from the beginning. As for Gertrude, she clearly indulged him, attracted not only by his obvious talent but by his vivacity, intensity and boyish good looks. Everything about him interested her. Furthermore, he was her discovery. Although Leo had initially brought Picasso's work to her attention, it was Gertrude who responded to the appeal of Picasso the man, at a time when the other Steins, including Leo, were still being swept away by Matisse.

As she watched Picasso at work, Gertrude pondered on her own creative techniques. If, in later years, Picasso was quick to dismiss any connection between his experiments in painting and hers in writing, there is no doubt that watching him paint made her think

about the texture and structure of her work. When she met him, she was experimenting with methods of extracting meaning from the texture of her prose in ways that would liberate her from traditional narrative forms and conventional grammar. The whole problem of composition, and the possibility of freeing narrative from the constraints of plot, fascinated her; and since she first saw Cézanne's painting *The Artist's Wife* she had also begun to take an interest in how paintings were constructed. In 1905, she was writing short stories inspired by Flaubert's *Trois contes*, which she was translating to help her learn French. (She must surely have known that Cézanne was a great admirer of Flaubert's work.) As she posed for her portrait, she sat silently composing in her head the story she was writing, inspired by the people she had moved among when she studied obstetrics in Baltimore (reminded of those days, perhaps, by life in Montmartre). It was a story about an African girl, Melanctha, and her boyfriend, Jeff, that explored mainly through dialogue the subtle nuances of the couple's personalities and the intricacies and impress of their gradually unravelling relationship.

She had put aside the substantial work she had already begun, an ambitious study of psychology she called *The Making of Americans*, to write the story of Melanctha. Since Harvard, she had been concerned with exploring 'what was inside myself to make me what I was . . .', and, at the basis of *The Making of Americans*, lay her fascination with what she called the 'bottom nature' of every human being, which she believed to be discernible despite attempts by people to deny their fundamental nature through social dissemblance and habit. As she translated Flaubert's *Trois contes*, with Cézanne's painting as a reference point above her desk, she had begun to experiment with language, using insistent phrasing to urge her meaning home through nuance and suggestion, paying more attention to the significance of individual words than to the structure of sentences or paragraphs. In the process, she invented a new style of dialogue which closely reflected the rhythms and repetitions of actual speech. ('"Melanctha Herbert," began Jeff Campbell, "I certainly after all this time I know you, I certainly do

know little, real about you. You see, Melanctha, it's like this way with me . . . Sometimes you seem like one kind of a girl to me, and sometimes you are like a girl that is all different to me, and the two kinds of girls is certainly very different to each other . . .'") At the time, as she wrote some years later, 'I was obsessed by this idea of composition, and the Negro story was a quintessence of it.' Soon, she was making her sentences and paragraphs longer and longer, until the preoccupation with narrative structure seemed to exhaust itself. 'I began to play with words then. Picasso was painting my portrait at that time and he and I used to talk this thing over end-lessly.'

Since neither she nor Picasso had either a good command of French or any command at all of each other's native language, they devised their own way of speaking French, discovering in the process that they had similar ideas about human equality. Gertrude thought children should be given the vote. 'After all,' as she pointed out, 'to me one human being is as important as another.' She related her social ideas to her study of composition in both writing and painting: 'you might say that the landscape has the same values, a blade of grass has the same value as a tree' – her own version, perhaps, of Signac's pictorial anarchy. In her writing, she was interested in 'the essence or as the painter would call it value', an emphasis she had so far discovered in writing only in the works of Russian authors. Though her concern was primarily with writing rather than painting, she claimed her ideas came 'largely from Cézanne'.

These ideas, if expressed somewhat elliptically, were path-breaking. She devised ways of telling a story in a series of frames, enabling her to depict what she called a 'continuous present' and to dispense with conventional structure and plotting devices. In this, as she later remarked, 'I was doing what the cinema was doing.' In seeking new ways to evoke the passage of time in a story – what she called 'the time-sense in the composition' – she predated Proust (first published in 1913), Virginia Woolf and James Joyce, taking her cue from Flaubert. When she talked about 'the quality in a com-position that makes it go dead just after it has been made', she was

expressing a concern, shared by painters including Picasso, with the problem of the duration of the image. In painting, Cézanne had already found ways of addressing this problem. His treatment of perspective in *The Artist's Wife* had given the figure a 'sprung' quality that invited the viewer to look 'round' the figure, rather than across the canvas from left to right in search of a narrative.

Gertrude also understood the demands the work of art makes on the artist, appreciating the degree of self-immersion required to sustain the artist's (paradoxical) search for impersonality, the forgetting of time and identity: 'And yet time and identity is [*sic*] what you tell about as you create.' As she expressed it, 'I am I not any longer when I see . . .' Her development of ideas was infinitely nuanced and subtle; she envisaged life as an artist and thought like a philosopher, working all the time in her head with paradoxes and parentheses as she pondered the role of time in the creation of a work of art:

> Time is very important in connection with master-pieces, of course it makes identity . . . and identity does stop the creation of master-pieces. But time does something by itself to interfere with the creation of master-pieces as well as being part of what makes identity. If you do not keep remembering yourself you have no identity and if you have no time you do not keep remembering yourself and as you remember yourself you do not create . . .

Perhaps it was just as well she and Picasso were unable to converse very fully in the same language – though she is unlikely to have spoken in quite the way she wrote. She also understood that only profound engagement with a particular phase of work creates the conditions for progressing to the next. She wondered why Picasso had chosen at this point to paint directly from a model, since he rarely did so, and concluded that 'everything pushed him to it, he was completely emptied of the inspiration of the harlequin period'.

Winter wore on and still the painting was not finished. Picasso's problem was the modelling of Gertrude's head. His notebooks for

the next year or so were filled with numerous sketches of heads, as he worked continually on the problem of how to angle those of a variety of figures. All through the winter and on into the spring, Gertrude patiently made her way up to the Bateau-Lavoir, where she sat many times for Picasso (some ninety times in all, she claimed; she was exaggerating, it must just have felt like ninety – or perhaps she had heard the story of Vollard's 115 sittings for Cézanne). In the evenings, back in the rue de Fleurus, she continued writing her story of Melanctha and Jeff. 'And so Jeff went on every day, and he was quiet, and he began again to watch himself in his working . . . He knew he had lost the sense he once had of joy all through him, but he could work, and perhaps he would bring some real belief back into him about the beauty that he could not now any more see around him.'

In December 1905, Kees van Dongen, his wife, Guus, and their baby, Dolly, moved into a minuscule studio in the Bateau-Lavoir. They became acquainted with Picasso through another couple of Dutch artists who had been living with their baby in the studio above Picasso's. When van Dongen expressed a wish to move into the Bateau-Lavoir, Picasso arranged it for him. He got along well with the Dutch painter; he may also have imagined that having him under his roof would limit the opportunities for van Dongen to develop any further intimacy with Fernande. And Picasso loved Dolly. He played with her for hours, training her to be an acrobat by swinging her above his head. The relationship was reciprocal: the child adored Picasso and called him Tablo. Fernande whittled her a little doll from a piece of wood. Van Dongen tried to persuade Picasso to do some illustrations for *L'Assiette au beurre* – why not try something lucrative? – but Fernande heroically dissuaded him, saying she did not want him distracted from his art.

Van Dongen's work had been shown for the past two years at Vollard's, the Salon des Indépendants and the Salon d'Automne; at the exhibitions, he had made the acquaintance of Derain and Vlaminck, who now came for the first time to the Bateau-Lavoir. On his first visit to Picasso's studio, Vlaminck, enchanted by the

unusual experience of a captive audience (Picasso, van Dongen, Salmon), sat recounting anecdotes from his novels, complete with incidental detail and annotation. He was not a boring storyteller and his subject matter was far from banal. This taciturn man, usually more likely to explode with rage than laughter, was reduced to tears of laughter telling his own stories. Having talked himself out, he asked for anecdotes from the others in return. They needed little encouragement, producing stories of their own lives, largely fictionalized. Vlaminck listened to every morsel, doubting nobody's word. 'And to think,' he said when everyone had finished, 'it was supposed to be I who was invited to entertain you!' Picasso's circle now began to broaden considerably, as artists continued to gather round him, attracted by his magnetic personality.

So the days went by, Fernande observing that Picasso's life seemed to be gradually changing, a process she put down to her influence – having a woman in his life surely counted for something. The dark winter evenings they still whiled away smoking opium, which had become a regular habit among the inhabitants of the Bateau-Lavoir. Picasso got a little lamp and a 'marvellous amber-coloured bamboo pipe with the penetrating smell', and twice or three times a week they indulged in 'that wonderful oblivion, when all sense of time and of oneself is lost'. Friends came to join them and they sat together drinking cold lemon tea, talking and smoking: 'Everything seemed to take on a special beauty and nobility; we felt affection for all mankind in that skilfully muted light from the big oil lamp, the only lamp in the house.'

10.

Immaculate Modigliani

January 1906 was unusually mild. In Paris, the pavements were swept with sunshine. In Montmartre, everyone was talking about a newcomer, a beautiful Italian boy aged twenty-one, dark and handsome as a movie star, with black hair and deep-set eyes, immaculate in a black suit with wide lapels, starched collar and cuffs, flowing black cape and red scarf. His name was Amedeo Modigliani. He had arrived in Paris with his Chilean friend nineteen-year-old painter Ortiz de Zárate, who had first come to France in 1904 and was now heading back to Paris, where he was studying at the École des Beaux-Arts. Together, they explored the sights of Paris, and the Louvre, before going up to Montmartre, where Zárate took Modigliani to the small galleries in and around the rue Laffitte. They found paintings by Renoir and Degas at Durand-Ruel's, Gauguins and Cézannes at Vollard's; and, at Sagot's and Berthe Weill's, works by Toulouse-Lautrec, Steinlen, van Dongen, Matisse and Picasso. Among his works by Picasso, Sagot had a painting of a blue-black raven that made a particular impression on Modigliani.

In the cafés, the Italian began to meet other artists from all over the world, though Picasso and his friends viewed him with circumspection from the start; their circle had begun to consolidate, and to some extent close ranks, before Modigliani's arrival – a misfortune of timing we can only regret. Modigliani knew about life in Montmartre; he had met an artist in Venice, the painter, writer and critic Ardengo Soffici. Soffici was later a vehement supporter of Futurism, and had lived in Paris and worked for *Gil Blas* with Steinlen and for the satirical French annuals *Le Rire* and *La Sourire* with Toulouse-Lautrec; for a while, he had lived in the Bateau-Lavoir. Modigliani was sitting in a café with a glass of red wine when he saw Picasso

pass by. He introduced himself, and told him he had seen and admired his work.

'Oh, those are old things,' said Picasso, 'though I cared about them at the time. What are you painting?'

'To tell you the truth, I'm still finding my way.'

'Where are you staying?' asked Picasso. Modigliani told him.

'Get yourself a room in Montmartre,' said Picasso. 'Van Dongen came to Montmartre when he started painting . . . He could get all the women he wanted to come up from the boulevard Rochechouart to the Bateau-Lavoir, where I'm living now . . . Go up to Montmartre, you'll see everything there: painting and all the rest of it, women, too, if that's what you like. Unless you want to paint flowers there's not much point staying in the Madeleine.'

At the top of the hillside, Modigliani discovered the Maquis, where by now practically all the cleared land had become a shanty town. He saw the windmills and quiet rural lanes bordered with tumble-down dwellings. He noticed that people had added bits of Virginia creeper to their shacks, some of which stood in patches of garden in a tangle of seringas, lilacs, hawthorn and roses. There were small expanses of green cut through with precipices, and streams trickled through the clay, detaching little by little the islands of greenery where goats grazed among the acanthus suspended from the rocks, as Romantic writer and translator Gérard de Nerval had poetically observed when he lived for a time at the top of the Butte in the Château des Brouillards. Modigliani, too, saw the place through the eyes of a romantic. The inhabitants seemed to him an eccentric mix; he noted that the prostitutes must be well kept by their employers, since though they lived in broken shacks they walked the streets like queens, creating a splash of colour as they strolled by. They certainly stood out among the rag-pickers, collectors of rabbit skins, barrow boys, upholsterers, scrap merchants and rag-and-bone men.

At the edge of the Maquis, in or near the rue Norvins, Modigliani found himself a vacant shack, with a cherry tree on the surrounding patch of scrubland. André Salmon went up to see where the newcomer

had settled himself. The shack was scantily furnished with a few chairs, a bed, a couch and a broken-down piano draped with a cashmere shawl – at least, that was the inventory as Salmon recalled it. (Jeanne Modigliani, the artist's daughter, later doubted the plausibility of there being a piano, but perhaps it dated back to the days when the Bateau-Lavoir had been a piano factory.) Modigliani had patched it up and cleaned it, pasting up reproductions of his beloved Italian masters; his own pictures remained in their stretcher frames on the floor, facing the wall. He was so self-conscious about his work, he rarely agreed to show it to anyone.

Anyone who observed him as he sat sketching at a café table could see straight away that he was talented. Vlaminck was among those who watched 'those intelligent hands tracing a drawing in a single line without faltering'. Modigliani seemed to have an ability to evoke the interior life of a sitter, even a stranger, in a few rapidly drawn lines. He had his own particular technique: he drew in pencil on paper, then, just before finishing the drawing, he slid carbon paper beneath it and made a simplified tracing. As for his paintings, if anyone asked to see them, he said he was still trying to find his way. He painted on a small scale (small sheets of paper were cheaper than large) and finished each painting with several layers of coloured varnish, sometimes as many as ten, glazing them like the works of the old masters. Yet his work did not satisfy him. He was ahead of his time, in some respects impatient for breakthroughs he had already made, with his subjective colours and pared-down forms. His uniqueness made him anxious and defensive, especially in a tiny community in which he knew he was under surveillance from those who had staked their claims in it before him. 'My damned Italian eyes are to blame,' he would complain. 'Somehow they can't get used to this Paris light, and I wonder if I ever will. But you can't imagine what I've conceived in the way of colours – violet, orange, dark ochre.' True, but his work would never meet his own standards; he was fatally self-deprecating. 'All junk!' he would say, if anyone asked to see his paintings.

Like Derain, he passionately admired the work of the Italian

primitives, which he had seen in Venice. In March 1903, he had enrolled in life classes at the Reale Istituto di Belle Arti, where he discovered the works of Bellini, Vittore Carpaccio, Giorgione, Titian, Tintoretto, Veronese, Tiepolo, and Botticelli, who had illustrated Dante's *Il Paradiso*. By the time he arrived in Paris, he had also been to Rome (with his mother, in 1901), and to the great marble quarries at Carrara, where he first began to sculpt, inspired by the great master, Michelangelo. It was in Venice that he had first dreamed of going to Paris. In 1903, Soffici had told him about the Salon des Indépendants and the Salon d'Automne and talked about the great artistic cauldron of Paris, where artists and bohemians of all ages and nationalities converged. By the time Modigliani returned to Venice two years later in 1905, Soffici was no longer there and everyone seemed to be talking about Paris. Modigliani had seen Toulouse-Lautrec's drawings reproduced in *Le Rire* (widely distributed in Italy from 1895 to 1900) and longed to see them for himself. His opportunity came when his maternal uncle died suddenly, leaving him a small sum of money – enough to travel. By early January 1906, he was in the French capital.

As Montmartre gradually became more accessible to visitors, renovations continued on some of the buildings, with stonemasons working on the façades. Modigliani made friends with them and went drinking with them in the evenings. They gave him blocks of stone, which he worked on with a hammer and chisel in the garden of his shack, carving primitive, elongated figures. The builders hid good pieces for him in the bushes, and even produced a wheelbarrow for him to trundle them home in after dark. The Métro line was also under development, in the process of being extended as far as Barbes Rochechouart, and the wooden ties made good-sized pieces for carving; sometimes, he went out after dark, scavenging for bits of wood among the debris caused by the excavations. He enrolled at the Académie Colarossi, in the rue Grande-Chaumière in Montparnasse, where in the daytime he studied the model there and made sketches in his large, blue-covered sketchbooks. Afterwards, back in Montmartre, he sat in the cafés where the models gathered,

getting strangers to pose for drawings he then tried to sell. Or he sketched the local women: neighbours, concierges, laundry workers. Occasionally, he visited the brothels but, as lovers, he preferred the laundresses. Despite his itinerant life, it was widely remarked that he somehow continued to maintain his immaculate appearance; his linen was always regularly mended and washed.

The Picasso gang sat in Mère Catherine's bar, in the tall old house on the place du Tertre, discussing the glamorous Italian. They were surprised that, although he had been seen in the Lapin Agile, he always seemed to steer clear of Picasso. Then, someone remarked, if he persisted in drowning his sorrows in red wine, any talent he had might never see the light of day. But, said someone else, it was not the drink that was worrying, but the women. Whenever they ran into him in the lanes around the place du Tertre, Modigliani was usually with a pretty girl. André Salmon had observed his tactics: he would 'accost the girl with a certain formality, then take her home with him, gently but firmly'. He was seen returning home late at night with women of varying descriptions. He had a brief affair with a girl, probably Spanish, known only as 'La Quique'; someone had seen them dancing together by moonlight in the waste ground outside his shack, Modigliani naked as a faun. For a while, he went around with Madeleine, the laundress who had modelled for Picasso, which may have been one reason he and Picasso seemed to be avoiding each other. In 1916, poet and film-maker Jean Cocteau took a series of photographs of Picasso and friends in which Modigliani appears, looking very much part of the group, but that was during the war, ten years later. In 1906, everyone was still wondering how he was ever going to produce a great work of art while he led such a dissolute life. They had noticed he was given to persistent, unexplained disappearances from his shack. Sometimes, he turned up asleep on the bench outside the Lapin Agile. There was certainly an air of mystery about him, and they could not work out how to reconcile his apparently 'aristocratic' image with his obvious penury. He spoke fluent French, taught by his mother at home in Livorno, and knew the works of Dante by heart, as Picasso's gang

discovered when he recited them, sometimes, in the bars late at night when he was in his cups. (Both his mother and his aunt were intelligent and well-read; though an indifferent pupil at school, Modigliani discussed literature with his mother and the philosophy of Spinoza with his scholarly aunt Laure.)

In Paris, he was shy, and physically weakened by the effects of the chronic tuberculosis which plagued him all his life. He hid behind drink and drugs, both freely available in Montmartre. When, from time to time, he did find himself in conversation with Picasso and his friends, 'his occasional remarks', as someone once observed, gave the impression of a lively intelligence, at least, so far as one could ever ascertain – 'before it blazed into incoherent brilliance'. And those primitive carvings of his had a peculiar power. Surely it was not possible that such a man could fail to produce something significant. However, his drinking made him a difficult companion. For the time being, it was not Picasso who became his closest friend but Maurice Utrillo.

Aged twenty-three in 1906, Utrillo had recently been released from a sanatorium for the mentally ill; he now wandered around Montmartre painting the crooked, broken-down houses in the lanes in thick, dry impasto, using high-key, subtly subjective colours, both cool and vibrant – but only when no one was looking; he hated to be watched as he worked. Like Modigliani, Utrillo was a true solitary and a natural wanderer. In 1906, he seemed to have no friends; only Modigliani took him seriously and admired his work, fascinated by his methods. Utrillo ground his pigments himself, mixing them with lime and cement, sand or glue to create texture, the better to evoke the crumbling façades. A familiar figure in the lanes of Montmartre, he could be seen at all times of the day and night meandering up the steps of the Butte with a bottle of cheap red wine, sometimes one in each hand.

Perhaps because he knew Utrillo's father, Miquel, Picasso kept his distance from both Utrillo *fils* and Modigliani but, for the Picasso gang, Modigliani was an object of ongoing fascination. They could hardly ignore the new arrival – he came and went among them, a

curiously talented, undeniably glamorous muse. Sometimes, he turned up in someone's studio in the Bateau-Lavoir (which occasionally he used as his address), but he showed no particular desire to stay there for long; it was tacitly established that he belonged somewhere just outside the rim of Picasso's immediate circle. Such associates were seldom seen in Picasso's studio, they usually met at the Lapin Agile or Mère Catherine's, or they went to Spielman's, with the sign of the hunting horn, or sometimes the Chalet, also known as Mère Adèle's, where the proprietress was so devoted to her artists, or to the Fauvet bar in the rue des Abbesses, where for two sous in the slot of the wooden peephole machine you could peer down and see a life-size wax figure of Salammbô perform a bellydance. The illusion was perfect after the third *mominette*, the cheap absinthe made from potatoes which everyone drank in Montmartre.

If January 1906 had been unseasonably mild, March was bitterly cold. In the Bateau-Lavoir, Fernande sometimes stayed in bed all day, just to keep warm. She had been living there with Picasso seven months now, and the tenor of their life had hardly changed. Often, they had no fire, no coal and no money to buy any unless Picasso sold a few drawings. Occasionally, he did; then there would be coal enough to heat the stove for supper. If there was no money, they sometimes went up to Azon's or Vernin's; though these were little more than 'soup kitchens', the couple always seemed to be able to dine there on credit. Most evenings they spent in the Bateau-Lavoir with friends. When the discussion moved to artistic matters, Fernande kept silent and listened. She had begun to work on her own painting sometimes during the daytime and wanted to take lessons, but Picasso discouraged her. 'Just paint to please yourself,' he would say. 'That's enough. What you're doing is more interesting than anything you would do if you had lessons.' This was frustrating, as she had hoped to be able to explore her ideas in more depth. She returned to her reading: at least lying comfortably on the sofa she could study that seriously.

Down at the Lapin Agile, Frédé's wife, Berthe, kept the tables clean and added her strong, clear voice to the singing in the dingy

old room with sawdust on the floor where the petrol lamps, suspended from the ceiling on two lengths of wire, smoked beneath their shades of red, honeycombed paper. As the evening wore on, the sound of thick glasses hitting the table crescendoed and the discussion gained momentum. Fernande was not, of course, permitted in the Lapin Agile without Picasso, even in the daytime. When she wandered in once to talk to Berthe, there was a scene when he came to find her. There were often scenes in the Lapin Agile; if Picasso thought someone was looking at Fernande, he would vehemently object and she would be forced to retaliate – after all, had she not seen him with a woman on his knee? The problem with these arguments was that they reminded her how desultory her life still seemed to be. Yet, if she pressurized him, he would come home with presents, a few notes to spend or a bottle of her favourite perfume. Despite their quarrels, she was confident they were still very much in love.

On Sunday mornings, they went to the open-air market in the place Saint Pierre, one of Fernande's favourite outings. They got up early and left at eleven, Fernande dressed for the occasion in her black lace mantilla, Picasso as usual in his blue worker's overalls. A bizarre assortment of merchandise would be spread out on the ground, strewn right to the edges of the pavements, including bales of cloth sold by the gross. You could get a whole, nearly new trousseau here; or a man's shirt for seventy-five centimes – or one franc forty-five, according to the delicacy of the colour. There were thick checked handkerchiefs or silk ones bordered with lace, lingerie in gaudy pink or blue, silk stockings from forty-five centimes to one franc ninety a pair, 'luxury' blouses in all colours that ran like butter after one wash, when they became marbled like endpapers in a book. There were battered hats decorated with flowers and hat shapes waiting to be decorated from packs of artificial flowers. There were dusters, towels, bedlinen, saucepans, umbrellas and children's toys. And there were piles of shoes, from the stoutest military boot to the lightest dancing slipper – although, once you selected one, there followed a long rummage to make up the pair.

The traders were all rigged out in items selected from the piles to entice their purchasers. They called their wares as if to see who could shout the loudest, haggling and bargaining as customers – men and women alike – peeled off their coats to try on a shirt or stood back to admire the effect of an outfit on a child sending up screams of protest. Everyone gathered here: the pimp found his peaked cap, his lady friend her luxury stockings; and it was here that Picasso acquired his famous (much photographed) red shirt with white spots, which he wore for years, treasuring it for so long because he liked the colour and it seemed indestructible. When the couple had exhausted the market at the place Saint Pierre they went to the flea market, where Picasso would find picture frames, books – even, for a few sous, stretchers for canvases – and the bits of curious bric-a-brac he could never resist collecting. He loved the market: it stopped him worrying about his prospects, brought him out of himself and gave him a break from the intensity of his work.

The North and South Poles of Modern Art: Picasso and Matisse

In spring 1906, Matisse was exhibiting at both the Salon des Indépendants and the Galerie Druet in the Faubourg St-Honoré. One of the more enterprising and inspiring dealers, Druet had run a popular bistro (patronized, among others, by Rodin) before setting up as an artist's photographer and instituting the 'Druet process', the production of large, handsome photographs taken to record an artist's paintings. Matisse's one-man show at Druet's opened on 19 March, the day before the *vernissage* of the 1906 Salon des Indépendants. Larger than his earlier show at Vollard's, it included some sixty works from the past decade but, despite the placard of brightly coloured sailing boats he had painted for Druet's window to advertise the exhibition, it attracted little attention, its only reviewer warning the public against this 'meretricious showman'. Druet took the long view, investing 2,000 francs in a stock of Matisse's latest work. Vollard promptly followed, purchasing work for a total of 2,200 francs.

To the 1906 Salon des Indépendants, Matisse had submitted only one painting, *La Joie de vivre*, the large Arcadian work painted in Collioure he had not been ready to exhibit in 1905. With this painting, he caused a sensation. Nothing quite like it had been seen since Vollard had exhibited Cézanne's *Three Bathers* (one variant of which Matisse had purchased in 1899). Signac had already seen *La Joie de vivre* (in January) and delivered his own verdict – Matisse had clearly 'gone to the dogs'. To him, the painting demonstrated nothing so much as Matisse's effective break with divisionism. In fact, the new painting clearly revealed the extent of his technical innovation, signalling his definitive departure from the conventions of illustrative art and a bold move towards abstraction. Though, at this point in

his life, Matisse showed no particular interest in the theatre, one distinctive feature of the painting is its resemblance to a stage set, consisting of 'multicoloured flats arching over a vista of yellow ground to a backdrop of horizontal blue sea and violet pink sky'. The figures are posed like dancers, composed in groups that look choreographed.

Relatively new to the Parisian art scene was the wealthy Russian collector Sergei Shchukin. In Moscow, he lived in the grand Palais Trubetskoy, where the walls were lined with works of art. He had been collecting modern art for eight years, starting with the Impressionists; first Monet and Renoir, then van Gogh. More recently, he had acquired works by Gauguin, which, had he displayed them, would have shocked his associates in Russia, so he kept them discreetly out of sight. He had noticed Matisse's work when he first came to Paris and, by 1906, already owned a few of his paintings. He had seen the show at the Galerie Druet by the time he saw *La joie de vivre* at the Salon des Indépendants and asked Ambroise Vollard to introduce him to the artist. During the next decade, Shchukin was to become not only Matisse's main financial backer but also a friend whose ambitious artistic taste and judgement he trusted and came to rely on. That relationship would soon bear fruit; in the meantime, however, it was not Shchukin but Leo Stein who purchased the painting.

Perhaps Shchukin's appearance on the scene – or, equally likely, the Steins' – had been responsible for Vollard's major acquisition of 1906. He had always particularly admired the eye-catching colours and bold lines of Derain's and Vlaminck's landscapes of the borders of the Seine. A new generation of painters was rapidly emerging and, alongside them, some powerful new buyers. Though always careful, Vollard realized he needed to stay active in the face of emerging competition. He had been daring in acquiring Impressionist works when there was little interest in them, and successful with the works of Bonnard, Vuillard and Maurice Denis by ignoring those who had advised him to be cautious. More recently, he had been equally successful with van Gogh and Cézanne. Among the

new young painters now beginning to emerge, there were bound to be new prospects, and he was prepared to take the occasional gamble. In February, he visited Vlaminck again, this time at his home in the village of Rueuil, where the artist had moved with his family, who welcomed Vollard and made a place for him at their table. He accepted the offer of a cigarette, as did Vlaminck's little daughter, who lit up, coughed, took a deep breath, then another drag.

'How old are you?' Vollard asked her.

'Seven.'

'And you're already smoking?'

She turned aside. 'What's it got to do with you, you old geezer?'

Her father seemed delighted.

Vollard selected forty-eight works, for which he paid Vlaminck twelve hundred francs, and promised to purchase everything he subsequently produced. He then went to Chatou to visit Derain, where he bought the entire contents of his studio, again with the exception of the one work which Derain insisted on keeping: the copy of the painting by Ghirlandaio he had made in the Louvre, in his student days. On the proceeds, Derain was able to spend the entire summer in the Midi, including a period in L'Estaque, where Cézanne had worked. For Vlaminck, in particular, the sale of his works was life-changing. He immediately left the house where he had been living and set up home – by himself, for a while – in the bois de la Jonchère, in the middle of the forest. Though he kept his local pupils, he resolved to have as little as possible from now on to do with other painters, 'frightened of any revelations and hints which might have made me doubt the value of my painting; it would have been too distressing to find that, after all, I might have made a mistake'. He seldom went to exhibitions, feeling exposed by seeing his own work on display. He spent the rest of the year painting landscapes throughout the valley of the Seine, liberated from worry for the first time in his adult life, enjoying, at least from an artistic point of view, 'undoubtedly the happiest and most fruitful period of his whole career'.

Finally, in spring 1906 came the long-anticipated meeting of

Picasso and Matisse. They were introduced by the Steins, who took Matisse and his daughter, Marguerite, now aged ten, up to the Bateau-Lavoir to see the portrait of Gertrude. As they made their way up the hillside through the lanes of Montmartre, people stopped to stare at the curious-looking group: the tall, lanky, golden-haired brother and his stout, bohemian-looking sister, both dressed in brown corduroy and wearing the distinctive, 'Grecian' leather sandals they now wore all the time, designed by Isadora Duncan's brother Raymond and inspired by a frieze on a Grecian vase in the British Museum. Matisse was, of course, no stranger in Montmartre. His nickname around the rue Laffitte was 'the doctor' because of his gold-rimmed spectacles and the frock coat and neat cravat Amélie insisted he always wear in town. In Montmartre, he was not a popular figure. Since his success at the previous Salon d'Automne, posters warning artists of the hazardous effects of lead paint had been defaced by graffiti and now warned against the effects of Matisse – the work, it was assumed, of one of the Picasso *bande*. (André Salmon vehemently denied this.) At the Bateau-Lavoir, the visitors were received by Picasso, Fernande and a very large dog.

Fernande's first impression was that there was 'something very pleasing about Matisse . . . he really looked like a grand old man of art'. She guessed his age at forty-five (she was adding ten years). She thought he seemed to be hiding behind his thick spectacles, and that although he talked incessantly he gave nothing away. He was dauntingly articulate, exuding self-assurance as he spoke persuasively about his work. She felt herself in the presence of an astonishingly lucid mind, 'precise, concise and intelligent'. She also suspected he was probably 'a good deal less simple than he liked to appear'. She realized that he and Picasso were already being pitched against each other as the two most promising painters of the time. Whether or not (as Picasso later claimed) both knew this from the start, Leo encouraged them to think so, although in Fernande's private opinion neither of them was actually the best painter in the Fauves style. She reserved that particular accolade for Derain, who, as she recalled it, had been the first to earn the soubriquet from Vauxcelles. As for

what Picasso thought, 'Matisse talks and talks,' he told Leo. 'I can't talk, so I just said *oui, oui, oui . . .*' As personalities, they had nothing in common, as Matisse quickly discerned. 'As different as the North Pole is from the South Pole,' he would say, when talking about the two of them.

Shortly after the openings of both the Druet and the Indépendants shows, Matisse left Paris for his first ever visit to North Africa, dropping off his luggage in Collioure (in anticipation of his return) and his family in Perpignan before travelling on to Algiers. On the way back, he broke his journey at Marseilles to visit an exhibition of tribal artefacts from the French colonies before returning to Collioure for the remainder of spring and summer. While he was there, his work was shown (in May) with the Modern Art Circle of Le Havre, newly founded by Charles Braque, father of Georges. In Collioure that summer, Matisse painted three new portraits, a self-portrait of himself in striped mariner's jersey (*Autoportrait, 1906, Collioure*) and a portrait in two variants of a local boy, a work he called *The Young Sailor*. One of these, with oval head and almond-shaped eyes, could have been a caricature portrait of Picasso. The other, with a more square-shaped jaw and black curly hair, bore a passing resemblance to Georges Braque.

In April, Michael and Sarah Stein travelled to San Francisco, where they still had property, following the devastating earthquake of 18 April. They took with them two canvases by Matisse. This would be the first time his works had been seen in America. Matisse's work struck the Steins' fellow citizens, no less than his own fellow Frenchmen, as 'gross, mad, monstrous products of a diseased imagination', reactions which did nothing to deter Sarah Stein. Later that year, she purchased the portrait of Madame Matisse entitled *The Green Line*, *La Gitane* and other works exhibited at Druet's, together with at least four more works by Matisse. When she departed for America in April 1906, she left her other significant new purchase behind for safe keeping at 27, rue de Fleurus – the seven-feet-high painting by Picasso from his Rose Period, *Boy Leading a Horse*, which Vollard had dismissed as worthless.

Sometime during 1906, Picasso painted Leo Stein's portrait, depicting him, in the style of Goya and using his new palette of earth colours, as a venerable old man with sparkling eyes and a long, golden beard. *Portrait of Leo Stein* was among the last works in the style to which Leo, Vollard and Fernande all longed for him to return. That April, Vollard paid an unexpected visit to the Bateau-Lavoir. He gave Picasso two thousand francs in exchange for virtually his entire output of recent work.

12.

Sculptures, Carvings, Icons

That summer, Picasso travelled with Fernande to Spain; with his two thousand gold francs from Vollard he could finally afford to take her to visit his native country. They were heading for the remote village of Gosol, above the Val d'Andorre in the Pyrenees. Fernande had never before travelled beyond France. She found the three-day journey by rail exhausting; she lay sleepless all night in their third-class compartment waiting for daybreak, rattled by the jolts of their carriage, which seemed to have no suspension. Picasso, a more seasoned traveller, passed the time reading Miquel Utrillo's just published monograph on El Greco.

Their arrival in Barcelona on 21 May coincided with a noisy and tumultuous Catalan demonstration: the anarchists were protesting about political issues largely to do with their antipathy to the Church. Fernande found the crowds and noise overwhelming and begged Picasso to take her home. Had there been a train about to leave, she might have succeeded in persuading him. Instead, they spent the next fortnight visiting family and friends, including Ricard and Benedetta Canals; she discovered that social life in Barcelona took place mainly at night, when the city became gay and animated. Then they resumed their travels. The journey to Gosol meant several hours on the back of a mule, Fernande's hands and knees scraped as they trotted for miles along the edge of a sheer drop.

Gosol itself she found enchanting. After Paris and Barcelona, the air was pure and the local people, most of them smugglers, were entertaining and hospitable. She sat with them, making out what they said through their gestures, while Picasso worked. He was painting a local man, Josep Fontdevila, aged at least ninety, his teeth wasted up to his gums, every single one either missing or decayed, giving his face a carved, primitive appearance. The sun gilded the

houses ochre, turning the stony ground white beneath a sky so blue she had never seen anything like it. Everything delighted her. In the village, old customs prevailed. The women rarely dined with their menfolk; they ate by themselves, standing in the kitchen, while the men talked, completely ignoring them. The saints, on the other hand, were greatly revered; the locals seemed to take a day off to celebrate once, sometimes even twice a week, when there was dancing in the square and an atmosphere of festivity and celebration.

On 27 June, Picasso wrote to his friend Casanovas, back in Paris, asking him to send some chisels so he could work the wood he had been given by the villagers. In July, he wrote again: 'I want you to buy or send me by mail a roll of twenty sheets of *papier Ingres* and as quickly as you can because I have finished the small stock of paper I bought in Barcelona . . . Could you send me in the same package two or three small *eines* [chisels] to work in wood?'

In Paris, the impact on everyone (not least Picasso) of Cézanne's portrait of his wife and Picasso's own experience of painting Gertrude's portrait had presented him with new formal problems. Now, in summer 1906, he began to approach his work in new ways. Perhaps taking his cue from Modigliani, he started to work on several woodblocks, making sculptures, including a boxwood figure which became known as the *Bois de Gosol*. In his paintings, he depicted carved-looking, sculpted figures which clearly showed the influence of ethnic figure carvings – his own, and those he had seen earlier in Paris, the statuettes Vlaminck had found in Argenteuil as well as the Iberian sculptures that went on display at around that time in the Louvre. Already, the delicate, elongated figures of the Rose Period had given way to a quite different treatment of the human form. His new painted figures were chunky, sturdy, the volumes clearly delineated. As his way of modelling forms changed, the surface of the paint became increasingly tactile and raw, his earlier rose palette replaced by brick and earth tones. And the proportions of his figures were changing, as he moved away from the classical ideal of beauty, creating instead larger heads, heavy shoulders and narrow hips, in keeping with the forms and features of Iberian sculpture.

Sometime in 1906, perhaps also in Gosol, he painted another self-portrait, a small, simple oil painting on canvas mounted on wood, which, though modest in size (26.7 x 19.7 cms) was radical in its treatment of self-portraiture. The figure of Picasso in a white, open-necked shirt, palette in hand, has a sculpted appearance, influenced perhaps by his own and Gauguin's rudimentary woodcuts. The face, mask-like, with one eye completely blanked out, recalled Cézanne's treatment of his wife's face in *The Artist's Wife*. In Picasso's self-portrait, the face and figure are stripped, pure, elemental, as if something is being pared down to the essence. In Gosol, his paintings of Fernande began to change, too. He depicted her without facial expression, treating her like a statue, breaking up the form of the face into facets and creating strange, sombre angles. He continued to work in this way throughout the summer. For three months, as one commentator put it, *il prépare sa révolution*. The summer wore on, neither Picasso nor Fernande showing any sign of being ready to leave, until, in mid-August, their stay came to an abrupt end. On the 13th, Picasso suddenly wrote again to Casanovas, telling him to forget the errands he had asked him to run; within a few days, he and Fernande would be returning to Paris. The landlady's daughter had contracted typhoid fever, and Picasso was always frightened of illness; he lived in mortal fear of contagious disease.

Back in the Bateau-Lavoir, it was stiflingly hot. They had a cat now, so at least the stench of mice was no longer overpowering, but the place was still airless. Picasso reverted to his habit of painting all night and sleeping all morning, though sometimes he was not allowed to sleep on undisturbed. Visitors unfamiliar with his timetable, including any potential purchasers, tended to come in the morning. 'M'sieur Picasso! M'sieur Picasso!' the concierge would shout up at his window. 'Get up at once, it's a serious visitor come to see you!' A young German dealer William Uhde, who had bought Picasso's painting *The Tub* back in 1901, had begun to mingle with the Picasso *bande*, often joining them in the Lapin Agile. Now, in 1906, he bought the painting that seemed to signify the end of

Picasso's concern with the acrobats and itinerant performers who had peopled a whole era of his work. The painting, *Death of a Harlequin*, shows a harlequin lifeless in his coffin. The Rose Period was almost over.

Gertrude Stein bought Picasso's self-portrait in a white vest, just for herself, she said; she thought it too *intime* for public display. Sergei Shchukin had also begun to take an interest in the painter. From now on, the pattern of sales of Picasso's work was set: his purchasers would always be friends or private collectors who exhibited his work in their own salons rather than in public exhibitions. He disliked negotiating, hated selling works he was not satisfied with and always said a painting was never finished, he was simply forced to part with it to buy painting materials for the next work. Even in the early days, he sold discreetly. After a visit from one such individual, Olivier Saincerre, who loved modern art and regularly bought a small piece, Fernande could again buy shoes, hats and perfume.

Despite the heat, on their return from Spain, Picasso got straight back to work. To Fernande's despair, he began to paint over some of his old canvases. She felt she was witnessing the passing of an era; she had loved the old melancholy Blue and delicate, early Rose Period works. Picasso embarked on various works, including *Nude Combing Her Hair* (1906), a carved-looking figure of a girl, and *Two Nudes* (1906), in which two squat, carved figures stand face to face – both resembling the works he had produced in Gosol. He was also working on ceramic sculptures, including a *Bust of Josep Fontdevila*, the all but toothless nonagenarian of Gosol; and a sculpture of Fernande, probably inspired by Gauguin's wood carvings, *Fernande Combing Her Hair*. Then he got out his unfinished portrait of Gertrude Stein.

Before leaving for Gosol, he had wiped out the head, telling Gertrude, 'I can't see you any more when I look.' He now repainted it, from memory. Perhaps, having read *Noa Noa*, he had also somewhere read Gauguin's words, 'It is well for young men to have a model, but let them draw the curtain over it while they are painting.

It is better to paint from memory, for thus your work will be your own.' The new face was almost expressionless; like a mask, or the mask-like side of Madame Cézanne's face in Cézanne's painting. And the portrait of Gertrude Stein was finished. 'But it doesn't look like me,' said Gertrude when he showed it to her. 'It will,' he replied. The Picasso *bande* had all read Oscar Wilde. But perhaps the remark referred not backwards to the Decadents but forwards to the art of the modern age. In its striking formal resemblance to Cézanne's *The Artist's Wife*, the portrait suggested more profoundly than any photographic likeness the concerns and principles that character-ized Gertrude as she was that winter; and (to borrow Gertrude Stein's idiom) it exactly reflected what it actually depicted – Ger-trude Stein, posing for Picasso.

When her friends saw the painting they were horrified, as was Leo. Gertrude herself came to recognize in it the principles of abstraction and reduction to essentials she had herself been seeking to express in her work. She also appreciated the sense in which, in its monolithic simplicity, it did succeed as a likeness. 'I was and I still am satisfied with my portrait,' she later inimitably wrote. 'For me it is I, and it is the only reproduction of me which is always I, for me.' When Picasso showed her the work he had done in Gosol, she noticed immediately the change in his palette: 'still a little rose but mostly an earth colour'. She recognized the influences, not only of the African carvings which by now were beginning to fascinate every-one, but also of Cézanne and Gauguin. Yet she saw, too, that Picasso's work was unique. As she put it, 'Picasso was the only one in painting who saw the twentieth century with his eyes and saw its reality and consequently his struggle was terrifying, terrifying for himself and for others, because he had nothing to help him, the past did not help him, nor the present, he had to do it all alone.'

That autumn, Picasso began to work alone in his studio, uninter-rupted for many hours at a time. The business of socializing, even at the Steins', had begun to distract and irritate him. He had a new idea, which he wanted to develop in solitude. As Gertrude Stein later noted, 'The rose period ended with my portrait, the quality of

drawing had changed and his pictures had already commenced to be less light, less joyous.' She qualified this; the subjects of the Rose Period had of course not all been joyful; in his paintings of the circus performers, he had incorporated a note of sadness and acknowledged the hardship and wretchedness of their lives. But his Rose Period had also been a time of light-heartedness, when 'he contented himself with seeing things as everybody did. And then in 1906 this period was over.'

The year 1906 had marked a period of considerable turbulence and change throughout France. There were over 1,300 strikes, most notably on 1 May, when the workers went out to demand an eight-hour working day. Confrontations between strikers and government were ubiquitously covered by the French press, which was then in its heyday. In all the major cities, there were up to a dozen newspapers and every city had at least four or five, all competing for circulation with the increasing numbers of gimmick papers, comic strips and supplements of photo engravings. *Le Matin* ran a daily column of domestic news by Félix Fénéon, a brilliant, somewhat shady figure who, though he kept a low profile, was known as a literary and art critic. He founded several magazines and edited several more, including *La Revue blanche*. A thin, dessicated-looking man with a sharply hooked nose, he was part anarchist, part aesthete. He had more or less discovered Paul Seurat, founded literary journals, worked for thirteen years as a clerk in the War Office, supported strikers and had allegedly thrown a bomb into the Café Terminus which caused a blast in which poet Laurent Tailhade lost an eye. After working for *La Revue blanche* until it folded in 1903, he had been a journalist for *Le Figaro* until early in 1906, when he joined the staff of *Le Matin*, where, after a few months, he was assigned the *faits-divers* column on page three, which he kept until November. In his daily column, he managed, partly through sheer brevity, to ginger the domestic events of the day with a mildly satirical edge. His stories, which he called 'novels in three lines', reflected with great economy the tenor of French life in 1906, revealing the growing importance and menace of the automobile; the medieval

conditions that still prevailed in rural areas; the inefficiency of fire-arms; the arrogance of the military; the unchangingly brutal state of factory labour; and the continuing rumbling threat of anarchist violence. Life in the middle of the Third Republic was tumultuous, with the prospect of German invasion again on the horizon and the previous year's separation of Church and State still a contentious issue, since it had reduced the power and income of the Church as well as its monopoly over primary education. Taken together, prac-tically any random selection of Fénéon's stories conveys the flavour of daily domestic life that year.

There were reports of abject poverty, gunpowder plots and of the 300-year-old cannon which, 'while thundering for the Republic', exploded in Chatou. No one was hurt. There were stories of women killing newborns and of children smothered when their parents could not afford to feed them. Cab drivers were demanding exces-sive tips, resulting in '27 violations'. The corpse of a man named Dorlay, aged about sixty, hung from a tree in Arcueil with a sign reading, 'Too old to work'. The court at Nancy jailed a parish priest for insulting a tax collector. Swindlers coloured the new maroon ten-centime stamps and sold them as rareties to unsuspecting punt-ers. People died drawing water, trampled by their own cows or run over by their own hay carts. Prostitutes were slaughtered on the pavement; a poacher from Ivry, shopped to the police by a pedlar, stuck a file in the pedlar's back. On separate occasions 2,700 feet of telephone cable were stolen in Gargan, 4,500 between Épinay and Argenteuil, another seven miles' worth between Paris and Arpajan; and it was still going on. A travelling freak show, with its 'horrible monsters and efflorescent skin diseases' had been burned down in the park at Saint-Cloud. Forty gypsies, with their camels and bears, were forced by police to leave Fontenay-aux-Roses, and, for that matter, the entire region of the Seine. In Montmartre, still clearly the enclave of the poor, a Monsieur Fraire (a labourer known as Cruddy) was informed by a lawyer of his inheritance, whereupon he died of shock.

The most significant social changes regarded labour laws and

education. On 1 May, schooling for girls was made legal; on 13 July, following a wave of strikes, a bill was passed granting a compulsory day of rest, Monday. In the Moulin de la Galette, Monday became '*cheveux*' day, with dress codes so relaxed that dancers were permitted to dance hatless. Proceedings in the dance hall became less formal that day and things sometimes became rowdier than usual on the workers' new day off. As for Fénéon, he was multi-talented: he could spot not only a good story but also a good painting. Bernheim-Jeune now brought him into their employ, to introduce promising young artists into their stable. For, as the twentieth century unfolded, as Gertrude Stein later observed, 'More and more the struggle to express it intensified.'

13.

New Expectations

The 1906 Salon d'Automne was formally opened at the Grand Palais by the President of France, Fallières, himself. It included Diaghilev's exhibition of the largest collection of Russian art Paris had ever seen – some four thousand works representing the art of historical and contemporary Russia. For the previous two years, Diaghilev's pursuit of modern French art had been temporarily stalled by events. By 1904, the year he published Matisse's work in what was to be the final issue of *Mir Iskusstva*, life in St Petersburg had already become precarious. In artistic circles, there was growing disillusionment with the imperial regime and, in February 1904, Russia had become embroiled in a disastrous war with Japan. Realizing that life in Russia was about to change irrevocably, Diaghilev had turned his attention to the artists of his own country. He had been working tirelessly to mount an exhibition of 'Artistic and Historical Portraits', making long journeys across vast areas of the country, visiting over a hundred disintegrating country estates. 'From rooms where the plaster was falling from the ceiling, from attics and old closets where the paintings hung loose in their frames, and from cellars where the damp had mildewed the canvas', he had uncovered thousands of portraits by Russia's forgotten masters, selecting paintings for his exhibition from a great cargo of artistic treasures.

By New Year 1905, there was tragedy in St Petersburg, with shooting in the streets, and many dead and wounded. In the evenings, the city was plunged into darkness. People stayed in their homes, not daring to venture out, amidst rumours that the railways would be stopped from running and water supplies cut off as the city witnessed the beginning of the civil unrest many would later see as the start of the revolution of 1917. In February, Diaghilev went ahead with his exhibition, held at the Tauride Palace in St Petersburg. At a

gala banquet to celebrate the opening, he gave a speech he wrote himself under the title 'The Hour of Reckoning'. As he journeyed 'the length and breadth of infinite Russia', he told his audience, he had been overwhelmed by the feeling that the portraits he was recovering, though as indisputably precious as the grand country estates that still housed them, already seemed consigned to the past. Change was afoot, the modern era already in a state of advance. 'The end was here in front of me.' The derelict, boarded-up family estates had struck him as 'palaces frightening in their dead grandeur, weirdly inhabited by dear, mediocre people no longer able to bear the weight of past splendours. It wasn't just men and women ending their lives here, but a whole way of life. And that was when I became quite sure that we are living in a terrifying era of upheaval; we must give up our lives for the resurgence of a new culture . . . I raise my glass,' he concluded, 'to the ruined walls of those beautiful palaces, and in equal measure to the commandments of the new aesthetic.'

His words were prophetic. On 17 October 1905, the Duma was created, establishing a radical new form of government. Though it included an amnesty for strikers (many of whom were artists), throughout 1905 and 1906, the political situation remained tense and dangerous, and this had a direct impact on the arts. Because Russia's cultural institutions, theatres, concert halls and galleries were run by the State, artists of all persuasions were vulnerable, even those with established reputations. Dissenting artists risked imprisonment, or worse. The destruction of large numbers of works of art resulted in the defection of many young artists, some of whom took refuge in Paris.

By May 1906, Diaghilev himself was in the French capital, with one of his friends from his student days, Alexandre Benois, a painter, theatrical designer and one of the illustrators for *Mir Iskusstva*. There, they met officials from the Russian embassy, French intellectuals and influential individuals, including Robert de Montesquiou and the Countess de Greffuhle (a prominent socialite and one of Paul Poiret's most influential clients). Léon

Benedict, a curator at the Musée du Luxembourg, put them in touch with the organizers of the Salon d'Automne, who by now included Derain as well as Matisse. Diaghilev successfully worked his charm on the director, Monsieur Jourdain. He now began outlining his plans for a spectacular show of Russian art there, to include a simulated conservatory, latticed and heavy with foliage, to show the sculptures; and a substantial collection of Russian icons, which he already envisaged displayed against a backdrop of sumptuous silk drapery. The exhibition would include the work not only of illustrious Russian painters and sculptors but also that of Russia's youngest contemporary artists.

In the world of rigid, legally imposed class distinctions that characterized imperial Russia, Diaghilev had always moved in elevated, cultured circles. His father and stepmother were both talented musicians (his mother died shortly after his birth), and Diaghilev had studied first (for six years) at the University of St Petersburg as a reluctant law student, then at the Conservatory of Music, under Rimsky-Korsakov. He met Benois at university in 1890; his other close friend was painter and illustrator Léon Bakst, a talented colourist and original set designer who had studied in Paris and who had also worked with Diaghilev on the production of *Mir Iskusstva*. Through the auspices of one of his friends, Prince Volonsky, Director of the Imperial Theatres, Diaghilev had entered the official world of the arts. The prince had invited him to edit the Imperial Theatre Yearbook for the year 1899/1900, a project which had also given his illustrators Alexandre Benois and Léon Bakst their first breaks. However, it was not until he founded *Mir Iskusstva* and began to gather around him a group of artists who, like him, admired the work of Aubrey Beardsley and the Decadents (the 'modern' artists who had first inspired Picasso) that he felt he had truly begun to learn about art. Through their links with Prince Volonsky, Diaghilev and Benois had also succeeded in staging one of the first experimental ballets, *Sylvia*, a dance piece liberated (even before Isadora Duncan's debut in Moscow later that year) from the restrictions of classical dance. Rows over the management of that

production had resulted in Diaghilev's dismissal, setting a precedent for the pattern of the next few years, during which he would be continually in and out of favour with the Russian imperial authorities as he searched for a way of making his mark on the development of modern art.

Now, at the Salon d'Automne, in twelve rooms of the Grand Palais (four of them vast) he was showing 750 Russian works of all periods, from medieval icons onwards, including the work of Mikhail Vrubel, whose flamboyant, vividly coloured, sensual paintings had strongly influenced the developing style of Léon Bakst. The Russian collection was shown as a separate exhibition (with concerts of Russian music to entertain viewers in the evenings) and went unmentioned in the catalogue, but it was open to all visitors to the salon free of charge. The Russian exhibition was a huge draw, and Paris in the final months of 1906 saw 'an invasion of Petersburgers'.

What of the Parisian viewers? Did either Matisse or Picasso see the work of the Russian artists, the display of icons? Could they possibly have missed – or dismissed – it? Particularly given his relationship with Shchukin and his connection with *Mir Iskusstva*, Matisse, if not Picasso, might feasibly have been interested in the Russian works ... Nevertheless, for the French artists the major sensation of the 1906 Salon d'Automne was not the Russian art but the retrospective exhibition of the works of Paul Gauguin, in which, together with drawings, ceramics and 227 paintings, his large, totemic wood carvings were shown for the first time.

Whether or not its viewers included the artists of Montmartre, the Russian exhibition was a public success, favourably reviewed in *Le Figaro*. Diaghilev, Benois and Bakst were made honorary members of the salon. The art of Russia had made its mark on Paris. Nonetheless, Diaghilev still had work to do, since an honourable reception did not amount to an artistic sensation. Compared, for example, with the impact of the Fauves in 1905, the Russians had a long way to go before being hailed as in any sense path-breaking. After the salon closed, the Russian exhibition travelled on to Berlin, and a selection of works was then shown at the Venice Biennale.

Then Diaghilev returned to St Petersburg until the end of the year, where he immediately began to work on his next idea, staging a series of Russian musical concerts at Paris's Grand Opéra. In the meantime, he had made his first impression, albeit indirectly, on the world of French contemporary art, at the same time taking the opportunity to bring himself up to date with all the latest developments.

Matisse was briefly in Paris for the Salon d'Automne, before returning to Collioure for the winter. Before he left, he showed Sarah and Michael Stein the three portraits of sailors he had painted there that summer – the *Self-Portrait* (in striped mariner's jersey) and the two portraits of a young sailor, which he initially pretended he had acquired from the postman in Collioure, before admitting he had painted them himself. Michael and Sarah purchased the new self-portrait and the first version of *Young Sailor*, which they considered more vibrant and less stylized than the second. They hung *Young Sailor, I* at the centre of the wall covered with pictures by the dining-room table in the rue Madame, beneath Matisse's new self-portrait. When she saw it, Gertrude brought out her small, intimate self-portrait by Picasso and displayed it on her own wall.

Before Matisse left for Collioure, he and Picasso met for the second time, on this occasion at the rue de Fleurus, as dinner guests of Leo and Gertrude Stein. On his way there, Matisse passed a shop in the rue de Rennes, where he happened to notice a little Congolese vili figure. He bought it, and took it with him to the Steins'. The story of Picasso's response to it is bizarre; by all accounts, he refused to be parted from the statue. According to Max Jacob, he stayed up all that night and was found (by Jacob) the next morning 'surrounded by drawings of a one-eyed, four-eared, square-mouthed monster which he claimed was the image of his mistress'. Whether or not the mistress was Fernande, why Matisse agreed to part with the statue and whether indeed the story was apocryphal must remain mysteries. What was becoming clear, especially since the recent exhibition of Gauguin's towering, totemic wooden figures, was the extent of everyone's growing fascination with such works.

Picasso could not now help but perceive Matisse as a potential rival. Ten years older than Picasso, the French painter already had the backing and continued interest of a growing number of purchasers, including Shchukin, Druet and the Steins. Sarah Stein was rapidly collecting his work, and introducing it to America. Matisse was well-dressed, articulate and already well known – by now – throughout Paris; he had also produced three children. To Picasso, he was a disconcerting presence from every point of view. In his work of the Blue and Rose periods, Picasso had continually taken as his subjects mothers, children and family groups. The children of the acrobats and circus performers had impressed him quite as deeply as had the adults. For several months, van Dongen, Guus and Dolly had brought the Bateau-Lavoir to life, but in December 1905 they had moved to a bigger apartment at the foot of the Butte, in one of the streets behind the Moulin Rouge. For van Dongen, at least, substantial success had followed from the 1905 Salon d'Automne, which had brought his Fauvist paintings of figures to the attention of a newly appreciative public – in commercial terms, it was his kind of 'wildness', not that of Derain or Vlaminck, that appealed to the sort of purchaser keen to own a painting of a woman in her undergarments which was also a work of art. Life in the Bateau-Lavoir was quiet without the van Dongens, and Picasso missed Dolly. Fernande's memoirs reveal that she and Picasso had hoped for a child of their own, but the long-term effects of her miscarriage six years ago meant she was destined to be disappointed – though Picasso may not yet have known that.

Picasso had surely seen *La Joie de vivre*, the large Arcadian work Matisse had exhibited at the Salon des Indépendants, and perhaps also his sailor portraits, before he embarked on the work he began that autumn. Even if he had somehow missed the former there, he would certainly have seen it regularly that autumn on the wall of 27, rue de Fleurus. It is thus possible, even likely, that Matisse's large work (and perhaps, too, *Luxe, Calme et Volupté*) was one influence on the development of the painting Picasso now began work on in earnest, alone in his studio, inspired also by Cézanne's *Bather* compositions. He

clearly had great expectations for this work; Leo had already noticed with amusement the huge canvas, eight feet square, he had had relined, as for a classic piece. Since it would have been impossible to work on a painting of this scale amidst the cramped and chaotic conditions of his current studio, the Steins rented a second for him, on a different floor of the Bateau-Lavoir.

Matisse left Paris in November for Collioure, first making a detour to visit Derain, who was in L'Estaque, painting the land-scapes which had inspired Cézanne. By the time news of Cézanne's death (in Aix on 23 October 1906) reached Paris, Derain was not the only painter to have returned to Cézanne as one of the major influences on his developing work. In L'Estaque, he and Matisse set up a wager as to who could paint the better blue nude, then Matisse retreated to Collioure for the winter. As for Picasso, all that autumn he painted alone in his new studio, locked away by himself with the large new work of which nobody, not even Fernande, had yet been permitted so much as a glimpse.

PART III

Carvings, Private Lives, 'Wives'

Picasso and Matisse: The Two-man Race

At 27, rue de Fleurus, Matisse's *Blue Nude: Memory of Biskra* glowed from the wall – the result of his wager with Derain. The concierge's five-year-old son had come running into the room and stopped in his tracks: '*Oh la la! Quel beau corps d'une femme!*' Picasso stood discussing it with Walter Pach, a 23-year-old artist on his first visit to the Steins'. The painting was certainly arresting. A broad-shouldered, flesh-coloured, blue-tinted nude with large breasts reclines in a contorted pose in an outdoor setting; perhaps a garden, but with jungle foliage. Matisse had developed the figure from drawings he had made from a male model in Algeria; the painted nude was blatantly erotic and hintingly androgynous. 'Does that interest you?' Picasso asked Pach, who replied that it struck him rather like a slap in the face; he did not really understand Matisse's thinking. 'Neither do I,' replied Picasso. 'If he wants to make a woman, let him make a woman. If he wants to make a design, let him make a design.' This was somewhere between the two.

By early 1907, the Steins' Saturday-night soirées were crowded with artists, dealers and bohemian hangers-on. The house at 27, rue de Fleurus was becoming a sort of sparring ground where artists could confront and debate with one another. It was also a place where they could see new work at a time when reproductions were rare and only in black and white – and paintings that had scandalized the public. Matisse had just shown *Blue Nude* at the Salon des Indépendants, where Leo Stein had quickly snapped it up. When Sarah Stein saw it, she decided she would from now on collect nothing but Matisse. She had already acquired over fifty of his works; she visited him nearly every week and would spend the rest of the year going through her collection, replacing other artists' work with his and in the process wresting a dozen recent works from Leo and

Gertrude, including *Blue Nude*. By this time, she was not Matisse's only supporter: interest in his work had steadily begun to increase. In February, Félix Fénéon, now acquiring new work for the Bernheim-Jeunes, wrote offering him a one-man show. Soon afterwards, he visited Matisse in his studio, where he bought three paintings and made him a proposal: the Bernheim-Jeunes were offering to purchase the bulk of all his future work in return for first refusal. With the Steins as competitors, the Bernheim-Jeunes would soon be setting prices for Matisse's work at thousands rather than hundreds of francs.

Now that the Steins were entertaining both the 'Matisseites' and the 'Picassoites' (as Gertrude Stein had divided them), Picasso could no longer keep out of Matisse's way. He, too, began to visit him regularly, keeping a close eye on his rival's emerging work and beginning a life-long competitive dialogue which they played out in their work. Picasso and his friends knew nothing of the struggles Matisse had endured throughout the preceding years. They saw only a well-dressed Frenchman beloved of the Steins, achieving ever more resounding successes with the Bernheim-Jeunes and other young dealers, travelling and exhibiting abroad and effortlessly articulate in the cause of promoting himself. In actual fact, Matisse was struggling to stay aloof from incessant criticism and taunts.

Sometime in 1907, observing a long-established tradition among artists, Picasso and Matisse exchanged paintings. Although Picasso later insisted they had both picked a painting they could learn from, Gertrude Stein remarked that each had surely chosen the picture he considered the worst example of the other's work. Matisse picked an experimental still life of a pitcher and a lemon, with unusual rhythms and slightly distorted forms. Picasso selected a simple portrait of Matisse's daughter, Marguerite, painted in the style of children's art, the features drawn in with a few broad lines, the nose added in profile. The intentional naivety of the picture was emphasized by the incorporation of the name 'Marguerite' scrawled in childlike lettering across the top. In painting it, Matisse had been

inspired not only by the work of the artisan painters he had seen in Algeria the previous year, but also by his own children's art. Picasso hung the picture in the Bateau-Lavoir, where his friends (if not Picasso himself) used it for darts practice. By now, the rumbling feud between the two men was clearly in place, intensified because there were no other obvious candidates; Leo Stein called it a 'two-man race'. If Sarah Stein continued to champion Matisse, Gertrude still quietly favoured Picasso.

Before returning to Paris in spring for the 1907 Salon des Indépendants, Matisse had been in Collioure for almost the whole of the past year. On 30 April, he left Paris once again to return there. The work he did in Collioure that summer included a series of studies, *La Musique*, *La Coiffure* and *Three Bathers*, each of which revealed the extent to which his figures were becoming expressive, simplified shapes, none resembling any particular sitter, all liberated completely from the restrictions of likeness and dynamically modelled as if freed into pictorial space to find their own way into the overall design. One painting in particular, *La Musique (Esquisse)*, seemed to be a vivid study in rhythm. A seated nude figure lies curled in the foreground as a violinist serenades two lightly draped girls dancing together. The whole painting is vibrant with the dynamic motion of the dancers. This work, which Matisse modestly called 'a painted sketch', announced his first real departure from the Fauve style, anticipating the appearance two or three years later of two of his greatest works, *La Danse* and *La Musique* (1909–10). The issue of spatial design was now his main preoccupation, as Picasso had already shrewdly observed.

That spring, Picasso paid his first visit to the Musée d'Ethnographie du Trocadéro (now the Musée de l'Homme). When he first saw the neglected, musty rooms full of ethnic sculpture, he found them disgusting; they reminded him of the fusty old bits of bric-a-brac for sale at the flea market. He wanted to go straight out again, but something made him stay. When he looked more closely at the exhibits, he was amazed. Like Vlaminck, Derain and Matisse, he was struck by their difference to Western art; unlike them, he also

perceived their power as fetishistic objects. Years later, he could still recall the intensity of their impact on him at the time: they weren't like any other pieces of sculpture.

Picasso's discovery came at a time when he was searching for new forms of expression. As he put it to himself later, he was rebelling against traditional definitions of beauty. Already, particularly following the exhibition of Gauguin's carvings at the 1906 Salon d'Automne, 'beauty' itself was open to redefinition. And, in spring 1907, Picasso was still impressed by magic and sorcery; a conjuring trick at the circus or on film could interest him as much as the classical art shown in the museums. The African artefacts in the Trocadéro made him think about – perhaps even identify with – the people who had made them and their motives for doing so. Perhaps it was with the idea that making art was a kind of magic that he continued to develop his new, large-scale work, hoping to create something similar on canvas: a work that would realize in artistic form – and thus guard against – the deepest terrors of desire. Whether the new work turned out to be a way of taking power or a kind of magic trick, at a time when he felt particularly insecure as an artist this discovery seemed to offer the possibility of new forms of expression.

Georges Braque (like Derain) had spent the winter months in L'Estaque. He returned to Paris in March in time for the Salon des Indépendants, where he was showing his work for the first time. (So, with Braque's encouragement, was Marie Laurencin, though the prospect of public exposure made her so unbearably nervous that, as soon as the exhibition opened, she fled to the coast with her mother to stay with friends.) The exhibition brought Braque his initial successes. Five of his works were purchased by William Uhde, the young German dealer who had already discovered Picasso and now acquired these works for the cautious sum of 505 francs, despite the warnings of friends, who urged him to invest more sensibly in better-known artists. The sixth work of Braque's to be purchased was bought by another German dealer new to the scene, Daniel-Henry Kahnweiler, who was just opening his first, tiny gallery,

sublet from a Polish tailor, in the rue Vignon, near l'Église de la Madeleine in the 8th *arrondissement*. For Braque, the support of Uhde and Kahnweiler amounted to public recognition that he was actually an artist. 'At that moment I understood that I was a painter. Until then I had not believed it.'

In L'Estaque, he had been working on paintings he had begun to think out in Paris. In their intricate construction, they bore the earliest marks of what would soon be readily identifiable as Braque's distinctive geometry. The significance of L'Estaque for Braque (as for Derain and Cézanne before him) was the special quality of the light in southern France, which affected the spatial qualities of what he saw. The unusual light of the region seemed to open up the sky, making it look higher than it did in the north; while there, Braque experienced a breakthrough of *sensation*. He had gone to the south specifically to examine the influence of this light on his work and had been surprised by its impact on his emotions: 'Just imagine,' he told his friends, 'I left the drab, gloomy Paris studios where you were still working in bitumen. There, by contrast, what a revelation, what a blossoming!'

It may have been William Uhde who first put Picasso in touch with Braque (assuming their paths had not crossed before). Although Picasso may have seen the latter's work at the Salon des Indépendants, if they met at all that spring it cannot have been more than fleetingly. On two occasions in March 1907, Braque went up to the Bateau-Lavoir and left visiting cards in Picasso's studio. On one he jotted 'memories in anticipation'. Picasso scrawled reminders in the sketchbook he was using – 'Write to Braque' and, inside the back cover, 'Braque, Friday' – these notes suggesting they may have been briefly introduced. Whether they had or not, there would have been no opportunity to follow up any initial contact, since, as soon as the exhibition closed, Braque went travelling again; from May to November, he was constantly away, in Le Havre, La Ciotat and L'Estaque. In the meantime, Picasso retreated again into his new studio, where he was still making studies of heads and drawing numerous experimental

figure sketches, some in pencil, some in shades of pink or vividly coloured in blues, greens and yellows, in preparation for his major new work. Fernande was making plans of her own.

2.

Raymonde

On 9 April 1907, Picasso and Fernande made their way through the lanes of Montmartre, past the little restaurant Au Coucou where they lunched out of doors when they had the money, along by the dilapidated houses Utrillo liked to paint, down the steps of the hillside to the orphanage run by the nuns in the rue Caulaincourt. At the orphanage, they were shown the children and invited to take their pick. They selected a girl, said to be nine years old, who was appealing, friendly and '*d'une beauté grave*'.

The adoption of a child had been Fernande's idea. Picasso was ambivalent – though he loved children, he was under no illusions how disruptive a child's presence was likely to be. Since the beginning of the year, Fernande had sensed that he had been growing distant. He had been happy in Spain the previous summer but, since he had returned, and completed Gertrude Stein's portrait with that strange, mask-like head, his work had continued to change. He seemed to be searching for new subjects now that he had exhausted, at least in his work, the acrobats and circus performers he continued to spend time with at the Cirque Medrano and in the Hôtel des Deux Hémisphères, where the clowns, trapeze artists, dancers and prostitutes still gathered. Fernande sensed that she, along with the acrobats, was gradually being moved from centre stage. He used to idolize her in his work, but now he seemed obsessed with his mounting collection of photographs of African women. He still sat in the square in the evenings, chatting to Derain and Vlaminck and his Catalan friends, but the talk had become less comprehensible to her. He was working incessantly on his sketches of individual figures, many of which had a carved appearance; he drew the human form over and over again, devoid of mood or setting, always improvising and experimenting.

Among the works of Picasso's Rose Period that Fernande particularly loved, some of the most affecting were of mothers, some with children in their laps or playing around their skirts; melancholy mothers tending shadowy infants or veiled madonnas with wispy, scaled-down acrobats at their feet. His own childhood, as the only, pampered boy in the family, had given Picasso a deep, even religious sense of the rhythms of life and of the significance of maternity. He took maternal love for granted and saw women as potential mothers. In Spain, Fernande had understood him better, observing that, there, he seemed different from the Picasso she knew in Paris, 'less wild, more brilliant and lively and able to interest himself in things in a calmer, more balanced fashion; at ease, in fact'. Spain had seemed to transform him: in the vast, empty landscape among the mountains, the paths bordered by cypress trees, he appeared 'outside society, of a different species'. Since they had returned from Spain, however, Picasso had seemed increasingly introspective, irritable and secretive about his work. These days, he had more to do with Derain, who since his return from Collioure had defected from the 'North' to the 'South Pole' and, like Picasso, seemed to be searching for a new direction in his work. Derain was intellectual; he had theoretical aspirations and ideas about geometric space. Between them, he and Picasso seemed determined to discover how to paint a future masterpiece. The French painter was pleasant enough, full of charm and bonhomie, but he was not a friend Fernande could share with Picasso, as she had shared van Dongen, the only one of the painters she had seemed able really to talk to.

She could see that Picasso was making significant changes in his work. His figures looked sculptural; the women he depicted had solid arms, thick legs and tiny feet, like the feet of the peasant women they had seen in Spain. When he made sketches of dancers, they were nothing like the dancers in the Hôtel des Deux Hémisphères, with their elaborate chignons and flamboyant costumes. Picasso's figures now were clearly based on primitive peasant dancers. In *Negro Dancer* (1907) he wraps the head of the dancer into the folding planes of the picture like leaves around a

flower, creating a sculpted figure fashioned from the breaking surface of the painting which renders it almost abstract, elemental. His work perhaps harked back to the wooden bust of Fernande he had carved in Gosol, a work that was impersonal, multifaceted, with broken surfaces that did nothing to enhance her natural beauty. She continued to take an interest in his work, but these new ideas did not interest her as his earlier work had, and she was beginning to feel excluded and rejected.

Picasso had tried to find Fernande a new friend. In Austin's bar that spring he ran into Guillaume Apollinaire again. Apollinaire was the illegitimate son of a Belarusian countess, born a Russian subject in Rome, a lover of art and literature who had written poetry about the saltimbanques. In 1907, aged twenty-seven, Apollinaire moved from his mother's home in Le Vésinet to a small, bourgeois apartment of his own at 9, rue Léon, at the foot of the Butte. He was gracious and learned, fascinated by Picasso's work and, from this point, they began to meet regularly to discuss poetry and painting. At about the same time, Picasso came across Braque's friend Marie Laurencin in Sagot's gallery. When he met her a second time that March, she struck him as the perfect fiancée for Apollinaire. Though he turned out to be right in one respect (Apollinaire was besotted), if he had envisaged Marie as a possible distraction for Fernande, Picasso had misjudged. Far from recognizing a potential soulmate, Fernande was horrified by Marie; she thought her silly and self-conscious, with a face like a goat's. Uncharacteristically, in judging her she looked no further than the surface, seeing only that she 'took a good deal of trouble to appear to be just as simply naive as she actually was . . . like a rather vicious little girl, or a little girl who wants people to think she's vicious'.

In fact, Marie was awkward in Picasso's company and awed by his circle of friends. In his studio, on one occasion her nervousness manifested itself when she was trying to show an interest in his work, rummaging short-sightedly through all his things as Fernande looked on, astonished by her unembarrassed curiosity. All of a sudden, Marie stopped and sat down. She appeared to be taking

an interest in the conversation until, just as abruptly, she uttered a shrill, inarticulate shriek. There was an astonished silence. Then, "'It's the cry of the Grand Lama," she informed us helpfully.' She then untied her hair, so that it billowed down for all to see.

Marie fascinated Apollinaire, but everyone else was bewildered. Fernande could only assume that Marie was simply unable to stop noticing the effect she had on others – perhaps hardly surprisingly, given the company. Her chief crime seemed to be that, unlike Fernande, she evidently made no attempt to be glamorous. That this jarred so profoundly on Fernande was a pity since, like Lepape and Braque, she had sensed straight away that Marie was unusual; it was just that, in Fernande's company, Marie seemed to find it impossible to be herself.

For the time being, Marie kept her own counsel. In her private notebooks (*Le Carnet des nuits*), she made no mention of Fernande. She did reveal that, despite her own considerable talent, she felt very distant from the male painters and their pictorial problems. She felt obliterated by their work and their genius, and wary of them because they were men and always seemed to her to create problems it was difficult to resolve. It was possible to live in their shadow, she felt, so long as she made no attempt to emulate them. The technicalities of cubism, in particular, she felt were beyond her. As a painter, she was essentially poetic. She filled her notebooks with original jottings and observations, including her thoughts on Goya (perhaps she had even discussed him with Picasso), whose work transported her into a world of dance and artifice; she described his figures as 'thoroughbred marionettes made of steel'. She wrote original poetry, too, whimsical, mythological poems in lyrical free verse expressing her own emotions and describing the natural world in fantastical images; she depicts zebras, in one poem, as cavorting Spaniards. With Apollinaire, she infiltrated Picasso's world, respected as a painter even though, as a woman, she would never quite be accepted as one of the *bande*.

As for Fernande, her mind was on other things. On that day in April, the 9th, she and Picasso brought their newly adopted

daughter, Raymonde, home to the Bateau-Lavoir, where she settled in among the general muddle and squalor. She was introduced to Picasso's friends and taken to school every morning. Picasso helped her with her mathematics homework. Fernande was always busy with the little girl's hair, brushing it and tying it in coloured ribbons before she left for school. Picasso's friends gathered to compete for the attention of the beautiful child. It emerged that Max Jacob, too, loved children (his only brief flirtation with a member of the opposite sex had been with a girl who made doll's clothes for a living, but after a while her incessant knitting of tiny garments had allegedly become too much for him, although this was not actually the most plausible reason for their break-up) and seemed particularly suited to the role of kindly godfather or *tonton*. Picasso painted a portrait of the young girl with Fernande, *Mother and Child*, the two simply drawn figures with primitive, doll-like masks facing forward, the mother's arms forming a curved frame around the child. Perhaps he saw in their connection a kind of performance, but they were not clowns but pierrots, and the double act hinted at pathos, not slapstick.

On 27 April, the Steins received an Easter card inviting them to the Bateau-Lavoir the following day, Easter Sunday. If Fernande had intended this as an opportunity to introduce Raymonde to Gertrude, the event went unrecorded. In general, time passed with Raymonde and Fernande amusing each other, trying on clothes and playing with dolls, while Picasso continued working through the night on sketches for the huge canvas he was still keeping out of sight in the studio the Steins had rented for him upstairs. During the spring and summer months of 1907, which covered the gestation of this mysterious work, he filled some sixteen sketchbooks with four to five hundred sketches. The melancholy abjection of the Blue Period was gone and now, as he worked on, so was the romantic lightness of the Rose Period. He continued to draw dynamic, animated figures in striking pinkish reds and oranges, or bright yellows, blues and greens. In among a large number of these figures, expressionist in form, Fauvist in colour, appear pencil and ink sketches of

acrobats, dogs and birds – simple line drawings he may have done to amuse Raymonde, or even to teach her to draw. Meanwhile, there was still no sign that the large-scale canvas was anywhere near completion.

In July, Matisse and Amélie visited Leo and Gertrude Stein in Florence, a trip made possible by a payment of 18,000 francs from the Bernheim-Jeunes, who had just exhibited 79 watercolours by Cézanne, the first show of that artist's work in Paris since his death. Everyone had crowded into the gallery to see for the first time examples of Cézanne's extraordinarily delicate draftsmanship. In Florence, by contrast, even the treasures of the Uffizi left Matisse unmoved, perhaps because Leo's attempts to instruct him drove him crazy. Leo made the mistake of asking him for a candid opinion of his own work, which the artist fatally provided. After their visit to Florence, Leo never bought another of his paintings.

Matisse and Amélie continued on to Venice, where Matisse was similarly unaffected by what he saw, until he discovered the works of primitive painters Piero della Francesca and Giotto (artists passionately admired by both Derain and Modigliani), which renewed his energy and revived his interest. At the end of the trip, he returned with relief to Collioure, where, in August 1907, he began to consolidate his ideas on painting with a view to publishing them. ('Notes of a Painter', or 'A Painter's Notes', was published more than a year later.) The focus of the 'Notes' was the integrity of composition, driven by the subjective response to both nature and the figure which Cézanne had called 'sensation'. Matisse explained his understanding of composition as 'the art of arranging in a decorative manner the various elements at the painter's disposal for the expression of his feelings', stressing the importance of harmony and balance that was achieved only by working and reworking a picture to reflect an integrity of understanding way beyond the artist's first impressions. 'What I am after, above all,' he wrote, 'is expression.' Like Cézanne, Matisse believed that artistic understanding could be achieved only by copying nature, but that

the practice of copying involved a profound emotional response. As Matisse put it, 'I cannot copy nature in a servile way; I must interpret nature and submit it to the spirit of the picture. When I have found the relationship of all the tones the result must be a living harmony of tones.' In selecting colour, he relied on observation, feeling and 'the very nature of each experience', rather than on any scientific system. In this, he distinguished himself overtly from his friend Paul Signac, the most keenly intellectual of the generation of painters who followed the Impressionists. Since the late 1880s, Signac had kept an open studio on the boulevard de Clichy, where painters and writers regularly converged. In his 'Notes', Matisse referred explicitly to Signac, explaining that while Signac relied on divisionist theory for the selection of tones, Matisse's own method of selection was intuitive – his colours corresponded with his emotions. He picked an unfortunate metaphor when he tried to describe his intended effect on the viewer: he wrote that he hoped his art of balance and purity would have 'an appeasing influence, like a mental soother, something like a good armchair in which to rest from physical fatigue' – a comparison almost bound to invite misinterpretation.

That summer, Matisse began work on a new painting, seven feet high, which he called *Le Luxe*. The setting was Collioure, the figure reminiscent of the figure in Botticelli's *Birth of Venus* and the picture was constructed in horizontal bands, like the frescoes he had seen in Italy. In a second version, he emphasized the fresco effect by mixing his paints with glue. By now, his work, like Picasso's, was becoming truly experimental, pushing the boundaries of formal constraints – but Matisse had the advantage over Picasso of having been exposed to a broader range of influences, including the art of the ancient Egyptians, ancient Greeks and Peruvians, Cambodian stone carving and Algerian textiles as well as African tribal figures.

In the Bateau-Lavoir, Picasso worked on, alone in his studio night after night, though when Raymonde came home from school in the afternoon he spent time with the child. Though his own childhood

had been happy in most respects, he had been a volatile pupil. His parents had removed him from his primary school when all attempts to teach him mathematics resulted only in ear-splitting screams, audible throughout the village. It was decided he would go to a new school. He consented to this only when allowed to take his pigeon; when there, he sat quietly at his desk all day making sketches of his caged bird. With Raymonde, he may have been doing his best to put matters right. He made little drawings of the things that had captivated him as a child: human pyramids of castellers (rural athletes) he had seen at folk festivals, the human tower rising and rising until the *enxaneta*, the child at the top, was forced to jump off. He did sums in his notebooks to instruct Raymonde in mathematics; he evidently took her seriously.

The one problem was Raymonde's age. Apollinaire thought she was nine, which may have been the age Picasso and Fernande were told when they selected her. However, it soon became apparent that Raymonde was approaching adolescence. One or two drawings made by Picasso betray the difficulty: adolescence removed her from the sphere of childhood into that of potential muse, even lover; there was, perhaps, too much temptation being put in his way. Some of his most gently beautiful 'carved' figures of a young girl combing her hair may have been inspired by Raymonde. The Steins purchased these, along with other paintings of individual figures which demonstrate the extent to which Picasso's style was undergoing a radical transformation.

Perhaps, as some said, Fernande simply became bored and disenchanted with the responsibilities of motherhood. Or perhaps (as John Richardson suggests) the prospect of Raymonde's approaching adolescence in the close quarters of the Bateau-Lavoir was too much for either adoptive parent to contemplate. Whatever went wrong, by now it was becoming clear that Raymonde's days with her new parents were numbered. In July, it was decided she must return to the orphanage. Late that month, Fernande took her back to the Sisters of Mercy. At first, the orphanage refused to accept her. You wanted her, argued the Mother Superior, you take

responsibility for her. Fernande had no choice then but to take her back to the Bateau-Lavoir, but that was no solution. Eventually, with Max Jacob leading her by the hand, Raymonde returned to her former home with the nuns.

The fate of the poor, orphaned child, though undeniably sad, can hardly have been unusual for the time and place. Raymonde had already been fostered and returned to the convent once, by an elderly couple who lost interest in her when she seemed unable to learn the violin. Montmartre, in particular, was a district in which illegitimate children abounded. Many were brought up by the matriarchs of the family but, equally, the convent orphanages were always full. It is virtually impossible to imagine a growing adolescent thriving in the cramped and squalid conditions of the Bateau-Lavoir, even without such eccentric adoptive parents as Picasso and Fernande. Although Raymonde's return to the convent may seem shocking to a modern reader, the nuns would have been used to such comings and goings, and at least in the convent she would have been sure of food, shelter and a decent education. (She was by no means alone; others at around this time suffered similarly peripatetic childhoods; Coco Chanel, for one.) Once Raymonde was back in the convent, Fernande was allowed to visit her on the first Sunday of every month; a postcard signed 'Raymonde' dated 22 June 1919 suggests she remained in touch. If, by today's standards, the story is indisputably miserable, in 1907 it would have shocked few who were familiar with the make-do-and-mend ways of the community of Montmartre.

The return of Raymonde to the convent did little to improve Picasso's mood. He spent whole days back in the Trocadéro, looking at Egyptian war gods and Negro fetishes. He accumulated a large collection of postcards of semi-naked African women, from which he made figure drawings. His vision of painting as a kind of exorcism clashed uncomfortably with the purpose of art as Fernande had always understood it – as an act of homage, a tribute to the muse – but she had had as yet no opportunity to see the new work in progress. In fact, Picasso had not been working very extensively

on the large canvas itself, but the group of women he was creating had nevertheless undergone some significant changes, particularly in the later stages. Only he knew that some of the figures were evolving into grotesques. The head of one now resembled the head of an ape; the painting seemed to have begun to possess him. Then, one day, he put the huge canvas aside. He continued work on his expressive figure drawings, as if his individual figures had been liberated from the herculean work he was still not quite ready to show to prospective purchasers and friends. It stayed shut in the attic a few weeks longer, while the artist allowed himself other distractions.

3.

Motion Pictures

In Paris, by autumn 1907 everyone was going to the movies. During the previous six or seven years, technological advances had been rapid. Cinema audiences could now see historical films, chase films, even drama documentaries – the first biopics. Picasso and his friends had started going to the pictures at least once a week, on Fridays when the programmes changed, an innovation introduced that August, when Pathé began to distribute films for rent. (Until then, cinema venues had bought film priced by the metre and used the print until it wore out and was melted down to make new stock.) The cinema now vied with the circus as Picasso's all-consuming passion. Film actors were being recruited from theatres, music halls and circuses and the actors themselves becoming the main draw; people now went to see a film because of its star. Posters on Morris columns all over Paris appealed to prospective cinema audiences with glamorous photographs of the new cinema stars, many of whom had already made their names in the theatre. One of the painters in Montmartre found a way of earning a few sous as a stuntman when all the professional actors turned the job down as too dangerous. He became so successful he gave up painting, and the Bateau-Lavoir gang went to the open-air cinema in the rue de Douai to see him in *Zigoto se suicide* and *Calino cambrioleur* (*Zigoto Commits Suicide* and *Calino the Burglar*).

By now, Fernande, too, was captivated, particularly by the heady appeal of the female stars. She modelled herself on the vamps and sirens of the screen and, thanks to the steadily increasing numbers of purchasers for Picasso's work, had taken to wearing extravagant outfits and hats top-heavy with feathers which looked, someone remarked, like an aviary in the Jardin des Plantes. The cinema, for Fernande, at least, had become associated with glamour. And the

quality of films was improving all the time. More films were colour-tinted, the tinting and stencilling done by Pathé's growing workforce. Over 1,200 workers, many of them female, had found employment splicing and colouring prints, a process similar to work they would otherwise have done in the textile factories. *Le Pêcheur des perles* (1907) was one such visually spectacular rags-to-riches story enhanced by tinting and stencil colour.

That year, hundreds of permanent cinema venues sprang up all over Paris. The first, the 300-seat Omnia-Pathé, next to the Théâtre des Variétés, had opened on 15 December the previous year. On the place de Clichy, the giant Hippodrome, formerly one of the major circus arenas, debuted as a cinema, and by December 1907 the Cirque d'Hiver's programmes also included films. Already by the summer, there were at least fifty new or converted permanent cinemas throughout the city, with posters on every wall, advertising films designed to appeal to audiences of all ages, from every social class. The main attractions were often Georges Méliès' new 'longer' films (five or ten minutes in duration; sometimes more), featuring increasingly eye-catching special effects. The programmes were interspersed with lantern slide shows and live vaudeville acts. Méliès' films were formulated in *tableaux* (scenes), so the cinema audience had the same experience as the theatregoer, with an orchestra providing the sound. The actors performed before sets, the walls, skies and backdrops painted in *trompe l'oeil*. Sometimes, to complete the illusion, the title of the film would rise like a curtain. Often, at the end of a scene, the actors returned to salute the audience and thank them for their anticipated applause. Outside the city, fairground cinemas sprang up, running on electricity produced by their own generators, which were transported by train along with the performers, who set up camp in fairground spaces for three or four weeks at a time, most of them using Pathé projectors and film. In France, the year 1907 was dubbed 'the year of the cinema'.

In an abrupt volte-face, the music halls, formerly the inexpensive haunts of the working classes, now became luxury entertainment. With entry to the cinemas so cheap, the cabarets of *bas* Montmartre

increased their entry fees. Entry to the Folies Bergère was now at least three francs; the newly renovated Moulin Rouge charged upwards of four francs; the Scala and the Olympia were seven or eight. The cinemas had even taken over the programming format used by the cabarets, normally a two-hour programme every evening, with an additional matinee on Thursdays and Sundays (unlike the American nickelodeons, where screenings were from morning to midnight). The popularity of the cinema had also spread to most other 'First World' countries. In France, the *café-concerts* and music halls survived by incorporating film showings into their live programmes, advertising exclusive screenings in mass dailies such as *Le Petit Parisien*. The domain of the cinema was a world of magical phantasmagoria. A few years later, Paul Éluard would describe the flickering enchantment of the silver screen: 'Between nine o'clock and midnight, between evening and bedtime, a plethora of real images overwhelmed this world of unreality. The cinema revealed a whole new world, an imaginary version of the real, like poetry; and when it tried to imitate the old world of nature or the theatre it produced merely phantasms.'

Cinematic technology evolved fast. Gags were accentuated by frame changes; objects could be absurdly transformed before the audience's eyes. In *L'Accordéon* (1906), the instrument expanded to giant proportions before being reduced to normal size; a paper-thin image of a young man then fell to earth from between its folds. Objects in films took on a life of their own, displaying 'magical', transformative powers, in their own way as powerful as the African carvings in the Trocadéro. By 1907, techniques had developed to incorporate moving shots, close-ups, reversals and altered or transformed objects.

The image in art was being destabilized by this new medium. Unlike the spectator at the theatre or the cabaret, the camera eye could change position, altering whatever was being looked at from one moment to the next. It was this multi-perspectival view that Gertrude Stein was aiming to incorporate into her shifting, repetitive narratives; this is what she meant when she compared her

techniques in writing to those of the cinema. The movie camera transformed the act of spectatorship. Whereas in the theatre or cabaret, the act of looking was always collective, in the cinema it became a more private, individual experience. Now, too, the peep-show found its way from the brothel, or the wooden box in the corner of a café, on to the big screen. Some of Pathé's earliest erotic (peepshow) films from 1902 onwards were about painters, for example, *Le Peintre et son modèle* (1902); *Borgia s'amuse* (1902); and *Le Bain des dames de la cour* (1904). In many of them the main attraction for the audience was the theatrical sensation of the voyeur being caught in the act of watching the erotic show, thus the artist and his model made ideal subjects; and the new technology even enabled sequences composed of two shots: one of a person looking; another of what was being viewed through the keyhole.

Cinema also exposed the fundamental difficulty of photography as art. If the cinema confounded everyone by projecting the moving image from all angles and in many changing perspectives, photography also posed a major challenge to the modern artist. The fact that the image in cinema could change drew attention to a whole range of infinitely complex pictorial problems and opportunities that had come to light with the use of photography. Druet, the art dealer who had started as a photographer and also dealt in photographic reproductions, was among those championing Matisse, but photographic reproductions and photographic works of art were two different things. One evening, as usual, the Picasso gang was gathered at the home of one of their Montmartrois neighbours. Though hardly new to most of them, on this occasion the opium they were smoking seemed to have a strong effect on them all. Max Jacob fell uncharacteristically silent. Apollinaire shouted out that he was in a brothel. Maurice Princet was in tears. Picasso, in despair, announced that there was nothing left for him to live for; he had discovered photography. His stricken lament may have been merely throwaway – or perhaps it was more profound. David Hockney would later note that 'Picasso and Braque saw the flaw in photography': that the act of looking from more than one viewpoint

creates problems of time as well as space; because there is not enough time within a single photograph to perceive the space being depicted, the photograph is rendered essentially static. Picasso and his circle would discuss this problem in the months and years to come.

And Picasso had yet to uncover his new masterwork – if such it was. Though he completed it during the summer of 1907, it was autumn (once Braque was back in Paris) before he found the confidence to reveal it. Who knew what would be unveiled? As Norman Mailer later pointed out, this was a period of great turmoil for the artist, one in which he and Fernande were regularly taking opium. The drug made Picasso's mind race with extraordinary images while at the same time inhibiting his desire to paint. If the previous summer in Gosol had had a calming effect, it was because there had been no distractions, no challenges from threatening competition – and no stimulants. In Paris, he was surrounded by friends (including Max Jacob), who practised various forms of mysticism, stimulated by various substances. Impeded rather than inspired by the effects of opium, Picasso was also increasingly aware of his main competitor, Matisse. If the latter's reputation was based on his skill as a colourist, perhaps – as has often been suggested – Picasso felt under pressure to prove himself by experimenting with form. For the time being, however, Picasso continued to work on his preparatory sketches and figure studies. And the painting was not his only problem. Picasso at this point was in two minds about Fernande. He had never felt entirely secure with her, especially in Paris. When he was anxious, he became combative, then inhibited, first accusing her, then being reduced to sullen silences.

4.

Alice B. Toklas

By August 1907, Fernande was convinced it was all over between her and Picasso. On the 24th, she wrote to Gertrude Stein, who was still in Italy, 'Would you like to hear some big news? My life with Pablo is over. We are going to separate definitively next month . . . What a disappointment!' She urged Gertrude not to assume that things would work out all right in the end. Pablo had had enough, he said; he had assured Fernande she was not to blame, but he was just not cut out for the kind of life she seemed to need. She was desperate, she told Gertrude, and confiding in her because no one else was really interested in her. She was doing her best to hide her unhappiness but, in her heart, she was disgusted with Picasso. Everything was hopeless; she was in despair. However, she was already making plans for her future alone. Did Gertrude think she could help her earn some money by giving French lessons? She was looking for somewhere to live and wished Gertrude could be there to help her search; it would be so much more fun.

On 2 September, she wrote again, signing herself Fernande Belvalet (for Belle-Vallée; no longer Picasso, as before). She had spent the last few days looking for somewhere to live. The place she had found, at 5, rue Girardon, was unsuitably close to rue Ravignan, but it would do for the time being. She would be leaving the Bateau-Lavoir in two or three days, a week at the most; she would already have left had Vollard not been out of Paris: she was waiting for him to return so that Picasso could give her sufficient funds to set up on her own. (In the event, she would have only a couple of weeks to wait.) Pablo, she told Gertrude, was fine. The prospect of their separation, despite the fact that they had been happy together for three years, was apparently having no effect on him at all. In fact, she suspected he was relieved, though she assured Gertrude she had never been a

burden on him or interfered with his work. Evidently, she had fol-
lowed the wrong path. She would simply have to trust to destiny to
set her on the right one. How was Gertrude? Was the weather fine
in Italy? In Paris, it was wet and stormy . . .

In her first letter, of 24 August, Fernande had referred to some-
one called Alice: 'Tell Alice I can't write to her, I'm too sad, I'm sure
she'll excuse me . . .' Unless (as seems very unlikely) Fernande's
friend Alice Princet was in Italy with the Steins, Gertrude must
already have mentioned her new friend, Alice B. Toklas, who was
shortly to join her in Paris from her home in San Francisco. Some-
time during September, after the Steins' return from Italy, Alice duly
arrived.

Alice B. Toklas was an extraordinary character. Of Polish-Jewish
extraction, in appearance she was bony and wafer-thin, with a
craggy face and long nose, like a figure in a drawing by Aubrey
Beardsley. She had got to know Gertrude through Harriet Levy, her
neighbour in San Francisco, who had been in Paris and there met
Gertrude and Leo Stein, probably through the Michael Steins, since
Alice had seen them in San Francisco the previous year when they
visited following the 1906 earthquake. They had shown her Matisse's
portrait 'of Madame Matisse with a green line down her face' (*The
Green Line*), which had impressed her immensely.

Alice B. Toklas had been raised in California, where her prospect-
ing maternal grandfather had bought a goldmine. As a child she was
taken to Europe, including England, before returning to California,
where she attended Miss Mary West's school, until a little girl in her
class asked her if her father was a millionaire. When Alice said she
did not know, the child asked her, had they a yacht? When she heard
this, Alice's mother decided it was time to send her to another
school, where the children were not so snobbish. At home, they had
a garden full of lovely flowers, her mother being a keen gardener.
She also displayed a unique ability to be both imaginative and
precise, from which Alice clearly learned. 'I once said to her, "You
have such lovely watery periwinkle blue eyes." "You mean, dearest,
'liquid eyes'," she corrected.' Alice attended the University of

Washington and studied music with Otto Bendix, a pupil of Liszt, graduating as a Bachelor of Music. On her grandfather's death, she inherited a quarter of his estate, and the family moved to a smaller home in O'Farrell Street, San Francisco, where Harriet lived next door. It was Harriet who had proposed they go to Paris together. They made frequent plans to do so; Alice was thirty by the time they finally left, in September 1907. They travelled by steamer, Alice with a copy of Flaubert's letters to read on the journey, Harriet dutifully burdened with a friend's 'tactless choice' of *Lord Jim* – which somehow beautifully sums up the difference between the two.

Later that month, they arrived in Cherbourg, where they stayed overnight and where Alice got her first taste of France, before continuing their journey by rail to Paris. Alice was immediately struck by the difference between France and their own country. Waking in the morning, she looked out of the window to see men cleaning the streets with water from small buckets and oddly shaped brooms – more like household cleaning, she observed, than the kind of street cleaning that went on in San Francisco. From the window of the train, she watched as fields dotted with poppies, marguerites and cornflowers streamed past beneath a 'heavenly' blue sky. Arriving in Paris, they found themselves in a station 'busier and noisier than any I had ever known. People were getting off and on [trains], hurrying to the right and to the left. It took me a long time to become accustomed to French confusion.'

They put up at the Hôtel Magellan, near the place de l'Étoile, and telephoned Michael and Sarah Stein. They then crossed Paris in a fiacre (a horse-drawn carriage – another fascinating novelty) to the rue Madame, Alice observing that the streets were all different: not only did no district resemble another; each house was different in character from the next. A grand-looking dwelling stood next to a grocery, which stood next to a laundry; she remarked with interest that one could thus shop without leaving one's own *quartier*. She noted also the proliferation of fine florists and flower markets, and that everywhere she looked there seemed to be something new to see. Alice had an unusual talent for observation: wherever she went

she seemed to see things it seemed nobody else had noticed. She was also a good listener. Arriving at Michael and Sarah Stein's home, she soon established that their building in the rue Madame had been built and once occupied by the Protestant Church and that the enormous living room had been the assembly and Sunday School room. In that room, where large, light windows gave on to a garden, she first encountered Gertrude Stein.

'It was Gertrude Stein who held my complete attention . . . She was a golden brown presence,' tanned by the Tuscan sun, with golden glints in her hair. She was dressed in brown corduroy and wore a large coral brooch; when she talked or laughed her distinctive voice seemed to rise up from her brooch, 'deep, full, velvety like a great contralto's, like two voices'. Alice also noticed her unusually fine bone structure and distinctive head, which some had compared to that of a Roman emperor, others to that of 'a primitive Greek'.

Alice and Harriet were given tea, and Alice was invited to visit Gertrude Stein in the rue de Fleurus the following afternoon, when Gertrude would take her for a walk. The next morning, she and Harriet decided to lunch in one of the restaurants in the Bois de Boulogne. Foreseeing that their lunch might make her a little late, Alice thoughtfully sent Gertrude a telegram to warn her. When she arrived at 27, rue de Fleurus, delayed by just half an hour, the door was opened by Gertrude, Alice's telegram in her hand. Since the previous day, she had been transformed into a 'vengeful goddess'. She said nothing, just paced about, unsmiling, beside her long Florentine table, before finally announcing, 'Now you understand. It is over. It is not too late to go for a walk. You can look at the pictures while I change my clothes.' As Alice philosophically observed, at least while all this was going on she had a chance to have a good look around Gertrude's apartment. In the studio, the walls were covered from floor to ceiling with pictures, and the dining room was dark with heavy, ornate furniture, dominated by a large, octagonal Tuscan table with clawed feet and a double-decked Henry IV dresser decorated with three carved eagles. There were interesting ornaments, too: pieces of Italian pottery and seventeenth-century

terracotta figures of women. Once Gertrude had calmed down, she reappeared and they walked round the corner to the Jardins du Luxembourg and saw children sailing their boats on the artificial lake and nurses in long capes and starched white caps with long, broad ribbons. Alice was led through the gardens into the Petit Luxembourg, then on down the boulevard Saint Germain as Gertrude asked her which books she had read on the journey and whether the Flaubert letters had been translated into English.

The following Saturday, Alice met Leo, the next to emerge through the glow of her imaginative observation. Leo, she observed, was 'golden', a vividly economical description of Picasso's 1906 portrait of him, which she would surely have been shown. She also noticed his graceful way of walking and the elegant way he carried himself, and that the two brothers, Leo and Michael, though they resembled each other, were quite different from Gertrude, the similarity between Leo and Gertrude being more or less restricted to their brown, unstructured, bohemian-style clothing and 'Grecian' sandals.

Alice was soon initiated into the rites of the Saturday soirées and forming her inimitable impressions of the regulars, who included Germaine, Picasso's one-time lover and the cause of Casagema's suicide (though Alice seems to have been spared those details), now married to Picasso's friend Ramon Pichot. She noted Matisse's 'astonishing virility' but found him paradoxically lifeless compared with the profound sense of vitality which emanated from Amélie, whom Alice wonderfully summed up in a single gesture: 'She always placed a large black hat-pin well in the middle of the hat and the middle of the top of her head and then with a large firm gesture, down it came.' Next, she met Marie Laurencin, observing her as she made her way through the studio looking at each picture in turn, 'bringing her eye close and moving over the whole of it with her lorgnette, an inch at a time. The pictures out of reach she ignored.' Marie told Alice, 'as for myself I prefer portraits and that is of course quite natural, as I myself am a Clouet'. Alice noted that she did indeed have the thin, square build of medieval Frenchwomen in the

paintings of the French primitives. Her voice, which Fernande found so irritating, she judged high-pitched and beautifully modulated. Having scrutinized all the pictures, Marie sat down with Gertrude Stein on the couch and told her the story of her life (which was the effect Gertrude tended to have on people), explaining that her mother, despite her temperamental dislike of men, had for many years been the mistress of an important personage, the union that had produced Marie herself. As for what the *bande* thought of Alice, there never seems to have been any question of her not being accepted; she was deceptively reticent, untiringly understanding and never did anything to upset or alarm anyone. She infiltrated Gertrude's social world so deftly that no sooner had she arrived than it seemed she had always been part of it.

Gertrude filled her in on recent events concerning Picasso and Fernande. It emerged that Gertrude had been counselling not only Fernande but also Picasso, who had been telling her 'wonderful tales'. Alice was thus given both sides of the story. According to Gertrude, Picasso had told her that 'if you love a woman you give her money'. He had added that, by the same token, if you wanted to leave her, you had to wait until you had sufficient funds to finance her independence. By 14 September, he had the wherewithal, 1,100 francs for eleven pictures from Vollard, and money from a separate sale of one of his paintings of the saltimbanques, to support Fernande in the business of setting up home alone. Meanwhile, Gertrude had taken seriously Fernande's request to find her a pupil.

The day before the *vernissage* of the Salon d'Automne, despite their imminent break-up, Picasso and Fernande were invited to dinner at the Steins'. When the time came, there was no sign of them, so everyone sat down to eat. Just as they did so there came 'a loud knocking at the pavilion door'. The maid announced the arrival of Monsieur Picasso and Madame Fernande, who entered, very flustered; Alice noticed at once Picasso's 'marvellous all-seeing brilliant black eyes'. He was explaining, 'You know how as a Spaniard I would want to be on time, how I always am.' Fernande, with a characteristic gesture, one arm extended above her head, pointing her

forefinger, asked Gertrude to excuse them. The new outfit she was wearing, especially made for the next day's *vernissage*, had not been delivered on time and there had of course been nothing for it but to wait. Alice, meeting them for the first time, observed Fernande. She saw 'a large heavy woman with the sensational natural colouring of a *maquillage*, her dark eyes were narrow slits. She was an oriental odalisque,' pleased by the attention she was attracting. While they were still at dessert, the maid announced that there were other guests waiting in the studio. Gertrude hurried off to receive them. They turned out to be 'a group of Montmartrois who surrounded Picasso like the cuadrilla does a bullfighter'. Among them was Georges Braque, evidently already so at ease with the Steins that Alice initially assumed he was American. Alice, Picasso and Fernande joined them to find Gertrude already seated on her high leather Tuscan armchair, her feet on a pile of cushions. From the description of this episode, it seems evident that Braque had somehow by now already made Picasso's acquaintance, or at least Fernande's, since Fernande and Braque were fooling around together, pretending to be ignoramuses. Gertrude took the opportunity of asking Alice if she would like to take French lessons from Fernande, assuring her Fernande was well educated; she had read aloud from La Fontaine's fables while Picasso painted her (Gertrude's) portrait.

Alice B. Toklas, Fernande announced to Picasso, would be taking French lessons from her. 'Ah, the Miss Toklas,' replied Picasso, 'with small feet like a Spanish woman and earrings like a gypsy and a father who is king of Poland like the Poniatowskis, of course she will take lessons.'

The following evening, Alice arrived early at the Grand Palais for the *vernissage*. She found Picasso surrounded by his gang, all except Braque, who once again seemed to be hanging around Fernande. Recognizing Alice and her friend Harriet, Fernande wandered over and introduced them to her friends Alice Princet and Germaine Pichot. The conversation turned again to the French lessons. Alice suggested mornings, from ten until one, and

that Fernande come over to her hotel. Fernande said she would charge 'Mees Toklas' two francs fifty an hour. When Alice said that she would of course pay her taxi fares, Fernande assured her there was no need, she would take the bus or the Métro. They arranged to start the following week. The room was crowding now, filling up with visitors and painters of all nationalities – American, Hungarian, German, Russian – and the odd student from Matisse's school. Among them, 'a very small Russian girl was holding forth explaining her picture, a nude holding aloft a severed leg. It was the beginning of the Russian horrors'. These were the catastrophic events of 1905, which brought large numbers of Russian emigrés to settle in Paris, including many of the dancers soon to be associated with Diaghilev's Ballets Russes.

The 1907 Salon d'Automne opened to the public on 1 October. This year, the exhibition was more extensive than ever; it was a monumental show including retrospectives of Berthe Morisot, Jean-Baptiste Carpeaux and Paul Cézanne. According to Félix Vallotton, who reviewed the show in *La Grande Revue* on the 25th, the main draw was a gigantic work consisting of fragments of a mural for the Vich Cathedral near Barcelona by Catalan muralist José-Maria Sert. Though Vallatton had reservations – he found the finished sections somewhat unattractive and the colours a little vulgar – he praised Sert for the gesture, since 'To exhibit frescoes for a cathedral is not an everyday thing to do.' Sert was a man of grand gestures. Descended from an immensely rich Catalan family of textile manufacturers, he had been commissioned to decorate the cathedral by King Alfonso XIII of Spain. A favourite of the royal family, he was flamboyantly talented, mercurial in temperament and immensely knowledgeable. In sombrero and cape, noticeably hirsute, he dashed around Paris, endowing every drawing room he entered with the kind of charisma so appreciated by the artistic upper crust of Paris. His passions were alcohol, morphine and the art of the museums, and his work included flourishes of quotation from not only Tintoretto but Goya and Velásquez.

For Picasso and his friends, the 1907 Salon d'Automne was significant not for the audacious mural but for the retrospective exhibition of forty-eight paintings by Cézanne. At this exhibition, where Parisian audiences saw Cézanne's luminous oranges for the first time, the artists of Montmartre first understood the extent of his genius and experienced what it felt like to be in the presence of his vivid colours. The objects seemed so alive on his canvases that their textures seemed to invite the viewer to touch them. To coincide with the exhibition, in October, *Le Mercure de France* published extracts from Cézanne's correspondence with Émile Bernard, a painter and friend of van Gogh and Gauguin who had lived for a while, as had van Gogh, at 10, rue Cortot. (It was there that Renoir painted the local girls in the garden; it is now the Musée de Montmartre.) Bernard had first noticed Cézanne's work in the cramped, dingy shop where Père Tanguy, friend to Cézanne, van Gogh and the Impressionists before him, had sold artists' materials and a few paintings before the turn of the century, sharing a smoke with them in the back room and taking their work off their hands for the price of a few tubes of paint. After discovering his work, Bernard visited Cézanne in 1904, and stayed with him for a month (publishing an article on his work in *L'Occident* that year), after which they exchanged letters (which appeared in *Le Mercure de France* in October 1907). The posthumous publication of these letters constituted the first public insight into Cézanne's thinking about art and created the first opportunity for painters of the younger generation to view his paintings in the light of his reflections. For the next few weeks – months – everyone was talking about Cézanne.

Cézanne's letters to Émile Bernard include the famous advice that there is no line in nature: 'In an orange, an apple, a ball, a head, there is a culminating point and this point is always – despite the tremendous effect of light and shade and sensation of colour – the closest to our eye.' Cézanne saw no separation between drawing and colour, since for him the process of harmonizing colour established form. ('*Quand la couleur est à sa richesse, la forme est à sa*

plenitude.') To explain this more graphically, he added that the painter should 'see in nature the cylinder, the sphere, the cone, putting everything in proper perspective, so that each side of an object or a plane is directed toward a central point'.

In fact, there are no visible cylinders or cones in Cézanne's work; no parallel or perpendicular lines – line being, for Cézanne, effectively the place where colour planes converge. His advice to Bernard was mainly that of a master to a new student, an attempt, perhaps, to find a way of simplifying or finding metaphors for things he himself understood without needing to analyse them. As he remarked to his son, Paul, it was easy to develop theories with Bernard, given his logician's temperament. The poet Rainer Maria Rilke, back in Paris working on his monograph on Rodin, wrote to his wife, sculptor Clara Westhoff, throughout that October about the impact on him personally of this intensity of Cézanne's work, in which things seemed more real even than in reality. In the room of the artist's works at the Salon d'Automne, he marvelled at his 'dense quilted blue', 'shadowless green' and the intense, reddish black of his wine bottles; 'the apples are all cooking apples and the wine bottles belong in the roundly bulging pockets of an old coat'.

As did many artists, Rilke returned to the Grand Palais several times, always making straight for the Cézanne room. He reflected deeply on the artist's working methods, remarking that he had painted throughout the last thirty years of his life in a state of constant rage in the attempt to achieve *'la réalisation'*, as he called it. After studying landscape painting in the open air at Pissarro's side, Cézanne had recognized what he wanted to achieve in the works of the Venetians whose paintings he had seen and admired many times in the Louvre. For his wife's benefit, Rilke described Cézanne's passionate will to achieve in painting: 'the conviction and substantiality of things, a reality intensified and potentiated to the point of indestructibility by his experience of the object'; this was arrived at only as the result of a rigorous ongoing interior dialogue. As Rilke understood it, Cézanne approached the object he was studying with complex circumspection, first describing the

darkest tones then covering those deep notes with a layer of colour and continuing until he established a contrasting element. Then he would begin again, continuing in the same way. He sensed a conflict within Cézanne between his perception and the struggle to make use of what he perceived; and that for him the process of painting involved a perpetual inner dialogue, which he spent a lifetime struggling to endure. During the last years of his life, Cézanne's reputation had been steadily growing in Paris. He still kept his studio in the Villa des Arts and he was flattered that young painters had begun to admire his work, but he had no time for celebrity, preferring to return continually to Provence, where the motif that now most occupied him, the Mont Sainte Victoire, rose up before him, presenting a multitude of challenges. Cézanne remained humble in the face of his own work. As Rilke wrote, 'it's natural, after all, to love each of these things as one makes it: but if one shows this, one makes it less well; one *judges* it instead of *saying* it'. Here, he put his finger on the paradoxical quest for impersonality on which the painters and poets of the early twentieth century, each in their different way, had begun. No serious painter who attended it was unaffected by the 1907 Cézanne exhibition; Picasso was no exception. Cézanne, he told the photographer Brassaï in later years, 'was my one and only master! Don't you think I've looked at his paintings? I spent years studying them. Cézanne! He was like the father of us all.'

Georges Braque went to the Salon d'Automne in 1907 to see Cézanne's work, rather than his own, which this year was not being shown. Following his success the previous year, he had submitted eight works to the Committee, which still included among its members Matisse. It rejected all but one. Salon rules would have allowed Braque to re-submit two, but instead he withdrew all eight in disgust. Apollinaire went to visit him shortly after this rejection in his lodgings in the rue d'Orsel, where he found him reading sixteenth-century polygraphs and smoking his pipe, trying to forget his disappointment. Though Braque had a low opinion of the art criticism Apollinaire had begun to publish, he respected him as a

poet, acknowledging also that from now on, 'The poets of that time were our best disseminators.' In their own medium, poets such as Apollinaire, Max Jacob and, soon afterwards, Pierre Reverdy, would soon be producing concrete poetry based on contingency and juxta-position, moving away from the Symbolist techniques of comparison and abstraction and bearing out the new maxim: No ideas but in things.

The emphasis in both poetry and painting was now on making, rather than mimesis. Modern poetry insisted on its own reality as a construction, artefact or art object instead of merely reflecting, illustrating or copying the 'real' world. Like the painters, the poets were searching for ways to express the inner structure of things. When, some years later, bookseller Adrienne Monnier (business partner of Sylvia Beach, who ran Shakespeare and Co. and in 1922 published James Joyce's *Ulysses*) described cubism as the search for 'a new classicism based upon inner constraint – no development – the emotion caught at its source', she was acknowledging the impulse in art that emerged during the first decade of the century, which began in poetry, with Apollinaire and Marie Laurencin, among others; in prose with Gertrude Stein; and in painting with Picasso, Braque and Matisse. As Reverdy was to put it later, what mattered in art were not illustrations or reflections but rapports.

Early in 1907, the year Braque met Picasso, Braque's paintings still showed the influences of van Gogh and Matisse: paintings such as *Le Golfe des lecques* (1907), its vivid dash of red reminiscent of van Gogh's *Self-portrait in a Landscape*; and *Femme nue assise* (also 1907), in which a green line connects the female figure, one hand raised to her hair, down through the background to the shadow at her feet. But the landscapes Braque brought back from L'Estaque that autumn were different. They seemed to be variations on landscape compositions – geometric improvisations, or riffs. From now on, his work continued to develop in drastically new directions as he began to turn his back on the influence of Matisse and the Fauves. Never-theless, the work Matisse produced in 1907, the towering *Le Luxe* and his dynamic, rhythmical painted sketch *La Musique (Esquisse)*,

confirmed that he was still the acknowledged leader of the avant-garde. The Steins purchased both *Le Luxe* and *La Musique (Esquisse)*. They displayed the latter at 27, rue de Fleurus, where it quickly attracted the attention of Sergei Shchukin.

One surprise exhibitor at the 1907 Salon d'Automne was Modigliani. He showed five watercolours and two paintings, both portraits, one of a friend (Ludwig Meidner), the other of a hauntingly beautiful woman, Maud Abrantes, with fine high cheekbones and deep-set eyes. Though his work went unremarked, he triumphantly wrote home to tell his mother, Eugenia, of his success in Paris. He, too, explored the works of Cézanne, and read and absorbed the letters in *Le Mercure de France*. To his collection of photographs of paintings, which he pinned to his wall or carried around in his pockets, he added one of Cézanne's paintings in the exhibition (lent by Vollard, who had purchased it in 1900), *Boy in the Red Vest* (or *Boy in a Red Waistcoat*; 1888–90).

The catalogue listed Modigliani's address as 7, place Jean-Baptiste Clément, where the artist had lately discovered an old shed made of swollen wood and crumbling brick, no less dilapidated than his old shack in the Maquis but with a small garden plot which had a view across the square and down the rue Ravignan, opening on a vista of Paris which stretched as far as the hillside of Meudon. Still intermittently homeless despite this discovery, Modigliani had been seen sleeping rough on a bench in the waiting room of the Gare Saint-Lazare. When he did find lodgings, he moved so often between them during these early years that no one could keep track of his address (so the addresses he gave galleries or dealers did not always tally with where he was actually living). André Salmon provides an itinerary; by his account, Modigliani lived first on the edge of the Maquis in the rue Lepic, then in the rue Norvins, then in the place Jean-Baptiste Clément. Utrillo's only other friend, André Utter, a blond, blue-eyed electrician and self-taught painter, helped him find this last. During the next year or so, Modigliani and Utter became close friends, and they and Utrillo were close companions until 1909, when Utter fell in love with Utrillo's mother, Suzanne Valadon (who was twenty-one

years his senior). When her husband retreated, Utter moved with Suzanne and Utrillo to a studio at the foot of the Butte, where their turbulent existence attracted the attention of the neighbours, regularly alerted by the sounds of screams and breaking glass – the locals called them *La trinité maudite*. From 1908 onwards, Modigliani's only addresses in Montmartre appear to have been in the rue Delta (where he never actually lived) and an abandoned convent in the rue de Douai; he also lodged for a while on the Left Bank in the Rotonde, an old pavilion with caryatids at the entrance on the plaine Vaugirard left undemolished after the World Fair, and converted now into sordid, unsanitary artists' dwellings. He still occasionally slept on the floor of someone's studio in the Bateau-Lavoir, which he sometimes gave as his address. He remained the outsider, although in his own way he was concerned with the same formal challenges and problems as Picasso's *bande*, most of whom – despite them keeping him at arm's length – continued to notice his comings and goings.

The following year, Modigliani was befriended by Dr Paul Alexandre, a young dermatologist native to Paris, who was then twenty-seven, loved Montmartre and had rented a large, near-derelict house at the foot of the Butte, behind the Moulin Rouge. It was set in a courtyard behind a wall plastered with peeling posters, at number 7, rue Delta. There, Alexandre created a colony of artists, who spent their time making life studies modelled by the local seamstresses, staging theatricals, or playing cards bent over flimsy tables (the rickety leg of one propped up by an old spoon) like Cézanne's card players. On the walls of the ground-floor room that functioned as a gallery, Modigliani displayed his work.

A frequent visitor to the Delta was Romanian sculptor Brâncuşi, who had been in Paris since July 1904. His ambition was to create huge sculptures which would stand in the open air. He wanted to create a sense of artistic totality in space, the first inspiration for Modigliani's own dream of producing large sculptures to be exhibited outside. The elongated stone figures he had been carving now metamorphosed in his imagination into a vision of life-size caryatids that would stand at the entrance of a great Temple to

Humanity, its weight borne by his 'columns of tenderness'. Though Modigliani never actually lived at the Delta, finding a room for rent in a disused convent in the nearby rue de Douai, Dr Alexandre put a studio at his disposal, where he worked intermittently for the next six or seven months.

In the evenings, Paul Alexandre and Modigliani also went to the circus, where the latter sketched the circus performers and harlequins, or to the Gaîté-Rochechouart theatre at 15, boulevard de Rochechouart, where he made line drawings from the auditorium. They sometimes had seats in the dress circle, so that he could draw the actors and actresses from above. Alexandre thought that the attraction of the theatre for Modigliani lay in its blend of reality and dream, since, with footlights still in use, stage lighting at that time, with its intense colours and strangely placed sources, was so unnatural that, to an artistic eye, it could seem dreamlike. In the Gaîté-Rochechouart, there were mirrors on the side walls, so from some seats the image of Miss Lawler, star of the Gaîté, was multiplied into a whole succession of small Miss Lawlers, each in the slender, ultra-modern dress that showed off her ankles and high heels. The stage itself was 'a brilliant rectangle at the end of a long dark corridor with its four walls blazing with colourful humanity'. Alexandre's description imagines the stage almost as a vehicle of projection, with rapidly changing perspectives, fluctuations between surface and depth, and the breaking surfaces that Picasso was already concerning himself with in his work. The spectacle of moving images seemed to be everywhere – as if the cinema had disrupted all the old ways of seeing. Modigliani took Alexandre to the Egyptian Galleries and ethnographic section of the Louvre, and to the fusty old Trocadéro, where they saw the row upon row of figures, masks and carvings that had made such a deep impression on Picasso. Though the sculptures from the Baoulé state (in what is now the Ivory Coast) were to show their influence on his work only two or three years later in his drawings and sculptures of caryatids, the African art Modigliani saw as early as 1908 impressed him as profoundly as had the works of the Italian primitive painters; the

elongated faces of the African statues reminded him of the early Italian works he had seen in Florence, Venice and Rome. 'What I am searching for,' he wrote in one of his sketchbooks, 'is neither the real nor the unreal, but the Subconscious, the mystery of what is Instinctive in the human Race'. The new goal for the modern artist was to find ways of expressing the interior life. In their own way, Picasso and Matisse, Derain and Vlaminck, Diaghilev and Poiret, Marie Laurencin and Gertrude Stein were all by now engaged in this quest.

5.

The French Lessons

A week after meeting everyone at the *vernissage* of the 1907 Salon d'Automne, Alice B. Toklas was given a lightning introductory tour of the Louvre by Michael Stein, who, during lunch one day at the rue Madame, declared it scandalous that she had not yet found time to go there; she had already been in Paris several days. As soon as lunch was over he walked her down to the Seine, across the bridge and into the Louvre, where she found herself abruptly before the *Victory of Samothrace*. She was then rushed up the stairs to the Salle Carré: 'It was a gorgeous surprise but only a moment was allowed me before Giorgione's *La Fête champêtre*. Down the long gallery I was rushed. So that you may know where to find things, explained Mike as we hurried past miles of pictures.'

Next, she was received by Fernande in her new studio apartment at 5, rue Girardon, which she had already furnished with a very large bed, a small tea table and a piano. With her again were her two friends Alice Princet and Germaine Pichot (wife of Ramon Pichot, one of the Catalan gang who had visited the World Fair with Picasso back in 1900). Alice B. Toklas now learned that Germaine was the wife of a Spanish painter and the lover of a circus performer. A Montmartroise born and bred, she had many sisters, each of whom had different fathers and were now married to men of different nationalities. As for Alice Princet, according to Fernande, she was the daughter of a workman, which explained the coarseness of her thumbs. Alice B. Toklas noted in her namesake 'a certain wild quality that perhaps had to do with her brutal-looking thumbs and was curiously in accord with her madonna face'.

The extent of this wildness was revealed, either on this occasion or soon afterwards. Married on 30 March 1907 to Princet, after years of being his lover, she had just that autumn been introduced to

Derain, an encounter that had brought to a dramatic end her brief marriage. The meeting with Derain had been love at first sight, a *coup de foudre*. When Princet, normally a mild-mannered man, discovered the deception he tore up the fur coat Alice had bought to celebrate her marriage: 'That settled the matter.' She left Princet, never to return. That October, she and Derain set up home together at 22, rue Tourlaque, at the top of the Butte, near the Château des Brouillards and the police station, the latter, in Derain's opinion, lending the address a certain cachet. (Alice and Princet were divorced on 26 February 1910; she and Derain finally married on 10 July 1926.) Vlaminck supported Derain, going up to visit him in his new apartment, where the more respectable clients of the Rat Mort, a café-restaurant at the foot of the Butte, came up the hill to offer their services as sitters. As for Princet, he took to spending much of his time with Picasso in the Bateau-Lavoir; for a while, he was there every day.

The French lessons took place not, as initially proposed, at Alice's hotel but at 27, rue de Fleurus (Gertrude paid Fernande's taxi fares). Fernande would arrive at the rue de Fleurus promptly at ten o' clock, and she and Alice B. Toklas would begin: 'Of course to have a lesson in French one has to converse and Fernande had three subjects, hats, we had not much more to say about hats, perfume, we had something to say about perfumes.' By now, Fernande was known throughout Montmartre for her passion for perfume. She had loved it when people said they could tell Picasso was not far away because the air was full of Madame Picasso's perfume. Everyone knew the story of the bottle of 'Smoke' for which she had paid eighty francs, which had no scent at all despite its glorious colour, 'like real bottled liquid smoke'. Her third subject of conversation was the categories of furs. She instructed Alice in all three: 'first category sables, second category ermine and chinchilla, third category martin fox and squirrel. It was the most surprising thing I had heard in Paris.' Their only other dialogue concerned descriptions and names of dogs then fashionable in Paris. The subject was here passed to Alice to initiate. She first had to describe a dog then, after

some hesitation, Fernande would guess the breed. It was all becoming a little monotonous, until Alice suggested meeting for tea or going for strolls around Montmartre, which improved things somewhat. They attracted attention as they took their turn around the square, Alice dressed like a Spaniard, all in black but for the flowers in her hat, Fernande in her draped, sack-like dress (inspired, perhaps, by Poiret) and broad-brimmed hat, trimmed with a jaunty dash of muslin. There, you see, Fernande would confirm, smiling radiantly, 'our hats are a success'.

Fernande confided her opinions of her other friends and acquaintances, including Marie Laurencin, whom she said was peculiar, nasty, made strange noises and irritated Picasso. She told Alice about van Dongen, who (she claimed) had made his name with his portrait of her; about the circus people and all the past and present inhabitants of Montmartre. She also discussed her 'one ideal', Evelyn Thaw (née Nesbit), the popular American chorus girl turned silent-movie actress, and heroine of the moment. According to Alice, 'Fernande adored her in the way a later generation adored Mary Pickford, she was so blonde, so pale, so nothing,' though she reduced Fernande to sighs of admiration – which suggests that Alice, though she knew Evelyn's story was in all the newspapers, had not seen Siegmund Lubin's 1907 film *The Unwritten Law* (subtitled 'A Thrilling Drama Based on the Thaw White Tragedy'). This early documentary film was the talk of Paris, based on the dramatic murder the previous year (on 25 June, while Fernande and Picasso were in Gosol) of Evelyn's devoted benefactor, eminent architect Stanford White, shot dead in Madison Square Garden Theatre by her millionaire playboy husband, Harry Thaw.

Though she appeared blonde in black and white photographs and in the film, Evelyn Thaw was actually, like Fernande, a striking redhead. Far from being 'nothing', Evelyn had worked her way out of poverty by becoming a photographic model and showgirl. She was adored and revered by her fans, a celebrity in her native America as well as in France. On the streets outside the courtroom where she testified to Harry Thaw's innocence, a crowd estimated at ten

thousand gathered to catch a glimpse of her. The case had hinged on whether or not, at the moment Thaw shot White in the head, Thaw would be judged to have been insane. In the courtroom, Evelyn, dressed like a schoolgirl in demure navy-blue suit and white blouse, had coolly recounted tales of sexual degradation at the hand of Stanford White, stories she was alleged to have told Harry Thaw, making him fatally jealous and determined to have his revenge. The newspapers in June 1906 had run headlines such as 'THAW MURDERS STANFORD WHITE'; '"You've Ruined My Life," He Cries and Fires'. There was some confusion as to whether he had actually said 'You've Ruined My Life' or 'You've Ruined My Wife'.

Fernande was smitten. If, in the witness box, Evelyn was intelligent, wily and quietly powerful, as a screen idol she was provocative. Her performance eventually secured Thaw's release, though he was later revealed to be a dangerous psychopath. Throughout the trial, the attention was all on Evelyn. On both sides of the Atlantic, her story had been the talk of 1906; in 1907, audiences watched it all over again on the cinema screen. Visually, she was riveting. Even the journalists were swooning. The *Evening World*'s reporter declared her 'the most exquisitely lovely human being I ever looked at', with enormous eyes like pansies and a mouth like crumpled rose petals. Evelyn had it all. Columnist Ada Patterson described her performance on the witness stand: Evelyn was like a little schoolgirl on speech day, helpless as a child. And, as the *Evening World*'s Irvin S. Cobb assured his readers, she was not merely acting a part: 'She could never have counterfeited it' – her vibrant, red lips trembling, her eyes mutely crying for mercy, her voice shaking with childlike emotion – 'The best emotional actress in America couldn't have done it as well.' Evelyn had become a star of the silent screen simply by playing herself.

Fernande could hardly have picked a more apposite role model. She may have admired Evelyn's beauty, her talent, her shrewdness – or all three; or she may simply have admired her celebrity, even before the Thaw–White case burst upon the world, as a photographic model and variety star. A photograph of Fernande taken in

a photographer's studio shows her lying back against a cushion, one breast exposed, her arms full of roses; had she, too, had ambitions to be a photographic model? Or perhaps she just admired Evelyn's success in securing a husband who (never mind his psychopathic tendencies) was a glamorous millionaire. Most likely, Evelyn impressed her from every point of view, not least for her ability to make herself the centre of attention. The comparison with Evelyn Thaw reveals much about Fernande, in particular her sense of self-dramatization and her strong self-image.

On 8 October, Fernande had written to Gertrude to confirm that Alice had paid her for the first week; the French lessons were under way, and going fine. In the same letter, despite this display of independence, she confided to Gertrude that she was very upset, and thinking about Picasso a lot. She hardly saw him and was making no attempt to do so; she was fully occupied looking for more work. She was also trying to harden herself so that silly reminders of their life together did not tempt her to return to him. She was with Alice more or less constantly, and they were almost always out, so if Gertrude wished to visit her she should let her know in advance, so that she could arrange to be at home. Gertrude had evidently congratulated her on her talents as a painter, since, in a postscript to her letter, Fernande modestly protested that she had overdone her praise.

Soon the French lessons were taking place three times a week. They spent the rest of their time going to exhibitions, or in Fernande's apartment, where they were usually in the company of Alice Princet and Germaine Pichot. Alice B. Toklas once suggested inviting them all back to her hotel for tea, but Fernande explained that Alice Princet's conversation would be too frank for Toklas's friend Harriet. The truth, as Alice B. Toklas soon deduced, was that Fernande was not an easy companion. She was jealous of other women, envious of their beauty and their ability to attract male attention. 'But she went into ecstasies over Evelyn Thaw . . .'

After a while, Alice and Harriet began to hanker after an apartment of their own. Harriet thought it should probably be furnished. Alice

consulted *Le Figaro* and found a discreet advertisement that a Count de C had a floor for rent suitable for two people in his home in the rue de la Faisanderie. When she arrived, the door was opened by a butler, who led her into a room full of eighteenth-century furniture, fine hothouse flowers and a piano. The apartment had three rooms and a bath, and two of the bedrooms faced on to a courtyard, where she saw a coachman cleaning an open carriage; there was even a telephone. After asking what she was paying for her hotel, Monsieur de Courcy said he would charge one third less. Food of gourmet standard would be provided, since he and his mother employed an excellent cook and there were good markets in the district. She and Harriet moved in without delay. On their first day, they were given lunch at a table laid with heavy silver and cut glass. The food was indeed exceptional – shellfish salad and a wild-strawberry ice, with a delicious white wine from the property of the Count's friends in the Loire. In the reception room, they were served coffee while Monsieur de Courcy entertained them with some Chopin studies, proving himself an accomplished, expressive player. They were then invited to accompany him that evening to the Folies Bergère.

They rested after lunch, before going out to do some window-shopping, returning in time to dress for the evening's entertainment. 'The performance at the Folies Bergère was elaborately staged and what was not understood was happily not understood.' It was evidently understood by Gertrude Stein, however, who had been sent the news of their fortunate new situation. A few days later, she arrived for lunch and put an abrupt end to their life in de Courcy's apartment. She had established that his mother was absent from her own home, explicable only if she knew nothing of the arrival of her new lodgers, and peremptorily advised Alice and Harriet to leave before they encountered any further complications. A hotel near the rue de Fleurus would naturally be the most expedient solution: '"Find a hotel in our quarter at once and move over," she said.' This time, if there was a problem, Alice was to send her a telegram. She recommended the Hôtel de l'Univers on

the boulevard Saint Michel, perfectly situated for Alice to walk across the Jardins du Luxembourg to the rue de Fleurus, thus convenient for them to take walks together, and half the price of the Hôtel Magellan. They had hardly finished packing before she arrived, bearing gifts: chocolates for Alice and a little bouquet for Harriet.

Away from Picasso, Fernande found herself thinking about his work. Perhaps, she reflected, this continual struggle of his was actually a rebellion against his deepest inclinations. Among his portraits of Fernande, there was one that particularly appealed to her, a classical study, quite different from his recent work. Looking at this, she began to wonder whether it was not simply inhibition that made him dissatisfied with the kind of art on which he was turning his back, since she was convinced it was really closest to his heart. Perhaps it was a kind of desperation that compelled him to develop his work in ways others would approve and admire. Or maybe he was in some way in revolt against himself, and that was why he needed to make dramatic changes that seemed to some as if he had begun to go too far. It was clear that he was determined to find a way of expressing something no one had expressed before. Whatever it was that had brought him to such a decisive turning point, Fernande had tried and failed to fathom it. He was already deeply embroiled in a new quest, which she suspected he would ultimately need to continue without her. For the time being, they remained apart, though she was invited back to the Bateau-Lavoir when Picasso finally unveiled his mysterious canvas.

6.

The Demoiselles *Unveiled*

The day finally came when Picasso was ready to reveal the painting that came to be called *Les Demoiselles d'Avignon*. He uncovered it first to Fénéon, then Uhde, Kahnweiler and Shchukin, before showing it to Fernande, Braque and Apollinaire. Fénéon's reaction did not bode well: 'You ought to do caricatures,' he suggested. ('And yet Fénéon was quite somebody,' mused Picasso later.) As far as Kahnweiler was concerned, the painting was unfinished. Shchukin kept his opinion to himself, confiding only in Gertrude Stein: 'What a loss for French art.' Braque afterwards described seeing it as his first encounter of any consequence with Picasso:

> My true meeting with him was in his studio, in the Bateau-Lavoir, in front of *Les Demoiselles d'Avignon*. I was with Apollinaire. There at once I knew the artist and the man, the adventurer, in the work he set down in spite of everything, as it seemed. People have talked about provocation. For my part, I found in it an unswerving determination, an extraordinary yearning for freedom asserted with a daring, one might almost say a calm fieriness, already sure of itself . . . But Picasso was very anxious, watching for my reaction.

At first, Braque was silent. Then, without revealing his true reflections, he said, 'It's as if you wanted to make us eat tow [hemp] or drink kerosene . . .' (In other words, who do you expect your viewers to be, circus performers and fire-eaters?) Next to see it was Derain. He drily predicted that Picasso would probably be found hanged behind his own canvas. By any standards, the painting was shocking. A group of five nude women stared out at the viewer, looming larger than life, all nearly seven feet tall, like a startling cinematic close-up – almost as disconcerting, perhaps, as that train

in the first film Parisian audiences ever saw, which had seemed about to come roaring out of the screen into the auditorium. The gigantic figures were outrageously, disconcertingly present, pressing to the surface of the picture plane, arrested in the moment as if placed on pause for a mere second, if at all. The scene was obviously a brothel. (But of course it was a brothel painting, Picasso told Braque, where else would you expect to find a group of naked women?) He was calling it *El Bordel*. Years later, André Salmon renamed it *Les Demoiselles d'Avignon*, after a bar in the Carrer d'Avinyó in Barcelona which (for no good reason) he claimed was a bordello. In the meantime, he, Max Jacob and Apollinaire nicknamed the painting *Le Bordel philosophique* (presumed to be their nod to the Marquis de Sade).

The disturbing nature of the work had to do not only with the size and attitude of the women: the flesh colours were disconcerting, rendering them starkly naked rather than acceptably nude. Unlike some of the earlier studies for the work, the final painting had a radically flattened perspective. Even the way the women were grouped was startling; there seemed to be no connection between them; each was engaged only with the viewer. They were clearly prostitutes – real prostitutes in the here and now, not artfully depicted courtesans distanced by their position within the frame with discreetly averted expressions or strategically placed drapery. Here, the drapery, such as it was, did nothing to subdue the overt sexuality of the figures; these were not only whores, but whores with attitude.

Though their impact was shockingly fleshy, they also had a carved appearance, like Picasso's individual figure drawings, but they lacked the exuberance and vitality of the Fauvist-style coloured figures that animate the sketchbooks he filled while he worked on the initial stages of the painting. Individually, the outsized figures on canvas were equally disconcerting. The head of one standing figure was mask-like, like the head of an African or Iberian carving. Another masked figure squatted, legs splayed, to face the viewer. The gazes of at least two of the three others were so rivetingly expressionless – fixed in time – that the feeling of being watched by

them seemed literally momentous, as if at any moment the expression of any one of the staring women might change. The sense of being locked by them into the moment, or frozen in time, only added to the bewildering impact of the work. The overall effect was of a moving image only momentarily stilled. 'For me the role of painting,' Picasso once said, 'is not to depict movement, to show reality in movement. Its role, for me, is rather to halt movement. You must go further than movement in order to halt an image.' The difficulty for the viewer was how to look at the picture. If you let the eye move across the frame from left to right, as in a conventional painting, you moved from naked, staring faces to masked ones. Looked at that way, there seemed to be no connection between the masked and the unmasked figures – no story. But, of course, that was not the intention: the impact was in the juxtaposition, and in the shock of the present moment there was no story, just the shock of confrontation.

The painting had undergone major changes during the six or so months of its gestation. In the sketch Picasso had begun with, there were seven figures: five women accompanied by a man standing to the left of the picture, drawing back the curtain, and, seated at the centre of the group, a sailor. (Was that figure included as Picasso's irreverent nod to Matisse, and the sailor portraits he had painted in Collioure the previous summer?) In May, Picasso removed the standing man on the left, giving the curtain to one of the female figures, so that the women were effectively now unveiling themselves. Only in June did he remove the sailor seated at the centre. In his fourteenth notebook of sketches, he had reworked the composition, changing the rhythms, turning up the feeling of aggression across the picture and adding a mask to the faces of one of the standing women and the squatting girl in the foreground. The juxtaposition of masked with unmasked figures gave the impression of a painting in two halves. This may have been (as Mailer suggests) one reason why Picasso struggled to complete it, since he seems to have changed his mind halfway through and never worked out how to reconcile the two halves. The depictions of the figures are

completely different in each. Perhaps, however, he had set out to extend the 'splitting' of the face first seen in Cézanne's portrait of his wife to the treatment of a group of figures. Also in the final stages, Picasso changed the colour scheme, introducing predominantly pink and flesh tones with blue and white negative spaces, and disrupted the surface of the picture so that the relationship between figures and space became chaotic, splintered, as if the women were at the point of bursting through the painted surface.

Now, all five women turned to face the spectator in an arrested moment, the surface of the picture about to be – as it were – 'unpeeled' by the one on the left; the way the figures are smashed into the background drapery suggests they have just emerged or are about to emerge through a screen. The whole way in which a painting (and, perhaps, a woman) could be viewed seemed to have been subjected to a radical new interpretation. It's as if Picasso is making the viewer look differently: he challenges the viewer's traditional assumptions so that the elements of time, the relationship between surface and depth and the function of perspective collapse into kaleidoscopic chaos as the picture seems about to fold back in on itself. Even the traditional painterly prop, the bowl of fruit, normally introduced to establish both perspective and a link to nature and so make the picture more 'real', was transformed. Pieces of fruit, unconfined by a container of any kind, are placed not on a table but at the women's feet – or perhaps just floating in space. Reduced to impossibly minuscule proportions in the foreground, they render the only remaining vestige of traditional composition in the painting absurd; each piece is shrunk from life-size in a dreadful conjuring trick, perhaps an instant earlier, like an absurdly transformed object in one of Méliès' *féerie* films. Nothing in Picasso's sketches gave an obvious indication of this degree of pictorial anarchy in the finished painting. Though the masks appear in a sketchbook, no preparatory drawing of the overall group reflects the stylistic disjunction between the three fleshy figures on the left and the two masked figures on the right. When he was asked later why the picture appeared to be in two 'halves', Picasso shrugged off

the question, saying he had changed his mind halfway through but decided to leave it as it was, assuming everyone would understand what he meant. No one did.

The cryptic reactions of Braque and Derain aside, everyone who saw the painting that winter seemed lost for words – except Matisse. The painting struck him as a blatant mockery of all he had been striving for years to achieve; he made no secret of the fact that he saw it as a personal attack. Perhaps that was true. *La Joie de vivre*, his large Arcadian depiction of a group of female figures revelling in the freedom of their nudity, may have acted as an initial provocation. The next thing everyone wanted to know was: who were the women? Fernande, replied Picasso, was clearly back centre; two of the others were Marie Laurencin and Max Jacob's grandmother. The artist was joking, of course: *Les Demoiselles d'Avignon* had nothing to do with painting likenesses. It was an exploration of exaggeration and distortion and an experiment with visual rapports. (Indeed, one of Picasso's sketches of the top of Fernande's bowed head bears a passing resemblance to the masked face of one of the figures.) What, then, did this curious work amount to? Was it a cinema still in oils? A cynical urban Arcadia set in a seedy cabaret, Picasso's anarchic retort to Matisse's Arcadian ideals? An opium-fuelled muddle? A flawed masterpiece? A masterpiece? There was no name for this kind of painting; nothing like it had ever been seen before. Gertrude Stein had already perceived that it was no longer possible for a painter to say that he painted the world as he saw it, since 'he cannot look at the world any more, it has been photographed too much' – photographed, and now filmed, in mesmerizing, sequential images that could be slowed down, speeded up or arrested, subjected to unpredictable, instantaneous transformations before the viewer's eyes. Perhaps Picasso's aim in *Les Demoiselles d'Avignon* was to stun the viewer into experiencing the present moment, just for an instant, before the scene changed. Perhaps that was the point: perhaps Picasso's nude figure group was neither an enduring image nor the illusion of reality but (merely) a projection. As Picasso himself remarked half a century later, 'You have to give

whoever is looking at it the means of painting the nude himself with his eyes.'

Perhaps it *was* a masterpiece. As Gertrude Stein wrote some decades later in 'What are Master-pieces . . .?', 'Everything is against them. Everything that makes life go on makes identity . . . But what can a master-piece be about?' Mostly, 'it is about identity and all it does and in being so it must not have any'. Picasso had evidently succeeded in producing a dispassionate, disinterested work. His problem now was that, having collapsed the elements of time and proportion and destroyed the traditional rapport between surface and depth, for the time being there seemed nothing left for him to do. And he had shut himself away for too long. On emerging, he discovered that the dealers were still wary of his work, his friends no longer understood him; his relationship with Fernande seemed to have disintegrated. Stein, still on the subject of masterpieces: 'It is very interesting that no one is content with being a man and boy but he must also be a son and a father and the fact that they all die has something to do with time but it has nothing to do with a masterpiece.' Picasso put the canvas away again. It would remain out of sight for another sixteen years.

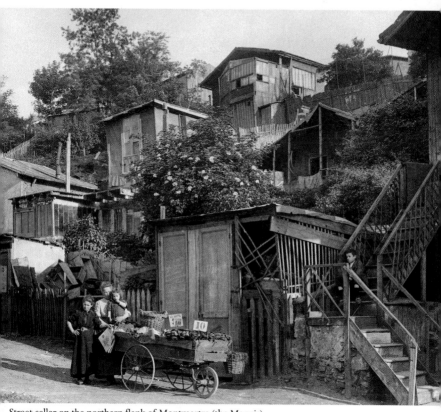

Street-seller on the northern flank of Montmartre (the Maquis)

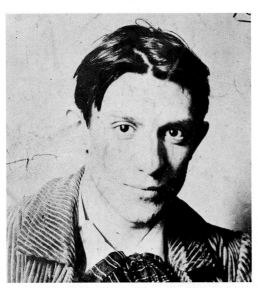

Pablo Picasso, 1904

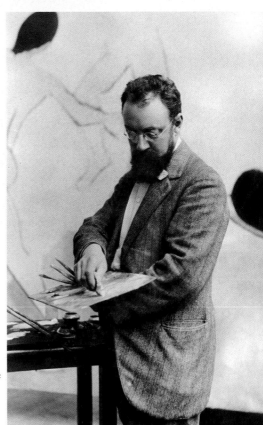

Henri Matisse

Gertrude Stein and
Alice B. Toklas

Gertrude Stein and her portrait by Picasso

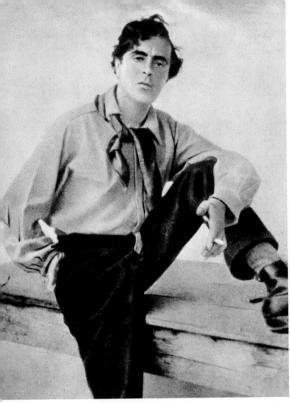

Amedeo Modigliani

Paul Poiret

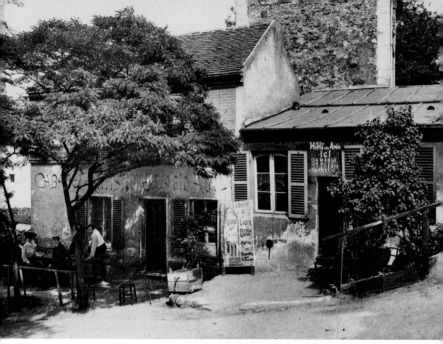

The Lapin Agile – Frédé's *cabaret artistique*

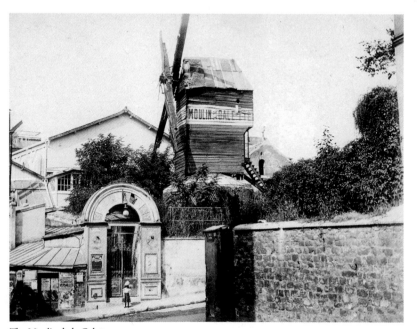

The Moulin de la Galette

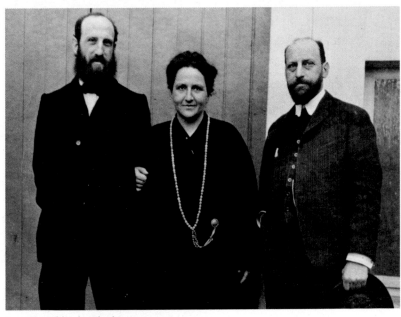

Leo, Gertrude and Michael Stein, *c.*1906

Sergei Diaghilev

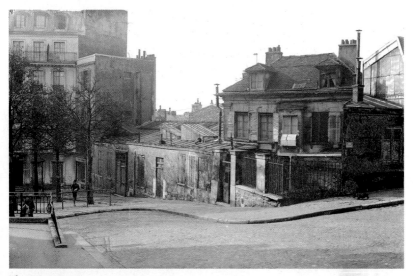

The Bateau-Lavoir

Georges Braque, 1908

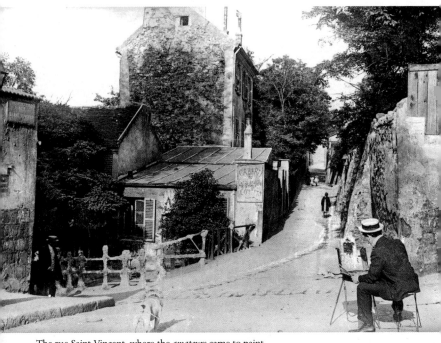

The rue Saint-Vincent, where the *amateurs* came to paint

7.

New Liaisons

In the Couvent des Oiseaux, Matisse had gradually been attracting student followers in increasing numbers; by now, the place had acquired the reputation of an organized school. When, in early December 1907, after fifteen years, he moved his family out of their apartment at 10, quai Saint Michel, they settled into the ground floor of a second disused convent, the Sacré-Coeur, at the corner of the boulevard des Invalides and the rue de Babylone. His students now came here for instruction. Amélie's sitting room looked out across the garden to the Hôtel Biron, where Rodin had his studio. Matisse's 'school' was upstairs on the first floor, where he worked, when not teaching, separated from his students by a screen. The school had been Sarah Stein's idea, inspired by her experience of being taught by the artist herself. Matisse's star pupil, she kept careful notes, which constitute a record both of his general views and his advice to individual students as he tried to get them to think holistically about the process of composition: 'Fit your parts into one another and build up your figure as a carpenter does a house. Everything must be constructed – built up of parts that make a unit: a tree like a human body, a human body like a cathedral . . . Close your eyes and hold the vision, and then do the work with your own sensibility.' He showed them ways of connecting with their own work in progress: 'To feel a central line in the direction of the general movement of the body and build about that is a great aid.' In sculpture, 'The model must not be made to agree with a preconceived theory or effect. It must impress you, awaken in you an emotion, which in turn you seek to express.' He taught that a drawing is essentially a sculpture, though with suggestively rather than definitively described forms. He introduced them to paintings by Georges Rouault (who had also studied with Moreau in the 1890s

and whose work had since been linked with that of the Fauves), van Gogh's drawings and his treasured possession, Cézanne's *Bathers*, which he put silently before them without comment.

Matisse was clearly the master, Picasso still the rebel. At 27, rue de Fleurus, Alice B. Toklas looked on as Leo took the latter into his study. Picasso emerged furious, complaining, 'He does not leave me alone. It was he who said my drawings were more important than Raphael's. Why can he not leave me alone then with what I am doing now?' Leo, equally riled, slammed the door to the apartment and retreated into his studio. This, observed Alice, was the beginning of the rift between Leo and Gertrude over both Picasso's painting and her writing. Both were moving in directions of which Leo disapproved. Anyway, Gertrude had had enough of his endless instruction. When Leo appeared and began explaining further, she interrupted him by dropping her books on the floor on purpose.

Impressively organized and strategically financed though it was, Fernande's independence was about to prove short-lived. One day, Gertrude asked Alice B. Toklas, 'Is Fernande wearing her earrings?' Alice said she didn't know. 'Well, notice,' said Gertrude. Alice reported back that yes, Fernande was wearing her earrings. 'Oh well,' said Gertrude, 'there is nothing to be done yet.' She was looking for signs that Fernande had pawned her earrings, a pair of gold hoops Picasso had given her which she wore all the time. The disappearance of the earrings would mean she was in trouble financially and unlikely to survive on her own for much longer. A week later, Alice announced that Fernande was not wearing her earrings. 'Oh well, it's alright then,' said Gertrude, 'she has no money left and it [the break-up] is all over . . . And it was.' Picasso and Fernande were together again.

Shortly before Christmas, they were invited to dinner at the Steins'. The reunion, and perhaps the approaching holidays, seemed to be a cause for celebration. Alice gave Fernande a Chinese gown from San Francisco and Picasso gave Alice a lovely drawing. (Leo and Gertrude's gift to themselves was Cézanne's *Cinque Pommes* (1877–8), which they purchased from the Bernheim-

Jeunes on 17 December). Fernande, Alice reasoned, had 'held Pablo by her beauty' – at least, for the time being. Fernande gave up her flat and moved back to the Bateau-Lavoir and Alice was pressed fully into commission to provide her with distractions, taking her shopping or to dog and cat shows, anything that would provide them with opportunities for conversation in French. Picasso, Alice somehow deduced, was grateful to her for 'taking Fernande off his hands'.

One further notable event marked the turn of the year. At around this time 'a new and alarming development occurred'. When back in San Francisco, Harriet had fallen under the influence of a formidable woman, wife of a High Church curate, who had been trying to bring her to God. One afternoon, she confessed her reluctance to do so to Gertrude, who – with heavy irony – replied that if she didn't go to God Harriet might as well put an end to herself, since her life would no longer be worth living. (Clearly, by this time, her patience with Harriet was wearing thin. It would fall to Alice, some months later, to arrange for Harriet's removal from their lives for good.) That night, Alice was woken by Harriet, calling her to come at once. She found her sitting up in bed, announcing, 'I have seen God.' Alice was to go straight over to Gertrude and ask her to come at once. When she arrived, Gertrude simply gave one of her 'large' laughs, seeing that Harriet had evidently decided that God – even for an atheist – was better than suicide. The matter was discussed with Sarah Stein, a Christian Scientist, who said she would not tolerate Gertrude's involvement in Harriet's Christian salvation, whereupon Gertrude replied that she had no wish to be involved. Sarah took it on herself for a while, until forced to admit that Harriet was distracting her from her studies with Matisse, to which she was deeply committed (despite the resentment of the other students, who disapproved of what they saw as Matisse's favouritism on the grounds that Sarah and her husband were among his major purchasers). To Alice, Gertrude had revealed her own position in the Matisse versus Picasso dispute; she had taken to referring to

Matisse as *'le cher maître*, in derision of course'. As for Matisse him-self, since the appearance of *Les Demoiselles d'Avignon*, his view of Picasso was that he was 'unsympathetic as a man and less than negligible as a painter'. He told Gertrude that she went to the Bateau-Lavoir only because it appealed to her sense of drama, which simply made her laugh again. The care of Harriet's spiritual development now passed to a Swedish sculptor, who confessed he had never before known anyone quite like Harriet.

For Gertrude and Alice the winter brought happiness. At first, Gertrude 'diagnosed' Alice as 'an old maid mermaid': 'the old maid was bad enough but the mermaid was quite unbearable'. However, in ways she was subsequently unable (or too discreet) to recall, the old maid mermaid tag 'wore thin and finally blew away entirely'. Throughout that winter, Alice continued to live at the Hôtel de l'Univers with Harriet, joining Gertrude most days and evenings for walks or visits to the rue de Fleurus: 'By the time the buttercups were in bloom, the old maid mermaid had gone into oblivion and I had been gathering wild violets.' Their relationship had evidently moved into a new gear.

8.

The Whole Story

In the vast, glass, light-filled pavilion of the 1908 Salon des Indépendants, Gertrude Stein found Alice and Harriet seated on a bench before two paintings. 'You have seated yourselves admirably,' she said. But why? 'Because right here in front of you is the whole story.' She explained that the paintings were by Derain and Braque. Alice had noticed only two large, similar pictures. She now saw that both were of roughly modelled, strange-looking figures, like wooden carvings, one depicting 'a sort of man and woman', the other, three women. The latter was surely Derain's *Bathers*, a painting of three female figures who look like articulated puppets, faceted from their joints as if suspended on strings. The painting by Braque was surely *Grand Nu*, depicting a chunky, sculptural figure shown in profile against a fragmented, unfolding background. (It's as if the figure is in the process of being unwrapped by the ground.)

When Picasso saw Derain's painting, he was indignant, since it was clear that, despite his scathing dismissal of *Les Demoiselles d'Avignon*, he had been influenced by the new developments in Picasso's work (though it is possible – even likely – that Derain had begun, or even completed, the *Bathers* before seeing the *Demoiselles*; in any case, by now such ideas were in the air). Tensions were rising. According to Gertrude Stein (who may have been mischievously – or unwittingly – helping the feud along), at the 1908 Salon, 'the feeling between the Picassoites and the Matisseites became bitter'.

For Matisse, the exhibition provided a second opportunity to meet Sergei Shchukin, whose life since he first met the artist had been devastated by recent events in Russia. After the violent revolution of 1905, one of his twin sons had disappeared, eventually to be found drowned in the River Moscow; he had committed suicide. Further tragedies had followed. In 1907, Shchukin's wife

died suddenly; in 1908, his brother committed suicide. In the wake of these tragedies, Shchukin spent his days in the Louvre, looking at Egyptian funerary art. He also found solace in Matisse's work, especially his paintings of nude figures, which for Shchukin evoked extreme emotions. Increasingly, he had begun to collect these, and he now formed a strong bond with Matisse, giving him encouragement, sharing his artistic opinions and taking an active interest in the development of his work. Following the Salon des Indépendants, he commissioned three new works, including a huge decorative panel for his dining room in the Palais Trubetskoy, where the walls were already covered with works by van Gogh, Monet, Gauguin and Cézanne. His increasing patronage came at a time when other opportunities were also finally coming Matisse's way; his work was being shown for the first time in New York, Moscow, London and Berlin. Though Shchukin also purchased several of Picasso's Blue Period works during 1908, in the Matisse versus Picasso race, Matisse was way ahead in terms of his arrival on the international scene.

During the previous couple of years, the make-up of the Picasso *bande* had gradually changed, having altered from the earlier gang of Catalan painters and hangers-on. Though the *bande* that regularly met in Azon's included Apollinaire, Max Jacob and Salmon (the latter, as of 1908, now living in a basement studio in the Bateau-Lavoir), the inner circle, once Derain had moved to the rue Tourlaque – at least, by Fernande's account – had re-formed into a gang of four consisting of Picasso, Derain, Vlaminck and Braque. This was the group that now regularly turned up together at the Steins'.

The relationship between Picasso and Derain seemed to have developed since Derain moved to the rue Tourlaque. When Derain had first arrived in Montmartre, André Salmon had noticed him making his way down the hillside in the mornings, always affable, always willing to surface from his reveries to give a friendly smile and bid whoever he passed good day, but he was surprised how little Derain seemed to have to do with Picasso. Since then, some said

Apollinaire had engineered a renewal of their earlier acquaintance; or perhaps Fernande had done so, hoping to encourage a stronger friendship between Picasso and her friend Alice's new lover. Or perhaps the four appeared to be a more intimate group than they actually were.

Whatever the truth, the new gang that surrounded Picasso (Derain, Vlaminck and Braque) made an impact in the streets of Montmartre, where people would turn round to look at them. Derain was still working on his (quasi-) English image, though even Fernande considered his elaborate waistcoats and green and red ties somewhat overdone.

Vlaminck struck her as the most confident of the four – with good reason. In February, Vollard had given him an exhibition of landscapes, seascapes and figures. His paintings had rendered the window of the gallery vivid with colour in the lilac-grey, early-evening light of Montmartre, turning the heads of those who wandered along the rue Laffitte. And where Vollard went, Kahn-weiler followed; throughout March 1908, he had shown twenty-seven paintings by Vlaminck. None of this seemed to interest Vlaminck particularly; his apparent nonchalance puzzled Fernande, to whom he seemed (perhaps intentionally) inscrutable. She was unaware that the apparent social solidity of the gang did not necessarily sig-nal consensus on artistic ideas and developments. In that respect, the gang of four was about to split down the middle.

As for Braque, Fernande distrusted him implicitly, seeing only his 'powerful head which made him look like a white negro', curly black hair and boxer's shoulders. She thought him studiedly casual in his ready-made department-store clothes and narrow black ties worn in a loose knot in the Norman style, believing him to be 'sus-picious, able and clever', in her view, a typical (French) Northerner. She also notes a hint of affectation in his casual gestures, coarse voice and brash expressions – the influence of the movies?

Among the most popular forms of entertainment in Montmartre was boxing. The Picasso gang were enthusiasts – all, that is, except Vlaminck, who was not above using brute force to make a point and

was strongly of the opinion that it was more effective than any box-ing manoeuvre – until, that is, Derain and Braque both challenged him to a fight. Picasso and Fernande met Vlaminck as he was leav-ing Derain's studio, 'his nose swollen like a potato and in a pretty sad state, though totally convinced'. Picasso's passion for the sport was as a spectator; one lesson with Derain had been enough to last him a lifetime. However, he liked to think that, given his thick-set build, when they went about as a gang of four he would surely be mistaken for a boxer (much as, in the early years, he always hoped to be taken for a clown). Braque, on the other hand, was not all machismo; his friends still included Marie Laurencin and Georges Lepape, now an illustrator for the fashion journal *La Gazette du bon ton*. (Within three years, he would be designing fashion plates for Poiret.) On Sunday afternoons, Braque still went waltzing at the Moulin de la Galette; on visits to the Bateau-Lavoir, he sat calmly smoking his pipe and playing his accordion.

However he fitted into the *bande*, Braque quickly became an indispensable companion for Picasso. Temperamentally, though, they were quite different: Picasso was volatile and expressive; Braque, friendly yet inscrutable, exuded sangfroid. Since his visit to the Bateau-Lavoir to see *Les Demoiselles d'Avignon*, however, Braque had begun to show a serious interest in Picasso's work and, as art-ists, they were almost uncannily complementary. Still only twenty-six and twenty-five respectively, they quickly became in-separable allies. (Matisse, at thirty-seven, with his increasing com-missions, his family life, his idyllic vision of Arcadia, suddenly seemed to belong to another generation.) Both Picasso and Braque relished the street life and popular culture of Paris and followed the new urban heroes of popular literature and the screen. They loved cowboy and adventure stories and were avid fans of the 'Nick Carter Library' of cheap, bi-weekly paperbacks, booklets with trendy, full-colour covers like movie posters. Nick Carter was the quintessential urban hero, swaggering, knowing, always able to outwit his enemies; the epitome of urban cool. The two exchanged paperbacks and went regularly to the movies together. And they were on a shared

quest to discover in painting new ways of depicting the modern world. Despite his comments about eating tow and swallowing kerosene, Braque had in fact quickly realized that, with *Les Demoiselles d'Avignon*, Picasso was breaking new ground. From now on, they began to develop similar ideas and Braque introduced Picasso to aspects of his technical repertoire. Braque understood, too, the significance of the ethnic art Picasso had seen in the Trocadéro; *l'art nègre* had been displayed in the museum at Le Havre since at least 1904 and, in 1905, he had bought his first tribal mask, from a sailor or a friend of his father. Fernande distrusted Braque from the start, understandably, since in many respects he had already begun to replace her. Picasso sometimes even referred to him as *'ma femme'* (a safe tag since, like Picasso, Braque obviously loved women); Max Jacob waspishly referred to him as the 'disciple'.

Picasso now began the process of trying to transform Braque's love life, with a view to finding him someone more suitable than the woman he seemed to be involved with, Paulette Philippi, a notorious *femme galante* who ran a sophisticated opium salon patronized by the literati. The extent to which Braque enjoyed her favours as a courtesan was never really known but, according to Henri-Pierre Roché (one of her coterie), Braque was regularly invited to her parties and was one of her special favourites: 'She set Braque apart, because he worked by inclination – *enough but not too much*' – which seems to have been how he went about most things.

It was decided among the *bande* that the daughter of Max Jacob's cousin, who owned the hideously tasteless Cabaret du Néant, might prove a more appropriate choice. The introduction was planned and the Picasso gang hired formal evening clothes for the occasion. After an evening in the Néant of such uninhibited pleasure that nobody was in a fit state to identify their own discarded finery, they were asked by the management to leave. They obliged, helping themselves to whatever garments they found in the cloakroom. Eventually, Picasso and Fernande came up with someone more suitable, Marcelle Lapré, a friend of Fernande. She lacked the more overtly decorative appeal of Jacob's cousin, being short and plump

with unusually protuberant eyes; Jacob referred to her as the little sea-monster. But Picasso and Fernande thought her charming, witty and discreet, so much so that it took Kahnweiler to reveal that she also went by the name of Madame Vorvanne and was probably thus living with, or even married to, a Monsieur Vorvanne. Picasso's matchmaking skills had once more been put to the test. Eventually, because (or in spite) of Picasso's intervention, Marcelle did indeed become Madame Braque, but not for some years. For the time being, Braque kept his own counsel – and Paulette.

Throughout the early months of 1908, nevertheless, he and Picasso were constantly in each other's company, exploring rather than denying the similarities in their work. Both were striving for a new kind of pictorial synthesis, moving away from mimesis and aiming for the creation rather than simply the illustration of an experience on canvas; they were creating formations that were three-dimensional, sculptural and poetic and challenging the relationships between surface and depth. Though in a sense Picasso had begun that endeavour in *Les Demoiselles d'Avignon*, in terms of subject matter the painting had been a one-off. Having gone as far as he could with the need to explore a particular kind of pictorial brutality, it was as if Picasso had freed himself to absorb other influences. Alongside him, Braque calmly developed his own ideas along similar lines, introducing a new geometry into both his figure studies and his landscapes. He saw Picasso frequently throughout the spring, but left Paris on 2 May for a brief trip to Le Havre to help organize an exhibition (mounted by the Cercle d'Art Moderne) of works by artists including himself, van Dongen, Derain and Matisse. In the middle of the month, he left again for L'Estaque.

9.

Festivities, Prospects, Tragedy

The tenor of life in Montmartre was gradually changing. One day at around this time, the spring of 1908, Paul Poiret arrived at the Bateau-Lavoir, immaculate in white gloves, with black cane and fashionable trilby, impressing Fernande with 'the most sensational of entrances' amidst all the general squalor. Surveying the scene for a masterpiece and seeing only a jumble of African carvings, collections of curious bric-a-brac, a pile of Fernande's blouses, a clutter of unwashed pots and pans and a mountain of ashes higher than the stove, he at last spotted with relief a little gouache portrait of a woman. 'Oh! Remarkable! Delightful! Admirable! A portrait of Madame?' 'Yes,' replied Picasso, 'it's a portrait of Madame . . . by Madame.' Despite his faux pas, Poiret began inviting Picasso and his friends to dinners and parties at his lavish apartment in the rue de Rome, where he made Fernande a gift of a rose-coloured, gold-fringed shawl and a spun-glass accessory for her hats the like of which she had never seen before.

Since 1906, he had been running his couture house more discreetly, from premises in the rue Pasquier, where, during the past two years, he had accumulated a cache of seriously rich and well-connected clients. Under his influence, fashionable women seemed to be becoming ever slimmer and more provocatively lithe. The Paris correspondent for *Vogue* reported in May 1908 on the new silhouette:

> The fashionable figure is growing straighter and straighter, less bust, less hips, more waist, and a wonderfully long, slender suppleness about the limbs. Here even the cab drivers and butcher boys have already become accustomed to seeing ladies stepping along sidewalks, holding closely in one hand the long skirt, which reveals

plainly every line and curve of the leg from hip to ankle. The petti-
coat is obsolete, pre-historic. How slim, how graceful, how elegant
women look! The leg has suddenly become fashionable.

(The following year, Poiret moved again, to a fabulously ostenta-
tious dwelling with gardens backing on to the Faubourg St Honoré.)

For all his charismatic charm and flamboyant mannerisms, Poiret
was personally unpretentious. The parties he threw were friendly,
lively occasions. Fernande, understandably, admired him. 'He saw
things on a large, a grand scale. His extravagant tastes were part of
this and so was the total absence of any kind of meanness in him
when it came to questions of value, whether in business or in art.'
At his parties over the next few years, the Picasso gang – Derain and
Vlaminck had been Poiret's friends from the early days in Chatou –
mingled with other artists and designers of Poiret's acquaintance.
They included Georges Lepape, since, though he saw less these days
of his old friends from the Académie Humbert, he was still in touch
with Braque and Marie Laurencin. Poiret's sister Nicole, recently
married to one of the artists in Montmartre, also knew Marie Laur-
encin. Perhaps through Nicole, Poiret had discovered Marie's talent
for fencing; she had often been seen, 'eyeglass in one hand and foil
in the other, exchanging thrusts with the Pasha of Paris'. He
designed a fencing costume especially for her and they fenced in his
fabulous apartment, with its 50-feet-wide façade, from which ten
doors gave access to the gardens, the lawns vivid with multicol-
oured crocuses in spring.

The network which would eventually link the bohemian world
of Montmartre with the more elevated artistic circles Diaghilev
moved in was thus gradually being established through chance
acquaintances and social contingencies, and flitting easily between
circles and providing stimulation everywhere he went was Poiret.
He had begun to purchase paintings by each of the artists in the
Picasso gang, unguided by anyone else's opinion, making choices
based entirely on his own personal taste. He would hang a still life
by Picasso next to a nude by van Dongen, accumulating works by

Matisse, Derain, Vlaminck, Marie Laurencin, Utrillo and Modigliani. (Over the years, he amassed a substantial, eclectic collection, including, in 1911, Brâncuşi's large copper sculpture *Bird in Space*.)

Each year, in May or June, the students of the École des Beaux-Arts planned and took part in the annual Quatres Arts ball. It was held at the Moulin Rouge, which closed for one night to its regular clientele, was cleared of its usual attractions and decorated by the students of the École. On the night of the ball, great crowds of artists came surging out of the courtyard and on up the rue Bonaparte, walking in crowds or being carried on floats, all in fancy dress (many of the costumes run up by the seamstresses who posed as life models in Paul Alexandre's house in the rue du Delta) as they processed from the Left Bank to Montmartre. In the small hours, the celebrations became increasingly decadent. Amidst the crowds of models and art students dressed in extravagant outfits, the life models from the studios paraded nude. Then came the mock Black Mass, which consisted of a naked woman stretched out on a cross covered with black velvet illuminated by flickering candlelight, a 'bishop' swinging a censer over the idol. This was followed by the 'Peacock Woman and her brilliant portrayal of Venus', crouching in a vast, shimmering peacock's tail of emerald and lapis lazuli.

As the festivities went on, students in various stages of undress emerged from the Moulin Rouge in a state of high intoxication. One year, a group of artists dressed as acrobats scaled the walls of buildings, waking the respectable neighbourhood when one unfortunate reveller, climbing on to the pedestal of the sculpture by Cordonnier in front of the Grand Palais, slipped and ruptured a kidney. Everyone would attend, and almost everyone was high on hashish. On another occasion, the revellers included Braque, who in 1906 was spotted, dressed as a Roman, sitting chatting in the streets with Paulette. They kept being disturbed by a float from the procession, which eventually he threatened to overturn. When the driver of the float called Braque's bluff, he peeled off his tunic and slid on all fours beneath the float. On the second attempt he caused

a stir, as he managed to lift it, higher and higher, before a cheering crowd. Paul Alexandre hazily recalled walking with his brother Jean after the ball, late at night along the Champs-Élysées – or was it the Quai d'Orsay? 'I could see the gas lamps rise up in tiers like notes of music on an imaginary stave and I began to sing the tune written there.'

Poiret also attended the ball, dressed in extravagant theatrical costumes of his own design. In 1911, he would send his models to open the ball, and they showed his latest creations, in sparkling textures and vibrant colours, as he had been invited by the École des Beaux-Arts to participate annually by organizing 'some sensational entry'. This consolidated his feeling of being part of the artistic scene. When Vollard began producing albums of artists' work (including, in 1908, an album of Picasso's etchings), Poiret followed suit. In 1908, he published an album of his own designs, illustrated by printmaker Paul Iribe. *Les Robes de Poiret racontées par Paul Iribe* was a portfolio of eleven colour plates featuring ten new Poiret gowns. The album, beautifully printed on fine Holland paper and published in a limited edition, was technically innovative, Iribe's illustrations announcing a significant departure in fashion illustration. His plates showed models in motion – leaning over, turning aside, conversing – against stylishly minimalist backgrounds. This was a new vision of women, quite different from the ramrod-straight models posed in ornate settings cluttered with plants, screens and art nouveau furniture which had characterized the fashion plates of earlier years. The decision to employ fine artists to illustrate designs was also novel; and the use of an innovative printing technique – *pochoir*, a kind of stencilling – made it possible to print with broad expanses of bright, strong colour and bold, simple lines. Poiret was one of the first to see the potential of this technique: it was one of the reasons he had chosen Iribe, a printmaker, as his illustrator. (For his next album, published in 1911, he would commission Braque's old friend from the Académie Humbert Georges Lepape.) The new printing techniques enhanced the simple cuts and elongated lines of Poiret's garments, which were

streamlined to suggest ease of movement and a more liberated life-style. In fashion, as in painting, the way the human form was presented was in the process of major change.

In addition to his albums of Picasso's etchings, in 1908 Vollard sold one of his Rose Period paintings, *Family of Saltimbanques*, which depicted a family of acrobats resting between performances on the waste ground of the Maquis. The painting was purchased by André Level, leader of La Peau d'Ours, the society of young dealers who had purchased Matisse's work two years earlier. Level paid a thousand francs for *Family of Saltimbanques*, a sum which, according to Vollard, had the effect of terrifying all the other collectors. These included Kahnweiler, who, after his initial reaction to *Les Demoiselles d'Avignon*, had soon realized that Picasso might after all be the man to bring about a new era in painting. New to the scene and still in his early twenties, he was learning fast from the established dealers in Montmartre and had begun to acquire works by van Dongen, Derain, Vlaminck and Braque as well as Picasso.

Kahnweiler was sociable and knew how to talk to the young artists. He went to the Cirque Medrano and the Rat Mort with Picasso and regularly raced his skiff and his motor boat, the *Saint Matorel*, on the Seine. He had already followed Vollard's example of mounting exhibitions of work by single artists and, when he saw his published albums of artists' works, he brought out similar publications, which were soon being sought after by connoisseurs. He now began to attract the attention of Sergei Shchukin, who would soon begin acquiring paintings through him. (In recognition of their steadily improving standard of living, Fernande had already appointed a *femme de ménage*, though her housekeeping seemed to consist mainly of beating their ornaments with a feather duster that had lost most of its feathers before settling down to read the newspaper in Picasso's armchair.)

In June 1908, further changes came about when tragedy struck the Bateau-Lavoir. The mellow opium evenings came to an abrupt halt when one of the residents, Karl-Heinz Wiegels, indulged in a cocktail of opium, hashish and ether. Several days later, he was still

unable to come down to earth. Everyone in the Bateau-Lavoir did their best to help him, but to no avail. Picasso went to his studio and found him; he had hanged himself. Wiegels' funeral cortège made a colourful sight as it processed through the muddy lanes of Montmartre. Led by Bibi la Purée in his habitual dilapidated top hat, ragged coat and shoes full of holes, the procession swayed through the streets, followed by a carriage containing some of the local whores, heavily made up and provocatively dressed, who leered and waved at onlookers as if it were a carnival procession. The Picasso *bande* vowed they would never touch opium again.

Rousseau's Party

Browsing in Soulier's junk shop in the rue des Martyrs one day among all the old clothes and second-hand bric-a-brac, Picasso happened to notice a painting jutting from a pile of canvases. When he pulled it out, he was fascinated by what he saw. In it, a stumpy woman stood stiffly before an ornate curtain, holding a sapling by its root; there was a small bird, apparently in flight, in the background. The picture was a portrait of a Polish schoolteacher, posing against a fantastical backdrop, which suggested an Arcadian scene. Picasso liked the painting's primitive mood and composition and thought it a penetrating psychological portrait; he admired its clarity and 'decision'. He also recognized the artist: the painting was by Henri Rousseau (familiarly known as the *douanier*, since everyone knew him as a customs official rather than a professional painter), whose work Picasso had first seen back in May 1901, probably at the Salon des Indépendants. Soulier let him have this one for a song – five francs. It was practically worthless, he said; he might as well have it for the price of the canvas: he could paint over it.

Henri Rousseau was a familiar figure in the lanes around the place du Tertre, where, when things were quiet, the shopkeepers sometimes sat for their portraits. As far as those who lived and worked in the area were concerned, he was nothing more than a local portraitist, or 'Sunday' painter. They paid him in groceries or bits of hardware, an arrangement with which he was perfectly content, thinking it quite wonderful that people would give him between thirty and fifty francs for a picture he was more than happy to sit peacefully working at to while away a sleepy afternoon. Despite his evident talent, it was easy to be dismissive of him; everyone in Montmartre joked about him. Some said he was a hoax invented by Alfred Jarry, creator of the monstrous Père Ubu, others

that *The Sleeping Gypsy*, Rousseau's picture of a stiff girl in a brightly coloured, striped dress asleep at the feet of a lion, had actually been painted by Picasso. Fernande had heard him tell Picasso, 'We are the two great painters of the age, you paint in the "Egyptian" style, I in the modern.' She was unconvinced. 'Poor, dear *douanier*, he was so easily "had" . . . so genuine!' (Today, Rousseau's *Sleeping Gypsy* hangs in the Metropolitan Museum of Art.)

Rousseau did nothing to dispel his reputation around Montmartre. He was sixty-four in 1908; on his retirement as a customs official he had taught himself to paint, and produced wondrous, 'primitive' scenes some said were based on photographs in the newspapers. His paintings – of lions and tigers, folkloric maidens with long, stiff hair, and jungly landscapes – seemed to contain echoes of Gauguin, but his colours were far more vivid than Gauguin's, and Rousseau's animals were fantastical, quasi-mythological creatures. His appeal lay in his ability to evoke a world that seemed primal, even childlike, liberated from convention and stripped of social constraint. Fernande suspected he did paint from photographs, but that he saw no difference between his paintings and the photographs he copied: 'he had the natural gift of a primitive painter' and something more, 'a unique talent, a sort of genius'. His motifs were partly figurative, partly figments of his imagination. When she asked him to identify the mountains in the background of the painting Picasso had bought, he replied that surely she could see they were the fortifications of Paris.

That summer of 1908, Picasso decided to spend August in France (like Braque, perhaps) rather than in Spain. The Steins financed his trip, and he modestly chose as his rural retreat the remote, unremarkable location of La Rue des Bois. Barely a hamlet, and surrounded by woods, the place consisted of ten houses, a farm and a few dwellings, with the River Oise on one side and an edge of the Fôret d'Halatte on the other, five miles from the manufacturing town of Creil. He rented a small outbuilding on the farm, where Fernande contentedly did the cooking, buying provisions from the farm, collecting freshly laid eggs from the hens and watching the

cow being milked: real country living. She happily took to it all, and wrote to tell Apollinaire how happy they were; they were even thinking of settling there permanently.

Picasso found a new subject in the form of his strapping landlady, widow Putman, who stood over six feet tall and weighed almost three hundred pounds. His portrait of her shows that he was continuing to 'carve' figures in paint, and, in its folkloric treatment, it clearly suggests the influence of Rousseau. That summer of 1908, he painted primitive landscapes quite unlike anything he had ever produced before, strongly echoing Rousseau's work in pictures such as *Landscape at La Rue des Bois*, in which, with more finesse than Rousseau, he imbued the forest with a recognizably Rousseauian atmosphere of primitive enchantment. Other, similar works followed: *La Rue des Bois*, in which the viewer is invited to look deeply into the foliage, in close-up; and *House at la Rue des Bois*. Both of these, in their treatment of geometry and perspective, also closely resembled Braque's paintings of houses in L'Estaque.

Fernande really did want them to settle in La Rue des Bois. For some reason, she, too, now hankered after the chance to live out the Arcadian rural dream (perhaps because she had Picasso to herself there); she even found an old hunting lodge suitable for rent. But Picasso had soon mined the place for ideas. By the end of the month, he was complaining it was too damp and green, and too far from Paris. After only a few weeks they were back, in time for the arrival of Braque, due in the city on 9 September. On their return, the Steins purchased at least three paintings, including two with the title *La Rue des Bois*, and a third, *Paysage*. Shortly afterwards, they also bought a fourth, which he had completed in his studio. In Kahnweiler's gallery, Modigliani and Paul Alexandre noticed 'a small, strange watercolour of Picasso's representing a young fir tree turning green in the middle of transparent blocks of ice'. By now, Kahnweiler was quick to purchase Picasso's work whenever the opportunity arose. During the course of 1908, he acquired as many as forty of his works. Times were changing for Picasso: he was no longer the struggling artist.

Braque was back in Paris in good time to prepare for his one-man

show of recent work at Kahnweiler's, which was due to take place in November. Included among the pictures were to be new landscapes of L'Estaque, which showed the extent to which Braque had discovered innovative ways, that summer, of building up pictorial structure. Despite his appearance of nonchalance, he was barely more confident than Marie Laurencin about seeing his work on public display. He was so shy that he was cautious about attending his own exhibition; he went 'only once at sundown when there was nobody around'. In the event, the exhibition would turn out to be auspicious in more ways than one, since it was here that the term 'cubism' first entered the artistic vernacular, coined by Louis Vauxcelles, the art critic who, back in 1905, had first called Derain a Fauve.

According to Vauxcelles, however, it was Matisse who had come up with the term 'cubism'; he had drawn a little sketch of 'two ascending and converging lines between which small cubes were set depicting a L'Estaque of Georges Braque' to demonstrate that Braque's paintings consisted of '*petites cubes*'. Matisse grew so tired of this story that after a while he simply denied it. Several decades later, he confirmed that he had seen Braque's work of that summer as the first example of cubism. Denouncing Gertrude Stein's theory that cubism was really a Spanish innovation, he recalled in particular 'a Mediterranean landscape that represented a sea-side village seen from above'. In Matisse's account:

> In order to give more importance to the roofs, which were few, as they would be in a village, in order to let them stand out in the ensemble of the landscape, and at the same time to develop the idea of humanity which they stood for, [Braque] had continued the signs that represented the roofs in the drawing on into the sky and had painted them throughout it. This is really the first picture constituting the origin of cubism and we considered it as something quite new, about which there were many discussions.

At first only Braque was dubbed 'cubist', but the use of the term quickly caught on, to the irritation of Picasso, who complained,

'When we invented cubism we had no intention whatever of inventing cubism. We simply wanted to express what was in us.' Braque said the same: 'Cubism, or rather my cubism, was a means that I created for my own use, whose primary aim was to put painting within the range of my own gifts.' Neither was prepared to reduce the advances in their work to handy definitions. As Jean Cocteau later noted, 'Cubism showed cubes where there weren't any. We should not forget that the spirit of mystification may exist at the beginnings of a discovery.'

In any case, definitions of cubism, then and since, have always varied. The geometry of early cubism, as exemplified by Picasso and Braque, was nuanced and suggestive. In their paintings of this period, the forms of objects no longer obeyed previous pictorial rules. Forms were instead juxtaposed and repeated and light sources obscured or made subject to variation in what appeared to be a kind of double exposure on canvas in which forms were enfolded or concertina'd. This made the fan a particularly conducive – even symbolic – object within cubist painting. Picasso often introduced this item into his cubist portraits; in one of his first of Fernande she is seated with a half-open fan.

For Picasso and Braque, what came to be called cubism fundamentally depended on drastically different ways of thinking about perspective. Since studying the landscape of L'Estaque, Braque had abandoned traditional perspective, which now seemed to him too mechanical: 'It has its origins in a single viewpoint and never gets away from it.' A fixed viewpoint assumed that the eye of the viewer was still, whereas cubism acknowledged that the eye moved constantly in the act of looking. Scientific perspective, by this account, was a kind of illusion, which prevented the artist from conveying what Braque called 'a full experience of space', since 'it forces the objects in a picture to disappear away from the beholder instead of bringing them within his reach, as a painting should'. As he also put it, 'It is as if someone spent his life drawing profiles and believed that man was one-eyed. When we arrived at this conclusion, everything changed, you have no idea how much.' The fundamental

discovery was that through the depiction of solid objects, space as depicted on canvas could be rendered in such a way as to create actual spatial experience: the solid object could be experienced as virtually touchable, a thing with space wrapped around it, which could be seen from all sides. The ability to see 'around' things had come about through a combination of influences – the work of Cézanne; the cinema; and the recent appreciation of the power of ethnic sculpture.

If solid objects, and space itself, were now being conveyed differently on canvas, so, too, was the human figure. As Braque had already revealed in *Grand Nu*, the human form in art could be constructed in facets, the interplay of which seemed to establish a new rhythm with every glimpse. While Matisse achieved a sense of dynamic movement by paring down forms, Picasso and Braque did so by rendering forms more complex – overexposing them, as it were, to the eye. The two last differed from each other in that, for the most part, Braque worked primarily with solid objects, whereas Picasso (after a short period of working with objects) focused primarily on the human figure, working faceted surfaces into his figures as well as the objects, experimenting with similar juxtapositions, resemblances and rapports. David Hockney has since explained the particular significance of cubism for Picasso, that it 'brought him closer to the human being, to a much more involved and interesting vantage point'; 'If there are three noses, this is not because the face has three noses, or the nose has three aspects, but rather because it has been seen three times.' For Fernande, this was precisely the problem, since she did not recognize herself, or anybody else, with three noses. Or, if she did, she was unable to see this novel treatment of people as flattering or beautiful.

She was not alone. Both Derain and Vlaminck found the new ways of seeing similarly disconcerting. Derain resumed his study of the old masters and continued his artistic research in the museums of Europe, finding cubism impossibly disquieting. Vlaminck also remained unconvinced by its 'strange alchemy', regarding it as an 'aesthetic revolution [which] would remain uncontrolled and would

allow all sorts of anomalies to qualify as courageous experiments'. Derain's view was that cubism was merely a form of graphic art. He worried that, in his cubist period, Picasso became less truly a painter than a draughtsman – though a draughtsman of genius. As Cocteau later saw it, 'Picasso never lectured. He never dissected the doves which flew out from his sleeves. He was satisfied with paint-ing, acquiring an incomparable technique and putting it in the service of chance.'

Everyone still dined at Vernin's, Père Bouscarat's, Mère Adèle's – all the old, familiar places. At Azon's, the artists sat smoking their pipes and talking until three in the morning, along with the masons and coachmen who were still the restaurant's main regular clients. Picasso's *bande* was sociable and talkative, but (unlike the Impres-sionists before them) fundamentally competitive. Looking back on those days, André Salmon remembered that they were 'terribly indi-vidualistic. Were we modest? Not really. But . . . No one dreamed of organizing a school, and we were our own leaders.' In the company of Max Jacob and Apollinaire, they played to the gallery, amusing everyone, making continual fun of everything and sharing jokes, rituals and expressions quite unintelligible to others. However, that was all on the surface. When Vlaminck visited Derain in his studio in the rue de Tourlaque it was 'to buck him up and to banish his doubts', since, though Derain was now personally happy, he felt he was losing his way as an artist. The discoveries that had been called Fauvist were no longer enough for either of them, as Derain had already begun to indicate in his letters of 1905, from Collioure. He was not looking for a definitive method; on the contrary, he was more likely to change styles simply to avoid falling into any one habit. As Vlaminck put it, though it was 'fun to work in pure colour and tone, a game into which I had thrown myself heart and soul . . . I worried because, confined to the blue and red of colour mer-chants, I was not able to be more forceful, and I had reached a maximum degree of intensity'.

Since the retrospective exhibition of Cézanne's work at the 1907

Salon d'Automne, the focus of the group discussions had moved on, from colour to problems of structure. As Vlaminck paraphrased (and simplified) the new challenge, if one colour could be changed (if hair could be green, a face yellow or lilac, a tree pink) without distorting the colour values of the whole, why not apply the same principle to the creation of forms? One line might be elongated or exaggerated without distorting the underlying geometry of the picture; and then . . . Vlaminck's private opinion was that none of them really knew what they were doing any more. He had a friend, an acrobat, who used to turn, turn, turn, with prodigious speed, then he would suddenly stop . . . 'Stop! That's enough!' he would say. Vlaminck felt as if – more or less since the Fauves exhibition of 1905 – the painters of his acquaintance had been turning head over heels in the air but, suddenly, nobody really knew how to keep turning. It struck him that at times like that an artist – spinning away, thinking he held God in the palm of his hand – could easily fall flat on his face. However, he kept his thoughts to himself.

When Derain left to spend the summer in Martigues, Vlaminck travelled to the Midi to join him. On arrival at Marseilles, he was revitalized, enchanted by the sight of the old harbour, bathed in light: 'It seemed as though everything was seen through a silken gauze . . . the rosy blue rings, touched with gold, made me think of some immaterial world . . .' He found the light of Provence so distracting that he was unable to paint – 'How could I dream of running when I was already out of breath?' Cubism was the great divider. Artistically, it set Picasso apart from Derain, Vlaminck and others. But, in any case, Braque, rather than anyone else – including Fernande – now directed Picasso's thoughts.

The two artists continued to work intensively, both separately and together, to develop their perceptions and determine how far it was possible to take them. When they were not working, they still hung around the streets together; in the evenings, they still went to the circus – Gertrude Stein came across them in William Uhde's gallery one day dressed as (auguste) clowns from the Medrano. Or they went to the movies, where they could now see Nick Carter,

hero of their favourite paperback detective stories, on the silver screen. That summer of 1908, the newly established film company Éclair had brought out the first Nick Carter movie, *Le Guet-Apens* (*The Doctor's Rescue*), in which the hero disguises himself as a disreputable beggar to mix with and outwit the local gangsters.

In the streets of Paris, picture houses of varying quality continued to proliferate. The establishment of new cinemas seemed unstoppable; outraged members of the public had been protesting in letters to the newspapers that these dens of iniquity (cinema was dubbed the '*théâtre des pauvres*') were now no longer confined to the working-class districts. These days, they were everywhere, even on the boulevards, despite the fact that, in some establishments, the entertainment amounted to little more than a curtain serving as a screen, on to which was projected a succession of blurry images. The cinema was still cheap entertainment and, by the end of 1908, the picture houses were invariably full. For twenty-five or fifty centimes, maybe a franc, patrons could spend the whole afternoon or evening in one, and they were becoming ever rowdier.

On 10 August 1908, the head of the police in Paris released a statute, to take effect from 1 September, issuing new regulations designed to introduce a degree of law and order into the theatres and cinemas of Paris. The main problems were risk of fire (the peculiar smell of burning oil or acetylene mingled with waffles, absinthe, incense or horse dung drifted from the cinemas), hygiene, and hats – more irritating in those days than mobile telephones in ours, since someone's elaborate hat could obscure an entire performance, and people often wore them just for the fun of causing annoyance to those in the rows behind. Under the new rules, the municipality was required to address the risk of fire by forbidding the conversion of certain music halls to cinemas; to demand that the picture houses keep their halls a little cleaner; and to resolve the question of hats (Article 220: 'It is forbidden to disturb the performance with hats, in whichever manner'). For the audiences, none of these problems detracted from the appeal of films such as those featuring Nick Carter, in which, in keeping with the books, the

scene was urban and edgy, the story gripping and the hero the epitome of modern machismo. The Nick Carter films may have had an additional appeal for Picasso, since the French Nick (unlike the young, muscular, white American in the United States version) was played by Jean-Baptiste Bressol, an actor with a compact but agile body and dark Mediterranean features. Perhaps it was not only Fernande who had begun to identify with the new screen celebrities.

At the Salon d'Automne that October, Modigliani and Paul Alexandre joined the crowds gathered in the Grand Palais around Rousseau's *Tiger in the Jungle*. Modigliani steered Alexandre away to show him 'a painting that enchanted him': *The Wedding*, Rousseau's portrait of two peasants dressed to be married, stiffly and incongruously posed in a jungle setting. Alexandre and Modigliani both knew Rousseau, and sometimes passed a quiet evening with him in his studio. By now, Vollard had also met the *douanier*, who had arrived in his gallery one day with two or three small canvases under his arm. He told Vollard he had fallen on hard times. He had been supporting himself by giving music lessons, but that had got him into a spot of trouble when one of his pupils had asked him to cash a forged cheque. No sooner had he done so than he was arrested. When he saw Rousseau between the arms of two policemen, the culprit had bolted. When he could not be found, Rousseau was brought before the judges. The case seemed to be a lost cause, until his advocate had the bright idea of showing the magistrate one of the defendant's paintings, which he happened to have with him, and declaring, 'Can you still doubt that my client is an "innocent"?' Rousseau had then, he told Vollard, approached Monsieur Jourdain, president of the Salon d'Automne, to ask him for a position as a guard. Suspecting one of the Fauves of playing a trick on him, Monsieur Jourdain had replied that, if Rousseau were employed as a guard, he would have no credibility as a painter and his paintings would have to be removed from the walls. So now Rousseau went regularly to the Salon d'Automne to make sure his work was still on display.

Sometime later, he arrived outside Vollard's gallery again, this time with a painting two feet high, battling with the canvas against the wind. When he finally got it through the door, Vollard complimented him on it, remarking that the painting was surely good enough for the Louvre. In that case, said Rousseau, would Monsieur Vollard consider giving him a certificate, just something to prove he was coming along? It would help his case with the father of the woman he wished to marry, since the man, a high official in the customs office where Rousseau had been a lowly clerk, had forbidden the liaison and had since discovered that his daughter had been secretly meeting Rousseau. Vollard advised him to be careful, since, if the girl was under sixteen, he could be prosecuted. 'Oh! Monsieur Vollard! She is fifty-four . . .' As if that were not enough, there was the problem of his name; if only it had been not Henri but Léon. Why? asked Vollard. Well, the girl's name was Leonie. 'So you see, Léonie . . . Léon . . .' In later years, Vollard often wondered whether Rousseau's naivety might have been a mask he hid behind. Whether or not, like everyone else, he could not help but see him as 'good-nature personified'. Derain and Vlaminck were both fond of him (he was, said Vlaminck, like a concierge who had retained the imagination of a five-year-old) and both admired his work.

After purchasing the portrait of the schoolteacher, Picasso received an invitation to one of Rousseau's evenings at home with friends. In his minuscule studio, Rousseau regularly entertained, and Picasso and Fernande arrived to find the place crowded with people: the grocer, the milkman, the butcher, the baker, their wives and various others, perhaps the neighbourhood concierges, who stood around looking embarrassed, together with actresses, poets and artists, including Apollinaire, Salmon and Braque. According to Salmon, everyone (perhaps even the tradesmen) had dressed for the occasion – to visit Rousseau, one dressed more carefully than when invited by Poiret, and certainly more flamboyantly than for an evening at the Steins'. Rousseau's studio was lit with Venetian lanterns and decorated not only with beautiful paintings but also with French flags and yellow banners stamped with the eagle of the tsars. He

also owned all manner of military paraphernalia which had been produced (along with memorabilia including cigar cases, glassware and jigsaw puzzles) to celebrate the Franco–Russian alliance, which Rousseau had taken as a sign that universal peace was at hand. He looked after his souvenirs, Salmon remarked, the way maids in the old houses of France took care of the best linen. When Rousseau had guests, at one end of the room a small stool served as a stage. The chairs would be put in rows, one close behind another, the benches against the walls. The soirée would begin with various people singing, then Rousseau would play the violin, and follow up with a vaudeville song, '*Aie! Aie! Aie! Que j'ai mal au dents!*', miming all the gestures.

Perhaps to return Rousseau's hospitality, on 21 November 1908 Picasso threw a party for the *douanier*, which has gone down in history as the culminating banquet of the 'banquet years' that characterized life in Paris before the Great War. The story of Picasso's party for Rousseau is legendary. Fernande, Gertrude Stein and Alice B. Toklas have all described it, in marginally differing versions. As the time approached for the guests to arrive, up in the place Ravignan, Fernande was preparing for the party by producing vast quantities of the *riz à la valencienne* she had learned to make in Spain. To accompany it, she had ordered ready-made dishes from Potin, a local restaurateur who delivered prepared food in his smart, covered van. But her party was already in crisis. Her guests were due and the dishes she had ordered had still not arrived. (They finally turned up, too late, the following day.)

Leo and Gertrude Stein and Alice made their way to a nearby café, where they had arranged to meet Harriet, to find Marie Laurencin, already high on Dutch courage, falling in and out of the arms of Apollinaire. Fernande, as Alice recalled it, 'burst in upon us filled with the tragedy of Félix Potin not having delivered the dinner she had ordered', despite his reputation as *le "premier" de l'alimentation à Paris*'. Alice suggested telephoning, an indication of the scale of the emergency – or perhaps she thought of it because she had just seen Lucien Guitry in a play by Bernstein which

featured portable telephones, the first she had seen. Fernande duly telephoned, but Potin's was already closed, so she prepared to scour the district and pick up whatever she could from wherever was still open. They agreed that, while she did so, Leo would help Apollinaire get Marie Laurencin up the hill; Gertrude, Alice and Harriet would follow. By the time they arrived at the Bateau-Lavoir, Fernande had managed to find enough dishes to supplement the mountain of rice. She was arranging these on trestle tables, warning everyone not to lean on them and decorating them with ivy leaves, when Frédé from the Lapin Agile arrived, uninvited, with Lolo the donkey. They were abruptly ushered out again by the hostess.

In some versions of the story, Marie Laurencin entered the Bateau-Lavoir and fell straight into a plate of jam tarts. By now, she was more or less accepted by the male painters as one of the *bande*, though not by Fernande. Gertrude and Leo had just purchased Marie's group portrait *Apollinaire et ses amis*, in which she appears with Apollinaire, Picasso and Fernande, an endorsement of her talent – and of her place in the *bande* – which (especially given that Gertrude had already been shown Fernande's work and made no such investment) could hardly have endeared her to Fernande.

When Rousseau arrived (accompanied by Apollinaire, Picasso or alone, depending on the version of events), he was shown to the seat of honour at the centre of the table. Seated opposite him was his portrait of the Polish schoolteacher, Picasso's purchase and the reason the party had come about. Picasso opened the proceedings. Monsieur Rousseau, he announced, *cher grand maître*, we are very honoured by your presence. Braque played a little fanfare on his accordion to welcome the honoured guest to his garlanded throne. Rousseau responded in a formidable tone, and the celebrations began. Apollinaire then stood on the table to read his celebratory rhyming poem '*À Notre Rousseau*'; everyone joined in the chorus. When he had finished, he jumped off the table, whereupon Salmon seemed spontaneously to disappear. In some versions of the story, Rousseau then serenaded the company on his violin; in others, he

sat stupefied beneath a lighted candle, unaware that it was slowly dripping cooling wax on to his head. Apollinaire asked Alice and Harriet to sing 'the national song of the Red Indians' and was perturbed to be told they did not think the Red Indians had one.

It was late by the time everyone retired to André Salmon's studio to retrieve their coats. They discovered that Salmon, now apparently comatose, had eaten a telegram, a box of matches and Alice's best hat with the yellow feather trimming (at least, according to Alice's version). An open carriage was ordered to take the guests home, Rousseau, Gertrude, Alice and Harriet, with Leo sitting up front with the driver. As they drove down the hill, 'Salmon came running past us with a wild cry and fled ahead of us in the darkness.'

PART IV

Street Life

Modern Dance

Matisse had spent February 1909 in Cassis, studying the rhythms of sunlight on water as preparation for *La Danse*, the wall panel he was painting for Shchukin. Although he had begun tentatively, with a pale, dreamlike scene, by mid-April he had produced a second, more dynamic variant, quite different from the first. It showed dynamically charged nudes dancing in a ring against flat bands of abstract green and blue. Its overt, uncanny physicality unsettled even Matisse himself; he suffered months of nervous tension and insomnia as he continued with his work.

Shchukin, back in Moscow, had been disconcerted by the sketch Matisse had sent him in early March, alarmed by the naked dancers and the clearly bacchanalian mood and style of the piece. In fact, Matisse's influences had been varied – some classical, some personal. The work was inspired partly by Greek vases and also by his happy memories of the dancers at the Moulin de la Galette performing the farandole; he had always admired its 'fast tempo and beautiful movement'. Shchukin, however, initially saw only that the depiction of stark-naked figures might cause consternation if the painting were a decorative piece in his Moscow mansion. Nevertheless, having expressed his concern, he had swiftly followed up with a telegram and a letter confirming the commission: 'I have decided to defy our bourgeois opinions and display on my staircase a subject with THE NUDE.' At the same time, he commissioned a second panel, this on the theme of music.

The retreat to Cassis had been an escape for Matisse from the demands of Paris and his school. Students were still arriving in steadily increasing numbers from all over Europe and America, each hoping to see the wild leader of the Fauves at work and disappointed when the legend turned out to be a reserved, bespectacled

gentleman who retreated behind a screen to paint. By the time he moved, that spring, across to Hôtel Biron, where Rodin had his studio, he was already finding his students a source of stress – they seemed to expect spiritual guidance as well as technical instruction, and he was beginning to feel overburdened. With the prospect of funds forthcoming from Shchukin, Matisse began to investigate the possibility of moving his family as far from the centre of Paris as possible while still remaining within reasonable reach of the capital. When he found a house for rent at Issy les Moulineaux, Amélie was ecstatic. She recklessly took a cab all the way there and made the driver wait while she picked spring flowers in the big, rambling garden, where Matisse would paint in a portable studio among the lilac trees. The story astonished even Gertrude Stein, who remarked: 'In those days only millionaires kept cabs waiting and then only very occasionally.'

In fashionable Paris, the season was already in full swing. Posters in the streets from Montparnasse to Montmartre were advertising the imminent arrival of the Ballets Russes; photographs of the dancers adorned every Morris column in town. Articles appeared in the press even before the first performance, *Le Figaro* reporting daily on rehearsals and preparations for the opening night, 17 May. By the 10th, tickets were selling so fast that extra performances were announced. Diaghilev had worked hard on pre-performance publicity. In the spring of the previous year, he had followed his 1906 exhibition of Russian art with an entirely different kind of spectacle, realizing an ambition he had harboured since putting on musical concerts for the visitors to the exhibition. He had successfully produced Mussorgsky's *Boris Godunov* at the Paris Opéra, in the process courting influential figures including Gabriel Astruc, a concert promoter and theatre manager (and Rimsky-Korsakov's publisher) who was familiar with the financial and bureaucratic infrastructure of Paris. With their support, since the close of the opera, Diaghilev had been working on a new idea – to put before Parisian audiences a novel style of dance drama. Despite the success of *Boris Godunov*, it had been made clear to him that the Opéra

would not this time be at his disposal; the only available venue was the Théâtre du Châtelet, in those days normally home to operetta and variety shows, which sometimes included ballet (danced by the indifferently talented little 'rats' of Montmartre) in the interludes. He had spent the weeks leading up to the first performance supervising the refurbishment of the theatre.

Since the events of 1905 the young generation of dancers in Russia had become increasingly restless with the traditions of Theatre Street and hungry for innovative ideas. In St Petersburg, the previous two years or so had been a period of passing fads, including a short-lived attempt to introduce into the traditional repertoire ideas inspired by the cabarets of Paris. In Montmartre, the music halls and variety theatres were full of Russian dancers, including some from the Ballets Russes, since their shows were cheap to produce and the emigrées needed the work. In the Russian capital, such ideas had been tried, tested and abandoned until the arrival on the scene of the choreographer Mikhail Fokine, who had studied the theories of Stanislavski. A gifted dancer himself, he had debuted on his eighteenth birthday with the Imperial Ballet School (now the Mariinsky) and taught Nijinsky's sister, Bronislaw. He believed that virtuoso ballet techniques did not constitute an end in themselves; his genius lay in his ability to reconcile a more liberated style of dance with the techniques of classical ballet. In Moscow, Fokine had seen Isadora Duncan and recognized her as the first serious dancer to perform the art as pure self-expression. He had also discovered and recruited young Vaslav Nijinsky, twenty in 1909 and still completing his training, who seemed to dance by instinct, propelled by some inner force, his leaps apparently defying gravity. He could even dance *en pointe*, a skill rare among male dancers at the time. Fokine stressed the importance of the ballet as a medium in which all the elements should work together to draw the spectator into an all-encompassing experience and sought original ways of staging the integration of music and gesture, seeing the music as not merely the accompaniment to but an organic part of a dance.

Diaghilev's production of *Boris Godunov* had been not only a

musical triumph but a visual marvel – the star of the opera, renowned Russian bass Feodor Chaliapin, had worn a resplendent robe encrusted with embroidery and beading; the stage, as one member of the audience had remarked, had 'streamed with gold'. Diaghilev had spent the previous year in St Petersburg, visiting scene-painting workshops, production studios and sewing-rooms, as well as attending orchestra rehearsals, wanting to be involved at every stage and with every element of the production. His aim was to revolutionize not merely dance but sets and costumes, to create a radical whole. He told Serge Lifar (later his premier dancer and biographer), 'Artists, who all their lives deal with epochs, styles, plastic forms, colour and line, elements with which no ballet master can hope to be equally familiar, must in the very nature of things be their closest and co-equal collaborators in the process of creating a ballet. Then, in full awareness of the scenic effect of decor and groupings, the ballet master works out his choreography accordingly.' When he commissioned Léon Bakst to design and paint the scenery for the new production, he boasted that, for the first time in the history of the stage, the sets were to be painted not by the usual hack scene-painters but by an artist of distinction.

The fortnight preceding the first performance was 'arduous, feverish, hysterical' for the dancers. Since 1900, the Châtelet had produced little other than operettas, variety shows and, occasionally, films, and Diaghilev had ordered a complete transformation of the theatre. The proscenium arch was to be redecorated, all six floors recarpeted, most of the seats reupholstered and the first five rows of the stalls demolished. The pit was to be removed and boxes installed. At the back of the stage, workmen hammered and sawed at a new trapdoor and, beneath the stage, laid pipes so that water from the Seine could spout from fountains in the final act of the ballet. Works were still under way when the two hundred and fifty dancers, singers and technicians converged on the theatre, together with the eighty-piece orchestra. The stage hands regarded the ballerinas as lunatics: '*Ces Russes, oh la la, tous un peu maboule*' ('They're all a little bit crazy'). Squashed in between workmen, the dancers rehearsed amidst a din

that tested everybody's powers of concentration and drowned out the sound of the piano. 'For mercy's sake, I cannot work with this blasted noise,' yelled Fokine. A voice from the dark kept promising all should soon be quiet . . . and, suddenly, silence descended. It was noon, when everything stopped, as if by magic; the French workmen had disappeared for lunch. The Russians, sustained by dishes ordered in from local restaurants, worked on.

On the opening night, the Parisian audience gathered for the first ever performance by Diaghilev's newly formed Ballets Russes. The programme included *Les Sylphides*, Fokine's plotless, 'plastic' ballet, together with *Cléopâtre* and *Le Festin*, a Russian medley primarily designed to showcase the talent of Nijinsky. Now, the interior of the huge Théâtre du Châtelet, which ballerina Tamara Karsavina (later principal of the Royal Ballet and a founder member of London's Royal Academy of Dance) had called 'a retail shop of cheap emotions, the paradise of concierges', had been completely refurbished by Diaghilev. In this unlikely venue, the circle shimmered with the diamonds, bare shoulders and head-turning glamour of *le gratin parisien*; the front row was composed of models, blondes alternating with brunettes. Diaghilev's associates had even 'designed' the audience – 'itself a work of art' – which included French and Russian ambassadors and their wives, cabinet ministers, fashionable painters, fashion designers, illustrators and sculptors. Rodin was among them, so were Isadora Duncan and the ailing Yvette Guilbert (at forty-four, well past her prime as a *chanteuse*). So, too, were Alice B. Toklas and Gertrude Stein, although Alice, uncharacteristically, recorded their attendance without passing any particular comment. Perhaps what they saw at the Châtelet was as pleasantly incomprehensible to her (or to Gertrude Stein), in its own way, as had been Alice and Harriet's startling introduction to the Folies Bergère.

The audience watched the leaps, spins and turns of traditional Russian folk dance with quiet absorption until about halfway through, when Nijinsky danced a *pas de trois* with his sister, Bronislaw Nijinska, and Karsavina. There was an audible murmur of appreciation. A ripple of whispers ran through the auditorium.

Then something completely unexpected happened. At the end of the piece, Nijinsky should have walked off the stage, but that night, instead, he spontaneously exited with a leap: 'He rose up, a few yards off the wings, described a parabola in the air, and disappeared from sight. No one in the audience could see him land; to all eyes he floated up and vanished. A storm of applause broke; the orchestra had to stop . . . all reserve thrown away, the evening worked up into a veritable frenzy of enthusiasm . . . You would have thought their seats were on fire.'

Paris went mad for the ballet; almost nothing else was talked about in fashionable circles, and the press reported the invasion, the explosion, the outburst of the Ballets Russes. Overnight, it had brought exotica to the city, and modern dance now seemed to con-sist only of Diaghilev's ballet. At Larue's restaurant (where Marcel Proust sat quietly at a corner table drinking hot chocolate like a pale-green ghost), Diaghilev, his designers and principal dancers were joined by a clamour of admirers, including a new hanger-on, the young Jean Cocteau, a striking presence in lipstick and rouge, 'irresistible at twenty', dancing on the backs of the banquettes. Diaghilev's company, he said, 'splashed Paris with colours'. Dance, now, not only painting, fashion and film, had come to the streets.

By 1917, Picasso would be working with Cocteau on sets for Diaghilev's ballets. For the time being, however, he kept to Mont-martre, where the artists still gathered in the cafés and sat talking until dawn. New faces were beginning to appear, young artists and writers who just seemed to want to lark about, among them painter André Warnod and 23-year-old novelist Roland Dorgelès, who wore his hair long and strode about flourishing an ostentatious cloak. André Salmon thought he only went up to the Lapin Agile to chal-lenge everyone's obvious admiration for Picasso and his friends. Picasso, when he could be bothered, humoured the newcomers. 'When you paint a landscape,' he told them, 'it must first look like a plate.' There was no answer to that.

2.

Summertime

Picasso was out of town for the first appearance of the Ballets Russes in Paris. When the city erupted into full-scale balletomania, he and Fernande were back in Spain, this time in Horta, the rural village where (in late 1898 and early 1899) he had spent several months as a young man, recovering from scarlet fever. They arrived in Barcelona on 11 May and were met by fifteen of Picasso's old friends, a reception Fernande found overwhelming. She had been ill before they left Paris, and by the time they reached Barcelona was in real pain, exacerbated by the journey. There, they consulted doctors, who diagnosed a suspected kidney complaint. They advised her to rest and, for the next few weeks, she did her best to recover, spending most of every day in bed because sitting was too uncomfortable, the pain so acute she felt as if she were going to die; she was freezing cold, chronically exhausted and weak. They had had to stay on for three days in Barcelona because she was haemorrhaging blood – why didn't Picasso take her home?

He passed the time making pen and ink drawings in their hotel room. In what was already a period of major transition, the sketches were further breakthroughs, enabling him to find solutions to pictorial problems he had been preoccupied with for some time. From them, he said later, everything else developed: 'I understood how far I would be able to go.' He experimented with drawing fluid forms (palm trees from memory or his imagination) juxtaposed with geometric shapes (the local buildings), developing ideas he had been exploring since he met Braque. On 5 or 6 June they travelled on, finally reaching Horta, where they stayed until September, although Fernande was still in chronic agony which at times drove her almost to despair, and anxious about being in a place where it was impossible to get treatment and where there was nothing she

could do but eat carefully and rest. She confided her fears in letters to Gertrude Stein, telling her she found the landscape pretty and the people congenial, but she was still worrying about what would happen if she did not get better.

She was not in pain every day, however, and on good ones she mingled with the villagers, who were amazed by Picasso's corduroy trousers and by her hats, which she considered a success. Since there was no entertainment, Picasso arranged for the pianola in the nearest bar to be moved so that they could dance with the villagers. On Midsummer Day, bonfires were lit throughout the village and children jumped over the blazing straw, processing through the streets with torches. Picasso was overjoyed to be back, inspired and energized by his surroundings. On 24 June, he wrote to tell the Steins that he had begun 'two landscapes and two figures always the same thing'. He was also taking photographs of the landscape and of the local people to send to Gertrude, ostensibly to tempt her and Alice to visit him but keen also to keep Gertrude abreast of developments in his work. Fernande wrote several times to Alice, describing the beauty of the landscape. Perhaps spurred on by Gertrude's recent emergence as an author, Fernande told Alice she was writing with publication in mind; she would be happy for Alice to publish her letters . . . but after a while she had to stop: she felt too ill to continue.

The highlight of the summer was to have been a trip to Madrid and Toledo, where Picasso had hoped to rediscover El Greco – still an important influence. However, although, in July, he managed to persuade the local doctor to agree to Fernande accompanying him, in the event she was too ill to make the journey. While they were still hesitating about whether or not to go, there was a sudden revolt in Barcelona. The anarchists were protesting, principally against the Church, in a series of riots which affected most of Catalonia. Railway bridges were blown up and travel became, effectively, impossible.

In Horta, Picasso continued with his work. He was discovering how to transpose his new experiments with perspective, so far

confined to his still lifes and landscape drawings, into faces and figures. In about fifteen paintings of Fernande, he fractured her face, the ground and solid objects, creating facets so that the viewer could walk 'around' the face or figure as if it were sculpture, seeing it from different viewpoints, in the process developing the way of painting Vauxcelles had called cubist, but which Picasso himself saw as a method of uncovering forms that was unnameable, as elusive and impalpable as perfume – nothing, really, at all to do with cubes. Back in Montmartre that autumn, he modelled a sculpture of Fernande's head in plaster, afterwards casting it in bronze but, having once realized his vision in three dimensions, he went back to creating the painted 'sculptural' forms on canvas that remained his primary concern. Unlike Modigliani, he had no particular ambitions as a sculptor.

Gertrude and Leo, Michael and Sarah Stein and their son, Allan, travelled to Florence for the summer, to the large Villa Bardi they rented in Fiesole. Alice and Harriet, at Michael's invitation, came to stay in the smaller Casa Ricci nearby. Their rail journey to Milan, as described by Alice, was colourful: 'Because of the heat I got rid of my cerise ribbon girdle in the dressing room of the train, throwing it out the window. When I returned to our compartment Harriet said, "What a strange coincidence, I just saw your cherry-coloured corset pass by the window."' They were driven from Florence to Fiesole, where they found Gertrude waiting to meet them.

In the mornings, Gertrude would come down to the Casa Ricci to collect Alice, and the two of them would go to Florence to borrow books from the Vieusseux library, or to run errands. In the city, Alice had boots 'beautifully made to order, the only luxury I allowed myself – or, rather, Mike allowed me'; Michael Stein was by now managing her finances, along with everybody else's. The whole party was in Florence the day on which Gertrude's book of stories *Three Lives* was published, an event that made the author 'rosy with pleasure'. Soon, reviews started appearing: 'Those were proud and happy days when we received the first clippings.'

By the time they returned to Paris, in September, Alice and Harriet had decided it was time to resume their search for an apartment of their own. (Alice's way of settling Harriet somewhere permanent, in preparation for her own move to the rue de Fleurus?) This time, they found one (for reasons Alice was later unable – or just too diplomatic – to recall) in Montmartre, in the rue Notre Dame des Champs, a location remarkably inconvenient for the rue de Fleurus. They proceeded to set up home, Alice hemstitching net curtains, buying cushions and hiring a servant, the niece of Gertrude's concierge. Gertrude resumed work on her masterwork, *The Making of Americans* (begun in 1903, taken up again in 1909 and completed in 1911). When she gave sections of it to Alice to read, Alice found portraits of all their friends, including 'an extraordinary one of Harriet', impossible for any reader outside their circle to identify definitively as such within the convoluted weave of the narrative, composed as it is of fluid, intricate descriptions of complex personality traits. Gertrude's narrative delved deep beneath the surface of a personality as she experimented to convey, in a faceted language nuanced with repetition, the inner lives of an ever more sprawling and indistinct array of characters, all of whom seemed to fuse and interlock at the level of the unconscious. The subject, as she baldly announced it on the opening page, was to be 'The old people in a new world, the new people made out of the old.' She continued with the assertion that personality is inherited, through antecedents and nationhood: 'We need only realize our parents, remember our grandparents and know ourselves and our history is complete.' She then proceeded, in over nine hundred pages, to examine the caveats and complexities, subtleties and shades of this tantalizingly misleading statement, developing the idea that, despite the durability of each person's 'bottom' or basic nature, the difficulty of being human is to do with the structure of personality as a whole, which consists of any number of other contradictory or complementary elements, layered up in a kind of nuanced free-form.

The narrative was infused with ideas based on Gertrude's earlier study of psychology. Alice read that there were two kinds of human

being, the 'dependent independent' (the 'resisting kind') and the 'independent dependent' (the 'attacking kind'). In 'resisting' people, 'emotion is not as poignant . . . as sensation'. In the 'attacking' kind, 'their substance is more vibrant in them, these can have reaction as emotion as quick and poignant and complete as a sensation'. The resisting kind were slower to respond, made nervous if under pressure to act too quickly, whereas the attacking kind might have more natural nervous energy but, if deprived of that nervous energy, they might lose the power to act. The 'attacking' types were actually the more conservative, their conservatism shored up by the convictions and traditions they were 'attackingly defending'. Of the 'resisting' type, wrote Gertrude Stein, slowly one felt 'the muggy resisting bottom that kept her from ever giving herself to any one unless some one needing her engulfed her by a need of her . . .'

Was she pondering on the differences between Harriet and Alice, even speculating as to why it seemed so difficult to prise them apart, even after the release of the old maid mermaid and the gathering of wild violets? In Fiesole, Alice and Harriet had been photographed clasped in an affectionate clinch. Gertrude, on the other hand, posed for her photograph alone, seated on a large stone, staring ahead like the Buddha in an attitude which resoundingly announces her solitude. *The Making of Americans* weaves fiction with reflections and includes, in the midst of the ongoing 'resisting'/'attacking' meditation, a cryptic personal note: 'I am all unhappy in this writing. I know very much of the meaning . . . I know it and feel it and I am always learning more of it and now I am telling it and I am nervous and driving and unhappy in it. Sometimes [some day?] I will be all happy in it.' She need not have worried: Alice (despite appearances) was about to take things in hand. Gertrude's research also consisted in closely observing and listening to everyone around her, including Alice, whom she asked to tell her everything she knew and how she came to know it. This Alice found 'very exciting, more exciting than anything else had ever been. Even, I said to her laughing, more exciting than Picasso's pictures promise to be.' She had been given the task of typing the manuscript, for which the latest technology

had been acquired. 'I had commenced the typewriting of *The Making of Americans* on a wornout little Blickensderfer. Gertrude decided we should have a proper machine, and Frank Jacot recommended that we buy a Smith Premier. We ordered one. It was a formidable affair. There were a great many appliances removed by an imposing personage who had delivered the machine. He put them in his bag, and I was surprised that they were not deducted from the bill.' Alice soon became proficient, achieving 'a professional accuracy and speed. I got a Gertrude Stein technique, like playing Bach.' Each morning, she made her way from the rue Notre Dame des Champs to the rue de Fleurus, where she typed until Gertrude, a very late riser, appeared for her breakfast coffee at one o'clock. Then they would talk over Gertrude's work for that day, which Alice would type the following morning. 'Frequently these were the characters or incidents of the previous day. It was like living history. I hoped it would go on for ever.'

Alice began to go down to the rue de Fleurus in the evenings as well, a habit Harriet disapproved of. She was concerned about Alice being out alone on the streets of Montmartre at night, particularly when she started coming home after midnight. The nocturnal walks passed without incident until, one evening, Alice was walking down the rue Vavin, where the pavements were very narrow, when she was suddenly aware of a man standing facing her. '*Eh bien*,' he said, did she not intend to let him pass? Never, replied Alice. '"How difficult the Creoles are," he said as he stepped off the sidewalk.' When she heard about this, Harriet was not amused. In fact, it was worse than unfunny, it was the final straw. In a rare display of initiative, she soon afterwards announced that she had invited a friend, Caroline Helbing, over from America to stay with them. She would put up at the hotel and join Alice and Harriet for lunch and dinner. It was all arranged, and Caroline was already on her way. When Caroline arrived in Paris, she was introduced to the female *bande*. Alice took her out to lunch to meet Fernande and Marie Laurencin, who reciprocated by inviting the group to her home to meet her mother, Pauline, an unprecedented event. Marie's affair with

Apollinaire had come to an end that year – more of a catastrophe, by that time, for him than for her – and Marie was cloistered once again with her mother. Fernande called for Alice, Harriet, Caroline and Gertrude and they all made their way to the Métro station – another first, at least for Gertrude. By the time the train pulled in at the first stop, she had seen all she wanted of life underground. 'Come on,' she said, 'we are getting off here, we will take a fiacre.'

At the foot of rue Fontaine, they located Marie Laurencin's apartment. The friends were invited into two rooms, which seemed to Alice as sparse and orderly as the rooms of a convent, painted white and devoid of decoration except for some of Marie's drawings. Marie asked Pauline to show the ladies some of her (Pauline's) embroideries, all of which seemed to be of monkeys, for which Marie appeared to have a weakness. She also showed them some wallpaper she had designed, with monkeys swinging from trees. They were then served 'very delicate tea'; Alice thought Marie must have crossed the river to find a good pâtisserie. At some point, Alice had evidently enquired about Marie's background, since she somehow gleaned – in an interesting mix of truth and dissemblance – that Pauline was from the Savoie and that, as a young woman, she had had an affair with a man rumoured to be the Préfet du Nord. Pauline said she had never seen Marie's father after her birth. (Marie did not learn until some years later that the monsieur who visited throughout her childhood – who was indeed, as it transpired, the Préfet du Nord – was actually her father.) As for Fernande, Alice noted that in the presence of Pauline, she was suddenly 'on her very best behaviour'.

3.

New Directions

When Picasso and Fernande contacted Gertrude Stein in September 1909, it was to invite her to their new home at 11, boulevard de Clichy. They had moved in that morning, though they were far from properly installed. Before they left Montmartre, Vollard visited Picasso in the Bateau-Lavoir, buying so many pictures (thirty, for two thousand francs) that by the time he had them all piled in a cab ready to leave, there was no room for him. Bystanders stood amazed as he climbed up beside the driver for the return journey. Picasso and Fernande were able to furnish the new apartment so lavishly that one of the packers remarked, 'these people must have hit the jackpot' as he heaved in all their new possessions.

The couple sent Gertrude an invitation each. Picasso's included a postscript, 'Shchukin has bought my picture at Sagot's, the portrait with the fan.' This was one of Picasso's earliest cubist portraits of Fernande, seated in an armchair. This apparently casual afterthought in fact marked the commencement of a significant new phase in Picasso's fortunes. Shchukin's first purchase of a work by Picasso was immensely significant, since it signalled an interest in abstract work which soon established the Russian dealer as one of the major purchasers of cubist pieces. Though it is sometimes assumed that Matisse had introduced Picasso to Shchukin, this is by no means certain (especially given the 'two-man race'). In fact, the collector had somehow become acquainted with Fernande; his purchase of *Woman with a Fan* (1908) was just as likely to have been influenced or even suggested by her. Though he did not immediately take to cubism, as Shchukin learned more about its methods, he began to follow its development carefully. Reluctant at first to add Picasso's work to his collection, since he felt it would strike a dissonant note, he was eventually persuaded, hanging *Woman with*

a Fan separately from the gallery which housed the rest of his collection, in a dark corridor where he passed it every day. Before long, it began to exert a strange hold over him. In the same way that he had found the more sensually charged works of Matisse and Gauguin cathartic, looking at Picasso's work, he experienced another kind of catharsis, this time of loss and grief, responding powerfully to what he described as the darkness of Picasso's work and reminded of the traumatic deaths of members of his family during and following the events of 1905 by Picasso's ability to take the viewer right through into the inner structure or essence of the picture in works the Russian described as 'ghostly'.

Kahnweiler was quick to observe that Shchukin was so far the only major admirer of cubism. The next time Picasso sent the former a whole series of works, Kahnweiler telegraphed Shchukin in Moscow, who immediately set out for Paris. That year, 1909, was the year Shchukin opened his Moscow mansion to the public to show his collection of French avant-garde works (Monet, Gauguin, van Gogh, Derain and Matisse); and he began to collect Picasso's work with a vengeance.

Gertrude and Leo Stein purchased two of Picasso's new landscapes of Horta, *Reservoir View* and *Houses on the Hill* (both painted in 1909). Gertrude said, 'When I hang these on the wall, everyone will naturally start protesting.' She was reassured when Picasso produced some photographs he had taken of the place; 'it always amused me', she wrote later, 'when everyone protested against the fantasy of the pictures to make them look at the photographs which made them see that the pictures were almost exactly like the photographs . . . Certainly the Spanish villages were as cubistic as these paintings.' She would always see these particular paintings as 'really the beginning of cubism', proof, so far as she was concerned, that cubism was essentially a Spanish conception. If Gertrude's conviction that 'only Spaniards can be cubists' was her way of explaining why she had failed to take much notice of Braque, she was certainly quick, as ever, to recognize the significance of new directions in Picasso's work.

By September 1909, Picasso's works had been selling so success-fully (during the past year, Leo and Gertrude Stein had acquired a large number) that he could have afforded to leave the Bateau-Lavoir earlier than he did. Perhaps Fernande finally put pressure on him to move, or perhaps he realized his opportunities for advancement would be significantly increased away from the ramshackle en-vironment of *haute* Montmartre and the Bateau-Lavoir. In *bas* Montmartre and Clichy, new dealers were rapidly establishing themselves, and Picasso's increasing success meant that he was able, had he wished it, to move in more elevated circles. (Also, the first of his paintings crossed the Atlantic, in the hands of Max Weber.) Although the couple had gone only as far as the foot of the hillside, they were now in a very different social arena. Gradually, one after another, by 1909 artists were beginning to leave Montmartre, as the serious artistic centre of Paris began to shift towards Montparnasse.

Despite his move to Clichy, Picasso retained both studios in the Bateau-Lavoir, as well as a third, which he sometimes used, at the foot of a garden in the rue Cortot, where, away from the watchful eye of Fernande, he had been trying out new ideas – and new female models. Although he now had a large, airy studio in the boulevard de Clichy apartment, he had no wish to make a definitive break with Montmartre. It was still the environment he found most inspiring. Matisse used to see him in 'the humblest galleries where the *"jeunes"* showed their work, always scrupulously keeping in touch with what his contemporaries were doing'. Another reason for delaying the move to a more salubrious address may have been that Picasso was still wary of anything to do with money. He kept his earnings in wads of notes stuffed in his inside pocket, secured with a safety pin, he had no confidence in banks and hated financial transactions. When he needed to pay someone, he made such inadvertently con-spicuous efforts to delve discreetly into his overcoat pocket that no one could help noticing. It was beginning to be a source of amuse-ment, especially when, one day, he noticed 'the pin wasn't fastened quite as usual. He looked searchingly at everybody ... convinced that somebody had been tinkering with his "safe".'

In the boulevard de Clichy, the two homeowners were as astonished as everyone else by the difference between their old premises and the new. This apartment was furnished eccentrically, reflecting Picasso's penchant for bizarre knick-knacks. In preparation for the move, they had gone on a hunt for furniture, since there had not been much to take with them from the Bateau-Lavoir other than linen, easels and books; they had lived for years in an atmosphere of makeshift bohemianism, sleeping on a bed base too short to accommodate their feet, eating on a table which had to be moved into a corner afterwards and hanging their linen to dry in an old wardrobe. Here, everything worth transporting from the Bateau-Lavoir fitted into the maid's room. They now ate in a dining room with mahogany furniture, served by a maid in a white apron (whose room, presumably, was full of junk), and slept in a deep bed mounted on heavy leather castors. At the back of the apartment was a little salon with a divan, a piano and various items of acceptable furniture, including a pretty Italian piece encrusted with ivory, pearl and tortoiseshell sent by Picasso's father. The walls were hung with African masks, carpets and musical instruments. On the tables, Picasso displayed the Negro carvings he had been collecting for the previous few years. Fernande made a point of these in her memoirs, where she records that it was Matisse who first discovered the artistic value of these African works, then Derain; but now that he had somewhere to store them, Picasso became fanatical about them, taking great pleasure in hunting down and accumulating statues, masks and fetishistic objects from every African country. Fernande admired them, too, especially those with necklaces, bracelets and beaded belts she would have liked to wear herself.

The spaciousness of the new apartment was enhanced by its outlooks. The apartment had windows at both front and rear, a luxury after the Bateau-Lavoir's single, bleak outlook across grimy rooftops. Leaning out of the windows, they could enjoy the sun, a view of trees, and even hear birdsong. In Picasso's studio in the boulevard de Clichy no one was allowed to touch anything, and no one entered without permission; the maid was authorized to clean only after he

had tidied it himself. He worked there from early afternoon until dawn, so, in the mornings, they left him asleep and, because nothing could start early, even the maid took to getting up late. Nevertheless, despite the choice of studios and all these domestic improvements, Picasso seemed unhappy.

He was not enjoying the social responsibilities he seemed to have acquired along with their new address. They were now 'at home' on Sundays and soon began receiving invitations from all kinds of socialites and celebrities. Perhaps they made him feel small. As Gertrude Stein noted in *The Making of Americans*:

> Some . . . spend all their living struggling to adjust the being that slowly comes to active stirring in them to the aspirations they had in them, some want to create their aspirations from the being in them and they have not the courage in them. It is a wonderful thing how much courage it takes even to buy a clock you are very much liking when it is a kind of one every one thinks only a servant should be owning. It is very wonderful how much courage it takes to buy bright coloured handkerchiefs when every one having good taste uses white ones or pale coloured ones, when a bright coloured one gives you so much pleasure you suffer always at not having them. It is very hard to have the courage of your being in you, in clocks, in handkerchiefs, in aspirations, in liking things that are low, in anything.

Picasso's collection of strange possessions did not appear to be a problem for him, but he was uncomfortable with his new social identity. With his work at a turning point, he found all social interruptions irritating; even Saturday evenings at the Steins' had begun to pall. Fernande failed to see why he did not simply turn down invitations. She, on the other hand, was in her element. Paul Poiret had invited them to join him on his colossal houseboat, *Le Nomad*, his pride and joy. It was moored on the Seine, and on it he gave lavish parties for his artist friends, taking along his cook from Paris and his accordion, with which he entertained his guests. Poiret was keen

to bring his friends, including the artists whose works he was purchasing, together on *Le Nomad*, where, after a good dinner, he plied everyone with the best Calvados and *marcs* and initiated long conversations about art and literature, particularly seeking everyone's opinion on his favourite subject, beauty. He was disappointed, however, when he tried to encourage them to take up their brushes; nobody seemed to want to rise to the challenge of painting riverside scenes from on board *Le Nomad*. The days of Impressionism were over; the painters were all talking about geometry, space and perspective.

During the next few years, Poiret was to form the private opinion that cubist paintings were merely artist's sketches and should never be seen outside their studios. He was already sceptical about the directions modern art was moving in; and the way the painters seemed to lose interest in their art once on board *Le Nomad* seemed to him odd, compared with his own reputation for industry, which continued to earn him fabulously wealthy, if temperamental, clients. Diaghilev's backer, the Comtesse de Greffuhle, had caused something of a stir when she visited Poiret's salons to try on a golden dress for her daughter's wedding, 'a marvellous gold sheath, bordered with sable' that made the entire salon look like a fairy's chamber. Having lifted her head and 'pointed her nose in every direction', she announced, 'I thought that you only knew how to dress *midinettes* and hussies, but I did not know that you were capable of making a dress for a great lady.' Those *midinettes*, replied Poiret, were the very seamstresses who had made her dress; and 'the great ladies of Belgium could always trust themselves to the taste of the *midinettes* of Paris'. When the comtesse visited again, his saleswoman quoted prices which had suddenly become astronomical; Poiret wasted no time with disrespectful clients. Other visitors included the British Prime Minister's wife, Margot Asquith, who had entered his Paris salons 'like a thunder-clap', displayed her violet satin knickers and nearly destroyed Poiret's reputation, along with that of the Prime Minister (a committed Free Trader). She had recklessly invited Poiret to show a collection at Downing Street,

which had been embarrassingly successful – 'FRENCH TRADE REP-RESENTED BY THE ENGLISH PREMIER', ran the headlines the following morning. Poiret and his trunks of fabulous garments had been promptly and unceremoniously dispatched back to France.

In his own country, Poiret was equally unabashed by scandal. One Sunday afternoon, he attended the Longchamp races accompanied by three attractive models dressed in his latest creations, Hellenic gowns, the sides split from knee to ankle and displaying glimpses of coloured stocking. Outrage. 'Wives dragged husbands towards the exits. Timid maidens dropped unconscious into the arms of eligible bachelors.' The scandal rocked the French nation, energetically inflamed by the press: 'Those gowns are . . . the worst of all the recent insanities' (*Le Figaro*); 'I shall have the charity to refrain from mentioning the name of the couturier who is guilty of this outrage' (*La Vie Parisienne*); 'To think of it! Under those straight gowns we could sense their bodies!' (*L'Illustration*).

In Issy les Moulineaux, Matisse was still working on *La Danse* and *La Musique*. With the move to Issy, he had made a definitive break with the artistic life of Paris. The house there was secluded and remote; when, occasionally, he returned to the city, he felt like an outcast. On one visit he wandered into a café in Montparnasse where Picasso and his friends were gathered; when he seated himself at the next table, they failed to acknowledge him. The episode compounded his feelings of rejection and increased his resentment of Picasso's popularity; everyone (perhaps especially Shchukin) now seemed to be converging on his rival. Perhaps the Picasso gang found it hard to forget that Matisse's Salon d'Automne committee had rejected Braque's work. And Matisse's feelings of acute anxiety and insecurity may not, despite appearances, have been any keener than Picasso's. Or, perhaps, in the busy, crowded café, the Picasso *bande* had simply failed to notice him. Whatever the reason, as Matisse himself put it, 'I rolled myself into a ball in my corner as an observer, and waited to see what would happen.'

The last two students to join his school had included two Russian

girls, unchaperoned and (unusually for those days) living independently. Maria Vasilieva and Olga Meerson had only recently arrived in Paris, where Olga had just exhibited with the official Paris Salon. An attractive redhead, she had studied at the Moscow School of Art before, in 1889, aged twenty-one, she had left home to join Kandinsky's colony of artists in Munich. Matisse told her that if she wished to study with him she would need to unlearn all she knew. She took two weeks to think this over before agreeing, whereupon the two girls moved into rented rooms in the attic above the Matisse family lodging. In October 1909, she visited him regularly in his new studio to pose for a sculpted clay nude. His connection with her was exhilarating for them both, especially as it coincided with a period of major new developments in his work. That year he also made experimental *bas relief* wood carvings, including a large figure study, *Nu de dos*, which he eventually created in three versions (the second in 1913, the third in 1916/17). The 1909 version is roughly carved, primitive, Gauguinesque. He later said of his work in wood, 'I did sculpture when I was tired of painting, for a change of medium. But I sculpted as a painter.' The agreement he had made with Félix Fénéon meant that, for the first time in his life, he now had the prospect of a regular income, since the Bernheim-Jeunes had firmed up their agreement to buy everything he painted for a fixed price (ranging from 1,875 francs for a large painting down to 450 for the smallest), with a royalty of 25 per cent on sales. Even so, the responsibility of the annual rent of three thousand francs on the new house and all the usual anxieties about the children's health and schooling continued to worry him. Work on *La Danse* and *La Musique* required intense effort and stamina as well as sustained periods of solitude, but even in the relative isolation of Issy, he could not slough off the responsibilities of family life, nor stop himself feeling inadequate and anxious.

The winter of 1909/10 brought spectacularly turbulent weather to France. It rained and snowed incessantly throughout half the country, causing conditions unprecedented for three centuries, especially

in the region of Paris, where the storms persisted unabated. At the turn of the year, snow fell in Montmartre, turning everything white. The streetwalkers' hair and make-up looked blacker, redder, than ever, their faces like masks against the strange light of dusk in the snow. At the foot of the Butte, the omnibus ran as usual, those on the roof crowded beneath a jostling huddle of umbrellas. The pavements shone. The lights of the place Blanche showed dully through squalls of wind, and snow hurled against the sodden benches, grey façades, newspaper kiosks and rooftops, though the sun sent blazing reflections through the branches of the trees amidst the whirling flakes.

On 26 January 1910, the Seine burst its banks and began piling up flotsam as, all along the river, the embankments burst, submerging the quays. Weeks went by and the river rose ever higher, at the Pont de l'Alma reaching almost to the shoulders of the four statues of soldiers on the bridge supports. Tugs and barges were thrown up, strewn across the nearby streets and left stranded. The bridges were impassable. Parisians gathered to watch the roaring, icy Seine as it foamed through the city. Not until the beginning of March would it eventually subside and return to its bed; the river traffic was finally able to run again after the apocalypse had broken, after well over a month.

The time had come for Harriet's friend Caroline to return to America. Alice took her to the boat train. 'I said to her, "Caroline dear, you must see that when Harriet goes back to America she does not return to Paris because it is already arranged that I should go to stay with Gertrude and Leo at the rue de Fleurus." "That is what I suspected," said Caroline, "you can count on me."'

4.

Flight

In January 1910, Fernande underwent surgery for her illness, from which she made a good recovery. Picasso had put the lease of the new apartment in her name, a sign, perhaps, of his insecurity about the move, as well as a way of placating (or reassuring) her. Nevertheless, it was already clear that their relationship had again begun to unravel. At the Steins' one Saturday evening, a full-scale row broke out when Fernande provoked Picasso by declaring that even the neighbourhood gangsters were better people than artists. Picasso replied, 'yes apaches of course have their universities, artists do not'. Fernande shook him until a button fell off his jacket, yelling, 'you think you are witty but you are just stupid . . . your only claim to distinction is that you are a precocious child'.

At the Salon des Indépendants that spring, the painting that attracted particular attention was an eye-catching, semi-abstract work entitled *Et le soleil s'endormit sur l'Adriatique*, painted by a clearly prodigiously gifted newcomer, named as Joachim-Raphael Boronali. The painting, however, turned out to be a hoax, carried out by Raymond Dorgelès, acting on a bet. He had produced it by tying a brush loaded with paint to Lolo the donkey's tail and – despite protests from Frédé – placing a large canvas behind the tethered donkey's back. No one was particularly scandalized – as someone remarked, if this prank had backfired, there would have been another. These sorts of jokes were typical of the new generation of artists and writers beginning to infiltrate Montmartre, though to Picasso and his friends, they were beginning to wear thin. All Picasso really wanted (like many artists, perhaps) was to live 'like a pauper, but with plenty of money'. Fernande complained that, apart from his work, all that seemed to interest him were the mounting piles of

masks and ceremonial figures, bronze, pewter and porcelain orna-
ments and his growing collection of bizarre *objets trouvés*, including
a little church organ which emitted a faint scent of incense when
the bellows were pumped.

Despite Picasso's reluctance to socialize, the couple regularly
entertained, waited on by their new maid in cap and apron; their
table comfortably sat four or five, but there were often many more
squeezed around it. Much as she enjoyed playing hostess, however,
the days were gone when Fernande had been content to stay at
home. Temptation lurked in the form of the Taverne de l'Hermitage,
conveniently located on the boulevard Rochechouart immediately
opposite their apartment, where regular performers included a San
Franciscan with a repertory of Negro songs and dances and a female
acrobat who was soon posing for Picasso. Incomparably livelier and
flashier than the old Lapin Agile, l'Hermitage attracted a large, var-
ied clientele, including people in sports and show business as well as
the 'pimps . . . clowns, acrobats, equestriennes and tightrope walk-
ers, who rekindled [Picasso's] delight in the circus'. The place was
also frequented by celebrity boxers, in whom Picasso and his friends
took a great interest; an especial favourite was Sam McVea, because
they thought he looked like Braque.

At l'Hermitage, codes of behaviour were urban and savvy; there,
people conducted themselves in nothing like the way they had in
the Lapin Agile. Women came in unaccompanied to meet young
men who stood about 'like characters from a Carco novel', waiting
for them to make an entrance. Occasionally, during the course of an
evening, a girl would ostentatiously abandon her partner for an art-
ist, causing a scene. There were ugly debacles, between drinkers as
well as lovers. Once, someone pushed past Picasso, and he punched
the man on the jaw, escaping with his life only because Braque inter-
vened, a victory for which Picasso nevertheless took the credit.
Everyone had their own clique and their own established corner of
the tavern. Groups of strangers eyed one another up suspiciously:
'Strange, disturbing figures would stand watching the group of art-
ists as they sat in their corner on the right side of the café, not too

near the orchestra . . .' Popular music, too, was on the brink of change; whereas everyone had found the orchestra charming up in the Moulin de la Galette, here it seemed embarrassing; people stood huddled in their cliques, as far away from it as they could. As Fernande later reflected, it might have been different had the band played Negro music, but, though in many ways, in 1909, everyone would have been ready for it, the days of black musicians and Josephine Baker were still to come.

One of the regular crowds at l'Hermitage consisted of dashing young Italian Futurists; they included Gino Severini, in Montmartre since 1906, when he had come to Paris to study at the Académie Julian. The Futurists' article 'The Founding and Manifesto of Futurism' had appeared on the front page of *Le Figaro* on 20 February 1909, signed by Filippo Tommaso Marinetti, who was intermittently in Paris (he had studied for his baccalaureate at the Sorbonne. After taking a degree in law at the University of Pavia, he had decided instead to become a man of letters. A minor car accident near Milan in early 1909 had had the effect of transforming his character: he became a pioneering advocate of modernism, determined to abolish art nouveau and all it stood for). The eleven tenets of the 1909 Manifesto hailed the onset of the modern age, in which advances in technology, the speed of travel and the uninhibited expression of emotion would be applauded. The Futurists would 'hymn the man at the wheel'. Aggression became a positive quality: 'No work without an aggressive character can be a masterpiece.' Cowardice was derided. The Futurists' vision was unashamedly iconoclastic; to make way for the future, they urged the wholesale destruction of the past: 'We will destroy the museums, libraries, academies of every kind . . .'

The manifesto had attracted widespread attention, which, a year later, showed no sign of waning. In 1910, two further manifestos appeared in Italy, the 'Technical Manifesto', published as a leaflet by *Poesia* in Milan on 11 April, and the 'Manifesto of Futurist Musicians', published in Bologna on 11 October. The former set out the Futurists' programme for 'the renovation of painting'; Severini was

among the signatories urging artists to be concerned no longer merely with form and colour, nor with simply reproducing a fixed moment on canvas. The aim of modern art was the expression of 'the *dynamic sensation* itself', already the concern of Picasso and others (and of Gertrude Stein, in writing), since the exhibition of Cézanne's works in Paris in 1907. The Futurists' other key focus was on the creation of perpetual motion; they urged artists to see human figures not as static entities but rather as 'persistent symbols of universal vibration'. And their agendas embraced one other major change – the nature of the artist's engagement with the audience. The Futurists' aim (like Cézanne's and, latterly, Picasso's) was to 'put the spectator in the centre of the picture'. In Paris, that revolution in the structure of seeing was already happening, begun in Montmartre, and central to the aims of both Picasso and Braque. The concerns of radical young artists in Italy seemed now to be converging with those of artists in Paris, though it would be impossible to determine the extent to which any of the Futurists' ideas were actually inspired by Severini's conversations with the artists (including Modigliani) he met in Montmartre.

While Diaghilev re-created the ballet as dynamic visual spectacle, while the Futurists worshipped sensation and speed, other advances were progressing, albeit at a more gradual pace. Anyone looking for Picasso and Braque in 1910 might well have found them on the outskirts of Paris, at the aerodrome at Issy les Moulineaux, watching as extraordinarily flimsy-looking contraptions made their perilous way into the air, the pilots, in helmet and goggles, seated precariously up front in their open-air cockpits. The pioneering flights of Wilbur and Orville Wright were the talk of France. In their studios, Picasso and Braque made paper sculptures and 'flying machines', mock bird constructions perhaps inspired by the Wright brothers' inventions. They used paper sculptures to experiment with three-dimensional construction, exploring techniques they fed back into their paintings. Braque showed Picasso methods of gluing the paper together so that it did not buckle but, even so, Picasso's sculptures

often had to be secured with pins. (Unfortunately, none of these sculptures survived; what came next were Picasso's and Braque's *papier collé* works, and the original inspiration for those was as much Braque's painting as the paper sculptures, since in some respects they harked back to the structural discoveries Braque had made two or three years earlier in his landscapes of L'Estaque.)

Wilbur Wright, particularly, was a popular hero in France from 1908 – the year of his public exhibition flight near Le Mans – until his untimely death from tuberculosis in 1912. The brothers had been working on aeroplanes since 1900. Their first successful flight, lasting fifty-nine seconds, was in 1903 and, during 1904 and 1905, they developed their flying machines into the first practical wing-fixed aircraft, using techniques that meant the craft could be effectively steered and its equilibrium maintained in the air. In 1906, Dumont in France made a short flight; in 1908, Wilbur Wright broke his record by flying for ninety-one minutes. Both Picasso and Braque were fired up by the idea of flight and closely followed Wilbur Wright's career. They both wore 'Vilbours', the replicas of the pilot's familiar peaked green cap on sale in all the department stores, and Braque acquired a new nickname, 'Vilbour'. Picasso was 'Pard', after 'Pardner', Buffalo Bill's sidekick. (The Buffalo Bill stories were now available in paperback and had begun piling up in the tin bath where Picasso kept them, with his regular instalments of books containing the adventures of Sherlock Holmes and Nick Carter.) Men could fly. 'If one plane wasn't enough to get the thing off the ground,' Picasso observed, 'they added another and tied the whole thing together with bits of string and wood, very much as we were doing.' In the modern world, he had decided, people no longer wanted painting, they wanted 'art', which included mass-produced objects. He and Braque would inspect a work and value it according to whether it consisted more of Dufayel (a department store) or the Louvre: 'And we judged everything like that. That was our way of judging the paintings we looked at. We said: "Oh no, that's the Louvre again. But there, there, is just a little Dufayel!". . .' The Futurists' aims may well have been behind this, with their denunciation of the

'eternal and futile worship of the past' and advocation of the destruction of museums; though neither Picasso nor Braque would have gone along with the Futurists' conclusion that art 'can be nothing but violence, cruelty, and injustice'. Perhaps, after all, the Dufayel/Louvre test was just (or at least, partly) a joke. At around this time, Vlaminck visited Derain in his studio in the rue Tourlaque. He found him flying a model aeroplane of his own invention, with a rubber propeller wound around a large bobbin, looking on with his typical air of bemusement as it collided with the furniture, crashing into glass and pots and tearing canvases.

Overtly or covertly, from early 1910 onwards, the Futurist agendas reflected or coincided with a turning point in the artistic life of Paris. New ideas, as reflected in the work of Picasso, Braque, Matisse, Bakst and others, and the desire to slough off old constraints increasingly reflected the way everyone now worked with a conscious eye to the future ... everyone, that is, except Modigliani. When Severini asked him to join the Futurists, he declined, saying he wanted nothing to do with any movement that called for the destruction of museums. In any case, he had other distractions. That summer of 1910, he enjoyed a brief liaison with 25-year-old Russian poet Anna Akhmatova, who had arrived in Paris with her husband. When he left to return to the family estate in Slepnyovo, she stayed behind and spent the rest of the summer wandering through the streets of Paris with Modigliani. Though she was barely at the start of her career as a poet and he was unable to read Russian, she translated her poetry for him and he recognized the power of her poetic intuition. When she left Paris, she promised to return. All winter long, they corresponded, Anna responding to Modigliani's love letters with poems. When she came back the following summer, she made her way to his studio, her arms full of roses. When she found it empty, she threw her flowers through the open window (perhaps she had seen *Columbine*, the movie of 1911 in which the heroine makes the same gesture). While Anna's husband attended seminars at the Sorbonne, she and Modigliani spent their days strolling through the Jardins du Luxembourg and exploring the

Latin Quarter and the Louvre. Inspired by the art of ancient Egypt, Modigliani made drawings of Anna's head; her face was slight, doe-eyed, serpentine, her hair styled like that of Egyptian dancers and queens. The Byzantine artists he admired reduced facial features to gestural marks, believing that life on earth is transient, while spirit endures. Modigliani began to do the same, and it may be possible to date from his meeting with Anna the closed or inward-looking eyes of his sitters, a device designed to evoke the spiritual quality of their interior lives.

Modigliani's sceptical attitude to the Futurists' agenda set him apart, since, for many, the Futurists were the new celebrities. By 1911, the handsome young Italians, one in particular, would succeed in exerting their influence over Fernande. For the time being, as Gertrude Stein observed, now that Fernande had a proper *bonne* capable of serving up soufflés, she should have been happier than ever before, but somehow she was not; and neither was Picasso. The problem was that Fernande could no longer fulfil his dreams. Yet the young Picasso was not ruthless; he knew what she had been to him – and perhaps still was.

5.

Exoticism

The reappearance of the Ballets Russes in spring 1910 sent Paris into a state of frenzy. Diaghilev and his company returned with a programme that seemed to audiences even more sensational than the one before. With *The Firebird*, a riot of blazing colour that again combined avant-garde choreography with traditional Russian motifs, he introduced 28-year-old Igor Stravinsky to the Parisian scene. The young Russian arrived solemnly contemplating the grey streets of Paris after the red and ochre splendour of St Petersburg. The tonal dissonance of his music was so startling that even the dancers joked that it sounded as if he hardly cared whether he hit the right notes. The season also included the orientally inspired *Scheherazade*, an extraordinarily sensuous production danced with fluid, flowing movements and set in a harem, with Nijinsky as the Golden Slave.

The Firebird was an awesome spectacle of colour, sound and moving image: what the French call '*animation*'. To audiences who still marvelled at the sight of coloured stills on screen, for whom the stuttering black and white animation of the motion picture was still captivatingly new, this unprecedented coloured spectacle of raw, sensual emotion was truly mesmerizing. It combined folkloric roots, symbolized by the Russian emblem of the firebird, with Stravinsky's astonishing music and Fokine's arresting choreography. The firebird crackled with staccato movement as she darted across the stage, arms outstretched, her fingers making exaggerated vibrato gestures like scarlet spurts of forked light.

Nevertheless, the real showstopper of 1910 was *Scheherazade*, with music by Rimsky-Korsakov, exotic sets and sensual dance moves such as had never before been seen on the public stage. The story was minimal (a harem of beautiful women take advantage of

their master's absence to indulge in an opulent orgy with a band of muscular Negro slaves), but the visual impact was unforgettable: 'Bakst's emphasis on bold, bright, sumptuous colours – vivid greens, blues and reds paired with oranges, purples and yellows – transformed colour into a dominant emotive force, enhanced by complex, swirling patterns and the revealing oriental costumes of the dancers. Colour attained a rhythm of its own . . .' – opulent, exotic, dramatic – in a spectacle that later commentators would readily identify as the epitome of Diaghilev's modern aesthetic. Léon Bakst's main inspiration in designing the set and costumes had been the (then recently deceased) modern Russian painter Mikhail Vrubel, whose work had been prominently displayed in the Russian exhibition at the 1906 Salon d'Automne. Vrubel painted with a vision all his own, applying brilliant colour in lozenge forms and jagged planes which earned him comparisons with Cézanne, as well as with the early cubists. The audiences at *Scheherazade* went wild.

In the wake of the 1910 Ballets Russes season, the celebrity everyone was talking about was not, as might have been predicted, Nijinsky (who was under contractual obligation to return to Russia) but set designer Léon Bakst, who was feted throughout Paris and interviewed in fashionable magazines. His art was shown in galleries and his designs for ballets purchased by the Musée des Arts Decoratifs. French and American actresses asked him to design dresses for them; artists and fashion designers clamoured to meet and to be seen with him; chic Parisian boutiques sold *étoffes Scheherazades*. Bakst was quick to acknowledge that his reputation as a designer had been preceded by Poiret's; he hailed Poiret – who commissioned twelve fashion drawings from him, for twelve thousand francs – as *le dernier cri*. Long after the end of the Ballets Russes season, the impact of *Scheherazade* went on reverberating, not least throughout the world of fashion. Women appeared at parties dressed in Poiret's vivid colours and oriental patterns, inspired by Bakst, wearing turbans, jewelled tunics and even harem pants, as if stylishly rushing into the modern age. Deciding to remain in Paris for another six months, on 25 June Bakst put down a deposit on the

studio in the Hôtel Biron just vacated by Matisse, who that month finally closed his school to settle definitively in Issy. This was Matisse's first encounter with the world of the Ballets Russes.

Over the next few years, Diaghilev took the company to Monte Carlo, London and Rome, delighting new audiences – with one notable exception: the first audience of Stravinsky's *The Rite of Spring*, which in 1913 scandalized even the French. With ever more avant-garde productions and sets, by the end of the First World War, Diaghilev had succeeded in appointing Derain, Picasso and Matisse as costume and set designers, continuing to develop what amounted to a radical modern aesthetics of the stage. Picasso's cubist 'sculpture-costumes' and decor appeared in the 1917 production of *Parade*; in 1919, Derain designed sets for Rossini's *La Boutique fantasque*. Derain loved the theatre; it was the medium in which he felt art made its most direct appeal to the emotions of the audience. 'Painting should inspire like this,' he remarked, 'par monstration *et non point par démonstration*' ('by presentation, not representation').

As far as Diaghilev was concerned, these French artists expressed his vision absolutely and, for the next few years, they continued to work for him on sets and costume designs – Matisse's graphic robes for *Le Chant du rossignol* (1920); Marie Laurencin's fluid, pastel costumes for *Les Biches* (1924); Picasso's backdrop for *Le Train bleu* (1924), which had heavy, carved-looking goddesses running around ecstatically before a vast blue sky (for this, Coco Chanel designed the costumes). In the meantime, he continued his habit of making impossibly ambitious plans for the future, even as he worked on current projects. His notebooks for 1923/4 list the names of artists he initially planned to appoint to contribute to future productions (Picasso, Matisse, Derain, Vlaminck, Marie Laurencin, Braque, Utrillo and Gris), though not all of these came to fruition. Diaghilev somehow managed to combine meticulous planning with a complete lack of a system. His aim was continual experimentation, and he was determined to incorporate into the ballet ever newer and more avant-garde forms of expression. Even when he returned a ballet to the stage he was determined never to repeat himself.

In 1928, a year before his death, he was still hoping to update *Scheherazade* by introducing new decors by Matisse – though Matisse in fact worked for him only once: he found Diaghilev's draconian style of management exhausting and the prospect of a long-term working relationship with him unimaginable.

In the cultural climate of 1910, in which, in the wake of the Futurists' declaration that 'a roaring car that seems to ride on grapeshot is more beautiful than the *Victory of Samothrace*' and fashionable women 'looked as though they had just escaped from Bakst's harem as they stepped down from the running boards of their Panhards and de Dion-Boutons', it can be difficult to remember that this was still pre-war Paris and, outside the sphere of the arts, old customs and superstitions prevailed. On 16 May 1910, almost exactly a year after the debut performance by the Ballets Russes, all Paris turned out to watch the sky. Huddled on balconies and terraces in a state of nervous anticipation, everyone was waiting for the appearance the following night of Halley's Comet, an event which the superstitious – that is, many – believed would mean the end of the world. The return of the comet (which occurs approximately every seventy-six years) was the main story in all the newspapers, upstaging even the magnificent funeral of Edward VII in London's Westminster Abbey, which was attended by all the crowned heads of Europe. According to *Le Figaro*, homes throughout Sèvres, Saint-Cloud and Meudon were crowded with people, telescopes poised on balconies to follow the path of the comet from midnight until four in the morning. By the following day, tension was mounting and terror rife, especially in 'the southern regions of Europe, where the population is convinced that the arrival of the comet will bring about the end of the world . . .' In Italy, the Pope instructed priests to reassure the faithful, as many prepared to spend the night in church.

On 18 May, the newspapers finally announced the anti-climactic news: 'We can report quite simply that today the world continues to exist: the comet passed by like a bomb that failed to go off. The end

of the world is deferred . . .' Nevertheless, on both sides of the Atlantic, the crowds stayed gathered, just in case.

That evening, Modigliani walked round to rue Vaugirard and posted a card to Paul Alexandre (it was postmarked 8.15 p.m.): 'Carissimo. The comet has not yet arrived (by ten to six). *Terrible.* I'll definitely see you on Friday – *after death* of course . . .' Two days later, the crowds were still anxiously waiting, *Le Figaro* reporting that, 'At the summit of the Butte Montmartre two thousand sightseers were stationed, as ironical and raucous as on the dawn of a public execution. A police contingent had to be called in . . . In faraway New York, "comet-parties" were organized on all the terraces of the large hotels. There was drinking, laughter, eating, dancing, but nothing was seen . . .'

By 1910 or so, the disparate, fragmented social circles that revolved around Picasso, Diaghilev, Poiret and the Steins had begun to overlap. In the arts, overt connections could now be made between painting, music, writing, couture and the ballet. From now on, painters and sculptors would, in their turn, find inspiration in modern dance. Rodin invited Nijinsky to sit for him; Picasso and Braque pursued their experiments, continuing to explore the problems of perspective and the 'projection' of objects on canvas. Poiret's latest fashions consisted of simple tunics and shift dresses worn with elaborate, spun fascinators in the evenings; his fashion advice focused on the individuality of the wearer rather than that of the designer: elegance had become synonymous with chance and circumstance, what Poiret called 'decorum'. 'Choose what is suitable, Madame,' he advised his clients, 'what is suitable to the hour, the circumstances, the temperature, the setting, the landscape . . . capital, spa, beach resort or country. Choose with taste what is suitable to your mood, what is most appropriate to your character, for a gown, like a faithful portrait, reflects a state of mind . . .'

And the circles were widening. In London on 8 November, Roger Fry, British painter and independent art critic of the *Athenaeum*, mounted an exhibition of contemporary French art at the Grafton

Galleries. Fry had studied art in Paris (he entered the Académie Julian in 1892) and in 1904 had been appointed, largely on the strength of his articles for the *Athenaeum*, to purchase examples of modern European art for the Metropolitan Museum of Art in New York. Following the curtailment of that post, he decided to bring modern French art before a London audience. He called his exhibition 'The French Post-Impressionists', a title intended to be non-committal as to genre and indicating simply that this was work that post-dated the introduction of Impressionism. (Manet was included, and was of course painting before – and alongside – the Impressionists, but, displayed in this new context, his work in some respects took on a more 'modern' appearance, with its strong colours, pared-down forms and references to the art of the past, than the work of Monet, Pissarro or Sisley.) The exhibition of works by artists including Manet, Cézanne, Matisse, van Gogh and Gauguin provoked the same general incomprehension, derision and ridicule as had the exhibition of the Fauves five years earlier in Paris. When Fry showed the works again in 1912, he defended them in a catalogue introduction (entitled, more simply, 'The French Group'), providing a lucid description of what they had collectively achieved in their work by the end of the first decade of the twentieth century. In Fry's estimation, the French painters, though clearly influenced by the Italian primitives, were best understood as 'modern men trying to find a pictorial language appropriate to the sensibilities of the modern outlook'. As he saw it:

> The difficulty [in the paintings' reception] springs from a deep-rooted conviction, due to long-established custom, that the aim of painting is the descriptive imitation of natural forms. Now, these artists do not seek to give what can, after all, be but a pale reflex of actual appearance, but to arouse the conviction of a new and definite reality. They do not seek to imitate form, but to create form; not to imitate life, but to find an equivalent for life. By that I mean that they wish to make images which by the clearness of their logical structure, and by their closely knit unity of texture, shall appeal to

our disinterested and contemplative imagination with something of the same vividness as the things of actual life appeal to our practical activities. In fact, they aim not at illusion but at reality.

He was echoing Braque, who by this time believed that 'The painter aims to construct not an anecdote but a pictorial fact. One must not imitate what one wishes to create. The painter thinks in terms of forms and colours. The aesthetic object is the pictorial fact – a lyrical and poetic object.'

Fry predicted that the logical outcome of such an ambition might be a movement towards abstraction; he could already see in Picasso's work evidence of 'a purely abstract language of form – a visual music'. There was no such evidence, however, in the work of Matisse, who was clearly working with recognizable objects, establishing forms 'by the continuity and flow of his rhythmic line, by the logic of his space relations, and, above all, by an entirely new use of colour'. In any case, Fry insisted it was too soon to make predictions about future directions. His main point was that ridicule might have been expected had any of the artists set out to make an exact copy of the model and found himself incapable of achieving a better likeness. As capable as anyone of copying nature, artists such as Picasso were 'here attempting to do something quite different'. Common to all was their simplification of forms; 'the great originator of the whole idea', in Fry's opinion, was Cézanne.

If the long lens of twentieth-century modernism thus takes in both London and New York, in real terms the art that later came to be thought of as a movement originated in the studios and cafés of Montmartre. In the book she published three decades later, *Paris France* (1940), Gertrude Stein put it all more simply, declaring that modernism could only ever have begun in France, where the habits of day-to-day life were paradoxically eternal. French traditions of rural and family life were profound, yet in her attitude to incomers France displayed the detachment of an artist. 'Foreigners' would come, go or stay; and through it all France would remain herself – which is why so many came to France to live as artists, when they

could not at home. In France, they lived as they pleased, painting, writing or dancing, for what the French really respected were art and letters. 'And that,' concludes Stein, 'is what made Paris and France the natural background of the art and literature of the twentieth century.' As for the French, 'their tradition kept them from changing and yet they naturally saw things as they were, and accepted life as it is, and mixed things up without any reason at the same time. Foreigners were not romantic to them, they were just facts, nothing was sentimental they were just there, and strangely enough it did not make them make the art and literature of the twentieth century but it made them the inevitable background for it.'

Throughout 1910 and 1911, Matisse continued to explore new ways of depicting the flow of rhythm on canvas. Following the completion of the *Danse* and *Musique* panels, he painted distinctive interiors such as *Le Studio rouge* and *Intérieur aux aubergines*, a large decorative piece around which Michael and Sarah Stein rearranged their room to display to best advantage. In *Fleurs et céramique* (1911), pattern is alert with movement and space enveloped by forms rendered dynamic with vivid colour. In *La Fenêtre bleue* (1911), solid forms seem massed and crouched, like dancers in a pose on a stage set. In November 1910, Matisse went to Spain, where he painted two versions of *Nature morte de Seville* (1910/11), an extraordinary work in which pattern, as distinguished painter and art historian Lawrence Gowing has remarked, 'finally broke loose and sprawled across the pictures' – like the firebird.

6.

The Interior Life

Picasso gradually settled into the boulevard de Clichy and the demands of his more sociable lifestyle. For the next four years, he made it his business to attend every annual Salon des Indépendants and Salon d'Automne. With Braque, he continued to explore the experiments with perspective by now widely referred to as cubism. At around the time of the appearance of the 'Manifesto of Futurist Musicians', they were both beginning to introduce musical instruments into their work. Picasso had been intrigued by the allegorical connotations of musical instruments since publishing an article in an issue of his short-lived magazine *Arte Joven* back in 1901, in which the author had compared the body of a woman with a guitar. As for Braque, he was naturally musical, understanding the sensuous properties of musical instruments and drawn to them now as subjects because, as he put it, 'they have the advantage of being animated by touch'. Throughout the first half of 1910, he and Picasso continued to work closely together, experimenting with ways of depicting solid objects on canvas that would make a viewer want to reach out and touch them. In a few months, they rapidly produced substantial quantities of new work, until summer came, and Picasso began once again to yearn for Spain.

The family of his friend Ramon Pichot owned a property and a boat near the bay of Cadaqués, Dalí's birthplace. (Dalí later claimed that as a child he had noticed Picasso, but Picasso had no memory of him.) Pichot, lanky, learned, with a serious face (later appointed to acquire rare books for Pierpoint Morgan, then director of the Metropolitan Museum of New York), still spent some of his time in Montmartre, where he prepared for exhibitions in his rose-coloured house behind the Lapin Agile. His sister, an opera singer, was also on her way to Cadaqués that summer; she had a free travel pass and

could include anyone accompanying her on her company's 'circus discount'. Already travelling with more than eighteen people, including family and friends, her dresser, accompanist, several dogs and a parrot, she generously offered to add Picasso, Fernande, their dog, Frika, and their maid to her party. They left on Friday 1 July 1910.

Pichot's mother, a native of Cadaqués, had turned their house into an artists' colony; members of the old El Quatres Gats group had been going there since the turn of the century. The place was so isolated, cut off by a mountain ridge two thousand feet high, that until (after 1910) a proper road was built, the easiest access was by sea. Fishing boats sailed from there as far as Cuba; many of the locals said they felt 'closer to Havana than to Madrid'. By land, the journey was four hours by train from Barcelona to Figueres, followed by a trek across rough terrain in a covered wagon which took a further seven hours and two changes of horses. Since the Pichots' house was already full, Picasso had rented a sparsely furnished cottage in the village, at 162 (now no. 11), Carrer d'es Poal, on the north side of the bay. 'We are paying a hundred francs a month for a house that has only two beds, two tables, and some chairs,' Fernande wrote to Gertrude Stein. Though she was not exactly bored, she was unimpressed. Perhaps because of her mood, she confided that, for her, the place had none of the charm of Horta, though the maid was getting used to it all – and doing all the chores.

Picasso was absorbed in his work, painting the local fishing boats – as Fernande described them, 'stranded in little heaps around the harbour'. Fishing boats had always been a subject for Braque; now, Picasso, too, studied the 'navicular structure – the dovetailing and the joinery' that made them ideal subjects for the structural methods of cubism. Braque had lent him an orthogonal grid which enabled him to adjust the tension, rhythm and structure of a composition, not unlike the traditional technique of squaring up a drawing for enlargement on the canvas.

Along with other artists at the time, both were also beginning to look at X-ray photographs, recommended by the Futurists in their 'Technical Manifesto of Futurist Painting', since, with their 'doubled

power of our sight', they enabled the artist to contemplate the human body not simply as a solid object but as a form with an interior life. The X-ray photograph provided new potential for experimentation – and for the introduction of an element of humour. From this point on, as Picasso's biographer John Richardson has noted, Picasso began to incorporate into his work objects such as knobs, keys and nails, which appear in his paintings like the 'swallowed safety pins, forgotten forceps, fatal bullets', which could now be detected by X-rays – a reference to the Futurists' 'Technical Manifesto', or a gentle jibe?

Picasso spent long hours alone in his studio. He was exploring how far he could take the experiment to position, or enfold, an object in pictorial space in such a way that the viewer could 'walk' around it, introducing into the painting a sense of time as well as space. The vivid colours of his first faceted still lifes and individual figure studies of 1907 had given way to monochrome experiments as he concentrated on exploring the limits in painting of three-dimensional form. Richardson has observed that the draining of colour from Picasso's Cadaqués works reflects the surrounding bleached, white houses and grey-black rocks, and the *calma blanca* of the small, secluded bay. And perhaps his works of this period which were 'faded' towards the edges of the picture frame, took their cue from film reels or photographs, which in those days always faded out towards the edges.

Picasso was also making engravings. Ramon Pichot had a printing press, which he put at Picasso's disposal so that he could work on a commission from Kahnweiler that he had accepted back in April to provide illustrations for Max Jacob's autobiographical fantasy *Saint Matorel*. In his engravings, Picasso also experimented with perspective and original methods of depicting objects, discovering, for example, ways of juxtaposing small with large objects to establish simple new perspective effects. All this seemed to calm him down, perhaps because he was experimenting having already laid the groundwork and working with a sense of being in dialogue rather than labouring, as it were, alone in the dark, as he had with

Les Demoiselles d'Avignon. Or, perhaps, for once in his life, he allowed the peace of his surroundings to influence his mood. Whatever the reason, that summer Picasso seemed uncharacteristically calm, working with quiet concentration throughout July.

As August approached, however, he began to crave company. Fernande was very much at home with the Pichot women, but Picasso missed the camaraderie of fellow artists – in particular, of course, Braque. He tried to persuade him to come to Cadaqués, but Braque was unwilling to leave Paris. So Picasso tried Derain, who, despite the fact that their work was increasingly divergent, gamely agreed to join them, as he had willingly joined Matisse five years earlier in Collioure. Derain and Alice (who had dyed and bobbed her hair, which made her look more Amazonian than Madonna-like) arrived towards the end of July. As they approached Cadaqués by covered wagon, they were startled in the darkness by a bearded passenger who joined them and sat jeering from the seat opposite. The stranger turned out to be Picasso, come in disguise to escort his friends on the final lap of their journey.

In Cadaqués, Derain took full advantage of the music and dancing organized by the Pichots, playing his instruments and joining in; he even persuaded Picasso to oblige them with a flamenco routine. Every weekend, a Catalan band playing pipes (the tibles and tenores which appeared in Picasso's paintings) struck up a *sardana* in the square, the villagers dancing solemnly (despite the lively steps) to the harsh, traditional music. The *sardana* was a serious dance, Picasso later told Braque, 'And difficult! Each step must be counted.' It was a 'communion of souls', he explained, in which all distinctions of class, social status and age were abolished. 'Rich and poor, young and old, dance it together . . . the servants hand-in-hand with their masters.'

If Derain threw himself with enthusiasm into all this, however, there were tensions between Fernande and Alice, who was being combative, and flirtatious with Picasso. On 6 August, she and Derain left, and Picasso and Fernande prepared to return to Barcelona. In her letters to Gertrude Stein, the latter admitted she had

never really taken to Cadaqués: 'At the risk of offending the Pichots I must admit the place is hideous. There is nothing but the sea, some wretched little mountains, houses that look as if made of card-board, local people without any character who may be fisherfolk but have as much allure as workmen . . .' Alice had obviously rubbed her up the wrong way.

Moreover, although Derain had always been dependably divert-ing company, the truth was that by now his artistic concerns had begun to depart significantly from Picasso's. He and Alice had just that June moved from Montmartre to a romantic attic on the Left Bank in the rue Bonaparte, directly opposite the École des Beaux-Arts. Derain, who had boasted of his salubrious address near the police station of Montmartre, now bragged about his proximity to the École, despite having never found anything very positive to say about it before. He especially loved being in the thick of things on the night of the Quatres Arts ball, when students in fancy dress swarmed through the streets by torchlight, singing and shouting beneath his window. With the move across the river, he appeared to have (temporarily) shed his image as an 'English' dandy; for the Left Bank, he dressed in old, thick woollen sweaters and sat smoking a long Red Indian pipe, telling tall stories of captains and horsemen he may or may not have encountered during his early years of mili-tary service – at least, that was André Salmon's story. Others noted that for the past year his primary preoccupation had been the study of Hindu thought.

Although already increasingly alienated artistically from Picasso and Braque, even after his move to the rue Bonaparte Derain had continued to socialize with them, meeting regularly at Azon's and elsewhere. After the holiday in Cadaqués, both he and Vlaminck began gradually to distance themselves. Both were alienated above all by the idea that art could be reduced to an aesthetic, or theory, which was how they viewed cubism. Acknowledged as inventors of a kind of 'lyricism of the *banlieusard*', neither had found a definitive artistic direction that took them satisfactorily beyond Fauvism. For Derain, the great merit of Fauvism had been that it had set the

painted picture free from all connections with naturalist imitation. In retrospect, he realized that, as Fauves, they had been pure colourists, applying that new freedom primarily to the use of colour without taking much account of the framework – an approach that, in some respects, had caused them to lose their way. For both he and Vlaminck, the theory that art should avoid any form of imitation had proved inhibiting rather than liberating. 'What was wrong in our attitude,' Derain later reflected, 'was a kind of fear of imitating life, which made us approach things from too far off and led us to hasty judgements'. He became increasingly convinced that the primary role of the artist was to find ways of transposing the true expression of his feelings on to canvas, without distortion: 'Where there is temperament, there can be no imitation. Thus it became necessary for us to return to more cautious attitudes, to lay in a store of resources from the outset, to secure patiently for each painting a long development.' The advantage of Fauvism had been that the canvas became a crucible from which the painter had been able to draw objects that were still alive in his imagination. The subjects of their paintings had thus been brought to life by the feelings of the artist – the *sensation* – which, as Derain insisted, was surely the very proof of his existence. In one of his last letters to Vlaminck he wrote that he was still seeking not a synthesis of unified expression in a given moment but rather a way of expressing fixed, complex things for all eternity. The young deist remained unprepared to relinquish his belief in the spiritual value of his work.

The cubists' emphasis on ideas alienated Derain and Vlaminck once and for all from Picasso and Braque. Suspicious of definitive statements, Derain believed painting had a function, and a dignity, that should make it substantial, profound, not constrained by any '*esthétisme hasardeux*' ('dangerous aestheticism'). As he put it, '*Un tableau ne commence pas par être une idée*' ('A picture does not begin by being an idea'). Vlaminck and Derain distrusted, too, the notion that trends in art supercede one another, each invalidating all that went before; as he lucidly put it, the point of one artist was not simply to replace another. Turning their backs on the cubists, both

returned to their original practice of painting out of doors, close to the soil. Ultimately, Derain came to believe that the great danger for the artist was an excess of culture, that the true artist would need to be (or feel) uncultivated, uneducated; wild in the truest sense. In reality, it was all a sublime game – a hazardous game of coincidence and chance – which departed from the life of the imagination only to return to it constantly, in a spirit of playful, sometimes exasperated, provocation.

Derain's argument – if such it was – was not only with Picasso. In a different way, he felt Matisse had oversimplified things. The ancients had known how to paint a wine glass, they had understood things in depth; they had not been satisfied with an intelligent glance, as Matisse seemed to be. In Derain's opinion, it was too easy, selling talent too short, this *'façon directe de sentir des choses'*. Eventually, he became disenchanted even with Cézanne, finding his search for perfection incompatible with the ludic freedom of human thought. The mistake of all theory was surely its aim to be definitive; for Derain, the wish to be definitive was death. Even the concession that the artist's temperament determined the nature of the work became suspect, since surely what counted was not the temperament of the artist but the personality of the man, expressed through character, conviction, free will.

Vlaminck agreed, unable to see cubism as in any sense the natural development of Fauvism, which for them had been not so much an attitude (still less a theory) but a way of life, a means of expressing a response to nature, society, the world. For him, cubism was inexplicable as a way forward because it sealed off emotional possibilities. He could see how it could inspire decorative applications, even introduce some valuable insights: *'Mais la Peinture, c'est autre chose.'*

Both returned to painting landscapes, in the South of France and in the region around Chatou. Paradoxically, they (particularly Derain) may be regarded as modernists more for what they said and wrote – about chance and coincidence – than for their later works, which may explain the distinction Jean Cocteau made between 'the

classicism of cubism [opposing] the romanticism of the Fauves'. As for Picasso, he offered no apology for or explanation of his work. He preferred anecdote to analysis and was often most serious when he seemed least so. 'If you can't paint the entire person,' he once told a crowd of young artists in the Lapin Agile, 'put the legs on the canvas, to one side.' No one dared ask him what he meant; it was just clear by now that no one would think of painting from life – at least, not in the old way – any longer. He once told Cocteau that in Avignon one day he had seen an elderly painter, partially blind, painting the castle in the square of the Château des Papes. His wife, standing beside him, looked at the castle through binoculars and described it to him: 'He was painting from his wife.' For a while, Picasso and Braque even left their works unsigned. As Braque put it, 'From the moment that someone else could do the same thing as I, there seemed to be no difference between the paintings, which therefore did not have to be signed.' They soon, however, began signing them again: 'I realized that a painter could not make himself known without his peculiar "tricks", without the slightest trace of individuality.'

Picasso's return to Paris in the summer of 1910 was disappointing. He had been hoping to interest Kahnweiler in the work he had brought back from Cadaqués, landscapes which clearly demonstrated a move towards abstraction. However, Kahnweiler made his old objection: they looked unfinished. He bought only one, a painting of boats. Vollard was less cautious, purchasing most of the remainder, though he was sceptical about the new direction of Picasso's work. In fact, it seemed, that summer, he had moved as far as he ever would towards abstraction. He may have been anxious that Shchukin would take his cue from Kahnweiler and also begin to lose interest in his work. That autumn, he accepted a commission to make a decorative piece for an American collector, a large-scale work capable of rivalling Matisse's *La Danse* and *La Musique*; but, unlike Matisse, he had no experience of working on a piece intended to be decorative on this scale. Furthermore, decorative panels required bold colouration, the virtuoso handling of

surface effects and an understanding of texture, which, for Matisse, went back to his early studies with Moreau, to his long familiarity with Byzantine mosaics and Islamic ornamentation, and perhaps even to his childhood and his proximity to the production and display of textiles. Picasso's decorative panel presented him with the insuperable difficulty of reconciling strong colour with the intricacies of cubist form, and the commission came to nothing.

Instead, he resumed work on the portraits of dealers – Uhde, Kahnweiler and Vollard – which he had been working on before leaving for Cadaqués, all multifaceted, essentially cubist works, which left Vollard, for one, unmoved. He remained sceptical of cubism and was never especially fond of his portrait; a year or two later, he sold it on to a Russian collector for three thousand francs. He kept an open mind, however, since he knew he had been wrong about Picasso in the past. He made the occasional purchase in the autumns of 1909 and 1910, but really he was waiting to see whether Kahnweiler could first establish a lucrative market for cubist art before taking any major risks himself. He arranged to give Picasso an exhibition (of works painted between 1900 and 1910), which opened on 20 December 1910, but his investment in the show was minimal; he provided no frames, produced no catalogue and sent out no invitations.

Cubism, nevertheless, was rapidly flourishing, already an acknowledged movement practised, as Vlaminck had anticipated, by the talented and the untalented alike. By 1910, there seemed to be cubists at every party. Though she did not even know his name, Alice B. Toklas had already met 'the youngest of the cubists', apparently destined for the diplomatic service as soon as he had completed his military service: 'How he drifted in and whether he painted I do not know. All I know is that he was known as the youngest of the cubists.' More promisingly for the development of cubism, in 1910 Juan Gris arrived in Montmartre, where Picasso arranged for him to rent van Dongen's old studio in the Bateau-Lavoir. Gris moved in with his lover and their baby, who could be seen suspended from the window in a makeshift hammock.

There was no room for a pram in the hall in the Bateau-Lavoir. Dark, reserved and handsome, he immediately attracted the attention of Gertrude Stein, fortuitously adding weight to her theory that cubism was really a Spanish invention.

The new cubists also included a former illustrator for the *Assiette au beurre*, a Polish cartoonist from Warsaw who signed himself Markus and had given up working as a graphic artist to take up cubism rather, as someone remarked, 'as one would join a religious faith' – though his cubism largely consisted of 'reducing the architecture of the Sacré Coeur to several volumes' on canvas and decorating the walls of a back room at the top of the rue Ravignon – Émile's bistro, the new rendezvous for painters and poets. As an illustrator, Markus had been successful. He lived in a large apartment in the rue Delambre with his lover, Marcelle Humbert, whom everyone called Eva (or Eve), who was pretty and petite and an accomplished housekeeper and hostess. The couple, who had so far resisted family pressure to marry, regularly gave dinners for 'visiting Poles and the more respectable Montmartre bohemians'. At the Cirque Medrano one evening, they met Picasso and Fernande, who immediately took to Eva.

Matisse spent the summer of 1910 in his studio in Issy, working well into the autumn on *La Danse* and *La Musique*. Since each panel measured eight and a half feet high and well over twelve feet long, he painted from stepladders, humming old dance tunes from the Moulin de la Galette as he worked, appearing to the casual observer to be slapping on paint with abandon. In fact, the process required intense concentration. The finished work seemed 'primitive, diabolical, barbaric, even cannibalistic' to those who first saw it. Matisse responded by insisting again, as he repeatedly had in the past, that all he was trying to achieve was an art of peace, harmony and balance.

La Danse and *La Musique* made their public debuts at the 1910 Salon d'Automne, where, five years on, the public reacted exactly as they had back in 1905 to the works of the Fauves. The day of the

opening was mild. As one reporter lyrically commented, the flowers in the beds of the *rond-pointe*, the elegant outfits of the women and the sunlight sparkling through the trees put one in mind of a painting by Bonnard, despite the crowd of unkempt bohemians shoving through the turnstile. It was a contrast that continued inside the exhibition hall, where the art of the past vied with contemporary pieces which still had the capacity to shock. At the sight of Matisse's work, old friends were dismayed, fellow artists outraged. The reviews were so damning that Amélie had to hide them, though reviewer Maurice Sembat made some attempt to paraphrase the artist's achievement: 'We have been to the Salon d'Automne,' he reported, 'where we have seen the astounding *La Danse* – pink movement turning on a blue background in a frantic round. The huge figure on the left leads the entire line. What rapture! What a bacchanal! This supreme arabesque, this thrilling curve that extends from the turned head to the projecting hip, and down through the turned-out legs, seems to embody the orgiastic dithryamb with which Nietzsche sums up his enthusiasm for ancient Greece.'

Within a week of the opening, Matisse left for Munich, where he barely had time to catch the last ten days of an exhibition of Islamic art before news reached him of his father's sudden death, on 15 October. He rushed home to Bohain, in Aisne in northern France, arriving to the sound of funeral bells tolling through the town.

7.

'Art'

At 27, rue de Fleurus, Alice B. Toklas was now living with Gertrude and Leo Stein. Harriet had already written from San Francisco, asking Alice to close the flat and carefully pack the paintings, especially Matisse's *La Femme aux yeux bleus*, and send them to her in California, where she was 'probably remaining'. When their landlady in the rue Notre Dame des Champs objected to Alice's abrupt termination of her and Harriet's tenancy, Leo helped her with letters to French lawyers: 'And with that I moved [sometime during the winter of 1909/1910] over to the rue de Fleurus, where I was given the small room that later we called the *salon des refusés*.' In the mornings, she typed Gertrude's manuscript; in the afternoons, they visited friends, including an old acquaintance of Gertrude from her Johns Hopkins days, Grace Lounsbery, 'an intimate friend of two of Gertrude's intimate friends. Gertrude thought that she was a false alarm.' Nonetheless, she was, as Alice realized, one of the two new 'infant prodigies of the social world', the nature of which was rapidly changing. Grace, who 'considered herself a Greek scholar and wrote Greek plays', had fallen in with Jean Cocteau, the other infant prodigy. Perhaps it was at the Steins', then, through Grace Lounsbery, that Picasso first encountered Cocteau (though not until about 1917) and, through him, soon afterwards, Diaghilev. (Cocteau later considered that the real founders of modernism were Picasso, Stravinsky and Modigliani – a story impossible to tell except, in the essential spirit of modernism, through nuance and juxtaposition, since, though their work had much in common, their paths rarely crossed until during and after the First World War.)

On 1 November 1910, Sergei Shchukin arrived in Paris, a week before the close of the Salon d'Automne. His catalogue of personal disasters was extended that year by the death of the second of his

twin sons, who took his own life on his deceased mother's birthday. The 'darkness' Shchukin had recognized in Picasso's work, he now sought almost obsessively. He wanted more of his work, especially paintings with overt references to death; in 1910, he purchased *Composition with Skull* (1908), as well as Derain's *Still Life with Skull*. His interest now extended to Picasso's early work, which he also began to collect, again choosing paintings that stirred up his own feelings of loss and despair, including the 1901 version of *The Absinthe Drinker*.

Shchukin had already seen the reviews of Matisse's *La Danse* and *La Musique*, and read them with dismay. Meanwhile, the Bernheim-Jeunes went bustling down to Issy with the news that the Russian collector was considering abandoning Matisse's panels in favour of a more suitable work by Puvis de Chavannes. In their opinion, the latter's work was so large that the only way of displaying it properly for Shchukin to make his decision would be to hang it in Matisse's studio alongside *La Danse* and *La Musique*. When he saw Matisse's panels of naked dancers alongside Puvis's ascetic *The Muses Greeting Genius: The Herald of Light*, with its 'ghostly pallor and elegant, etiolated figures', Shchukin decided he had no choice but to choose the latter's work. He returned immediately to Moscow, leaving Matisse devastated. Just as before, no sooner had he made his decision than he immediately wrote to revoke it. But the damage was done; Matisse was traumatized by the whole episode. He felt betrayed, not only by Shchukin, whom he had thought was his friend, but also by the Bernheim-Jeunes. For the next two months, he was in deep despair.

It was early December before he began to recover and, by the time Shchukin sent a new request for a pair of large still lifes, Matisse was in Spain. In Seville, the artist saw Spanish gypsies dancing, 'a miracle of suppleness and rhythm'. He spent the next few months in Madrid, exploring the art of the museums. He extended his stay, not even returning home for Christmas but travelling instead through Spain well into the New Year. In spring 1911, despite having resolved to have nothing further to do with the art world of Paris,

he sent a large painting of Amélie in Spanish costume (*The Spanish Woman*) to the Salon des Indépendants. It was to be almost the last time she modelled for him. When he returned to Paris, rumours were already spreading – what had Matisse been doing for the past few months in sunny Spain, without his wife? Within five days of the opening of the Indépendants on 21 April, he had withdrawn his own painting, tortured by the sight of it. In its place he sent the work he had just completed, *Pink Studio*. The target of the gossip press now became Olga Meerson and her 'monstrous images', worse even, reported the *Journal*, than the barely mentionable 'frightful *Spanish Woman* of M. Henri Matisse'.

By 1911, in the streets, shops, bars and theatres of Paris, 'art' (as redefined by Picasso and Braque) was everywhere. Art was performance, pastiche, mimesis; art was visual spectacle, speed and urban chic, incorporating and celebrating everyday life just as Severini and his fellow Futurists had urged it should. The success of Diaghilev's 1911 season, which featured *Petrushka* (a folkloric ballet that told the story of three puppets), was colossal. The avant-garde mood and strange, articulated dancing – Nijinsky, his toes turned in, wearing a tragic, mournful expression like a clown's – were dramatically underpinned by Stravinsky's extraordinary dissonant music, the accordions' tuneless 'breathing'. Stravinsky's composition ingeniously unified all the heterogeneous elements of the score, making his listeners aware of the significance of every note and every tonal shift. Like a cubist painting, the suggestive rapports of Gertrude Stein's writing, or the new medium of narrative cinema composed in successive frames, *Petrushka* celebrated the eclectic, nuanced vision and method of radical juxtaposition now emerging across all the arts. Admirers of the music this time included Picasso, who went around singing his favourite air from the production (always the same one) 'very joyously . . . his eyes all [lit] up with the glow of the footlights'. Art encompassed street life, commerce and personal style. At the Belle Jardinière department stores, Braque found Picasso one of the much coveted

'Singapores', natty blue American-style suits that were *très à la mode* worn with a *cloche* hat. Braque had returned from a trip to Le Havre with a whole parcel of these hats, part of a job lot of a hundred which he picked up at an auction for twenty sous each. They both wore them, looking like a couple of Second Empire bookmakers. Picasso took a pile of them to Céret, the elegant town with ancient cloisters nearest to Collioure on the Catalan border, where he spent the summer of 1911. He and his friends wore them with cork-smudged sideburns and false moustaches.

When Picasso went to Céret that summer he travelled, for the first time since they had met, without Fernande. That year, so far, Braque and Picasso had been more or less inseparable: 'Each of us *had* to see what the other had done during the day. We criticized each other's work. A canvas wasn't finished unless both of us felt it was.' At first, Picasso missed Fernande, writing on 8 August to tell her he loved her, asking when she was coming to Céret. She had barely arrived when they were joined by Braque, who immediately replaced her as the centre of Picasso's attention. Braque tactfully waited until Picasso had left before travelling on to nearby Collioure, where he (his words) 'bumped into' Matisse. (In later years, once Braque had revealed his interest in Picasso's rival, the Picasso–Matisse feud had settled into a kind of mutual respect. Though there would always be a rivalry based on competition, in succeeding years their regard for each other steadily grew; one measure of it was Picasso's acquisition, over the years, of eleven works by Matisse, all gifts, the result of their continuing habit of exchanging paintings.)

Back in Paris, Picasso and Fernande renewed their friendship with the couple they had met at the circus, Markus the illustrator-turned-cubist and his lover, Marcelle (or Eva/Eve). One evening in 1911, Picasso and Fernande took them both to meet Gertrude Stein and Alice B. Toklas, who understood immediately what Fernande saw in Eve: she was 'a little French Evelyn Thaw, small and perfect'. After they left, Gertrude asked Alice, 'Is Picasso leaving Fernande for this young thing?' Some days later, the two women went up to

Montmartre, to Picasso's studio in the Bateau-Lavoir. He was out, so Gertrude left her visiting card. The next time they visited, there was a new painting on his easel. Painted into the lower corner, collage-style, was Gertrude's card; also incorporated were the words 'ma jolie'. As they left, Gertrude remarked, 'Fernande is certainly not ma jolie, I wonder who it is. In a few days we knew.' His new love, the woman for whom he finally abandoned Fernande, was Eve.

8.

Endings

In Montmartre in 1911, the long-projected clearance of the Maquis for reconstruction finally began to take place. To facilitate works, most of the old windmills up on the Butte were demolished, as the shanty town that had been the Maquis was practically razed to the ground. In Montparnasse, the Café Rotonde opened, marking the definitive removal of artistic café life from Montmartre to Montparnasse. Although Picasso still kept his studios at the Bateau-Lavoir, he knew the days of the intimate community village life of Montmartre were over. In years to come, he always said he had never been so happy as he had been in the old days there. One day, Frédé's son was seen in heated argument with a young girl. Soon afterwards, though no one knew whether the two events were connected, he was shot and fatally wounded at the bar of the Lapin Agile. After that, the place was never the same again. Already, by 1911, the district had become a tourist attraction, the funicular bringing increasing numbers up the hillside to the cafés in the place du Tertre. *Amateurs* sat at their easels in the lanes painting portraits of passers-by, but the serious artists had moved across the river. In the early days, Frédé's *cabaret artistique* had been full of painters – Picasso, Braque, Matisse, Derain, Vlaminck, van Dongen, Modigliani – as well as actors, musicians and writers, all sitting together on the little terrace in the shade of the old plane tree. On the wall of the Lapin Agile, a plaster figure of Christ had seemed to watch over them all. On the same wall, for a long time, a painting by Picasso hung by a nail. It lit up the place, painted in vivid reds and yellows. One day it vanished, discreetly spirited away by a canny collector, its disappearance a sign of loss, change, good times and prosperity to come.

In November 1911, Matisse made his first visit to Moscow, where he visited Shchukin in his grand home, the Trubetskoy Palace, which

was regularly open to the public and by now hung throughout with Matisse's work. *La Danse* and *La Musique* (the latter bearing a fresh daub of red paint acting as a fig leaf) were displayed on the staircase for all to see. (By 1914, Shchukin's collection as a whole included over two hundred and fifty paintings, including thirty-eight by Matisse, sixteen by Derain, sixteen by Gauguin and eight by Cézanne – by which time his 'Picasso gallery', which Matisse may not have seen in 1911, as it was always kept separate from the rest of Shchukin's collection, contained over fifty works.) The morning after his arrival, Matisse won the hearts of the Russian people when he told a reporter from the *Moscow Times* that he had fallen in love with Russia's icons. He became an overnight sensation, the whole of Moscow's art world gathering to see him. He was taken to the most sought after venues, including The Bat, Moscow's smartest cabaret, where he was presented with a painting showing himself on a pedestal surrounded by a ring of half-naked ladies. The caption read '*Adoration du grand Henri*'. Shchukin proposed a commission, on an unprecedented scale, for a row of decorative panels to be displayed above the still lifes in his drawing room. Only in Moscow, Matisse told his captive audience, had he found true connoisseurs of modern art, able to understand the future because of the richness of their artistic heritage. Presumably, he omitted to mention that Diaghilev had painstakingly introduced that very heritage, those very icons, to Paris when he exhibited Russian art in the Grand Palais back in 1906.

Matisse's stay in Russia brought about the disintegration of his marriage, after he wrote home to both Amélie and Olga. When the former intercepted a message intended for the latter, life in Issy was thrown into turmoil. Amélie immediately fell ill; Olga was admitted to a clinic to treat her drug addiction. Meanwhile, 'le grand Henri' was preparing a retrospective, to be held on his last night in Moscow, in Shchukin's drawing room. There, for the next two years, his works hung, floor to ceiling, in gold and silver cases like the tiers of Russian icons Matisse was seeing in the churches, 'the true source', he announced, 'of all creative search'.

<div align="center">*</div>

It would be another eight years (following Eve's untimely death from cancer, in December 1915) before Picasso met and fell in love with one of Diaghilev's dancers, Olga Khokhlova, whom he married in Paris, in the Russian Orthodox Church in the rue Daru, in 1918. The previous year, through Cocteau, Diaghilev had commissioned set designs from Picasso for his new ballet, *Parade*, a word Larousse defines as 'a comic act, put on at the entrance of a travelling theatre to attract a crowd'. The plan for *Parade* was to produce an entirely contemporary spectacle, a ballet every bit as avant-garde as Diaghilev's earlier triumph of 1911, *Petrushka*; and, this time, it would overtly incorporate the sights and sounds of the modern urban world. The title suggested the worlds of circus and music hall, and the performance was intended to be noticeably democratic, bringing everyday life, and the theatre of the people, before the cream of Parisian society. To Satie's music (against Satie's better judgement), Cocteau added the sounds of cars backfiring, typewriters clacking and the whirring of machinery. Picasso went to Rome with him to work on the ballet, designing the drop-curtain, costumes and scenery. It was to be the beginning of an ongoing working relationship with Diaghilev.

By the time Picasso met his Russian dancer, the seeds of change had been sown, beginning back in 1900. By the end of the decade, the art world already encompassed dynamic new forms of expression and a heady sense of interconnectedness. From now on, painters, dancers, musicians, designers, photographers, film-makers and writers were all set to share similar and overlapping concerns. The struggles of a few dedicated, near-destitute artists working in the broken-down shacks and hovels of rural Montmartre seemed to have created the foundations for the wider arena of modern art. In retrospect, the bohemian world of the artists in Montmartre in the first decade of the century may be seen as a kind of living *parade*, a brief, dynamic, entertaining drama containing all the seeds of the main, twentieth-century show – and all the fun of the fair.

Acknowledgements

Warm thanks to my literary agent Gill Coleridge of Rogers, Coleridge and White for support and encouragement from the start, and to Cara Jones; also to Melanie Jackson of Melanie Jackson Agency, New York; and to my editors Juliet Annan of Fig Tree and Ginny Smith and Jeff Alexander of Penguin, New York; and to copy-editor, Sarah Day. Thanks also to the team at Documentations Orsay, Musée d'Orsay, Paris, for kindly supplying information. In researching this book, I benefited greatly from visits to the museums of Paris and Collioure, particularly the Musée de Montmartre and the Musée du Cinéma, Bercy, Paris, the Musée de Collioure and the Médiathèque Ludovic Massé, Céret. In researching the pictures, I was very grateful for the assistance of John Moelwyn-Hughes of the Bridgeman Art Library; Mark Dowd of TopFoto; and Sue Bateman and Jehane Boden-Spiers of Yellow House Art Licensing. Steve Ward has generously supported and encouraged me throughout. I was in grateful receipt of generous support from the Authors' Foundation, via the Society of Authors.

Notes

Introduction

p. xiii 'My inner self is bound to be in my canvas . . .': Pablo Picasso, in Hélène Parmelin, *Picasso Says . . .*, p. 70

p. xiii 'All the rest': ibid.

p. xvi 'like a kaleidoscope slowly turning': quoted in Gertrude Stein, *The Autobiography of Alice B. Toklas*, p. 98

p. xvi 'a new beauty: the beauty of speed': F.T. Marinetti, 'The Founding and Manifesto of Futurism, 1909', in Umbro Apollonio (ed.), *Futurist Manifestos*, p. 21

Part I: The World Fair and Arrivals

p. 3 'Me': in Dan Franck, *The Bohemians: The Birth of Modern Art: Paris 1900–1930*, p. 18

p. 4 'Every member . . . had a listening-tube . . . with the pictures': Claude Lepape and Thierry Defert, *From the Ballets Russes to Vogue: The Art of Georges Lepape*, p. 15

p. 4 '*visions d'art*': Richard Abel, *The Ciné Goes to Town: French Cinema 1896–1914*, p. 17

p. 4 'roses twelve feet in diameter . . .': Lepape and Defert, *From the Ballets Russes to Vogue*, p. 16

p. 4 'the Fair shows . . . a new era in the history of humanity': Jeanine Warnod, *Washboat Days: Montmartre, Picasso and the Artists' Revolution*, p. 50

p. 10 '*modernisme*': John Richardson, *A Life of Picasso, 1881–1906*, Volume I, p. 110

p. 10 'Catalan art nouveau with overtones of symbolism': ibid.

p. 11 'to translate eternal verities . . . as it contemplates the pit': ibid., p. 113

p. 11 'We prefer to be . . . unstable . . . rather than fallen and meek': ibid.

p. 12 'full of crazy places . . . a goldmine . . .': ibid., p. 161

p. 12 'with extensions': ibid.

p. 14 '*À la moule! . . . Couteaux! Couteaux!*': Jean-Paul Crespelle, *La Vie quotidienne à Montmartre au temps de Picasso, 1900–1910*, p. 21

p. 17 'as if they were breaking stones': Hilary Spurling, *Matisse: The Life*, p. 80

p. 17 'a kind of hell-hole near the Buttes Chaumont': Francis Carco, *L'Ami des peintres*, p. 231

p. 18 'a world of exotic fantasies . . . under a veneer of religious iconography': Bernard Denvir, *Post-Impressionism*, p. 148

p. 18 'a kind of literary and symbolic idealism': Raymond Escholier, *Matisse from the Life*, p. 28

p. 18 'pure painting': ibid.

p. 18 'Don't be satisfied . . . go down into the street': ibid., p. 33

p. 19 '*un grand comic triste de café-concert*': Georges Hilaire, *Derain*, p. 9

p. 19 'to me . . . pure, absolute painting': Escholier, *Matisse from the Life*, p. 32

p. 19 'transposing rather . . . pure vermilion': André Derain, in ibid., p. 32

p. 20 'pommes frites and chloroform': Rainer Maria Rilke, *The Notebooks of Malte Laurids Brigge*, p. 4

p. 24 'pompous bachelors . . .': Richardson, *A Life of Picasso*, Volume I, p. 160

p. 24 'lots of deaths, shootings, conflagrations . . .': ibid., p. 161

p. 26 'The workmen pay for the oil . . . I am safe from a strike': Ambroise Vollard, *Recollections of a Picture Dealer*, p. 219

p. 29 'Speculators! Buy art! . . . worth 10 000 Francs in ten years' time': Franck, *The Bohemians*, p. 15

p. 31 'never a real Impressionist . . . since Cézanne': Maurice Sembat, in Escholier, *Matisse from the Life*, p. 38

p. 32 'as still as an apple': Richard Verdi, *Cézanne*, p. 155

p. 32 'a man of learning and introspection': ibid.

p. 33 'a head like a door': Alex Danchev, *Cézanne: A Life*, p. 296 (quoting Giacometti, interviewed by Georges Charbonnier, 16 April 1957, in *Le Monologue du peintre* (1959) (Paris: Durier, 1980), pp. 186–7

p. 33 'beginning to catch on with the public': Verdi, *Cézanne*, p. 196

p. 34 'masterpieces everywhere, and going . . . for a song': Vollard, *Recollections of a Picture Dealer*, p. 22

p. 34 '*la cave*': Isabelle Cahn, *Ambroise Vollard: un marchand d'art et ses trésors*, p. 22

p. 37 'the painter, utterly and beautifully . . .': Marilyn McCully, ed., *Picasso: The Early Years, 1892–1906* (exhibition catalogue), p. 35

p. 37 'youthful impetuous spontaneity . . . easy success': ibid.

p. 38 'every kind of courtesan': Richardson, *A Life of Picasso*, Volume I, p. 198

p. 43 'I believe the Realist period is over . . .': André Derain, October 1901, in Gaston Diehl, *Derain*, p. 25

p. 43 'feeling and expressing are two entirely separate actions . . .': ibid.

p. 44 '*bougre des guinguettes fleuries*': Maurice Genevoix, *Vlaminck*, p. 7

p. 44 'You need to be rich to paint!': Carco, *L'Ami des peintres*, p. 59

p. 44 'I must have been about eight or ten . . .': ibid.

p. 45 'Hey, look, André . . .' . . . 'Oh yes . . . all in black!': ibid., p. 20

p. 45 'a nobler occupation . . .': Maurice Vlaminck, *Dangerous Corner*, p. 61

p. 46 'wrapped in an expensive fur . . .': ibid., p. 65

p. 46 'more serious, more worthwhile': ibid., p. 67

p. 46 'with a few colours in a box . . .': ibid., p. 66

p. 47 'a tremendous urge to re-create . . .': ibid., p. 74

p. 47 '*Je n'ai pas pu dormi de la nuit*': Carco, *L'Ami des peintres*, p. 21

p. 47 'I really do not care': ibid., p. 61

p. 48 'hard-bitten and tenacious old liberals': Vlaminck, *Dangerous Corner*, p. 64

p. 48 'I heightened all my tone values . . .': ibid., p. 74

p. 49 '*pommes frites*' . . . '*gâteaux*': Paul Poiret, *King of Fashion: The Autobiography of Paul Poiret*, p. 30

p. 49 'ferocious air and savage look': ibid., p. 54

p. 49 'they produced quite a good impression': ibid., p. 55

p. 49 'I can still see them by the flowery banks . . .': ibid.

p. 50 'dressed the passing moment': ibid., p. 35

p. 50 'all Paris had stopped at least once': ibid.

p. 51 'orgy of colours': Palmer White, *Poiret*, p. 17

p. 51 'anything that was cloying . . .': ibid., p. 23

p. 51 'and my sunburst of pastels made a new dawn': ibid.

pp. 51–2 'the inspiration for my creations . . .': ibid., p. 28

p. 52 'To dress a woman . . .': ibid., p. 39 (*Vogue*, 15 October 1913)

p. 52 'All the talent of the artist consists in a manner of revealment': ibid.

p. 56 'facility in capturing attitudes': McCully (ed.), *Picasso: The Early Years*, p. 37

p. 56 'brilliant, clamorous': ibid.

p. 56 'all nerve, all verve, all impetuosity': ibid.

p. 57 'cameos showing painful reality . . .': ibid., p. 39

p. 57 'What drawing! . . .': ibid.

p. 58 'the greatest swindle of the century': Hilary Spurling, *La Grande Thérèse*, p. 77

p. 61 Georges Lepape . . .: Note: Lepape dates his entry to the Académie Humbert as 1902, but this must be a typographical or other form of error, as he entered the same year as Braque, 1903. Lepape and Defert, *From the Ballets Russes to Vogue*, p. 19

p. 61 'And what a teacher . . .': ibid., p. 21

p. 61 'If only he'd been willing to pass on his tips . . .': ibid.

p. 62 'the oil to use as an additive . . .': Alex Danchev, *Georges Braque: A Life*, p. 19

p. 63 'I'm quite good at marbling . . . quite fascinating': Lepape and Defert, *From the Ballets Russes to Vogue*, p. 20

p. 63 'Here? Never . . .': ibid.

p. 64 'I'll never be a painter': Flora Groult, *Marie Laurencin*, p. 49

p. 64 'colours . . . terrified me': ibid., p. 53

p. 65 'Our lonely Sundays . . .': Marie Laurencin, *Le Carnet des nuits*, p. 22

p. 65 'without the music and the airs . . .': Groult, *Marie Laurencin*, p. 40

p. 65 'nothing else at all . . .': ibid., p. 44

p. 66 'Yesterday Braque and I were being lazy . . .': Danchev: *Georges Braque*, p. 27

p. 66 'the shoulders of a gorilla and the neck of a bull': Lepape and Defert, *From the Ballets Russes to Vogue*, p. 26

p. 67 'If a couple indulged in wayward behaviour . . .': ibid., p. 27

p. 70 'like a Spanish guitarist': Fernande Olivier, *Souvenirs intimes: écrits pour Picasso*, p. 173

Part II: The Rose Period

p. 75 *'Et couché, el soir . . .'*: André Salmon, *L'Air de la Butte: souvenirs sans fin*, p. 16

p. 75 'I just tell them, you didn't win': ibid., p. 17

p. 76 *'C'est ici'*: ibid., p. 18

p. 76 'The artists Messrs . . .': John Richardson, *A Life of Picasso, 1907–1917: The Painter of Modern Life*, Volume II, p. 293

p. 80 'travelling jugglers and acrobats . . .': Norman Mailer, *Picasso: Portrait of Picasso as a Young Man*, p. 171

p. 80 'not so much the circus proper . . .': ibid., pp. 171–2

pp. 80–81 '"How much?" asked Vollard . . .': Jean-Paul Crespelle, *La Vie quotidienne à Montmartre au temps de Picasso, 1900–1910*, p. 75

p. 83 'There is a Spanish painter . . . *personnalité émouvante'*: Fernande Olivier, *Souvenirs intimes: écrits pour Picasso*, p. 165

p. 83 'like a heated roof': ibid., p. 111

pp. 84–5 'canvases which restore light . . . are they not also decorations?': Hilary Spurling, *Matisse: The Life*, p. 112

p. 85 'a tall, powerful fellow . . .': Ambroise Vollard, *Recollections of a Picture Dealer*, p. 200

p. 85 'squeezed out of tubes of paint in a fit of rage': ibid.

p. 86 'a wooden tie of his own invention . . .': ibid., p. 201

p. 87 'but . . . what chaos!': Olivier, *Souvenirs intimes*, p. 192

p. 88 'strange, tender and infinitely sad': Fernande Olivier, *Picasso and His Friends*, p. 28

p. 88 'a deep and despairing love of humanity?': ibid.

p. 88 *'étrange et sordide maison* . . . like the doorway of a Protestant chapel': Olivier, *Souvenirs intimes*, p. 111

p. 88 *'C'est moi qui les fais . . .'*: ibid., p. 113

p. 89 *'en grand tralala'*: ibid., p. 125

p. 90 'perhaps I could love this boy one day': ibid., p. 186

p. 93 *'Le premier devoir d'un honnête homme . . .'*: Francis Carco: *Promenades pittoresques à Montmartre*, p. 12

p. 94 the work may have been painted earlier: See Crespelle: *La Vie quotidienne*, p. 162

p. 96 '*Là, tout n'est qu'ordre et beauté . . .*': Charles Baudelaire, '*L'invitation au Voyage*', *Les Fleurs du Mal* (Paris: 1st edn published 1857; 2nd edn published 1861)

p. 97 'crude, violent . . . altogether bizarre canvases': Anonymous, 'Autumn Salon is Bizarre', *New York Sun*, 27 November 1904, quoted in Lyn Hejinian, and author cited as James G. Huneker, in Introduction to Gertrude Stein, *Three Lives*, p. 15

p. 97 'tang of the soil': ibid., p. 16

p. 98 '"Now," . . . "the picture is ours!". . . someone they loved' Vollard, *Recollections of a Picture Dealer*, p. 137

p. 98 'a bit like a desperado': Janet Hobhouse: *Everybody Who was Anybody: A Biography of Gertrude Stein*, p. 36

p. 98 'felt myself growing into an artist': ibid.

p. 99 'atmosphere of propaganda': ibid., p. 45

p. 99 'I said that I did not . . .': ibid.

p. 99 'Cézanne debauch': ibid.

p. 99 'As this was regarded as a criminal waste . . .': ibid., p. 46

p. 100 'the obligation that I have been under . . .': ibid.

p. 100 'Big Four': ibid.

p. 101 'It's such a terrible waste of time . . . everything I'm showing': Marilyn Cully (ed.), *Picasso: The Early Years*, pp. 44–5

p. 101 'a good image maker': ibid., p. 44

p. 101 'flowers, draperies, dresses . . .': ibid.

p. 101 'Exposition Picasso – *Lundi* . . .': Max Jacob and André Salmon, *Correspondance 1905–1944*, p. 21

p. 102 '*chef d'école*': Spurling, *Matisse*, p. 115

p. 105 'Monsieur André': François Bernadi, *Matisse et Derain à Collioure été 1905*, p. 22

p. 106 'a sort of giant . . .': ibid., p. 26

p. 106 'Poor me! He'd have made . . . five of me': ibid.

p. 106 'blonde, gilded light . . .': André Derain, *Lettres à Vlaminck*, p. 148

p. 108 'But what can he possibly see in them?' . . . '. . . pictures in the calendar': Bernadi, *Matisse et Derain*, p. 34

p. 110 '*la couleur pour la couleur*': ibid., p. 30

p. 110 'I'm taking advantage of the rain': Derain, *Lettres à Vlaminck*, p. 154

p. 110 'a new conception of light': ibid.

p. 111 'I'm fed up, but not really about anything . . . on the ground': ibid., p. 159

p. 111 'oh, to never have to go back to Paris': ibid., p. 160

p. 112 'pecuniary embarrassments': Maurice Vlaminck, *Dangerous Corner*, p. 73

p. 112 'I had had quite enough of Paris . . .': ibid.

p. 113 'A yellow moon in a green sky! . . .' Bernadi, *Matisse et Derain*, p. 36

p. 114 'little girls': Olivier, *Picasso and His Friends*, p. 40

p. 114 'A caprice had flung me into your arms . . .': Olivier, *Souvenirs intimes*, p. 188

p. 114 '*Mais je m'en f*—': ibid., p. 191

p. 115 'erected in memory of a woman he had loved': ibid., p. 47

p. 115 'inherited with his mother's Italian blood': ibid., p. 48

p. 117 'always thick with the hot, slightly sickening smell': ibid., p. 127

p. 117 'Mme Conception facilitates . . .': Salmon, *L'Air de la Butte*, p. 32

p. 118 'He loved anything with strong local colour . . .': Olivier, *Picasso and His Friends*, p. 126

p. 118 'How foreign he was in France': ibid.

p. 119 'the coarsest people imaginable': ibid., p. 127

p. 119 'I was completely captivated by the circus! . . .': Brassaï, *Conversations with Picasso*, pp. 18–19

p. 119 'tornadoes of laughter and hysteria': Olivier, *Picasso and His Friends*, p. 127

p. 120 'very much like the circus . . .': *Entretiens avec Federico Fellini: Les Cahiers RTB Séries Télécinéma* (1962), reprinted in Suzanne Budgen, *Fellini* (London: BFI Education, 1966), p. 62; quoted in Helen Stoddart, *Rings of Desire: Circus History and Representation*, p. 147

p. 122 'So that you can make a study of them . . .': Olivier, *Picasso and His Friends*, p. 43

p. 124 'Fauvism was our ordeal by fire': Denys Sutton, *Andreé Derain*, p.20

p. 124 'It was the era of photography. This may have influenced us . . .': ibid.

p. 125 'Was it because I had been working in the blazing sun? . . .': Jeanine Warnod, *Washboat Days: Montmartre, Picasso and the Artists' Revolution*, p. 125

p. 125 'the same feeling of wonder . . .': Vlaminck, *Dangerous Corner*, p. 71

p. 126 'That's not painting': Spurling, *Matisse*, p. 131

p. 128 'Matisse has been a disappointment . . .': Vollard, *Recollections of a Picture Dealer*, p. 201

p. 128 'Forsaking those greys . . .': ibid., pp. 201–202

p. 128 'Poor Matisse! . . . friends here!': ibid., p. 202

p. 128 'a Donatello among the wild beasts': Louis Vauxcelles, quoted in Spurling, *Matisse*, p. 132

pp. 128–9 'long lines of revolutionaries . . .': ibid.

p. 128 'felt he had been decidedly outflanked': ibid.

p. 129 'something decisive': Hobhouse, *Everybody Who was Anybody*, p. 46

p. 129 'a tremendous effort': ibid.

p. 129 'the nastiest smear of paint . . .': ibid.

p. 129 'the unpleasantness of the putting on of the paint': ibid., p. 47

p. 129 'really intelligent': ibid., p. 48

p. 129 his 'explaining' period'

p. 130 'amazing, wildly expressive': Gaston Diehl, *Derain*, p. 42

p. 130 'I got a green suit and a red jacket . . .': Crespelle, *La Vie quotidienne*, p. 50

p. 130 'You look as if you're just back from Monte Carlo': ibid.

p. 131 'No . . . This is the real thing': Hobhouse, *Everybody Who was Anybody*, p. 49

p. 131 'monkey's' feet: ibid., p. 50

p. 132 'But my dear lady . . . your last day is imminent': Olivier: *Picasso and His Friends*, p. 45

p. 132 'one of those characters . . . an introducer': Gertrude Stein, *The Autobiography of Alice B. Toklas*, p. 50

p. 132 'He had . . ."Roché is very nice but he is only a translation"': ibid.

p. 133 'surprised that there was anything left . . .': Richardson, *A Life of Picasso*, Volume I, p. 398

p. 133 'just completely there . . .': ibid.

p. 133 'thin, dark, alive with big pools of eyes . . .': ibid., p. 400

p. 133 'beautiful masterpieces': Olivier, *Picasso and His Friends*, p. 89

p. 133 'solemnly and obediently looked . . . understood each other': Richardson, *A Life of Picasso*, Volume I, p. 400

p. 133 'outsiders might easily have imagined themselves . . .': Vollard, *Recollections of a Picture Dealer*, pp. 136–7

p. 134 'excellent for the digestion': ibid., p. 137

p. 134 'the investigator whom nothing escapes': ibid., p. 138

p. 134 'the fellow leaning with both hands . . .': ibid.

p. 135 'the normal is so much more simply complicated . . .': Hobhouse, *Everybody Who was Anybody*, p. 17

p. 135 'just like Dickens . . .': ibid., p. 31

p. 135 'Picasso sat very tight on his chair . . .': Stein, *The Autobiography of Alice B. Toklas*, p. 53

pp. 135–6 '"Non," he replied': ibid.

p. 136 'millionaires from San Francisco . . .': Salmon, *L'Air de la Butte*, p. 144

p. 136 'some kind of visceral reverence': Richardson, *A Life of Picasso*, Volume I, p. 407

p. 136 on first-name terms from the beginning: *Matisse, Cézanne, Picasso . . . l'aventure des Stein*, p. 327

p. 137 'what was inside myself . . .': Hobhouse, *Everybody Who was Anybody*, p. 16

p. 137 'bottom nature': Gertrude Stein, *The Making of Americans. Being a History of a Family's Progress*, p. 343

pp 137–8. '"Melanctha Herbert," began Jeff Campbell . . .': Gertrude Stein, 'Melanctha', in Gertrude Stein, *Three Lives*, pp. 245–6

p. 138 'I was obsessed by this idea of composition . . .': Gertrude Stein, interview with Robert Haas (1942), p. 15, quoted by Lyn Hejinian, ibid., p. 42

p. 138 'I began to play with words then. Picasso was painting my portrait . . .': Gertrude Stein, interview with Robert Haas, Gertrude Stein, 'What are Master-pieces . . .?', in Gertrude Stein, *What are Master-pieces . . .?* p. 100

p. 138 'After all' . . . 'to me one human being is as important as another': ibid., p. 98

p. 138 'you might say that the landscape has the same values . . .': ibid.

p. 138 'the essence or as the painter would call it value': ibid

p. 138 'largely from Cézanne': ibid

p. 138 'continuous present': Gertrude Stein, 'Composition as Explanation', in Stein, *What are Master-pieces . . .?*, p. 31

p. 138 'I was doing what the cinema was doing': Gertrude Stein, 'Portraits and Repetition', in Gertrude Stein, *Look at Me Now and Here I Am, Writings and Lectures 1909–1945*, p. 106

p. 138 'the time-sense in the composition': Stein, 'Composition as Explanation', in Stein, *What are Master-pieces . . .?*, p. 37

p. 138 'the quality in a composition that makes it go dead . . .': ibid.

p. 139 'And yet time and identity is [sic] what you tell about': Stein, 'What are Master-pieces . . .?', in Stein, *What are Master-pieces . . .?*, p. 92

p. 139 'I am I not any longer . . .': Gertrude Stein, 'Henry James', in Stein, *Look at Me Now and Here I Am*, p. 292

p. 139 'Time is very important in connection with master-pieces . . .': Stein, 'What are Master-pieces . . .?' in Stein, *What are Master-pieces . . .?*, p. 92

p. 139 'everything pushed him to it . . .': Gertrude Stein, 'Picasso' (1938), in Gertrude Stein, *Picasso: The Complete Writings*, p. 34

p. 140 'And so Jeff went on every day . . .': Stein, 'Melanctha', in Stein, *Three Lives*, pp. 330–31

p. 141 'And to think . . .': Salmon, *L'Air de la Butte*, p. 29

p. 141 'marvellous amber-coloured bamboo pipe . . .': ibid., p. 49

p. 141 'that wonderful oblivion . . .': ibid., p. 50

p. 141 'Everything seemed to take on a special beauty . . .': ibid.

p. 143 'Oh, those are old things . . .': the meeting is described in various sources, the exact words of the (possibly apocryphal) conversation quoted variously, e.g. Christian Parisot, *Modigliani*, pp. 83–5; André Salmon: *Modigliani: A Memoir*, pp. 41–3

p. 144 'those intelligent hands . . .': François Bergot, quoted in Noel Alexandre, *The Unknown Modigliani: Drawings from the Collection of Paul Alexandre*, p. 9

p. 144 'My damned Italian eyes are to blame . . . dark ochre': Pierre Sichel, *Modigliani: A Biography of Amedeo Modigliani*, p. 101

p. 146 'accost the girl with a certain formality . . .': Salmon, *Modigliani*, p. 46

p. 147 'his occasional remarks . . . incoherent brilliance': ibid., p. 47

p. 148 'The illusion was perfect after the third *mominette*': ibid.

p. 148 'Just paint to please yourself . . . lessons': Olivier, *Souvenirs intimes*, p. 194

p. 151 'Druet process': Alfred H. Barr Jr, *Matisse: His Art and His Public*, p. 82

p. 151 'meretricious showman': anonymous reviewer quoted in Spurling, *Matisse*, p. 137

p. 151 'gone to the dogs': Paul Signac, quoted in ibid., p. 136

p. 152 'multicoloured flats arching over a vista . . .': Barr, *Matisse*, p. 89

p. 153 'How old are you?' . . .: Dan Franck, *Les Années Montmartre: Picasso, Apollinaire, Braque et les autres*, p. 24

p. 153 'frightened of any revelations . . .': Vlaminck, *Dangerous Corner*, p. 75

p. 153 'undoubtedly the happiest and most fruitful period . . .': Jean Leymarie, quoted by Denys Sutton in his Introduction to ibid., p. 13

p. 154 'something very pleasing about Matisse . . .': Olivier, *Picasso and His Friends*, p. 88

p. 154 'precise, concise and intelligent': ibid.

p. 154 'a good deal less simple . . .': ibid.

p. 155 'Matisse talks and talks . . .': Picasso, quoted in Spurling, *Matisse*, p. 142

p. 155 'As different as the North Pole is from the South Pole': Olivier, *Picasso and His Friends*, p. 84

p. 155 'gross, mad, monstrous products . . .': Spurling, *Matisse*, p. 141

p. 158 'I want you to buy or send me . . .': Richardson, *A Life of Picasso*, Volume I, p. 444

p. 159 'M'sieur Picasso, M'sieur Picasso . . .': Warnod, *Washboat Days*, p. 12

p. 160 'I can't see you any more when I look': Hobhouse, *Everybody Who was Anybody*, p. 74

p.p. 160–61 'It is well for young men to have a model . . .': Gauguin, quoted in John Berger, *The Success and Failure of Picasso*, p. 54

p. 161 'But it doesn't look like me' . . . 'It will': variously quoted and translated, e.g. Mailer, *Picasso*; p. 214; Franck, *Les Années Montmartre*, p. 68

p. 161 'I was and I still am satisfied . . .': Stein, 'Picasso' (1938), in Stein, *Picasso*, p. 34

p. 161 'still a little rose . . .': ibid., p. 51

p. 161 'Picasso was the only one in painting . . .': ibid., p. 52

pp. 161–2 'The rose period ended with my portrait . . .': ibid., p. 51

p. 162 'he contented himself with seeing things . . .': ibid.

p. 163 'while thundering for the Republic': Félix Fénéon, *Novels in Three Lines*, p. 6

p. 163 '27 violations': ibid.

p. 163 'Too old to work': ibid., p. 17

p. 163 'horrible monsters and efflorescent skin diseases': ibid., p. 110

p. 163 'More and more the struggle to express it intensified': Stein, 'Picasso' (1938), in Stein, *Picasso*, p. 52

p. 165 'From rooms where the plaster was falling . . .': Romola Nijinsky, *Nijinsky*, p. 73

p. 166 'The Hour of Reckoning': Sjeng Scheijen, *Diaghilev: A Life*, p. 133

p. 166 'the length and breadth of infinite Russia': ibid., p. 134

p. 166 'The end was here in front of me': ibid.

p. 166 'palaces frightening in their dead grandeur . . . the new aesthetic': ibid.

p. 168 'an invasion of Petersburgers': ibid., p. 150

p. 169 'surrounded by drawings . . .': Spurling, *Matisse*, p. 149

Part III: Carvings, Private Lives, 'Wives'

p. 175 '*Oh la la! Quel beau corps* . . .': Alfred H. Barr Jr, *Matisse: His Art and His Public*, p. 95

p. 175 'Does that interest you?' . . . ' . . . make a design': Hilary Spurling, *Matisse: The Life*, p. 153

p. 177 'two-man race': ibid., p. 142

p. 179 'At that moment I understood that I was a painter . . .': Alex Danchev, *Georges Braque: A Life*, p. 42

p. 179 'Just imagine . . . I left the drab, gloomy Paris studios . . .': ibid., p. 41

p. 179 'memories in anticipation' . . . 'Braque, Friday': John Richardson, *A Life of Picasso, 1907–1917: The Painter of Modern Life*, Volume II, p. 68

p. 181 '*d'une beauté grave*': Richardson, *A Life of Picasso*, Volume II, p. 29

p. 182 'less wild, more brilliant . . .': Fernande Olivier, *Picasso and His Friends*, p. 93

p. 182 'outside society, of a different species': ibid., p. 94

p. 183 'took a great deal of trouble . . .': ibid., p. 85

p. 184 '"It's the cry of the Grand Lama" . . .': ibid., p. 86

p. 184 'thoroughbred marionettes . . .': ibid., p. 51

p. 186 'the art of arranging in a decorative manner . . .': Barr, *Matisse*, p. 119

p. 186 'What I am after, above all . . .': ibid.

p. 187 'I cannot copy nature in a servile way . . .': ibid., p. 121

p. 187 'the very nature of each experience': ibid.

p. 187 'an appeasing influence, like a mental soother . . .': ibid., p. 122

p. 192 'the year of the cinema': Richard Abel, *The Ciné Goes to Town: French Cinema 1896–1914*, p. 25

p. 193 'Between nine o' clock and midnight . . .': Paul Éluard, Foreword to Nicole Védrès: *Images du cinéma français*, p. 7

p. 194 'Picasso and Braque saw the flaw in photography': David Hockney, *Picasso*, p. 49

p. 196 'Would you like to hear some big news? . . .': Fernande Olivier, *Souvenirs intimes: écrits pour Picasso*, p. 218 (24 August 1907)

p. 197 'Tell Alice I can't write to her . . .': ibid., p. 219 (postscript to letter of 24 August 1907, above)

p. 197 'of Madame Matisse with a green line . . .': Alice B. Toklas, *What is Remembered*, p. 18

p. 197 'I once said to her . . .': ibid., p. 10

p. 198 'tactless choice': ibid., p. 19

p. 198 'busier and noisier . . .': ibid., p. 22

p. 199 'It was Gertrude Stein . . . primitive Greek': ibid., p. 23

p. 199 'vengeful goddess': ibid.

p. 199 'Now you understand . . .': ibid., p. 24

p. 200 'golden': ibid., p. 26

p. 200 'astonishing virility': Gertrude Stein, *The Autobiography of Alice B. Toklas*, p. 42

p. 200 'She always placed a large black hat-pin . . .': ibid., p. 41

p. 200 'bringing her eye close and moving . . .': ibid., p. 68

p. 200 'as for myself I prefer portraits . . .': ibid.

p. 201 'wonderful tales': *Matisse, Cézanne, Picasso . . . l'aventure des Stein*, p. 327

p. 201 'if you love a woman you give her money': Stein, *The Autobiography of Alice B. Toklas*, p. 23

p. 201 'a loud knocking . . .': Toklas, *What is Remembered*, p. 27

p. 201 'marvellous all-seeing brilliant black eyes': ibid.

p. 201 'You know how as a Spaniard . . .': ibid., p. 27

p. 202 'a large heavy woman . . .': ibid.

p. 202 'a group of Montmartrois . . .': ibid., p. 28

p. 202 'Ah, the Miss Toklas . . .': Stein, *The Autobiography of Alice B. Toklas*, p. 28

p. 203 'Mees Toklas': Toklas, *What is Remembered*, p. 29

p. 203 'a very small Russian girl was holding forth . . .': ibid.

p. 203 'To exhibit frescoes for a cathedral . . .': Félix Vallotton, quoted in Arthur Gold and Robert Fizdale, *Misia: The Life of Misia Sert*, p. 127

p. 204 'In an orange, an apple, a ball . . .': Cézanne, quoted in John Rewald, *Cézanne: A Biography*, pp. 225–6

pp. 204–5 '*Quand la couleur est à sa richesse* . . .': Cézanne, quoted by Merleau-Ponty in Émile Zola, et al. *Cézanne vu par . . .*, p. 34

p. 205 'see in nature the cylinder, the sphere, the cone . . .': Cézanne, quoted in Rewald, *Cézanne*, p. 226

p. 205 'dense quilted blue', 'shadowless green': Rainer Maria Rilke, *Letters on Cézanne*, p. 29

p. 205 'the apples are all cooking apples . . .': ibid.

p. 205 '*la réalisation*': ibid., p. 34

p. 205 'the conviction and substantiality of things . . .': ibid.

p. 206 'it's natural, after all . . .': ibid., p. 50

p. 206 'was my one and only master! . . .': Picasso, quoted in Brassaï, *Conversations with Picasso*, p. 107

p. 207 'The poets of that time were our best disseminators': Danchev, *Georges Braque*, p. 47

p. 207 'a new classicism . . .': Adrienne Monnier, *The Very Rich Hours of Adrienne Monnier*, p. 84

p. 210 'columns of tenderness': June Rose, *Daemons and Angels: A Life of Jacob Epstein*, p. 76

p. 210 'a brilliant rectangle . . .': Noel Alexandre, *The Unknown Modigliani: Drawings from the Collection of Paul Alexandre*, p. 62

p. 211 'What I am searching for . . . in the human Race': Modigliani, in ibid., p. 91

p. 212 'It was a gorgeous surprise . . .': Toklas, *What is Remembered*, p. 30

p. 212 'a certain wild quality . . .': Stein, *The Autobiography of Alice B. Toklas*, p. 29

p. 213 'That settled the matter': ibid.

p. 213 'Of course to have a lesson in French . . .': ibid., p. 31

p. 213 'like real bottled liquid smoke': ibid.

p. 213 'first category sables, second category ermine . . .': ibid.

p. 214 'our hats are a success': ibid., p. 19

p. 214 'one ideal': ibid., p. 33

p. 214 'Fernande adored her . . .': ibid.

p. 215 'THAW MURDERS STANFORD WHITE . . . ': Gerald Langford: *The Murder of Stanford White*, p. 22

p. 215 'the most exquisitely lovely human being . . .': ibid., p. 93

p. 215 'She could never have counterfeited it . . . done it as well': ibid., p. 118

p. 216 'But she went into ecstasies over Evelyn Thaw . . .': Toklas, *What is Remembered*, p. 35

p. 217 'The performance at the Folies Bergère . . .': ibid., p. 33

p. 217 'Find a hotel in our quarter . . .': ibid.

p. 219 'You ought to do caricatures': Hélène Parmelin: *Picasso Says . . .*, p. 36

p. 219 'And yet Fénéon was quite somebody': ibid.

p. 219 'What a loss for French art!': Richardson, *A Life of Picasso*, Volume II, p. 106

p. 219 'My true meeting with him . . .': Danchev, *Georges Braque*, p. 51

p. 219 'It's as if you wanted to make us eat tow . . .': ibid., p. 52

p. 221 'For me the role of painting . . . halt an image': Parmelin, *Picasso Says . . .*, p. 39

p. 223 'he cannot look at the world any more . . .': Gertrude Stein, 'What are Master-pieces . . .?', in Gertrude Stein, *What are Master-pieces . . .?*, p. 87

p. 224 'You have to give whoever is looking at it . . .': Parmelin, *Picasso Says . . .*, p. 92

p. 224 'Everything is against them . . .': Stein, 'What are Master-pieces . . .?', in Stein, *What are Master-pieces . . .?*' p. 91

p. 224 'it is about identity and all it does . . .': ibid.

p. 224 'It is very interesting that no one is content . . .': ibid., pp. 93–4

p. 225 'Fit your parts into one another . . .': Barr, *Matisse*, p. 550

p. 225 'To feel a central line . . .': ibid., p. 551

p. 225 'The model must not be made to agree . . .': ibid.

p. 226 'He does not leave me alone . . .': Toklas, *What is Remembered*, p. 64

p. 226 'Is Fernande wearing her earrings?' . . . '. . . And it was': Stein, *The Autobiography of Alice B. Toklas*, p. 33

p. 227 'held Pablo by her beauty': Toklas, *What is Remembered*, p. 35

p. 227 'taking Fernande off his hands': ibid., p. 36

p. 227 'a new and alarming development occurred': ibid.

p. 227 'I have seen God': ibid., p. 37

p. 227 'large' laughs: ibid.

p. 228 *'le cher maître . . .'*: ibid., p. 38

p. 228 'unsympathetic as a man . . .': ibid., p. 39

p. 228 'an old maid mermaid . . . quite unbearable': ibid., p. 44

p. 228 'wore thin and finally blew away entirely': ibid.

p. 228 'By the time the buttercups were in bloom . . .': ibid.

p. 229 'You have seated yourselves admirably' . . . 'a sort of man and woman': Stein, *The Autobiography of Alice B. Toklas*, p. 23

p. 229 'the feeling between the Picassoites and the Matisseites . . .': ibid., p. 72

p. 231 'powerful head which made him look like a white negro': Fernande Olivier, *Picasso and His Friends*, p. 103

p. 231 'suspicious, able and clever': ibid.

p. 232 'his nose swollen like a potato . . .': ibid., p. 104

p. 233 *'ma femme'*: Danchev, *Georges Braque*, p. 107

p. 233 'disciple': Richardson, *A Life of Picasso*, Volume II, p. 83

p. 233 'She set Braque apart . . .': Danchev, *Georges Braque*, p. 29

p. 235 'the most sensational of entrances': Olivier, *Picasso and His Friends*, p. 115

p. 235 'Oh! Remarkable! Delightful! . . .?' 'Yes . . . by Madame?': ibid.

pp. 235–6 'The fashionable figure is growing straighter . . .': Palmer White, *Poiret*, p. 41

p. 236 'He saw things on a large, a grand scale . . .': Olivier, *Picasso and His Friends*, p. 116

p. 236 'eyeglass in one hand and foil in the other . . .': Claude Lepape and Thierry Defert, *From the Ballets Russes to Vogue: The Art of Georges Lepape*, p. 40

p. 237 'Peacock Woman and her brilliant portrayal . . .': Jean Lorrain, in Philippe Jullian, *Montmartre*, p. 132

p. 238 'I could see the gas lamps rise up in tiers . . .': Alexandre, *The Unknown Modigliani*, p. 53

Notes

p. 238 'some sensational entry': Paul Poiret, *King of Fashion: The Autobiography of Paul Poiret*, p. 54

p. 241 'decision': Richardson, *A Life of Picasso*, Volume II, p. 110

p. 242 'We are the two great painters of the age . . .': Olivier, *Picasso and His Friends*, p. 92

p. 242 'Poor, dear *douanier* . . .': ibid., p. 90

p. 242 'he had the natural gift of a primitive painter': ibid., p. 92

p. 242 'a unique talent, a sort of genius': ibid.

p. 243 at least three: Note: In addition, during the course of 1908, they bought a large number of works by Picasso. See *Matisse, Cézanne, Picasso . . .*, pp. 314–16

p. 243 'a small, strange watercolour of Picasso's . . .': Alexandre: *The Unknown Modigliani*, p. 62

p. 244 'only once at sundown . . .': Richardson, *A Life of Picasso*, Volume II, p. 102

p. 244 'two ascending and converging lines . . .': ibid., p. 101

p. 244 *'petites cubes'*: ibid.

p. 244 'a Mediterranean landscape . . .': Henri Matisse, in Georges Braque et al., *Testimony against Gertrude Stein*, p. 6

p. 244 'In order to give . . .': ibid.

p. 245 'When we invented cubism . . .': Richardson, *A Life of Picasso*, Volume II, p. 105

p. 245 'Cubism, or rather my cubism . . .': ibid.

p. 245 'Cubism showed cubes where there weren't any . . .': Jean Cocteau, *The Journals of Jean Cocteau*, p. 93

p. 245 'It has its origins in a single viewpoint . . .': Richardson, *A Life of Picasso*, Volume II, p. 105

p. 245 'a full experience of space . . . as a painting should': Danchev, *Georges Braque*, p. 73

p. 245 'It is as if someone spent his life . . .': Richardson, *A Life of Picasso*, Volume II, p. 105

p. 246 'brought him closer to the human being . . .': Hockney, *Picasso*, p. 48

p. 246 'If there are three noses . . .': ibid., p. 50

p. 246 'strange alchemy': Maurice Vlaminck, *Dangerous Corner*, p. 77

pp. 246–7 'aesthetic revolution [which] would remain uncontrolled . . .': ibid.

p. 247 'Picasso never lectured . . .': Cocteau, *The Journals of Jean Cocteau*, p. 93

p. 247 'terribly individualistic . . .': André Salmon, in Jeanine Warnod, *Washboat Days: Montmartre, Picasso and the Artists' Revolution*, p. 102

p. 247 'to buck him up and to banish his doubts': Vlaminck, *Dangerous Corner*, p. 76

p. 247 'fun to work in pure colour and tone . . .': ibid.

p. 248 'It seemed as though everything was seen . . .': ibid., p. 79

p. 248 'How could I dream of running . . .?': ibid., p. 80

p. 249 'It is forbidden to disturb the performance with hats . . .': Michel Fontana, *L'Année 1908 en France* (Thesis, Université de Paris III, Sorbonne Nouvelle, Departement d'Études et de Recherches en Cinéma et Audiovisuel, Mémoire pour le Diplôme d'Études Approfondies, Septembre 1997, Documentations du Musée du Cinéma, Bercy, Paris (11. 01 FRA FON), p. 107; cited in *Ciné-Journal*, 1 September 1908)

p. 250 'a painting that enchanted him': Alexandre, *The Unknown Modigliani*, p. 62

p. 250 'Can you still doubt that my client . . .?': Ambroise Vollard, *Recollections of a Picture Dealer*, p. 216

p. 251 'Oh! Monsieur Vollard! . . .': ibid., p. 218

p. 251 'So you see, Léonie . . . Léon . . .': ibid., p. 219

p. 251 'good-nature personified': ibid., p. 215

p. 252 *'Aie! Aie! Aie!* . . .': Olivier, *Picasso and His Friends*, p. 70

p. 252 'burst in upon us filled with the tragedy . . .': Toklas, *What is Remembered*, p. 56

p. 252 *'le "premier" de l'alimentation à Paris'*: Hubert Juin, *Le Livre de Paris 1900*, p. 102

p. 254 'the national song of the Red Indians': Toklas, *What is Remembered*, p. 57

p. 254 'Salmon came running past us . . .': ibid.

Part IV: Street Life

p. 257 'fast tempo and beautiful movement': Alfred H. Barr Jr, *Matisse: His Art and His Public*, p. 135

p. 257 'I have decided to defy our bourgeois opinions . . .': ibid., p. 555 (31 March 1909, Moscow)

p. 258 'In those days only millionaires . . .': Gertrude Stein, *The Autobiography of Alice B. Toklas*, p. 102

p. 260 'streamed with gold': Misia Sert, *Two or Three Muses: The Memoirs of Misia Sert*, p. 111

p. 260 'Artists, who all their lives . . .': V.J. Svetlov, in Serge Lifar, *Serge Diaghilev: His Life, His Work, His Legend*, pp. 130–31

p. 260 'arduous, feverish, hysterical': Tamara Karsavina, *Theatre Street: The Reminiscences of Tamara Karsavina*, p. 235

p. 260 *Ces Russes, oh la la . . .*': ibid., p. 236

p. 261 'For mercy's sake, I cannot work . . .': ibid.

p. 261 'a retail shop of cheap emotions . . .': ibid., pp. 235–6

p. 261 'itself a work of art': Richard Buckle, *Nijinsky*, p. 88

p. 262 'He rose up, a few yards . . .': Karsavina, *Theatre Street*, pp. 240–41

p. 262 'irresistible at twenty': Misia Sert, in Arthur Gold and Robert Fizdale, *Misia: The Life of Misia Sert*, p. 136

p. 262 'splashed Paris with colours': Jean Cocteau, *The Journals of Jean Cocteau*, p. 50

p. 262 'When you paint a landscape . . . like a plate': Francis Carco, *From Montmartre to the Latin Quarter*, p. 32

p. 263 'I understood how far I was able to go': John Richardson, *A Life of Picasso, 1907–1917: The Painter of Modern Life*, Volume II, p. 124

p. 264 'two landscapes and two figures . . .': ibid., p. 128

p. 265 'Because of the heat . . .': Alice B. Toklas: *What is Remembered*, p. 48

p. 265 'beautifully made to order . . .': ibid.

p. 265 'rosy with pleasure': ibid., p. 50

p. 265 'Those were proud and happy days . . .': ibid., p. 53

p. 266 'an extraordinary one of Harriet': ibid., p. 49

p. 266 'The old people in a new world . . .': Gertrude Stein, *The Making of Americans. Being a History of a Family's Progress*, p. 3

p. 266 'We need only realize our parents . . .': ibid.

p. 266 'bottom' or basic nature: ibid., p. 343

p. 267 'dependent independent' . . .' 'resting kind': ibid., p. 344

p. 267 'independent dependent' . . . 'attacking kind': ibid.

p. 267 'emotion is not as poignant . . .': ibid., p. 347

p. 267 'their substance is more vibrant . . .': ibid.

p. 267 'attackingly defending': ibid., p. 348

p. 267 'the muggy resisting bottom . . .': ibid., p. 352

p. 267 'I am all unhappy in this writing . . .': ibid., p. 348

p. 267 'very exciting . . .': Toklas, *What is Remembered*, pp. 41–2

p. 268 'I had commenced the typewriting . . .': ibid., p. 54

p. 268 'a professional accuracy . . .': ibid.

p. 268 'Frequently these were the characters . . .': ibid.

p. 268 *'Eh bien'* . . . 'off the sidewalk': ibid., p. 55

p. 269 'Come on . . . take a fiacre': ibid., p. 60

p. 269 'very delicate tea': ibid., p. 61

p. 269 'on her very best behaviour': ibid., p. 60

p. 270 'these people must have hit the jackpot': Richardson, *A Life of Picasso*, Volume II, p. 143

p. 270 'Shchukin has bought my picture . . .': quoted in Fernande Olivier, *Souvenirs intimes: écrits pour Picasso*, p. 238

p. 271 'When I hang these on the wall . . .': Francis Carco, *L'Ami des peintres*, p. 19

p. 271 'it always amused me . . .': Gertrude Stein, *Picasso: The Complete Writings*, p. 35

p. 271 'really the beginning of cubism': Richardson, *A Life of Picasso*, Volume II, p. 131

p. 271 'only Spaniards can be cubists': ibid.

p. 272 'the humblest galleries where the *"jeunes"* showed their work . . .': Carco, *L'Ami des peintres*, p. 236

p. 272 'the pin wasn't fastened . . .': Fernande Olivier, *Picasso and His Friends*, p. 118

p. 274 'Some . . . spend all their living struggling . . .': Gertrude Stein, *The Making of Americans*, p. 463

p. 275 'a marvellous gold sheath . . .': *Paul Poiret, King of Fashion: The Autobiography of Paul Poiret*, p. 92

p. 275 'pointed her nose in every direction . . . *midinettes* of Paris': ibid., p. 93

p. 275 'like a thunder-clap': ibid., p. 40

p. 276 'FRENCH TRADE REPRESENTED BY THE ENGLISH PREMIER': ibid., p. 41

p. 276 'Wives dragged husbands . . .': Palmer White, *Poiret*, p. 41

p. 276 'Those gowns are . . . the worst of all the recent insanities' (*Le Figaro*); 'I shall have the charity to refrain from mentioning the name of the couturier who is guilty of this outrage' (*La Vie Parisienne*); 'To think of it! Under those straight gowns we could sense their bodies!' (*L'Illustration*): ibid.

p. 276 'I rolled myself into a ball . . .': Henri Matisse, in Hilary Spurling, *Matisse: The Life*, p. 194

p. 277 'I did sculpture when I was tired of painting . . .': Henri Matisse, Galeries of the Centre Pompidou

p. 278 'I said to her . . .': Toklas, *What is Remembered*, p. 61

p. 279 'yes apaches of course . . .': Richardson, *A Life of Picasso*, Volume II, pp. 142–3

p. 279 'you think you are witty . . .': ibid., p. 143

p. 279 'like a pauper . . .': ibid.

p. 280 'pimps . . . clowns, acrobats . . .': ibid., p. 145

p. 280 'like characters from a Carco novel': Olivier, *Picasso and His Friends*, p. 172

p. 280 'Strange, disturbing figures . . .': ibid., p. 171

p. 281 'hymn the man at the wheel': F.T. Marinetti, 'The Founding and Manifesto of Futurism, 1909', in Umbro Apollonio (ed.), *Futurist Manifestos*, p. 21

p. 281 'No work without an aggressive character . . .': ibid.

p. 281 'We will destroy the museums . . .': ibid., p. 22

p. 281 'the renovation of painting': ibid., p. 27

p. 282 ' the *dynamic sensation* itself': ibid.

p. 282 'persistent symbols of universal vibration': ibid., p. 28

p. 282 'put the spectator in the centre . . .': ibid.

p. 283 'If one plane wasn't enough . . .': Alex Danchev, *Georges Braque: A Life*, p. 69

p. 283 'And we judged everything like that . . .': Hélène Parmelin, *Picasso Says . . .*, p. 39

p. 284 'eternal and futile worship of the past': Marinetti, 'The Founding and Manifesto of Futurism, 1909', in Apollonio (ed.), *Futurist Manifestos*, p. 23

p. 284 ' can be nothing but violence . . .': ibid.

p. 287 'Bakst's emphasis on bold, bright . . .': Shari Greenberg, 'Léon Bakst

and Scheherazade', in *Mariinsky Ballet, 50th Anniversary Season* (London: Royal Opera House, 25 July–13 August, 2011), p. 25

p. 288 'Painting should inspire like this . . .': Georges Hilaire, *Derain*, p. 23

p. 289 'a roaring car . . .': Marinetti, 'The Founding and Manifesto of Futurism, 1909', in Apollonio (ed.), *Futurist Manifestos*, p. 21

p. 289 'looked as though they had just escaped . . .': Gold and Fizdale, *Misia*, p. 140

p. 289 'the southern regions of Europe . . .': Noel Alexandre, *The Unknown Modigliani: Drawings from the Collection of Paul Alexandre*, p. 99

pp. 289–90 'We can report . . .': ibid.

p. 290 'Carissimo . . .': ibid.

p. 290 'At the summit of the Butte Montmartre . . .': ibid.

p. 290 'Choose what is suitable, Madame . . . a state of mind . . .': White, *Poiret*, p. 41

p. 291 'modern men trying to find a pictorial language . . .': Roger Fry, 'The French Post-Impressionists' (1912), in Roger Fry, *Vision and Design*, p. 167

pp. 291–2 'The difficulty [in the paintings' reception] springs . . .': ibid.

p. 292 'The painter aims to construct not an anecdote . . . Braque, in Jeanine Warnod, *Washboat Days: Montmartre, Picasso and the Artists' Revolution*, p. 140

p. 292 'a purely abstract language . . .': Roger Fry, *Vision and Design*, p. 167.

p. 292 'by the continuity and flow . . .': ibid., p. 168

p. 292 'here attempting to do something quite different': ibid.

p. 292 'the great originator . . .': ibid.

p. 293 'And that . . . twentieth century': Gertrude Stein, *Paris France*, p. 17

p. 293 'their tradition kept them from changing . . .': ibid.

p. 293 'finally broke loose . . .': Lawrence Gowing, *Matisse*, p. 111

p. 294 'they have the advantage of being animated by touch': Richardson, *A Life of Picasso*, Volume II, p. 150

p. 295 'closer to Havana than to Madrid': ibid., p. 154

p. 295 'We are paying a hundred francs . . .': ibid., p. 156

p. 295 'stranded in little heaps . . .': ibid., p. 157

p. 295 'navicular structure . . .': ibid.

pp. 295–6 'doubled power of our sight': Umberto Boccioni, Carlo Carra, Luigi Russolo, Giacomo Balla, Gino Severini, 'Futurist Paintings: Technical Manifesto, 1910', in Apollonio (ed.), *Futurist Manifestos*, p. 28

p. 296 'swallowed safety pins . . .': Richardson, *A Life of Picasso*, Volume II, p. 158

p. 297 'And difficult!'. . .: ibid., p. 164

p. 297 'communion of souls': ibid.

p. 297 'Rich and poor, young and old . . .': ibid.

p. 298 'At the risk of offending the Pichots . . .': ibid., p. 165

p. 298 'lyricism of the *banlieusard*': Hilaire, *Derain*, p. 53 (quoting Jean Cassou: '*cet élan de lyricisme banlieusard*')

p. 299 'What was wrong in our attitude . . .': André Derain, in Denys Sutton, *André Derain*, p. 21

p. 299 'Where there is temperament . . .': ibid.

p. 299 '*esthétisme hasardeux*': Hilaire, *Derain*, p. 53

p. 299 '*Un tableau ne commence pas . . .*': ibid., p. 117

p. 300 '*façon directe de sentir des choses*': ibid., p. 36

p. 300 '*Mais la Peinture, c'est autre chose*': Maurice Genevoix, *Vlaminck*, p. 19

pp. 300–301 'the classicism of cubism [opposing] the romanticism of the Fauves': Jean Cocteau, *The Journals of Jean Cocteau*, p. 48

p. 301 'If you can't paint the entire person . . . to one side': Francis Carco, *Promenades pittoresques à Montmartre*, p. 14

p. 301 'He was painting from his wife': Cocteau, *The Journals of Jean Cocteau*, p. 49

p. 301 'From the moment that someone else could do the same thing . . .': Georges Braque, quoted in Warnod, *Washboat Days*, p. 140

p. 301 'I realized that a painter could not make himself known . . .': ibid.

p. 302 'the youngest of the cubists': Stein, *The Autobiography of Alice B. Toklas*, p. 121

p. 302 'How he drifted in . . .': ibid.

p. 303 'as one would join a religious faith': Warnod, *Washboat Days*, p. 169

p. 303 'the architecture reducing': ibid.

p. 303 'visiting Poles . . .': Richardson, *A Life of Picasso*, Volume II, pp. 179–80

p. 303 'primitive, diabolical, barbaric . . .': Spurling, *Matisse*, p. 199

p. 304 'We have been to the Salon d'Automne . . .': Maurice Sembat, quoted in Warnod, *Washboat Days*, p. 143

p. 305 'probably remaining': Toklas, *What is Remembered*, p. 61

p. 305 'And with that I moved . . .': ibid., p. 62

p. 305 'an intimate friend of two . . .': ibid., p. 63

p. 305 'infant prodigies of the social world': ibid.

p. 305 'considered herself a Greek scholar . . .': ibid.

p. 306 'ghostly pallor and elegant, etiolated figures': Spurling, *Matisse*, p. 204

p. 306 'a miracle of suppleness and rhythm': ibid., p. 208

p. 307 'monstrous images': ibid., p. 213

p. 307 'frightful *Spanish Woman* . . .': ibid.

p. 307 'very joyously . . .': Parmelin, *Picasso Says* . . ., p. 96

p. 308 'Each of us *had* to see . . .': Danchev, *Georges Braque*, p. 111

p. 308 'bumped into': Richardson, *A Life of Picasso*, Volume II, p. 186

p. 308 acquisition . . . of eleven works by Matisse: Jean-Paul Crespelle, *La Vie quotidienne à Montmartre au temps de Picasso, 1900–1910*, pp. 123–4

p. 308 'a little French Evelyn Thaw . . .': Stein, *The Autobiography of Alice B. Toklas*, p. 122

p. 308 'Is Picasso leaving Fernande . . .?': Toklas, *What is Remembered*, p. 66

p. 309 'ma jolie' . . . 'Fernande is certainly not . . .': Stein, *The Autobiography of Alice B. Toklas*, p. 122

p. 311 'the true source . . . of all creative search': Spurling, *Matisse*, p. 234

Bibliography

Abel, Richard, *The Ciné Goes to Town: French Cinema 1896–1914* (Berkeley, Los Angeles and London: University of California Press, 1994)

Alexandre, Noel, *The Unknown Modigliani: Drawings from the Collection of Paul Alexandre*, with a Preface by François Bergot (London: Royal Academy of Arts, 1994, in association with Fonds Mercator)

Allwood, John, *The Great Exhibitions* (London: Studio Vista, 1977)

Apollonio, Umbro (ed.), *Futurist Manifestos*, with a new Afterword by Richard Humphreys (Boston, Massachusetts: MFA Publications, a division of the Museum of Fine Arts, Boston, 1970)

Barou, Jean-Pierre, *Collioure 1905: Matisse Fauve* (Perpignan: Éditions Mare Nostrum, 2005)

—, *Matisse ou le miracle de Collioure*, with a Preface by Michel Déon (Paris: Éditions Payot et Rivages, 2005)

Barr, Jr, Alfred H., *Matisse: His Art and His Public* (New York: MOMA, New York, published by Arno Press, 1966)

Benois, Alexandre, *Memoirs*, translated by Moura Budberg, with a Foreword by Peter Ustinov (London: Columbus Books, 1988; 1st published 1960)

—, *Memoirs, Volume II*, translated by Moura Budberg (London: Chatto & Windus, 1964)

Berger, John, *The Success and Failure of Picasso* (Harmondsworth: Penguin, 1966; 1st published 1965)

Bernadi, François, *Matisse et Derain à Collioure été 1905*, edited by Les Amis du Musée de Collioure (Collioure: Musée de Collioure, 1989)

Borchert, Bernhard (Introduction and Notes), *Modigliani* (London: Faber and Faber, 1960)

Braque, Georges, and Eugène Jolas, Maria Jolas, Henri Matisse, André Salmon, Tristan Tzara, *Testimony against Gertrude Stein*, Transition Pamphlet no. 1 – a supplement to Transition, 1934–5 (no. 23), February 1935 (The Hague: Servire Press, 1935)

Brassaï, *Conversations with Picasso*, translated by Jane Marie Todd (Chicago and London: University of Chicago Press, 1999)

Buckle, Richard, *Diaghilev* (London: Weidenfeld & Nicolson, 1979)

—, *Nijinsky* (Harmondsworth: Penguin Books, 1975; 1st published 1971)

Bury, Stephen (ed.), *Breaking the Rules: The Printed Face of the European Avant-Garde, 1900–1937* (London: The British Library, 2007)

Cahn, Isabelle, *Ambroise Vollard: un marchand d'art et ses trésors* (Paris: Gallimard, 2007)

Carco, Francis, *L'Ami des peintres* (Paris: Gallimard, 1953)

—, *De Montmartre au Quartier Latin* (Geneva: Éditions du Milieu du Monde, 1942)

—, *From Montmartre to the Latin Quarter*, translated by Madeleine Boyd (London: The Cayme Press, n.d.)

—, *Montmartre à vingt ans* (Paris: Albin Michel, 1938)

—, *Promenades pittoresques à Montmartre*, illustrated by 6 eaux-fortes and with 25 drawings by Eugène Véder (Paris: Éditions Léo Delteil, 1922)

Cocteau, Jean, *The Journals of Jean Cocteau*, edited, translated and with an Introduction by Wallace Fowlie, illustrated with 16 drawings by the author (London: Museum Press, 1956)

Cowling, Elizabeth, *Visiting Picasso: The Notebooks and Letters of Roland Penrose* (London: Thames & Hudson, 2006)

Crespelle, Jean-Paul, *La Vie quotidienne à Montmartre au temps de Picasso, 1900–1910* (Paris: Hachette, 1978)

Daix, Pierre, *Cubists and Cubism* (Geneva: Skira, 1982)

—, *Picasso: Life and Art*, translated by Olivia Emmet (London: Thames & Hudson, 1993; 1st published 1987)

Danchev, Alex, *Cézanne: A Life* (London: Profile Books, 2012)

—, *Georges Braque: A Life* (London: Penguin, 2007; 1st published 2005)

Denvir, Bernard, *Post-Impressionism* (London: Thames & Hudson, 1992)

Derain, André, *Lettres à Vlaminck* (Paris: Flammarion, 1955)

Diehl, Gaston, *Derain*, translated by A.P.H. Hamilton (Milan: The Uffici Press, n.d.)

Douglas, Charles, *Artist Quarter: Reminiscences of Montmartre and Montparnasse in the First Two Decades of the Twentieth Century* (London: Faber and Faber, 1941)

Escholier, Raymond, *Matisse from the Life*, translated by Geraldine and H.M. Colville (London: Faber and Faber, 1960)

Essers, Volkmar, *Henri Matisse: Master of Colour* (Cologne: Taschen, 2006; 1st published 1987)

Faure, Élie, *André Derain* (Paris: Les Éditions G. Crès et Cie, 1923)

Fénéon, Félix, *Novels in Three Lines*, translated and with an Introduction by Luc Sante (New York: New York Review Books, 2007)

Findling, John E. (ed.), *Historical Dictionary of World's Fairs and Expositions, 1851–1988* (New York, Westport, Connecticut and London: Greenwood Press, 1990)

Franck, Dan, *The Bohemians: The Birth of Modern Art: Paris 1900–1930*, translated by Cynthia Hope Liebow (London: Phoenix, 2002; 1st published 1998)

—, *Les Années Montmartre: Picasso, Apollinaire, Braque et les autres* (Paris: Menges, 2006)

Fry, Roger, *Vision and Design*, edited by J.B. Bullen (Mineola, New York: Dover Publications, 1998; 1st published London: Chatto & Windus, 1920)

Genevoix, Maurice, *Vlaminck* (Paris: Flammarion, 1954)

Gold, Arthur, and Robert Fizdale: *Misia: The Life of Misia Sert* (New York: Knopf, and London: Macmillan, 1980)

Gowing, Lawrence, *Matisse* (London: Thames & Hudson, 1979)

Greenhalgh, Paul, *Ephemeral Vistas: The 'Expositions universelles', Great Exhibitions and World's Fairs, 1851–1939* (Manchester: Manchester University Press, *c.*1988)

Groult, Flora, *Marie Laurencin* (Paris: Mercure de France, 1987)

Haskell, Arnold L., *Ballet Russe: The Age of Diaghilev* (London: Weidenfeld and Nicolson, 1968)

—, (in collaboration with Walter Nouvel), *Diaghilev: His Artistic and Private Life* (London: Victor Gollancz, 1935)

Hilaire, Georges, *Derain* (Geneva: Pierre Cailler, 1959)

Hobhouse, Janet, *Everybody Who was Anybody: A Biography of Gertrude Stein* (London: Weidenfeld and Nicolson, 1975)

Hockney, David, *Picasso* (Madras and New York: Hanuman Books, 1990)

Homans, Jennifer, *Apollo's Angels: A History of Ballet* (London: Granta, 2010)

Horne, Alistair, *Seven Ages of Paris: Portrait of a City* (London: Pan Macmillan, 2003; 1st published 2002)

Jacob, Max, and André Salmon, *Correspondance 1905–1944*, edited and with Notes by Jacqueline Gojard (Paris: Gallimard, 2009)

Jacobus, John, *Henri Matisse* (New York: Harry N. Abrams, n.d.)

John, Augustus, *Chiaroscuro: Fragments of Autobiography* (London: Arrow, 1962; 1st published 1952)

Juin, Hubert, *Le Livre de Paris 1900* (Paris: Pierre Belfond, 1977)

Jullian, Philippe, *Montmartre*, translated by Anne Carter (Oxford: Phaidon, 1977)

Karsavina, Tamara, *Theatre Street: The Reminiscences of Tamara Karsavina*, with a Foreword by J.M. Barrie (London: William Heinemann, 1930)

Kluver, Billy, *A Day with Picasso: Twenty-Four Photographs by Jean Cocteau* (Cambridge, Massachusetts: MIT Press, 1997; 1st published 1993)

Kostenevich, Albert, *Matisse to Malevich: Pioneers of Modern Art from the Hermitage* (Museumshop Heritage Amsterdam, *c*.2010)

Krystof, Doris, *Modigliani 1884–1920: The Poetry of Seeing* (Hong Kong, Cologne, London, Los Angeles, Madrid, Paris and Tokyo: Taschen, 2009; 1st published 1996)

Labrusse, Rémi, and Jacqueline Munck: *Matisse–Derain: À la Vérité du Fauvisme* (Hazan: published with the assistance of the Centre National du Livre, n.d.)

Langford, Gerald, *The Murder of Stanford White* (London: Victor Gollancz, 1963)

Lanzoni, Rémi Fournier, *French Cinema: From Its Beginnings to the Present* (New York and London: Continuum, 2010; 1st published 2002)

Laurencin, Marie, *Le Carnet des nuits* (Brussels: Éditions de la Nouvelle Revue Belgique, 1942)

Lee, Jane, *Derain* (Oxford: Phaidon, 1990)

Lepape, Claude, and Thierry Defert, *From the Ballets Russes to Vogue: The Art of Georges Lepape* (Paris: Presses de l'Imprimerie, 1947)

Leymarie, Jean, *André Derain ou Le Retour à l'ontologie* (Geneva: Éditions d'Art Albert Skira, 1948)

Lifar, Serge, *Serge Diaghilev: His Life, His Work, His Legend* (New York: Da Capo Press, 1976)

Mailer, Norman, *Picasso: Portrait of Picasso as a Young Man* (London: Abacus, Little, Brown and Company, 1997; 1st published 1995)

Mann, Carol, *Modigliani* (New York and Toronto: Oxford University Press, 1980)

Matamoros, Josephine, et al., *Matisse–Derain, Collioure 1905: un été fauve* (Paris: Gallimard, 2005)

Matisse, Henri, *Matisse*, text by John Jacobus (New York: Harry N. Abrams, n.d.)

Mellot, Philippe, *La Vie secrète de Montmartre* (Paris: Omnibus, Place des Éditeurs, 2008)

Melville, Joy, *Diaghilev and Friends* (London: Haus Publishing, 2009)

Meyer-Stabley, Bertrand, *Marie Laurencin* (Paris: Pygmalion, 2013)

Milner, John, *The Studios of Paris: The Capital of Art in the Late Nineteenth Century* (New Haven and London: Yale University Press, 1988)

Modigliani, Jeanne, *Modigliani: Man and Myth* (London: André Deutsch, 1959)

Monnier, Adrienne, *The Very Rich Hours of Adrienne Monnier*, translated, with an Introduction and Commentaries, by Richard McDougall, and an Introduction by Brenda Wineapple (Lincoln: Bison Books and University of Nebraska Press, 1996; 1st published 1976)

More, Julian, *Impressionist Paris: The Essential Guide to the City of Light* (London: Pavilion Books, 1998)

Nietzsche, Friedrich, *Thus Spake Zarathustra*, translated by Graham Parkes (Oxford: Oxford World's Classics, 2008; 1st published in a single volume 1892)

Nijinsky, Romola, *Nijinsky* (London: Victor Gollancz, 1933)

Nucera, Louis, *Les Contes du Lapin Agile* (Paris: Cherche Midi, *c.*2001)

O'Brian, Patrick, *Pablo Ruiz Picasso: A Biography* (London: Collins, 1976)

Olivier, Fernande, *Picasso and His Friends*, translated by Jane Miller (London: Heinemann, 1964)

—, *Souvenirs intimes: écrits pour Picasso* (Paris: Calmann-Levy, 1988)

Parisot, Christian, *Modigliani* (Paris: Éditions Pierre Terrail, 1992)

—, *Modigliani* (Paris: Gallimard, 2005)

—, *Modigliani: Catalogue Raisonné: Dessins, Aquarelles*, Volume I, edited by Giorgio and Guido Guastalla, text by Christian Parisot, Jeanne Modigliani, Fulvio Venturi (Livorno: Éditions Graphis Arte, 1990)

Parmelin, Hélène, *Picasso Says . . .*, translated by Christine Trollope (London: Allen and Unwin, 1969; 1st published 1966)

Pédron, François, *Les Rapins: L'Âge d'or de Montmartre* (Paris: Dépôt Légal, 2008)

Penrose, Roland, *Picasso*, with Notes by David Lomas (London: Phaidon, 1971)

—, *Picasso: His Life and Work* (London, Toronto, Sydney and New York: Granada, 1981, 3rd edn; 1st published 1958)

Poiret, Paul, *King of Fashion: The Autobiography of Paul Poiret*, translated by Stephen Haden Guest (London: V&A Publishing, 2009; 1st published as *My First Fifty Years*, 1931)

Pritchard, Jane (ed.), *Diaghilev and the Golden Age of the Ballets Russes 1909–1929* (London: V&A Publishing, 2010)

Ramuz, C.F., *Cézanne: Formes* (Lausanne: International Art Book, 1968)

Reeder, Roberta, *Anna Akhmatova: Poet and Prophet* (London: Allison & Busby, 1995; 1st published 1994)

Reiss, Françoise, *Nijinsky: A Biography*, translated by Helen and Stephen Haskell (London: Adam & Charles Black, 1960; 1st published 1957)

Rewald, John, *Cézanne: A Biography* (B.V. The Netherlands: Harry N. Abrams, 1986)

—, *Cézanne, the Steins and Their Circle* (New York: Thames & Hudson, Inc., 1987; 1st published 1986)

Richardson, John, *A Life of Picasso, 1881–1906*, Volume I (London: Pimlico, 2009; 1st published, Fine Arts Ltd, 1991); Volume II: *1907–1917: The Painter of Modern Life* (London: Pimlico, 2009; 1st published 1996); Volume III (London: Jonathan Cape, 2007)

Rilke, Rainer Maria, *Letters on Cézanne*, edited by Clara Rilke, translated by Joel Agee (New York: Fromm, 1983)

—, *The Notebooks of Malte Laurids Brigge* (New York: Vintage, 1985; 1st published 1910)

Rose, June, *Daemons and Angels: A Life of Jacob Epstein* (London: Constable, 2002)

Sabartés, Jaime, *Picasso: An Intimate Portrait*, translated from the Spanish by Angel Flores (London: W.H. Allen, 1949, rev. edn; originally published in France, n.d.; 1st published in America, 1948)

Sadoul, Georges, *Le Cinéma français (1890–1962)* (Paris: Flammarion, 1962)

Salmon, André, *L'Air de la Butte: souvenirs sans fin* (Paris: Les Éditions de la Nouvelle France, 1945)

—, *Modigliani: A Memoir*, translated by Dorothy and Randolph Weaver (London: Jonathan Cape, 1961; 1st published 1957)

Schechter, Betty, *The Dreyfus Affair: A National Scandal* (London: Gollancz, 1967)

Scheijen, Sjeng, *Diaghilev: A Life* (London: Profile, 2010; 1st published 2009)

Schneider, Ilya Ilyich, *Isadora Duncan: The Russian Years*, translated by David Magarshack (New York: Da Capo, Harcourt, Brace & World, 1968)

Schwartz, Paul Waldo, *The Cubists* (London: Thames & Hudson, 1971)

Seckel, Hélène (ed.), *Les Demoiselles d'Avignon (catalogue raisonné)* (Paris: Musée Picasso, 1988)

Sert, Misia, *Two or Three Muses: The Memoirs of Misia Sert*, translated from the French by Moura Budberg (London: Museum Press, 1953)

Shattuck, Roger, *The Banquet Years: The Origins of the Avant-Garde in France: 1885 to World War I* (London: Jonathan Cape, 1969, rev. edn; 1st published 1955)

Sichel, Pierre, *Modigliani: A Biography of Amedeo Modigliani* (London: W.H. Allen, 1967)

Sprigge, Elizabeth, *Gertrude Stein: Her Life and Work* (London: Hamish Hamilton, 1957)

Spurling, Hilary, *La Grande Thérèse: The Greatest Swindle of the Century* (London: Profile, 2006; 1st published 1999)

—, *Matisse: The Life* (London: Penguin, 2009)

—, *Matisse the Master: The Conquest of Colour, 1909–1954*, Volume II (London: Hamish Hamilton, 2005)

—, *The Unknown Matisse: A Life of Henri Matisse, 1869–1908*, Volume I (London: Hamish Hamilton, 1998)

Stein, Gertrude, *The Autobiography of Alice B. Toklas* (London: Penguin Books, 2001; 1st published 1933)

—, *Look at Me Now and Here I Am, Writings and Lectures 1909–1945*, edited by Patricia Meyerowitz, with an Introduction by Elizabeth Sprigge (Harmondsworth: Penguin, 1984; 1st published 1967)

—, *The Making of Americans. Being a History of a Family's Progress. Written by Gertrude Stein, 1906–1908* (New York, Frankfurt and Villefranche-sur-Mer: Something Else Press, 1966)

—, *Paris France* (New York and London: Liveright, 1970; 1st published 1940)

—, *Picasso: The Complete Writings*, edited by Edward Burns, with a Foreword by Leon Katz and Edward Burns (Boston: Beacon Press, 1970)

—, *Three Lives*, with an Introduction by Lyn Hejinian (Copenhagen and Los Angeles: Green Integer, 2004)

—, *What are Master-pieces . . .?* (New York, Toronto, London and Tel Aviv: Pitman Press, 1970; 1st published c.1940)

Stewart, Allegra, *Gertrude Stein and the Present* (Cambridge, Massachusetts: Harvard University Press, 1967)

Stoddart, Helen, *Rings of Desire: Circus History and Representation* (Manchester and New York: Manchester University Press, 2000)

Sutton, Denys, *André Derain* (London: Phaidon, 1959)

Szymusiack, Dominique, and Joséphine Matamoros: *Matisse–Derain 1905, un été à Collioure* (Paris: Hors Série Découvertes Gallimard, n.d.)

Toklas, Alice B., *What is Remembered* (New York, Chicago and San Francisco: Holt, Rinehart and Winston, 1963)

Védrès, Nicole, *Images du cinéma français*, with a Foreword by Paul Éluard (Paris: Les Éditions du Chêne, 1945)

Verdi, Richard, *Cézanne* (London: Thames & Hudson, 1997; 1st published 1992)

Vlaminck, Maurice, *Dangerous Corner*, translated by Michael Ross, with an Introduction by Denys Sutton (London: Elek Books, 1961; 1st published as *Tournant dangereux*, 1929)

Vollard, Ambroise, *Recollections of a Picture Dealer*, translated from the original French manuscript by Violet M. MacDonald (London: Constable, 1936)

—, *Souvenirs d'un marchand de tableaux* (Paris: Albin Michel, 1937)

Vrubel, Mikhail, *Vrubel*, compiled and with an Introduction by S. Kaplanova (Leningrad: Aurora, 1975)

Walsh, Stephen, *Stravinsky: A Creative Spring, Russia and France, 1882–1934* (London: Pimlico, 2002; 1st published 2000)

Walther, Ingo F., *Pablo Picasso: Genius of the Century* (Hong Kong, Cologne, London, Los Angeles, Madrid, Paris and Tokyo: Taschen, 2007)

Warnod, Jeanine, *Washboat Days: Montmartre, Picasso and the Artists' Revolution*, translated by Carol Green (New York: Orion, Grossman, 1972)

White, Palmer, *Poiret* (London: Studio Vista, Cassell and Collier Macmillan, 1974; 1st published 1973)

Woolf, Virginia, *Roger Fry: A Biography* (Harmondsworth: Penguin, 1970; 1st published 1940)

Zola, Émile, et al., *Cézanne vu par . . .*, texts chosen and annotated by Laure-Caroline Semmer (Paris: Beaux-Arts Éditions, 2011)

Exhibition Catalogues

Catalogues of the Salons d'Automne, 1903 onwards, Documentations Orsay, Paris

André Derain, Grand Palais, 15 February–11 April 1977 (Rome: Edizioni dell'Elefante, 1976, and Paris: Éditions des Musées Nationaux, 1977)

Diaghilev and the Golden Age of the Ballets Russes 1909–1929, edited by Jane Pritchard (London: V&A Publishing, 2010)

Hopmans, Anita, *Van Dongen* (Paris: Musée d'Art Nationale de Paris, 2011)

Kahng, Eik, et al., *Picasso and Braque: The Cubist Experiment 1910–1912* (Santa Barbara Museum of Art/Kimbell Art Museum, Fort Worth, distributed by Yale University Press, New Haven and London, 2011)

Matisse, Cézanne, Picasso . . . l'aventure des Stein (Paris: Grand Palais, Galeries Nationales, 5 October 2011–16 January 2012; San Francisco: San Francisco Museum of Modern Art, 21 May–6 September 2001; New York: The Metropolitan Museum of Art, 22 February–3 June 2012) Éditions de la RMN – Grand Palais, 2011.

McCully, Marilyn, *Picasso 1900–1907: les années parisiennes* (Musée Picasso, Barcelona, 30 June–15 October 2011 and Van Gogh Museum, Amsterdam, 18 February–29 March 2011)

— (ed.), *Picasso: The Early Years, 1892–1906*, National Gallery of Art, Washington, 1997; Museum of Fine Arts, Boston, 1998 (New Haven and London: Yale University Press, 1997)

Utrillo, Valadon, Utter, 12 rue Cortot: un atelier, trois artistes, Foreword by Yanick Paternotte (Sannois, Val d'Oise: Musée Utrillo-Valadon, Sannois, 2008)

Index